# Performing Arts Center Management

Performing arts centers (PACs) are an integral part of the cultural and creative industries, significantly influencing the cultural, social, and economic vitality of communities around the world. Virtually all PACs are community-based and serve the public interest, whether structured as a public, nonprofit, for-profit, or hybrid entity. However, there is a lack of knowledge about the important community role of performing arts centers, especially those that mainly host and present work produced by other arts organizations. This gap is startling, given the ubiquitous presence of PACs in urban centers, small communities, as well as colleges and universities.

This coedited reference book provides valuable information at the intersection of theory and practice in the professional field of executive leadership of performing arts centers. Drawing on the expertise of leading academics, consultants, and executives, this book focuses on institutions and practices in the United States and is contextualized within additional fields such as cultural planning, urban revitalization, and economic development.

*Performing Arts Center Management* aims to provide valuable theoretical, conceptual, empirical, and practice-based information to current and future leaders in creative and cultural industries management. It serves as a unique reference for researchers, university students, civic leaders, urban planners, public venue managers, and arts administrators aspiring to improve or advance their work in successfully managing performing arts centers.

**Patricia Dewey Lambert** is Associate Professor of Arts Management at the University of Oregon (UO), USA, where she leads the performing arts management specialization.

**Robyn Williams** has worked across the United States in the public assembly facility management field for more than thirty years, and is currently Executive Director for Portland'5 Centers for the Arts in Portland, Oregon, USA.

# Routledge Research in Creative and Cultural Industries Management

Edited by
Ruth Rentschler,
*University of South Australia Business School, Australia*

For a full list of titles in this series, please visit www.routledge.com

Routledge Research in Creative and Cultural Industries Management provides a forum for the publication of original research in cultural and creative industries, from a management perspective. It reflects the multiple and inter-disciplinary forms of cultural and creative industries and the expanding roles which they perform in an increasing number of countries.

As the discipline expands, there is a pressing a need to disseminate academic research, and this series provides a platform to publish this research, setting the agenda of cultural and creative industries from a managerial perspective, as an academic discipline.

The aim is to chart developments in contemporary cultural and creative industries thinking around the world, with a view to shaping future agendas reflecting the expanding significance of the cultural and creative industries in a globalized world.

Published titles in this series include:

**Arts and Commerce**
The Colonization of No Man's Land
*Edited by Peter Zackariasson & Elena Raviola,*

**Artistic Interventions in Organizations**
Research, Theory and Practice
*Edited by Ulla Johannson Sköldberg, Jill Woodilla
and Ariane Berthoin Antal*

**Rethinking Strategy for Creative Industries**
Innovation and Interaction
*Milan Todorovic with Ali Bakir*

**Arts and Business**
Building a Common Ground for Understanding Society
*Edited by Elena Raviola and Peter Zackariasson*

**Performing Arts Center Management**
*Edited by Patricia Dewey Lambert and Robyn Williams*

# Performing Arts Center Management

Edited by Patricia Dewey Lambert
and Robyn Williams

Routledge
Taylor & Francis Group

NEW YORK AND LONDON

First published 2017
by Routledge
711 Third Avenue, New York, NY 10017

and by Routledge
2 Park Square, Milton Park, Abingdon, Oxon OX14 4RN

First issued in paperback 2018

*Routledge is an imprint of the Taylor & Francis Group, an informa business*

© 2017 Taylor & Francis

*Library of Congress Cataloging in Publication Data*
A catalogue record for this book has been requested.

ISBN 13: 978-1-138-33995-8 (pbk)
ISBN 13: 978-1-138-69593-1 (hbk)

Typeset in Sabon
by Apex CoVantage, LLC

Dedicated to all the performing arts center leaders who, for half a century, have been working tirelessly to develop this field.

# Contents

# Tables, Figures, and Boxes

## Tables

## Figures

## Boxes

# Preface

Performing arts venues come in all shapes and sizes—from small community-based or faith-based centers, to collegiate theaters and auditoriums, to major urban facilities. This book is about leading and managing performing arts centers (PACs), particularly those that are located in urban regions and serve a diverse, community-wide audience base. These PACs typically provide a home for the city's symphony orchestra, opera, and ballet and offer to their local audience touring productions like Broadway musicals, commercial concerts, and comedy. Although performing arts centers are a key element of cities' arts infrastructure, and often serve to anchor cultural districts and otherwise support arts economic development initiatives, surprisingly little attention is paid to these organizations. It seems to be taken for granted that these complex, multimillion-dollar institutions will be built and maintained by communities, and be responsibly managed by whatever organization is working behind the scenes to support a vibrant and dynamic local arts scene.

But running a performing arts center is anything but easy. Leaders of these organizations need to work seamlessly across governmental entities, diverse community groups, a wide array of nonprofit arts organizations, and numerous revenue-generating activities. They have to lead their organization within complex and ever-changing environments, responding to shifting public expectations for what these kinds of institutions should provide to their communities. They must embrace their leadership role within the community infrastructure and within the local arts community. The performing arts center type that is the focus of this book is an institution that mainly hosts or presents performing arts produced by another entity rather than produced by the PAC itself. Very few reference materials exist on this type of cultural institution, even though the institution type is generally recognized as a core element of a community's creative and cultural industries infrastructure. We are grateful to the editorial team of the Routledge series on Research in Creative and Cultural Industries Management for recognizing this gap in existing published scholarship, and for encouraging us to move forward with this project.

The coeditors of this book first met in 2003 when Patricia moved to the University of Oregon to head up the performing arts management concentration area of the university's master's degree program in arts management. At that time, Robyn had been serving as the executive director of the Portland Center for the Performing Arts (now Portland'5 Centers for the Arts) for three years. For more than a decade, we have been collaborating in building professional development opportunities for graduate students and young professionals in the niche specialization of performing arts center management. During this time, the performing arts committee of the International Association of Venue Management (IAVM) and leaders in this field of expertise from throughout North America have provided excellent input into our thinking about professionalization of this field through the annual IAVM Performing Arts Manager's Conference.

This book project was a logical next step for us. We were delighted with the enthusiastic response of the contributing authors we invited to participate in this project—and the result is a collection of writings from a veritable who's who of executives, consultants, and academics currently focused on this field. The authors mostly come from the United States, which was a decision we intentionally made to delimit this project, although we recognize that the field of performing arts center management is enormous (and growing) throughout the world. *Performing Arts Center Management*, we hope, will launch an array of future publications that will continue to contribute to research and practice in this field.

We wish to thank all of the contributing authors for their willingness to share their unique knowledge and expertise in this book. We are especially grateful to Larry Henley for his support in integrating this project within the 2016 IAVM Performing Arts Manager's Conference and Ken Harris for enthusiastically joining us as a wonderful partner in developing the final chapter of this book. Robyn gratefully acknowledges the assistance of her many industry friends and colleagues in supporting her role in this book project, especially Millie Dixon, Ted Dedee, and Phil Jordan. Patricia thanks her graduate research assistant, Tara Burke, for her important role in serving as the book project coordinator throughout the 2015–2016 academic year. She also thanks her many performing arts management graduate students over the years who have helped inform development of this professional field of expertise, especially Mindy Linder, Rebecca Black, Courtney Hurst, and Annie Salamunovich Wilson. We thank Dianne Dewey for her proofreading skills, and Stephanie McCarthy for her excellent graphic illustration talents. Finally, we thank the editorial and production staff at Routledge for their hard work in bringing this book to print.

Patricia Dewey Lambert and Robyn Williams

# 1 The Professionalization of Performing Arts Center Management

*Patricia Dewey Lambert and Robyn Williams*

## Introducing the American Performing Arts Center

Performing arts centers (PACs) are an integral part of the creative and cultural industries, significantly influencing the cultural and economic vitality of communities around the world. Throughout North America, PACs contribute to civic vitality, enhance the vibrancy of city centers, promote cultural tourism, serve historic preservation goals, strengthen creativity and the arts in society, provide arts education, and encourage a rich cultural identity. Virtually all PACs are community based and serve the public interest, whether structured as a public, nonprofit, or for-profit entity. However, there is a lack of knowledge about the important leadership role of performing arts centers in America's arts and culture sector. This is startling, given these organizations' ubiquitous presence in urban centers and small communities, as well as colleges and universities throughout the United States and internationally.

Performing arts management researchers tend to focus on the management work of *producing* companies (i.e., organizations that fund and create their own artistic work, utilizing their own artistic, administrative, and production personnel). In contrast, extant research on *presenting* organizations (which "buy" productions and sell them to audiences) or *hosting* organizations (which provide opportunities for other producing or touring companies to rent the venues and facilities) is very thin. The performing arts center of interest to this book project is a presenting or hosting organization, which is a facility "with multiple users, where there is a management organization in place that activates a building with some combination of rentals, presented events, producing, and community programming" (Webb, 2004, p. x). A PAC that hosts or presents the performing arts is an organization that "works to facilitate exchanges between artists and audiences through creative, educational, and performance opportunities. The work that these artists perform is produced outside of the presenting organization" (Hager & Pollak, 2002, p. 9). Despite the prevalence of hosting and presenting PACs, published research and reference materials for management of such organizations are scarce. *Performing Arts Center Management* addresses the field's

need for relevant scholarship positioned at the level of advancing strategic executive leadership of such organizations.

An authoritative source for the number of PACs in North America is not available. Even the field's main professional associations—the International Association of Venue Managers (IAVM) and the Association of Performing Arts Presenters (APAP)—do not have complete listings, as not all PACs are members of these organizations. Presently, the most robust data sources for performing arts centers can be found through VenueDataSource of the IAVM Foundation (www.iavm.org/vds/vds-home), and PACStats developed and overseen by AMS Analytics LLC (ams-online.com/pacstats). An additional treasure trove of data on performing arts centers in the United States can be found on the website of the "Set in Stone" study[1] conducted within the Cultural Policy Center of the University of Chicago. Ample evidence also exists regarding significant investment in performing arts venues currently underway internationally—especially in the Asia-Pacific region—yet, again, only rough estimates exist for the large number of performing arts centers that exist in communities throughout the world.

It is difficult to investigate the role of performing arts centers within the creative and cultural industries because PACs are found everywhere and have many diverse community functions and organizational forms. As Webb (2004) explains, a PAC can be owned and operated by local government; a division, department, or agency of a city, county, or state government; an educational institution; a church or religious organization; a private nonprofit organization; or a commercial organization. The matter of PAC oversight is further complicated by the fact that the PAC's owner and operator are frequently not the same entity.

According to Hager and Pollak (2002, citing data from the Association of Performing Arts Presenters) as well as Webb (2004, p. x) major issue areas affecting the leadership and operation of all performing arts centers are the increasing use of technology in the performing arts, changing revenue streams, changing audience behaviors and preferences, an increasing and diversifying role that these organizations play in their communities, and the ever-increasing complexity of PAC management responsibilities. Furthermore, one must consider the important role of performing arts centers in helping make it possible for nonprofit professional performing arts organizations to present their work in their communities. Urban performing arts centers often host *resident companies*, which are local arts organizations that work with their own hired talent—either local or contracted from out of town—to produce and perform their own productions in a subsidized "home." A PAC's resident companies typically comprise the city's symphony orchestra, opera company, and ballet company, along with any number of additional performing arts groups. Revenue from presenting touring commercial productions and other events makes it possible for a PAC to subsidize the use of the hall for its local resident companies.

## The PAC in the Local Creative Economy

In the United States, policy action and investment in the arts and culture sector and the creative economy is concentrated at the local level, often mediated by local arts agencies and local economic development departments of government (Wyszomirski, 2008). Urban cultural planning efforts often seek to engage the arts and culture sector in revitalizing and developing vibrant, sustainable communities through focusing on the local creative economy (Borrup, 2006; Evans, 2001; Landry, 2000; McCarthy, Ondaatje, & Novak, 2007). If artistic, administrative, and technical workers are at the core of the performing arts within the entire creative economy, it can be argued that PAC facilities and venues serve as a crucial support element of the "downstream distribution infrastructure" of the creative and cultural industries sector (Cherbo, Vogel, & Wyszomirski, 2008):

> The *downstream distribution infrastructure* connects the creative industries to their markets and consumers. This includes retail outlets; media and advertising; presentation and exhibition venues; the services of agents, brokers, and other intermediaries such as critics and art dealers; market and audience research services; and an ever-changing cast of partners and collaborators that links the artists and arts organizations to new audiences and instrumental uses.
>
> (pp. 15–16)

When conceiving of the performing arts center as a key player in the arts and culture distribution infrastructure in any given local community, it is easy to see how the PAC might become a central focus of urban cultural planning and development efforts. Indeed, performing arts centers appear to often be the "crown jewel" of urban development and revitalization efforts. Although major performing arts venues have long been located at the heart of cities, the past 30 years have observed a dramatic expansion of cultural facilities as an explicit element of urban development strategies (Strom, 2003).

> By the 1980s . . . cities began to promote their arts—real and invented— as a major quality-of-life asset in the belief that a vital artistic sector would increase their competitive edge in attracting visitors, residents, and the creative worker. Business in turn would be attracted by the opportunity to capitalize on this critical mass of consumers and highly skilled employees. That the arts can play an important role, even a linchpin role, in a municipal redevelopment strategy is an idea that has gained sufficient traction to warrant a measure of confidence in the arts as a key element of revitalization policy.
>
> (Stewart, 2008, p. 113)

Cities are growing increasingly competitive in developing urban communities that feature cultural amenities to attract and stimulate creativity

and innovation. In the first decade of the twenty-first century, communities routinely commissioned cultural plans, establishing cultural districts, investing significant sums of money in cultural facilities, and developing new revenue sources earmarked for support of the arts (Markusen & Gadwa, 2010, p. 379). Arts-based revitalization and the promotion of cultural districts have become important policy tools for cities. As Galligan (2008) explains, a *policy tool* is "an instrument or plan of action undertaken by a municipality in achieving social, economic, political, or aesthetic goals with clearly delineated outcomes in mind" (p. 129). While a *cultural district* may simply refer to an area of a city that is recognized for a high concentration of cultural and entertainment facilities (Smith, 2007), a definition more useful to urban planning is that "a cultural district is a well-recognized, labeled, mixed-use area of a city in which a high concentration of cultural facilities serves as the anchor of attraction" (Frost-Kumpf, 1998, p. 7).

Furthermore, a municipality's strategic investment in the development of a cultural district is frequently intertwined with economic and tourism goals. Markusen and Gadwa (2010) identify two widely employed strategic choices made by urban regions: "(1) designated cultural districts anchored by large performing and visual arts spaces versus dispersed 'natural' cultural districts with smaller scale nonprofit, commercial, and community cultural venues and (2) tourist-targeted versus local-serving cultural investments" (pp. 379–380). Throughout North America, many communities have now created cultural districts "where informality and aesthetic stimulation combine through the juxtaposition of performance spaces, eclectic stores, and new-style eateries" (Donnelly, 2011, p. 33). It is beyond the scope of this book to explore in-depth the diverse goals, structures, and operations of cultural districts, but the role of major performing arts facilities in the planning and ongoing life of a cultural district is referenced in many chapters of this book and begs further investigation.

## A Typology of Performing Arts Centers in the United States

To begin an in-depth study of the relationship between performing arts centers and their communities—which is the overarching theme of the chapters in this book—one must first understand the basic governance models, institutional forms, functions, and revenue streams of these entities. In the United States, performing arts centers are divided into four main types: *mega-PACs*, *small market PACs*, *collegiate PACs*, and *major metropolitan PACs*. A further key distinction among venue is found among venue types that are *presenting* or *hosting* organizations, as discussed earlier in this chapter, as well as whether or not the PAC hosts local resident companies. Regardless of the category or type, leaders of all PACs see themselves as community engaged, and most aspects of PAC structure and operation are quite similar (with the exception of ownership and governance). What

differs dramatically among PACs is the scale of operations, as determined by budget, number and size of venues, mission, and programming.

In the United States, one "typical" set of PACs is venue management organizations that serve a large urban region. The *major metropolitan PACs* may run one venue or multiple venues, and can be further differentiated by budget, programming, and art education programs, along with other community engagement initiatives. The funding of these organizations varies significantly in all three categories of government support, nonprofit funding streams, and commercial revenues (as well as various combinations of funding streams). The governance and local politics associated with the PAC also vary enormously. Because of these institutions' important role in providing benchmarks for the field as a whole, Chapter 7 of this book analyzes a sample set of major metropolitan PACs in detail.

In comparison with the typical PAC found in all urban communities, well-known large PACs like Lincoln Center, the Kennedy Center, and the Sydney Opera House—which we term *mega-PACs*—possess identical structures and function to the typical urban PAC, but have resources available to make the scale of operations much larger. Mega-PACs also tend to have national and international reputations as cultural institutions. In contrast, *small market PACs* tend to be community arts based and community-focused venues. The mission and programming of these PACs reflect the smaller venue size (typically fewer than 1,000 seats), as well as lower budgets. Throughout the United States, a wide range of PACs is also managed under the auspices of colleges and universities. In terms of basic operations and programming, *collegiate PACs* do not differ significantly from other types of PACs. However, the academic mission, student focus, university governance system, and funding streams distinguish this set.

## Functions and Operations of Performing Arts Centers

A snapshot of the range of types of arts and culture programming and for-profit activity exhibited by "typical" (major metropolitan) PACs throughout the United States may help to introduce the professional management functions and organizational structure required of these entities.

Performances and activities that take place within PACs appear to fall into four major categories: resident company performances, other performing arts presentations, community-focused events and activities, and profit-making activities. Support of resident companies is a particularly interesting (and often-frustrating) mandate of PACs. This responsibility includes assisting resident companies by providing privileged use of the venue calendar, as well as subsidized use of the facilities, which dramatically impacts the capacity of the PAC management to program other performances and activities with higher revenue streams. Table 1.1 lists the main subcategories of both venue programming and ancillary revenues. This wide range of activity

*Table 1.1* Main Types of PAC Programming and Ancillary Revenues

| Venue Programming | Ancillary Revenues |
| --- | --- |
| Resident company performances | Concessions and restaurants |
| Broadway series | Merchandise sales |
| International touring and presenting | Parking income |
| National/regional touring and presenting | Facility fees/user fees |
| Commercial concerts | Ticketing commissions |
| Family/kids programs | Equipment and utility charges |
| Lectures | Other for-profit activity |
| Community events | Labor charges |
| Conferences and meetings | Rental fees |
| Weddings, banquets, and receptions | Advertising |
| Other private events | Sponsorship |
| Other venue rentals | |

suggests the need for managerial competency in balancing seemingly anti-thetical mandates and responsibilities.

In reviewing the list in Table 1.1, one is struck by the complexity of planning and tracking diverse revenue streams in PAC operations. In order to meet public mandates of supporting resident companies and serving as a convener for community events, the PAC leadership must efficiently make money and save money. Obviously, the form of ownership, governance, and management structure will greatly impact the PACs ability to do so. Governance and ownership models for PACs are discussed in detail in several chapters of this book; in the following, we provide an introduction to PAC organizational structure of management.

Although the administration of PACs can be structured in highly diverse ways—corresponding to the wide range of ownership and governance of PACs—considerable similarity in the main functions of management seems to exist. Reviewing leadership titles and staffing of performing arts centers across the United States reveals organizational structures that are strikingly similar to those of nonprofit professional performing arts organizations. One might speculate that patterns of professionalization of nonprofit arts organizations from the mid-1960s to today have greatly influenced professionalization of performing arts centers in the same period.

The first main grouping of PAC functions has to do with executive oversight and financial systems. A chief executive officer (a position that has many different titles) oversees an executive office staff, financial management personnel, and information technology systems and support, all of which are closely linked to the daily operations of the chief executive's office. Many PACs have strong development departments, which often include personnel expertise in individual, foundation, government, and corporate fund-raising. Human resources functions of the PAC are often as externally focused as they are internally focused. Many PACs promote active "friends"

groups and volunteer opportunities, many of which are closely linked with the education and community engagement programs supported by the organization. Some PACs have large education departments that correspond with the organization's mission. Marketing and public relations functions mirror those of a nonprofit performing arts company, but ticketing operations are often greatly expanded to support a wide range of ticket sales corresponding with the diverse programming activities of the PAC. Marketing and PR operations also vary considerably among PACs, depending on the nature of collaboration and support of resident companies, as well as the distinction of the PAC as a presenting or a hosting organization.

Where the management of a PAC differs most from that of a nonprofit performing arts organization has to do with the nature, scope, and extent of programming and venue operations. A programming (or artistic) director sometimes exists in the entity, but frequently the emphasis of the organization is on securing venue bookings and providing effective production operations. The programming role of the PAC—that is, reflecting the artistic mission and curatorship responsibility of the entity—only rarely appears to be a focus of the *hosting* PACs. *Presenting* PACs embrace their curating role to a much greater extent as a way to support their mission, but PAC leadership and management across institutions tend to emphasize professional venue management functions. Professional organizational functions may include any or all of the following: *operations* (security, housekeeping, hospitality, concessions); *production* (technical responsibilities, production management, stage management); *rentals and booking*; and *event services*. In short, where a PAC differs from a professional nonprofit arts organization is in the PAC's significant focus on bricks and mortar assets as well as on guest services such as safety and security, food and beverage, and the general guest experience in the facility.

From this discussion of organizational models, functions, operations, and revenue streams of performing arts centers, it may be inferred that a distinct set of core leadership and management competencies is required. In their organizations, PAC leaders are working at the nexus of public administration, nonprofit management, and for-profit entrepreneurship. In their communities, PAC leaders are engaged as an advocacy voice for the arts in promoting their venues as a community asset. In both contexts, PAC executives must provide visionary, strategic, and transformational leadership. *Performing Arts Center Management* presents diverse perspectives on what the distinct set of core PAC leadership and management competencies should include. Ultimately, the final chapter summarizes and synthesizes across the chapters to develop recommendations for advancing executive leadership in the field.

## Professionalization of PAC Leadership

Most individuals who currently hold executive-level positions with performing arts centers throughout the United States developed their field-specific knowledge and skills through their years of on-the-job experience. With

the increasing sophistication of PAC business operations, however, executives now frequently require MBAs to become chief financial officers, and more and more universities are offering sports management, entertainment management, or arts administration preprofessional training that includes a significant focus on venue management. These educational programs reflect the need for specialized management training due to public venues' highly complex business models, multimillion-dollar budgets, the demands of asset and capital project management, myriad software systems and other technologies used in these organizations, and the increasing complexity of booking, contracting, and event management operations.

In addition, professional associations such as the International Association of Venue Management (IAVM) offer their own professional development system and education programs. Foremost among these is the IAVM's Certified Facilities Executive (CFE) Program, a professional distinction that requires recertification (requiring continuing professional development) every three years. The rigorous certification process requires professional development and service, a written examination, and an oral interview.

The IAVM offers web-based education through an e-Learning Center and various webinars, as well as occasional specialized professional development programs in Asia and the United States. In the United States, several specialized programs exist for safety, security, and technology: the Academy for Venue Safety and Security (an IAVM school); the School of Ice Technologies; and U.S. Department of Homeland Security courses. In the United States, three general facilities management institutes are run by the IAVM: the Public Venue Management School (PVMS), the PVMS Graduate Institute, and the annual Senior Executive Symposium.

As the chapters of this book argue, however, the field is rapidly changing and requiring an increasingly nuanced set of arts leadership expertise. After all, PAC leaders are now engaged as key supporters of the entire performing arts infrastructure, and as an advocacy voice for the full arts and culture sector in their communities. The manifold competencies and skills required of performing arts center leaders suggest a need for a distinct capacity-building approach. Such an approach would need to address the hybrid mix of public administration, nonprofit management, and for-profit entrepreneurship competencies required of these leaders. It would need to address international, domestic, and organizational spheres of engagement, as PAC managers serve a significant leadership role in cultural policy functions such as cultural diplomacy (through international touring and presenting), as well as promoting domestic (regional and local) arts engagement and community cultural development.

The need for current and future PAC executives to exhibit strategic leadership and strong change management capacities may be best addressed by developing a systemic capacity building approach. At a macro level, the

context within which PAC leaders operate calls for the development of five key change management capacities. Engagement with international touring and presenting, as well as engaging diverse cultures within the community requires the capacity *to manage international cultural interactions and to represent cultural identity.* Shifts in audience behavior and the constant increase of competition from diverse leisure activities require the capacity *to promote innovative methods of audience development.* The diverse revenue streams involved in PAC management require the capacity *to foster a sustainable mixed funding system.* Most important, PAC leaders must exhibit *effective strategic leadership,* including constant strategic awareness and an entrepreneurial focus on changing environmental demands in the international, domestic, and organizational spheres of engagement (Dewey, 2005, p. 13).

These change management capacities, along with basic content-based training material specific to performing arts center management, can be provided through a system of formal university education, non-degree-granting professional development programs, and on-the-job training. The performing arts center management specialization might be best viewed as a distinct area of training within arts administration. Arts administration (also commonly referred to as cultural administration or arts management) is gaining recognition internationally as a specialized field in both professional and academic spheres. Indeed, specialized publications, conferences, higher education training programs, and professional organizations in the field of arts management all point to this academic field and profession evolving consistently over the past four decades. As discussed previously, a similar process of professionalization of the larger venue management field has taken place during the same time.

It is common knowledge that, throughout the world, municipalities, cultural districts, communities, and institutions of higher education have performing arts centers that require professional leadership and management. Although there are many university-level arts administration programs and several professional development programs focused on facilities management, the time may now be right to develop specialized programs designed to develop leaders in performing arts center management. Such programs would likely focus on graduate students and on early to mid-career professionals.

The chapters in this book illuminate many distinct capacity-building needs for performing arts center professionals. While specific approaches to professional development for (emerging) executive directors have not yet been fully developed at the university level, representative topics for the content of such capacity building are listed in Box 1.1. Two core competency areas emerge as key to the ongoing professionalization of the field: (1) advancing the role of PAC executive leadership within and for the community and (2) cultivating specialized expertise required of performing arts management within the PAC context.

## Box 1.1   Professional Competencies Required of PAC Managers

### Competency Area 1: PAC Executive Leadership and the Community

- Executive leadership in the performing arts across the public, nonprofit, and for-profit sectors—how performing arts center leaders require competencies in all three spheres
- The role of performing arts centers in urban planning, development, and renewal; in cultural districts; and in institutions of higher education
- Political acumen and advocacy skills to work with governmental entities
- Diverse governance systems, institutional structures, and functions of performing arts centers
- The changing context of performing arts management and changing audience behaviors and expectations
- Audience development, arts education, and community engagement
- International touring and presenting, cultural exchange, and cultural diplomacy
- Performing arts centers and historic preservation, public art spaces, and art galleries

### Competency Area 2: Performing Arts Management in the PAC

- Organizational structure and functions in the performing arts center
- Working with nonprofit resident companies and for-profit presenters
- Financial management acumen; developing earned and contributed revenue streams (marketing and fund-raising functions in the performing arts); developing ancillary revenues
- Programming, touring, presenting, and scheduling in the performing arts
- Managing international and cross-cultural interactions in the performing arts
- Artist management, artist contracts, and artist relations
- Union negotiations and contracts
- Performing arts center design and technology
- Production management and stage management

Professional development in performing arts center management is challenging due to the thin corpus of relevant published resources to support instruction. Given the primary focus of this book on performing arts centers in the United States, we limit our overview of educational materials that follows to resources generated by American scholars and practitioners in the field. At the time of writing this chapter, only three reference books (Stein & Bathurst, 2008; Webb, 2004; Woronkowicz, Joynes, & Bradburn, 2015) directly address some of the skills needed by performing arts center management. Additional reference materials serve as key resources for the basics of facilities management (Mahoney, Esckilsen, Jeralds, & Camp,

2015), as well as PAC facilities design and development (Kliment, 2006; Petersen, 2001). An excellent introduction to theater management and production management is provided by Conte and Langley (2007), and numerous references are available to develop stage management skills (e.g., Fazio, 2000). Two good sources of information about the world of performing arts touring and presenting have been provided by Micocci (2008) and Shagan (1996). More general to performing arts management, Kotler and Scheff's (1997) *Standing Room Only: Strategies for Marketing in the Performing Arts* remains the leading reference in the field. Publications by Bernstein (2007, 2014) and Colbert (2012) provide helpful strategies to performing arts center managers for marketing, communications, and audience development. Those who wish to acquire a more solid basic introduction to the field of arts administration will also wish to consult *Management and the Arts* by Byrnes (2014), *Fundamentals of Arts Management* by Korza, Brown, and Dreeszen (2007), and *The Arts Management Handbook* by Brindle and DeVereaux (2011).

Ongoing professionalization of performing arts center management urgently needs published resources, educational offerings, and professional development opportunities to meet the ever-increasing leadership demands in this industry. *Performing Arts Center Management* has been written to synthesize across existing knowledge and practice in the field, to provide valuable expertise to current and future leaders, and to set an agenda for continued research and capacity building for this specific field within the creative and cultural industries.

## Overview of the Book Chapters

This coedited reference book provides valuable, timely, and relevant information at the intersection of theory and practice in the professional field of executive leadership of performing arts centers. Contributing authors represent a unique mix of academic researchers, internationally renowned consultants in the field, and some of the most respected senior executive leaders in the field. Voices from these authors span styles that can be characterized as expert essays (which read much like an in-depth interview) to analyses drawn from highly rigorous qualitative and quantitative field research. As a result, this book as a whole is positioned squarely at the intersection of theory and practice, and results in a descriptive, critical, and pragmatic reference that is highly accessible to all readers and should appeal equally to university students and practitioners in the field.

The topics addressed in *Performing Arts Center Management* flow logically as a series of questions for scholars, executives, and community leaders. The book begins with several chapters that unpack the question: *What are performing arts centers and what should these organizations do in their communities?* The next two chapters seek to frame the question: *What kind of theater should you build, and how should your community go about*

*building or significantly renovating a performing arts center?* The following three chapters address the question: *How should you structure the ownership, governance, and operational aspects of your community's performing arts center?* The book then provides three case-study chapters that effectively investigate specific key aspects of performing arts center leadership; namely, the impact of the PAC on the local community, ways in which the PAC can offer models of collaboration and partnership among local performing arts organizations, and international horizons in performing arts center management. The final chapter of the book synthesizes across all of the preceding chapters to provide a wrap-up critical analysis of emergent needs for executive leadership for performing arts centers.

Drawing on the expertise of current leading academics, consultants, and executives, this edited volume focuses on institutions and practices in the United States and is contextualized within additional fields such as cultural planning, urban revitalization, and economic development. This book aims to serve as a valuable resource for researchers, university students, urban planners, public venue managers, and arts administrators. The chapters that follow are packed with information, insight, and expertise that will educate university students and guide professionals in this specialized area of theory and praxis.

*Performing Arts Center Management* begins with several chapters that introduce the performing arts center as a unique cultural organization and provide an overview of what takes place within the facility, how the PAC connects with its community, and what the major functional areas of PAC management entail. In Chapter 2, drawing on more than 25 years as a leading consultant in the field, author Steven Wolff argues that contemporary PACs are sophisticated businesses run by highly trained professional staff and guided by deeply engaged boards. In a dynamic environment that includes rapidly changing communities, complex redefinition of the marketplace, and new realities of operating economics, it is critical that all aspects of the organization are highly functioning, well organized, and effective. Data and an understanding of best practices are at the heart of a successful operation. Wolff's chapter, titled "Evolution of the Performing Arts Center: What Does Success Look Like?" explores five generations of PACs, providing business and programming models that illustrate their evolution. The chapter examines different operator/owner models (nonprofit, government, and commercial) and programming approaches (landlord, host, presenter) to illustrate the activity and financial evolution of performing arts centers by using exemplars from the author's planning and consulting work over the last 27 years. The chapter also investigates how the role and public value of the performing arts center have evolved over the last five or six decades, describes how PACs are typically structured, and suggests the most appropriate and effective roles for organizational leadership.

A second foundational chapter is provided by another leading consultant in the field, Duncan Webb, in Chapter 3, titled "Trends in the Development

and Operation of Performing Arts Centers." This chapter explores some of the major forces and trends at work in the performing arts sector and how they are impacting the development and operation of performing arts centers. These forces include changes in consumer behavior and patterns of arts participation, shifting economic pressures on nonprofit arts organizations, new priorities in economic and community development, and ebbs and flows in the sources of funds available to support the performing arts. These trends are changing the way that performing arts facilities are being developed and operated—how different sizes and shapes of buildings are being brought to life, how operating organizations are created and staffed, and how sustainability is being pursued with different resources and tools. In this chapter, Webb provides a series of recommendations for how performing arts center leaders might proactively respond to these changes. He highlights the role and responsibility of the PAC executive in facilitating the purpose and value of the PAC to its community.

A third foundational chapter is provided by Tony Micocci in Chapter 4, titled "Programming the Performing Arts: Balancing Mission and Solvency." This chapter explores senior management's perspective on programming the stages of PACs and provides a comprehensive overview of programming options—from renting through commissioning, presenting, and producing. The chapter addresses this from the perspectives of organizations established as commercial entities with purely profit motives, and those that are designated nonprofits seeking a balance of fiscal stability and service to cultural and community missions beyond profit. The two primary lenses used in this chapter are (a) *the role of risk* in the choices and models available to PAC managers and (b) *the history of PAC programming* from early roles as passive "roadhouses" to current expectations of greater proactivity in programming and community cultural leadership. In this discussion, Micocci discusses events that significantly affected the industry nationally, such as the groundbreaking Next Wave Festival at the Brooklyn Academic of Music in the early 1980s and the national branding of "Broadway." Overall, this chapter offers the reader excellent insight into how the role of the programming and presenting functions of a PAC have evolved over the years and provides an inventory and a critical assessment of strategic approaches that PAC leaders might want to take in developing their presenting role in their communities.

The next two chapters of the book shift the reader's focus to reenvisioning the PAC facility—especially the theater design—and to developing a community's plan for building or renovating its performing arts center. Richard Pilbrow, one of the world's preeminent theater consultants, contributes, as Chapter 5, an essay titled "Magic of Place: An Unrecognized Revolution in Theater Architecture." Pilbrow's narrative inspires readers to discover ways in which exciting theater design and supportive architecture can make a community's theater space something special indeed—a lively, thrilling heart to the modern performing arts center. This essay explores the intricate

biographical history of the author as he became internationally renowned for theater design consultancy. He shares his observations of how theaters have evolved in their architectural design over the years, and he advocates for the crucial need to focus on the audience experience within theaters. Pilbrow also provides insight into the work of a theater consultancy team and the crucial role of this group of experts in conceptualizing, designing, and constructing a successful venue. Throughout the essay, Pilbrow argues compellingly for the need for theaters to create a "sense of place" that provides a vibrant place for the community to gather and to "belong."

Chapter 6, "Building Performing Arts Centers," continues the focus on the performing arts facility, but turns to community leadership approaches to successfully build or significantly renovate a PAC. Author Joanna Woronkowicz suggests that arts leaders across the country often have similar motivations for building a new PAC. For example, a PAC is seen as a solution to the problem of not having adequate space for regional performing arts groups. Or, a new downtown PAC is used as a tool to help spur economic development. Yet many new PAC initiatives fail to pass muster when it comes to financing the center's operations and staying true to its original mission after the project is completed. Local governments and board trustees are sometimes asked to contribute more money, or PAC leadership must find other revenue-generating activities ancillary to the organization's mission of educating the public through the arts. This chapter explores from a leadership perspective how arts leaders can try to predict whether the time is right to build a new PAC. Using data from over 400 PAC projects built in the United States between 1994 and 2008, the author explores the question, "Should you build?" The chapter outlines a series of best practices based on the experiences of others who built PACs in the latest cultural building boom. It also offers management insight for leading large PAC projects based on psychological research on decision-making.

When a community decides to build or renovate a performing arts center, it must also make crucial decisions regarding the ownership, governances, and operational structures and staffing of the organization. In Chapter 7, "Ownership and Governance of Urban Performing Arts Centers," contributing coeditors Patricia Lambert and Robyn Williams analyze original research on ownership and governance structures associated with a "typical" set of PACs that serve a large urban region. The data set reveals three major forms of community ownership: (1) the PAC is run by/as a nonprofit 501(c)3 organization, (2) the organization is run by/as a cultural district or a cultural center, and (3) the PAC is run by a department or division of a city, county, or state government. Multiple variations and hybrid forms of community ownership exist within these three main types, and in most cases, the ownership, governance, and management model is a unique and complex public/nonprofit hybrid. So, how can a community decide to structure its PAC ownership and governance structure so that it is best suited to the local context? Many questions should be explored, such as (1) Is the PAC to be

directly owned and operated, or run at arm's length, or structured as an organization independent from the city's public administration? (2) Is the PAC to be primarily a public (government-run) organization, a nonprofit organization, or some kind of quasi-governmental or mixed organizational form? and (3) Does the city wish to distinguish ownership and maintenance of the facility from leadership required for the operations and programming of the facility? By analyzing and profiling diverse ownership and governance models that currently exist, this chapter provides crucial guidance to civic leaders.

In Chapter 8, Patrick Donnelly then turns to a detailed overview of senior leadership functions involved in "Managing Venue Operations for a Newly Opened PAC." Donnelly explains that, as construction begins on a new or renovated performing arts center, two countdown clocks start: one for completing the building project on time and one for preparing to operate the PAC when its doors open. The clock leading up to day one of venue operations involves a range of managerial decisions that influence how the PAC interacts with tenants and client organizations, with event guests and other patrons, and with the community as a whole. They are not small decisions, in that they shape business relationships and influence the operating income and expense profile for the PAC for a time span measured in years. Drawing on his considerable experience as director of theater operations for the Kauffman Center for the Performing Arts in Kansas City, Missouri— which opened in 2011—Donnelly addresses in this chapter an array of crucial senior management areas of oversight for which decisions must be made and policies established before opening the venue's doors. Such areas include furniture, fixtures, and equipment; safety and security; insurance; scheduling policies; ticketing services; parking infrastructure; food and beverage; building maintenance, financial management and budgeting; staffing; and public relations.

Given the prevalence of performing arts centers affiliated with America's colleges and universities, this book would not be complete without a chapter that provides insight into the specific ownership, governance, and operational dimensions of "Managing Performing Arts Centers in a University Setting." In Chapter 9, contributing author Larry Henley—renowned as a "go-to" senior executive who specializes in this field—gives readers an overview of what those who seek a career in PAC management within a university context will encounter in the field. This chapter provides a highly experienced perspective on how collegiate performing arts centers contribute to their university and local communities and how these organizations generally are governed and run. Henley describes in detail the distinct role of collegiate PACs in supporting the academic mission of their institution, and the unique challenges that the managers of these PACs face in programming, funding, operations, staffing, security, contracting, risk management, and event management. As Henley explains, managing collegiate PACs is highly complex as these organizations serve a dual purpose. First, university

PACs serve an educational mission by existing as training centers and performance spaces for students enrolled in theatre, music, opera, dance, and technical production programs. Second, and of equal importance, is that collegiate PACs also represent their institutions as an important gateway into the communities that they serve.

Building from Henley's specific focus on unique executive leadership challenges and opportunities in managing a collegiate performing arts center are the next three chapters, each of which explores a specific aspect of PAC leadership through an in-depth case-study analysis. Chapter 10 begins this part of the book. Author Ann Patricia Salamunovich Wilson explains that, although there have been reports and studies highlighting the economic and fiscal impact of performing arts centers, a significant gap exists in measuring and describing a more comprehensive value of these institutions to their communities. To begin to address this need for a thorough investigation into defining and measuring myriad community values provided by performing arts centers to their communities, this chapter describes and analyzes the *economic*, *cultural*, and *public engagement* values of Portland'5 Centers for the Arts to Portland, Oregon. In "Impact of the Performing Arts Center on the Local Community," Wilson frames her in-depth case study by two main questions: What is the community value of Portland'5 Centers for the Arts to the city of Portland and its surrounding region? More specifically, how does this organization contribute to and create community through public engagement impacts, economic impacts, and cultural impacts? This chapter presents findings from a yearlong comprehensive study—the first study of its kind—that assessed multifaceted and multiperspective community value of a PAC. It is hoped that the design of this study will be replicable for other communities and that PAC managers will find the embedded financial analysis of PAC subsidy of resident companies to be particularly insightful and informative.

The next case study chapter, Chapter 11, is titled "The PAC as Intermediary: Models of Collaboration and Partnerships Among Local Performing Arts Organizations." In this chapter, author Gretchen McIntosh identifies typical shared services in the performing arts and how the partnerships and collaboration among performing arts organizations are facilitated by the community performing arts center. Models of shared services are becoming more prevalent nationally, as nonprofit performing arts organizations in their quests for financial sustainability, artistic vitality, and public value often choose to partner with other performing arts organizations. The performing arts center frequently acts as an intermediary in the creative ecology to establish and define these partnerships and collaborations. The largest exemplar of a PAC administrative shared service model is the focus of this chapter, a case study of six arts organizations in a shared service agreement with Columbus Association for the Performing Arts (CAPA) in Columbus, Ohio. In this chapter, McIntosh provides an important cautionary tale to civic leaders as they consider how their own local PAC might act as a hub for

combining and sharing services among local performing arts organizations. Within the shared services model that is analyzed, there is increased access to highly skilled labor and scarce resources, as well as a sense of enhanced financial stability. However, this case study also highlights significant concerns and cultural policy implications that arise as one resource provider grows as the only viable service, tied organizations lose their autonomy, mission fulfillment becomes difficult, and reduced or centralized administrative negatively affect the long-term sustainability of the tied performing arts organizations.

The third case study chapter is titled "International Horizons in Performing Arts Center Management." The author of Chapter 12 is Douglas Gautier, an Australian PAC leader who is highly engaged in Asia-Pacific international engagement, collaborations, professional development, capacity building, and associational infrastructure development. This case study provides insight into a 10-year strategic plan undertaken by the Adelaide Festival Centre to establish itself as a prominent international arts leader, interlocutor, and collaborator. This chapter provides valuable lessons to senior PAC managers in cities around the world regarding approaches and strategies to adopt international horizons in their organization's vision, mission, goals, and operations. The most valuable lesson is that the PAC's international focus and leadership must be clearly identified as long-term strategic goals, requiring the right vehicles and partners to be put into action. Additional key lessons for PAC leaders have to do with the need for strategic programming, educational partnerships, and professional networking initiatives. With communities' increasingly global focus due to ease of international communication, travel, and trade, Gautier models strategic steps that PAC leaders might take to position their organizations at the forefront of international engagement initiatives that benefit their entire community.

Chapter 13 of the book is a team-written contribution that synthesizes across all the chapters to both summarize key content from the contributing authors and to launch into a final discussion of the need for transformational leadership for performing arts centers. In "Executive Leadership for Performing Arts Centers," the contributing coeditors have been joined by coauthor Ken Harris and three focus group members (Paul Beard, Ted Dedee, and Adina Erwin) to critically assess the main findings from the book chapters and to clearly articulate the challenges and opportunities for current and future executive leaders in the field. This team—representing a diverse group of renowned PAC senior executives—begins the chapter by offering a summary of the major concepts, ideas, strategies, approaches, practices, and lessons discussed throughout the prior twelve chapters. Interwoven with this summary is a discussion of how leaders in the field perceive the role of PACs to be changing in their communities. In short, the "public value" of a PAC is being reconceptualized in terms of what the PAC is or can be in America's communities. It follows that there is an urgent need for transformational leadership in performing arts centers due to these

organizations' changing role in their communities. This chapter draws on all of the strengths of this collaborative book project to articulate key strategies and approaches to effective executive leadership for performing arts centers.

## Conclusion

*Performing Arts Center Management* comes to print at a time of significant change in the role of this important member of the creative and cultural industries. Executive leadership of these institutions in cities and communities across the nation—and internationally—has reached a point in its ongoing professionalization that a full array of capacity building approaches for the field is both required and necessary. The first step in developing professional development options for current and future leaders in the field is to compile present-day experience and expertise into one comprehensive and accessible reference book. This book project has been developed with precisely this goal in mind. The contributing authors to *Performing Arts Center Management* all aspire to contribute to the scholarly dialogue on the creative and cultural industries, to lay a foundation for continuing professionalization of the PAC field, and to propel an active research trajectory on additional relevant topics of study.

## Note

1 See http://culturalpolicy.uchicago.edu/sites/culturalpolicy.uchicago.edu/files/setinstone/index.shtm.

## References

Bernstein, J.S. (2007). *Arts marketing insights: The dynamics of building and retaining performing arts audiences*. San Francisco, CA: Jossey-Bass.

Bernstein, J.S. (2014). *Standing room only: Marketing insights for engaging performing arts audiences*, 2nd edition. New York: Palgrave Macmillan.

Borrup, T. (2006). *The creative community builder's handbook: How to transform communities using local assets, arts, and culture*. St. Paul, MN: Fieldstone Alliance.

Brindle, M., & DeVereaux, C. (Eds.). (2011). *The arts management handbook*. New York: M.E. Sharpe, Inc.

Byrnes, W.J. (2014). *Management and the arts*, 5th edition. New York: Focal Press.

Cherbo, J.M., Vogel, H.L., & Wyszomirski, M.J. (2008). Toward and arts and creative sector. In J.M. Cherbo, R.A. Stewart, & M.J. Wyszomirski (Eds.), *Understanding the arts and creative sector in the United States* (pp. 9–27). New Brunswick, NJ: Rutgers University Press.

Colbert, F. (2012). *Marketing culture and the arts*, 4th edition. Montréal: HEC.

Conte, D.M., & Langley, S. (2007). *Theatre management: Producing and managing the performing arts*. Hollywood, CA: Entertainment Pro.

Dewey, P. (2005). Systemic capacity building in cultural administration. *International Journal of Arts Management, 8*(3), 8–20.

Donnelly, P. (2011). Arts facilities—schedules, agreements, and ownership. In M. Brindle & C. DeVereaux (Eds.), *The arts management handbook* (pp. 13–37). New York: M.E. Sharpe, Inc.

Evans, G. (2001). *Cultural planning: An urban renaissance?* London: Routledge.

Fazio, L. (2000). *Stage manager: The professional experience.* Boston, MA: Focal Press.

Frost-Kumpf, H. (1998). *Cultural district: The arts as a strategy for revitalizing our cities.* Washington, DC: Americans for the Arts.

Galligan, A.M. (2008). The evolution of arts and cultural districts. In J.M. Cherbo, R.A. Stewart, & M.J. Wyszomirski (Eds.), *Understanding the arts and creative sector in the United States* (pp. 129–142). New Brunswick, NJ: Rutgers University Press.

Hagar, M.A., & Pollack, T.H. (2002). *The capacity of performing arts presenting organizations.* Washington, DC: The Urban Institute.

Kliment, S.A. (Ed.). (2006). *Building type basics for performing arts facilities.* Hoboken, NJ: John Wiley & Sons, Inc.

Korza, P., Brown, M., & Dreeszen, C. (Eds.). (2007). *Fundamentals of arts management.* Amherst, MA: Arts Extension Service, University of Massachusetts.

Kotler, P., & Scheff, J. (1997). *Standing room only: Strategies for marketing in the performing arts.* Cambridge, MA: Harvard Business School Press.

Landry, C. (2000). *The creative city: A toolkit for urban innovators.* London: Earthscan Publications Ltd.

Mahoney, K., Esckilsen, L., Jeralds, A., & Camp, S. (2015). *Public assembly venue management: Sports, entertainment, meeting and convention venues.* Dallas, TX: Brown Books Publishing Group.

Markusen, A., & Gadwa, A. (2010). Arts and culture in urban or regional planning: A review and research agenda. *Journal of Planning Education and Research, 29*(3), 379–391.

McCarthy, K.F., Ondaatje, E.H., & Novak, J.L. (2007). *Arts and culture in the metropolis: Strategies for sustainability.* Santa Monica, CA: RAND Corporation.

Micocci, T. (2008). *Booking performance tours: Marketing and acquiring live arts and entertainment.* New York: Allworth Press.

Petersen, D.C. (2001). *Developing sports, convention, and performing arts centers.* Washington, DC: Urban Land Institute.

Shagan, R. (1996). *Booking & tour management for the performing arts.* New York: Allworth Press.

Smith, M.K. (2007). Towards a cultural planning approach to regeneration. In M.K. Smith (Ed.), *Tourism, culture & regeneration* (pp. 1–11). Cambridge, MA: CABI.

Stein, T.S., & Bathurst, J. (2008). *Performing arts management: A handbook of professional practices.* New York: Allworth Press.

Stewart, R.A. (2008). The arts and artist in urban revitalization. In J.M. Cherbo, R.A. Stewart, & M.J. Wyszomirski (Eds.), *Understanding the arts and creative sector in the United States* (pp. 105–128). New Brunswick, NJ: Rutgers University Press.

Strom, E. (2003). Cultural policy as development policy: Evidence from the United States. *International Journal of Cultural Policy, 9*(3), 247–263.

Webb, D.M. (2004). *Running theaters: Best practices for leaders and managers.* New York: Allworth Press.

Woronkowicz, J., Joynes, D.C., & Bradburn, N. (2015). *Building better arts facilities: Lessons from a U.S. national study.* New York: Routledge.

Wyszomirski, M.J. (2008). The local creative economy in the United States of America. In H.K. Anheier & Y.R. Isar (Eds.), *The cultural economy* (pp. 199–212). London: Sage.

# 2   The Evolution of the Performing Arts Center

## What Does Success Look Like?

*Steven A. Wolff*

The contemporary North American performing arts center (PAC) is a highly evolved business. While modern arts centers date back only to the 1960s, in their sixth decade these organizations are now sophisticated enterprises run by highly trained professional staff and guided by deeply engaged boards. In an environment of dramatic change that includes rapidly changing communities, a fast and complex redefinition of the marketplace, and new realities of operating economics, it is critical that all aspects of the organization are highly functioning, well organized, and effective.

This chapter explores how the role of the performing arts center has evolved, how they are now typically structured, and how their operating economics have changed.

## Introduction

> The whole idea of a center, as envisaged by its creators and the member organizations, is that there will be a certain amount of interaction. Each organization, it is hoped, will be stimulated by the others.
>
> —Schonberg (1960, p. 10)

In a *New York Times Magazine* article in December 1960, "The Lincoln Center Vision Takes Form," author Harold Schonberg describes the coming realization of "almost ten years of aspiration, dreams, frustration and legalities" about creating a "cultural utopia" (p. 8) for New York City, first imagined by John D. Rockefeller III in late 1955. An entirely new form of civic enterprise, a showcase for the performing arts would be realized, and an unprecedented era of investment and development of capital facilities for the performing arts would be launched.

The contemporary performing arts center as we now know it, typically a collection of theaters under one roof or a campuslike setting of performing arts venues, hosting a range of performing arts activity including music, dance, theatre, and/or opera, is still a relatively new concept. Planning for New York City's Lincoln Center began in the mid-1950s, and the complex first opened its doors in 1962 with Philharmonic Hall. It was followed by

the New York State Theater in 1964, The Vivian Beaumont and Mitzi E. Newhouse Theaters in 1965, the (new) Metropolitan Opera House in 1966, and Alice Tully Hall in 1969. The Music Center of Los Angeles County's Dorothy Chandler Pavilion opened in 1964 and the John F. Kennedy Center for Performing Arts, both a performing arts center and a Presidential Memorial, opened less than 50 years ago in 1971. Prior to this time, America's major performing arts organizations either occupied "auditoriums" that were shared with other companies or produced in stand-alone, purpose-built venues like New York City's first Metropolitan Opera House (built in 1883) or Chicago's Orchestra Hall (opened in 1904).

By the mid-1950s an interesting confluence of conditions was emerging. Cities were exploring strategies to counter the flight of the middle class to the suburbs and to redevelop urban slums. Arts organization leaders were looking for new strategies to enhance the success of their growing organizations.

A highly visible and complex enterprise, the contemporary performing arts center has since become an important nexus of arts and cultural activity in communities across the United States and around the world. Ironically, no inventory of performing arts centers exists, so no one knows exactly how many PACs there are. But what we do know, is that onetime bastions of elite organizations and almost exclusively Western European–derived content, the performing arts center, as a concept, has progressed through several evolutions and has become a major, positive force in the arts and cultural ecosystem and the economic vitality of many communities. By moving beyond simply being the "home" of the traditional performing arts enterprises—symphonies, operas, and ballet companies—to becoming relevant, authentic celebrations of cultural diversity, the PAC is in many cases leading the way in ensuring that the performing arts have a place in the cultural identity and expression of citizens and communities worldwide. Figure 2.1 illustrates four distinct phases in the evolution of the contemporary performing arts center. This chapter profiles each of these generations.

The contemporary performing arts center is often one of the largest and most diverse arts organizations in a community. It is expected to be a leader in the arts sector and to support civic priorities. But the environment in which performing arts centers operate is one of dramatic change. From rapidly diversifying communities to universal on-demand access to content via the Internet; from a new, more sophisticated definition of the competitive

*Figure 2.1* Evolution of the Performing Arts Center

marketplace to high customer expectations and an expanded definition of who "artists" are, as well as new economic realities, it is no longer possible for a performing arts center simply to be what it once was envisioned to be, an "island of culture." The contemporary performing arts center must respond to changing times and changing conditions. This chapter explores how the place, the programming, and enterprise have changed and introduces some ideas of what the future might hold.

## Generation 1—Home

The first generation of performing arts centers was planned as the home of symphony orchestras, the opera, ballet companies, and, from time to time, live theatre. With an almost exclusive focus on excellence, these first centers in major cities around the world were the domain of the great companies, impresarios, and artists of the mid-twentieth century. They not only featured great artists and important companies but were also designed by noted architects, were host to galas and the glitterati, and were places to see and be seen.

Beyond New York, Los Angeles, and Washington, D.C., cities such as Denver, Atlanta, Ottawa, and others followed suit, seeking to make their mark as international cities featuring important artists showcased in substantial buildings.

One of the defining characteristics of the early performing arts centers was their role as landlords. By consolidating some operational functions, PACs enabled their constituents, which were known as "resident companies," to focus on their artistic missions. Harold Schonberg, again in the *New York Times Magazine* in December 1960, noted that

> [t]his Lincoln Center will have several functions; It will serve as a landlord . . . it will also serve as a prod to make the constituents expand their services to the public . . . the autonomy of each [organizational] member is guaranteed, and none will lose its identity—it will be doing it longer. Lincoln Center hopes to supply ideas and the impetus that might end up making the enterprise a permanent festival of performing arts, in operation 52 weeks of the year.
>
> (p. 10)

Ironically, in 1996, more than 30 years after it first opened, Lincoln Center, Inc. would launch the Lincoln Center Festival to present "visionary international programming of dance, music, opera and theater by artists from more than 50 countries" (About Lincoln Center).

Another theme of the early performing arts centers was the democratization of the arts. In Los Angeles, much of this conversation focused on the efforts of Dorothy Buffum Chandler to realize a center of arts and culture. In a *Los Angeles Times* article in 2014, reporter Deborah Vankin quotes

University of Southern California history professor and author Kevin Starr who was discussing the emergence of Los Angeles as a national capital:

> Los Angeles was a deeply divided city then, with 'old money' families entrenched in Pasadena and San Marino and a Jewish community on the Westside, newly prosperous from work in the motion-picture industry. Anti-Semitism was rampant, historian Starr says, but Chandler blurred ethnic and geographical boundaries, venturing into what was considered a Jewish country club, Hillcrest, to meet potential donors. In doing so, she changed the social landscape of the city.
>
> (10th para.)

A city councilwoman at the time, Rosalind Wyman, was cited in the same article: "There were people on the City Council during the time I served that believed you shouldn't spend any money on the arts," Wyman says. "Then there were people like me, who felt the opposite—and Buff was a real leader, she turned people around, she was tenacious. She believed you didn't have a major city unless you had major arts" (4th para.).

Providing access to a broad array of the performing arts in cities across the country was one of the central accomplishments of this first generation of PACs.

The governance and funding of Generation 1 performing arts centers were reasonably straightforward. Typically, as a nonprofit corporation, the board of directors was composed of leading citizens, most often those capable of making the significant financial contributions. These contributions were essential for balancing the venue's operating budget, which typically required equal parts philanthropy and earned revenue. As the early performing arts centers were generally the "home" of resident performing arts companies, the most significant portion of ticket revenue went to the performing company. The PAC operator recovered its operating costs through rent, typically subsidized for not-for-profit users, and modest ancillary revenues and contributions. A key to the economic viability for Lincoln Center was the shared parking garage it operated beneath the main plaza. The developers of first-generation performing arts centers were typically government entities and not-for-profit entities. Precursors of contemporary public–private partnerships (P3s), these initiatives brought together the land planning and development tools of the public sector with the financial resources and leadership of the private sectors. Not unlike their forbearers with names like Vanderbilt, Morgan, and Rockefeller, the advocates for and leaders of the development of performing arts centers were civic advocates who wanted to see their cities as successful, visible, and competitive on a world scale.

The first Sydney Opera House, a theater for comic opera and vaudeville, was established in a warehouse in 1789 (Sydney Opera House History). It was condemned in 1900. Again, in the mid-1950s, leadership began to

focus on creating a performing arts center that would bring notoriety to the city. The Premier of New South Wales, the Honorable JJ (Joe) Cahill convened a conference to explore the possibility of developing an opera house in Sydney. According to conference proceedings he noted that

> [t]his State cannot go on without proper facilities for the expression of talent and the staging of the highest forms of artistic entertainment which add grace and charm to living and which help to develop and mould a better, more enlightened community . . . surely it is proper in establishing an opera house that it should not be a 'shadygaff' place but an edifice that will be a credit to the State not only today but also for hundreds of years.
>
> (Report of the proceedings . . .)

The Sydney Opera House, which comprises an opera hall, a concert hall, and three theaters went on to finally open in September of 1973 after much architectural controversy and, today, stands as an international icon and World Heritage Site. The 1995 Statement of Values for the Sydney Opera notes that the "Sydney Opera House reflects its pivotal place in Australia's creative history, an individual face for Australia in the world of art" (cited in Frampton & Cava, 1995, pp. 247–295).

Between the opening of Lincoln Center and the Sydney Opera House, observers of urban development noted an important secondary effect of the development of performing arts centers. Beyond hosting the finest in the performing arts, providing accessibility to a broader, if somewhat homogeneous public, and showcasing their cities on a global stage, performing arts centers were driving redevelopment. All around them, new enterprises were springing up to cater to the artists and audiences that were frequenting the centers. While "economic impact" was not yet a term in use, civic leaders noted the benefits of PACs and sought to leverage that energy to define or redefine their communities. The second generation was born. In a 2003 article in *The New York Times*, reporter Hilary M. Ballon quoted Jane Jacobs, who said in 1958, "Lincoln Center is planned on the idiotic assumption that the natural neighbor of a hall is another hall." What Robert Moses, then chairmen of the Committee on Slum Clearance, had put forth as a radical strategy to clean up Lincoln Square had, 45 years later, "had a catalytic effect that changed the character of the neighborhood. Large audiences in the performances translated into increased pedestrian traffic, bringing customers to neighboring shops and restaurants" (Ballon, 2003). The complex, which included not just theaters but also a library, film theaters, a park, a plaza, and other elements, had disproved much of contemporary urban planning theory, and that did not go unnoticed. It turned out that a performing arts center could be more than a "home" for the traditional performing arts and the best of international performing artists.

## Generation 2—Place

As major cities which had long been host to a broad mix of classical and popular arts and cultural programming were merging urban redevelopment (or development) and cultural facilities development, smaller and emerging cities began to take notice of the secondary benefits of these investments. In the early part of the 1980s, northeastern cities like Pittsburgh and Cleveland envisioned performing arts centers as strategies to give life to decaying urban cores. In newer communities, from Anchorage to Fort Lauderdale, performing arts centers were imagined as community anchors, "bringing credibility" and attracting businesses and people. These were viewed as the necessary capital of successful communities and a second generation of performing arts centers emerged.

The Generation 2 PAC was very different from the Generation 1 PAC. While some of the older Rust Belt cities had an inventory of traditional performing arts groups (symphonies, opera companies, and ballet companies) and were looking to accommodate these existing companies in vastly higher quality facilities, in many cases their programming was reduced from what it had been as the traditional forms struggled and they alone (generally) could not justify the construction of new facilities. The Generation 2 performing arts center had to look outside of their host cities for content.

In 1892, the City of Cleveland was home to 85 millionaires (Smith, 2014), making it one of the richest cities in the world. In the 1920s, five major theaters were constructed along Euclid Avenue, giving the city one of the highest per capita theater counts in the country and the area around the theaters became called "Playhouse Square." But by the late 1960s, entertainment had followed the population to the suburbs, and all but one, the Hanna Theater, were closed and boarded up. By the 1970s, Cleveland's population had dropped to three-quarters of a million people, down more than 165,000 in 20 years (Roberts, 2011, p. 1). America itself was tied up in struggles over the Vietnam War and protests in Ohio, at nearby Kent State University, had turned tragic when four students were killed by National Guardsmen during a protest. As the city struggled to find its way, two of the city's most magnificent theaters, the Ohio and the State, were threatened with destruction.

Community leaders formed the Playhouse Square Association and developed an audacious plan to save the theaters. The Junior League led efforts to bring grass-roots support to the goal of saving the theaters. In 1973, a three-week run of *Jacques Brel Is Alive and Well and Living in Paris* opened in the lobby of the Ohio Theater. In the end, it ran for two years, energizing efforts to save the theaters for generations to come, and demonstrating that audiences could be drawn downtown for the performing arts.

A decade later, building on the lessons of Lincoln Center and others that showed how a city could regain its vibrancy through investing in cultural facilities, a renovated Ohio Theater reopened. This became the first of eight theaters to be operated by the Playhouse Square Foundation. But unlike

the first generation of performing arts centers, Playhouse Square followed a different pattern. It wasn't only to host the city's traditional performing arts organizations; it would also offer a broad mix of programming ranging from Broadway shows and concerts to comedy and dance, children's programming, and an arts education program. Playhouse Square would become a key player in the redevelopment of the Euclid Avenue corridor, taking seriously the charge to be responsible for the neighborhood in which it operated. Today, Playhouse Square is the country's largest performing arts center outside of New York.

By 2004, eight Playhouse Square theaters were drawing more than 1 million people a year downtown and had a reported annual economic impact "in excess of $43 million . . . (according to a Cleveland State University 2004 study)" (Playhouse Square History, "History"). This success was repeated across the country in communities like Pittsburgh, Denver, Anchorage, and Portland. Community leaders recognized the power of arts and entertainment programming to draw audiences downtown and reactivate the urban core. The Playhouse Square Foundation today operates and manages more than 1 million square feet of commercial space, has developed a major hotel, a joint center for broadcast and community programs with Ohio's public radio and television consortium Ideastream, and hosts Cleveland State University's theatre department in its facilities. Art Falco, CEO of the Playhouse Square Foundation noted three key innovations in the development of the Idea Center: (1) a programming and distribution partnership between two closely aligned community assets, (2) an economic development partnership—that converted a formerly empty downtown building into productive use, and (3) a community partnership that blended resources from the for-profit and not-for-profit communities to create new assets for the community from broadcast to corporate training to satellite uplinking. In describing the transformation that was represented by the Idea Center project, Falco said, "[W]e are only inhibited now by our imaginations" (A. Falco, personal communication, January 16, 2015).

Not an organization to rest on its laurels, in 2015, Playhouse Square Foundation realized a complete transformation of its neighborhood with a significant placemaking and streetscape project that made national news and set the standard for arts district branding. The Playhouse Square Foundation led the sector again in this effort, and their role in advancing Generation 4 PACs is described later in this chapter.

Another example of place making using the performing arts center is the transformation of the City of Pittsburgh's red-light district from a collection of porn shops and noxious businesses to a thriving cultural district housing multiple restored theaters, galleries, and related businesses. In the early 1980s, as Pittsburgh faced a suburban migration common to many northeastern cities, civic leader H.J. "Jack" Heinz II believed that the arts could drive the regeneration of an entire section of downtown. Together with community partners, he formed the Pittsburgh Cultural Trust under

the leadership of Carol Brown, who realized the renovation of the three theaters, the construction of a new downtown home for the Pittsburgh Public Theater, the generation of pocket parks and planning for a riverfront walk. Writing in *The Atlantic* magazine in 2014, author John Tierney quotes the chief executive officer of the Pittsburgh Cultural Trust Kevin McMahon, who says, "We're sitting in what used to be a massage parlor. Here in Pittsburgh, they could have torn down all these buildings and that would have been a tragedy" (28th para). Instead, building on the experience of venues like Lincoln Center and the vision of leaders like Jack Heinz, the city has embarked on a 30-year effort to reimagine its downtown. Pittsburgh used a performing arts center—in this case, not a group of buildings clustered on a campus but rather a distributed series of restored and new venues—to change the face of the city and the perception of the community. The Cultural Trust now hosts First Night—a New Year's Eve celebration and has assumed responsibility for the Pittsburgh Dance Council, the Three Rivers Arts Festival, and the International Children's Festival. It is home to the first and most significant arts-based "shared services" enterprise in the United States and is seen as a case study in successful urban transformation, visited by arts and city planners from around the world.

By the 1980s, many of the major symphonies, ballet, and opera companies no longer toured in the United States. The costs were simply too high, and depending on local support was too risky. Many communities developing Generation 2 PACs did not have established performing arts institutions with extensive production seasons that would fill their calendars, so they relied on access to touring concert artists, entertainers, and Broadway productions originating out of New York City, and occasionally around the world, to activate their buildings. The Community Concerts Association movement that had been brought to scale by Columbia Artists Management Inc. in the 1930s was one source of this programming. A key component of this business model was the subscription series. Organizers in America would solicit community members to "subscribe" to a series of concerts, paying in advance and securing the funding to engage the visiting artists. In the late twentieth century, as regional professional theater took hold, arts managers grew this business approach to scale. The subscription model was adopted by all manner of performing arts companies who had previously survived on hoped-for single-ticket sales and the generosity of donors. Danny Newman, the press agent for the Lyric Opera of Chicago, who is regarded as the father of the modern subscription, developed the techniques that were documented in his 1977 book *Subscribe Now!* This ability to commit audiences for a season of activity without necessarily knowing all the programs that would be offered was key to the second element of success for Generation 2 PACs.

Until the mid-1950s, Broadway productions and touring shows had been largely limited to a small number of "try-out cities" outside of New York, and "sit-down cities," where first-class tours settled in for extended runs.

Many of these theaters were controlled by the Shubert Brothers. A 1956 court decision broke up the Shubert Organization's control of the industry (Wirth, 2011, p. 98). By the mid-1970s, touring bus and truck productions burgeoned, playing civic auditoriums and community venues. These tours often played single nights or half-weeks and were nowhere as impressive as the original New York productions. But the desire to see fully staged productions in cities across America was real, and the success of subscription series laid the foundation for a dramatic expansion of the touring Broadway business. As with Community Concerts, operators of emerging Generation 2 performing arts centers could presell an annual series of Broadway shows, which would limit their risk and guarantee New York producers that they would at least cover their costs and make a modest profit. It was off to the races. By the early part of the twenty-first century, touring Broadway was nearly a billion-dollar business selling over 20 million tickets a season and vying with New York's Great White Way, which was the bigger part of the business. Economic data from the Broadway League illustrate the growth of the Broadway touring industry, as provided in Figure 2.2 (Broadway League, 2016).

The third leg of the stool for Generation 2 center was local arts organizations. Like their predecessors, many PACs were host to the traditional "high arts," the local ballet and opera company, and perhaps the symphony if the symphony did not have a hall of their own. But they were also sought-after showcase venues for emerging programs. The Generation 2 performing arts center was now both the "home" to the traditional performing arts and a "showcase" that supported the rapidly growing market for touring

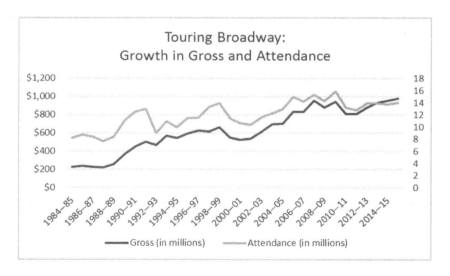

*Figure 2.2* Growth of Broadway Touring Across America

product from Broadway to entertainment celebrities. Most important, it was a proven tool for economic development leading to investments in the billions of dollars in communities across North America.

With this expanded role, there were two other key shifts. The senior management of PACs transitioned from impresarios to professional managers often with backgrounds in government, law, or business. As the centers themselves took on more responsibility for programming, what had been essentially "landlord-like" operations with the center's management running the facilities and the resident companies promoting the activity, saw PACs develop a significant capacity to program and market shows, and fund arts education initiatives. This resulted in significant growth of the size of governing boards as they were most often the first source of private philanthropy, a key revenue stream for PACs, and the political capital needed to access government support.

As touring programs grew in number and became an increasing part of the programming mix, Generation 2 PACs across America began to look quite similar. You could see the touring production of *The Phantom of the Opera* in dozens of cities across the country. The guest artist series looked the same as leading entertainers toured the same routes. There began to emerge a concern that PACs were duplicates repeated from city to city.

As we approached the end of the millennium, civic leaders observed that for such a significant investment, many performing arts centers were highly underutilized. PACs were often dark during the day, only operating around performance times and during some limited visits by students, the occasional business meeting or conference, and participation in arts education programs. More important, leadership and arts organizations observed fundamental changes afoot in America's cities. Community demographics were rapidly changing. More diverse populations called for more inclusive and varied programming. But, the economic model for nontraditional programming was not as reliable as that of the traditional performing arts, and even that model was shifting rapidly. Governments were constraining their support of PACs, whether due to the "culture wars" of the late 1980s and 1990s, which drew attention to artists and the arts sector, or simply because of other more pressing demands. Some major, national foundations which had long supported the arts were shifting priorities or narrowing their geographic focus. And, perhaps most important, as Internet access and bandwidth burgeoned, potential customers now had universal on-demand access to an effectively unlimited array of content.

In the mid-1980s, Tampa Bay's community leaders, noting a lack of cultural offerings in the area, embarked on the development of Tampa Bay Performing Arts Center (now the Straz Center for the Performing Arts). It was first of the many multivenue performing arts centers to be built across Florida over the next thirty years. The Tampa Mayor and former Florida governor Bob Martinez, who is credited with laying the groundwork for the performing arts center, proposed a penny sales tax in 1982, which was

defeated handily at the polls. The community switched tactics and joined with the private sector in a partnership to raise funds for the Center, and it opened in 1987. After struggling for its first years, the Tampa Bay Performing Arts Center found its footing as host for a major touring Broadway Series, which was co-presented with the Florida Theatrical Association and PACE Theatricals. The resulting net income from the Broadway Series shifted the Center's operating model by generating increased earned income and reducing the PAC's reliance on contributed revenue or government support. This allowed the Straz Center not only to host its local resident companies but also, four years after its opening in 1991, to launch the center's education department, which initially offered programs ranging from a community youth orchestra to free summer theatre camp.

These programs became so successful that the Center opened the Patel Conservatory in 2004 (a signal of the Straz Center's evolution to a subsequent generation of performing arts center), which now hosts more than 100 programs at the PAC and another 40 in the community. While the Center always had a strong educational mission, a substantial gift from Dr. Pallavi Patel and his family enabled the center to "go to scale" with arts education programs on- and off-campus. The center now offers classes for youth and adults not only at the center but also through "conservatory to go," a program that reaches into schools (public and private) and community centers, providing training for teaching artists and assuring high-quality training and accreditation. CEO Judi Lisi noted that "we are community builders. That is what we are here for, because the Center belongs to the community" (J. Lisi, personal communication, October 21, 2014). The Patel Conservatory filled a need the community was crying out for. Like New York, Cleveland, and Pittsburgh, Tampa had observed changing market conditions and responded by leading another evolution—anchoring itself firmly in the community.

## Generation 3—The Community Center

At the turn of the century, performing arts centers needed to reposition themselves in a time of shifting support and increasing competition. Almost overnight, it became important to be distinct, authentic, and relevant to the local community—not a clone of a performing arts center in another major city. In Madison, Wisconsin, a 1928 movie house, the Capitol Theater, had evolved to showcase touring music from the 1940s through the 1970s, hosting artists from the Lawrence Welk Orchestra to the Beach Boys (Overture Center History). In the mid-1970s, the city launched plans for a new Civic Center, adding a smaller playhouse and an art gallery to the mix. By the 1980s and into the 1990s, the Civic Center took on the appearance of many Generation 2 PACs. It was home to the local orchestra, home to a resident professional theatre company, and hosted short engagements of Broadway shows and touring acts. As the state capital and a growing city, local arts

leaders felt that Madison deserved more than repurposed buildings, a proposition that attracted the attention of philanthropist Jerry Frautschi. Deeply invested in Madison, Frautschi felt strongly that if Madison was to be successful, it needed better facilities. Through his almost singular generosity, the Overture Center for the Performing Arts was realized. Overture would be the home to 10 local resident companies, the Center for Contemporary Art and, like earlier Generation 2 PACs, a driver of economic development as property values and development in the immediate neighborhood burgeoned.

A 2009 report by AMS Planning & Research documented these outcomes for the Overture Center:

- Aggregate property value in Downtown has increased by $1.9 billion in the decade between the announcement of the Overture project (1998) through its opening and full operations (2008), a gain of 176 percent as compared to an increase of 116 percent in the balance of the City,
- Net annual property taxes paid Downtown grew by $18.9 million from $18.1 to $37.1 million in the period,
- Activity by the Overture Center and its Resident Companies drew over 541,000 people in 2008,[1] an increase of 35 percent from 1998.

But the Overture Center desired to position itself differently. In its 2012 Report to the Community, Overture Center leadership wrote of Madisonians, "We are committed to our communities, however we define them . . . from our neighborhoods to our affiliations to our global community. We take a great deal of pride in our community and we very often put our money where our mouth is" (p. 3). The report continues: "Only in Madison would the community expect, in fact demand, a world-class arts center to provide cultural and educational experience for all citizens, regardless of income or race or age. And only in Madison would that arts center say, 'Yes, of course'" (p. 3). The Overture Center was emblematic of the next evolution of performing arts centers with a dramatically increased focus on community programs. In 2012, Overture delivered 15 distinct community programs attracting nearly 116,000 people to activities other than ticketed performances (p. 4). These programs ranged from artists residencies and workshops to preshows, special free, after-work performances, programs for kids, and a writers series.

Whereas the Overture Center was an existing civic center reimagined, the New Jersey Performing Arts Center (NJPAC) was meant to be a different kind of performing arts center from its earliest planning. The only PAC to be built in the Northeast in 30 years, the center opened in 1997 after more than a decade of planning. The project was called audacious and proponents found themselves, as founding President Lawrence J. Goldman put it, "having to create reality before reality" (L. Goldman, personal communication, January 12, 2013). The center was intended to reframe the perception of Newark—for residents of the surrounding suburbs and, more

important, for residents of the city. The goal was to move beyond the tragic legacy of the 1967 riots, to reengage all of the state's citizens, and to create a foundation for redevelopment. Located in one of the most ethnically diverse cities in America at the time, NJPAC set out to respect and engage that diversity from the outset. Prior to opening, the Center launched arts education programs for inner city youth. Designers featured Kente cloth patterns and showcased art from African communities throughout the building. The management team was recognized for its commitment to using a local workforce, and its staff was reflective of the city's demographic makeup from the outset. An editorial in *The New York Times* just prior to the center's opening described its broad charge accurately:

> From the beginning the project was meant to be more than just a beautiful building. Part of its mission is to be an arts education mecca for the whole state. The center will run workshops for teachers, a school-time theatre series, a dance academy, after-school training for young musicians and arts camps to serve thousands of students from the city and its suburbs. Another of its announced purposes is to be a catalyst for commercial and residential development. That will take longer to achieve and is more problematic, although new arts developments in cities such as Cleveland and Pittsburgh have in fact encouraged development by attracting visitors day and night.
>
> (An arts center for New Jersey)

According to NJPAC's *2014 Report to the Community*, the PAC now hosts more than 400 events each year. One highly featured program dated from the center's early years is the Geraldine R. Dodge Poetry Festival, which "is one of the few places where thousands of high schoolers, teachers and aspiring writers can converse with U.S. Poet Laureates" (Fowler, 2014, p. 9). In 2008, NJPAC opened its doors to the community with live simulcasts of the inauguration of President Barack Obama. By 2012, this kind of open access was being repeated in PACs across the country.

Generation 3 PACs are distinguished by this kind of inclusiveness and community-based programming. This evolution was not limited to PACs in the United States, as the same trend can be seen in Canada and as far afield as Australia. The Living Arts Centre in Mississauga, Canada opened in 1997. This new PAC had two performance spaces, but it also incorporated seven arts and craft studios used by resident visual artists who also hosted classes for community members of all ages. In Melbourne, Australia, where the Victorian Arts Centre (now the Arts Centre Melbourne) had opened three years earlier, the PAC is home to the Performing Arts Collection, one of the leading specialist collections available to researchers and the public in the world. With over a half a million artifacts, from costumes to librettos, the collection is another example of the broad range of programs that Generation 3 PACs developed to engage, uniquely, the communities where they were based.

Another leading example of a Generation 3 PAC is the Adrienne Arsht Center for the Performing Arts of Miami-Dade County (originally the Carnival Center for the Performing Arts) in Florida. Planned over the course of almost 20 years, the center opened in 2006 in America's first minority-majority city and from its first performances was determined to be accessible, inclusive, and engaged with the entire community. Originally planned to house five resident companies, by the time of the center's opening, two had unfortunately closed their doors due to unrelated internal issues, and a third had started planning for its own home. The center was forced to reconsider its role and responded aggressively, developing series that featured artists from South Florida and across the world. They developed a jazz series, Jazz Roots, in collaboration with Larry Rosen, which Quincy Jones called "the most important concert and educational jazz series in America" (cited in Arsht Center, "Jazz"). They also developed *Rock Odyssey*, a rock opera–style presentation that every fifth grader in Miami is invited to annually. They built partnerships with national organizations including the Alvin Ailey Dance Foundation and co-produced AileyCamp Miami each summer. Camp Broadway partnered for a major initiative, which offers an immersive summer experience built around some of Broadway's most well-known work. When the center opened, *The New York Times* noted that "[d]rawing in Spanish-speaking residents has been a defining mission of the Carnival Center from its inception" (Tommasini, 2007). The center is also noted for its many community activities, which have included free, monthly family festivals, a regular, free Sunday gospel concert series, and regular commissions awarded to local artists.

As Generation 3 PACs were being developed, many of the original Generation 1 venues were expanding their programming to better engage their communities. In late 1997, the John F. Kennedy Center for the Performing Arts introduced the Millennium Stages. Located in the Hall of States, these two informal stages offered free performances every day. In a recent interview, Lawrence Wilker, the CEO of the Kennedy Center at the time, noted that the free daily performances were an extension of the center's Performing Arts for Everyone program and were part of an effort to "really open up the Center. [At that time the Kennedy Center] was struggling as an institution that was perceived as elitist." The center's goal was to serve local residents and tourists with programs that did not require a paid admission and illustrated the breadth of artistic talent found across the Washington, D.C., area. The goal was to demonstrate "that art is a part of everyday life, not so much a special occasion" (L. Wilker, personal communication, February 2016).

As Generation 3 PACS moved beyond Generation 1 (Home) and Generation 2 (Showcase) centers, they added characteristics that distinguished their operations and activities. They became interlocutors, meeting places, and a focus for civic activity and discourse. The Generation 3 arts center became a place of learning and that celebrates exploration, diversity,

and inquiry. It recognizes opportunities in arts education and arts appreciation. The PAC collaborates with nearby and distant organizations to develop and offer programs that provide access for youth, the underserved, and lifelong learners. While arts education programs could be found even in the original Generation 1 PACs, with the emergence of Generation 3 PACs, this function can be described as "mission-critical" and significant institutional resources are devoted to programming.

Another defining characteristic of Generation 3 PACs is their recognition of the importance of collaboration as an effective strategy to achieve success. The Generation 3 center invests its resources, both human and financial, in developing programming that it alone would not be able to deliver to the community. Partnership is a watchword. Another characteristic of the Generation 3 PAC is a shift in the role of its chief executive. In earlier evolutions, on-stage programming often consumed the greatest portion of the director's time. As PACs matured, executives saw their focus increasingly shift from an internal, operational focus to external concerns. Now deeply involved in activities from neighborhood development to stakeholder relations, chief executives need to rely on significant and specialized professional teams to manage day-to-day operations, while they focus on community engagement and demonstrating public value. Generation 3 centers also saw a shift in the nature and composition of their boards of directors. While still important for the access to philanthropy, it became increasingly important that board members were well connected, with political capital and business acumen that could be leveraged to facilitate partnerships and the center's increasing leadership role in community success.

While each of these first three generations is generally associated with a specific period, in many cases, earlier PACs also developed and expanded their role over time. Nearly all of the original Generation 1 PACs now exhibit characteristics of their progeny, the Generation 2 and 3 PACs. Some have leapfrogged their successors and are now exploring new strategies to maximize their value to the communities that support them. As we entered the twenty-first century and the sector began to rethink what success meant for a performing arts center, it became increasingly clear that "art for art's sake" was no longer enough of a compelling argument. Nor was it enough to be able to claim the most efficient operation as success unto itself. Performing arts centers were being called upon to provide programs and services that supported mayors in their efforts to differentiate their cities. PACs were an important amenity that encouraged businesses to locate there and their employees to live and work there. Performing arts center leaders began to see themselves as fully engaged in their community's success. They were becoming "entangled" in the complex system that is the creation of public value as described by Harvard University professor Mark Moore and in his book, *Recognizing Public Value*, which explores the characteristics of high-performing nonprofit and nongovernmental organizations (Moore, 2013). As we adapted for performing arts centers, Moore's notion of finding success

at the intersection of operational capacity, legitimacy, and support, and the creation of public value suggested that it is necessary to build on the excellence of the art that PACs produced or presented. PACs also needed to build on their professional capacity, the strong private and government support that engendered, and needed to focus more directly on creating public value, making the communities where they were based more successful and vital.

## Generation 4—Nexus

In 2006, the Urban Institute published a research report, *Cultural Vitality in Communities: Interpretation and Indicators*. In that report, Maria Rosario Jackson and her coauthors documented that essential elements of vital communities was a concept they termed "cultural vitality" (Jackson, Kabwasa, & Herranz, 2006, p. 13). Building on research in an earlier monograph where these researchers had explored multiple indicators of cultural vitality, they identified that three were particularly helpful in "understanding the impacts of arts and culture" (p. 7):

1   Facilitating the presence of opportunities for cultural expression
2   Enabling participation in arts and cultural activity
3   Providing support for arts and cultural activity

The report acknowledged performing arts centers as one of the "pillar" organizations that contribute to cultural vitality (p. 15). Based on more than a decade of carefully studying the outcomes of the operation of PACs, it can be argued that PACs uniquely deliver on all three of the criteria established by Jackson et al. and realize public value as described by Moore, perhaps even more effectively than any other type of arts and cultural organization. As hosts, presenters, and producers of increasingly diverse and inclusive programming, Generation 4 PACs facilitate extensive opportunities for cultural expression through performances, education initiatives, and community outreach programming. The diverse programming on their stages enables audiences of all types to participate in those programs, and the Generation 4 center in its role as a collaborator, partner, and educator provides a broad array of support for those programs. From commissions to marketing expertise, from facility operations to guest services, the contemporary PAC can be an incubator of new ideas, an innovator of new types of delivery, and a thought leader facilitating civic discourse and critical dialogue.

The Brooklyn Academy of Music (BAM) opened in 1861, and over the course of 150 years it has been in the vanguard of many important moments in the arts and culture sector. First envisioned as "a cultural center for all of Brooklyn" (BAM 150 Timeline, p. 1) by the Philharmonic Society of Brooklyn, the building opened in 1861. Over the course of the nineteenth century, the venue saw everything from public rallies to President Lincoln's emancipation policies to performances of Shakespeare featuring John Wilkes

Booth. The Boston Symphony Orchestra had an annual residency there for 75 years (BAM 150 Timeline, p. 1). In many ways, BAM was a Generation 3 performing arts center 100 years before the concept took hold in the late twentieth century. BAM's current primary facility, the Academy of Music, opened on Lafayette Street in 1908 and between then and the 1960s, the Brooklyn Institute of Arts and Sciences (as BAM was then known), offered concerts, lectures and recitals by the likes of Booker T. Washington, Gustav Mahler, Helen Keller, Sergei Rachmaninoff, and Martha Graham. BAM became recognized worldwide for its leadership role in contemporary performing arts as it featured choreographers from Merce Cunningham to Twyla Tharp and companies including the Alvin Ailey American Dance Theater. BAM hosted theatre companies from around the world and by the 1970s was closely associated with avant-garde performing artists like Steve Reich. Launching the Next Wave Festival in 1983 signaled another evolution, which is discussed in detail by Tony Micocci in Chapter 4 of this volume. BAM was becoming much more aware of its important role as a catalyst for the development of its Fort Greene neighborhood in Brooklyn. In the late 1990s, recognizing the dramatic changes occurring in the borough, BAM reimagined one of its theaters as a multiplex cinema (the BAM Rose Cinemas), converted its event space into the BAM café, and invited the community into the building throughout the day.

Like many large, international performing arts centers at the time, BAM leadership was asking themselves, "How can we make a profound and meaningful impact on our local community?" When Harvey Lichtenstein retired in 1999, new president Karen Brooks Hopkins and executive producer Joseph V. Melillo, both protégés of Lichtenstein who had each spent decades at BAM, undertook to continue BAM's innovative traditions but also to reimagine what success looked like. They redoubled efforts in partnership with the Brooklyn Partnership to accelerate the development of the BAM Cultural District. The neighborhood saw the addition of new homes for the Mark Morris Dance Company and Theatre for a New Audience (TFANA), along with rehearsal spaces and other arts infrastructure throughout the neighborhood. BAM continued to expand its programming: they hosted early broadcasts of the *Metropolitan Opera: Live in HD*, celebrated the 25th anniversary of the Next Wave Festival, and hosted dozens of signature performances.

Through extensive study including community surveys, focus groups, meetings with teenagers, parents, kids living in public housing, and residents of Tony Park Slope, BAM had identified a gap. It was not serving residents of its immediate neighborhood in the best way possible. This led to the development the BAM Richard B. Fisher Building, an arts and community center. President Karen Brooks Hopkins noted that "the Fisher Building is all about finding value in community connections" (K. Hopkins, personal communication, January 2013). BAM partnered with the Kennedy Center's DeVos Institute[2] to offer 16 local organizations a yearlong professional

development program. Each year, six of these were given a week of free use of the building to present culminating performances, applying everything they had learned about production, marketing, and community building with support from the BAM staff. Affordability was a key to success, and careful planning of everything from a tension wire grid to a difficult union negotiation necessary to allow non-union labor in the Fisher venue was engaged. BAM's "vastly ramped-up" program of educational offerings includes workshops, summer classes, professional development for teachers, and family programs—all funded through a capital campaign called "Ignite the Promise of Art" that raised more than $15 million. The Fisher Building project was directly aligned with civic goals to drive the notion that "Brooklyn is cool," which, in turn, enhances BAM's reputation and encourages its key investors to look forward to another successful 150 years. This transformation marks BAM's evolution to a Generation 4 PAC.

The Generation 4 PAC adds value and creates opportunity by ensuring that diverse programs are accessible to diverse audiences, and by providing support for high-quality programs while also enabling innovation in content and delivery. Today's PAC must be nimble, provide a high level of technical and functional accommodation, and be able to take risks to expand programming and support activity already present in the community. This chapter does not address the incredible impact of the Internet and social media on the making and dissemination of arts content. The shifts in delivery systems and the changes in modes of communication had material impacts on performing arts centers, their constituencies, and their modes of production. This topic is addressed by other authors in this book.

A Generation 4 PAC is also a learning environment through which new experiences are generated and new knowledge is created, enhancing cultural awareness and expression. Importantly, a Generation 4 PAC sees itself not just as a performing arts business but as a civic leader and a thought partner as well. Its executives and board leadership are active players in community planning, often in leadership roles. They are idea generators and spokespeople for their cities, ceaseless cheerleaders at home and around the world.

As their roles grew, so too did their average operating budget. Data from a representative group of performing arts centers reported in PACStats, an industry benchmarking tool provided by AMS Analytics LLC, demonstrated that the average operating budget grew by 42 percent from 2005 to 2014 as shown in Figure 2.3. During this same period, earned revenue grew by 51 percent and contributed revenue by 58 percent. As illustrated in Figure 2.4, all categories of contributed revenue grew during this time, with the biggest gains in individual giving.

Like other evolutions, the Generation 4 PAC continues to see changes in its staffing and governance structure. As noted, the Internet and social media have asserted itself in daily operations. Social media coordinators and bloggers are part of the Generation 4 team. Boards are shifting

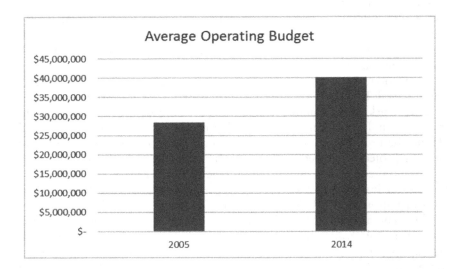

*Figure 2.3* Performing Arts Center Operating Budget, 2005 and 2014

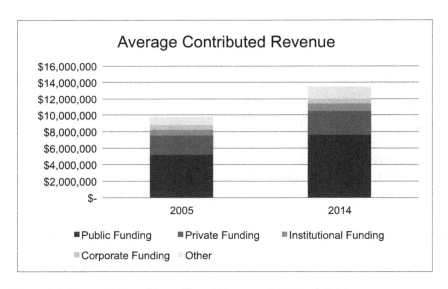

*Figure 2.4* Composition of Contributed Revenue, 2005 and 2014

their role and becoming much more engaged in the overall vision for their business and are deeply engaged in identifying priorities. In their book *Governance as Leadership*, authors Richard Chait, William P. Ryan, and Barbara E. Taylor (2005) note two traditional governing modes for contemporary boards: fiduciary and oversight. They also introduce a third

role, generative thinking. Engaging this essential role is the next evolution for performing arts center's boards of directors. Bill Ryan in a conversation with The Bridgespan Group notes that *generative thinking* "frames the problems that we solve, it determines what needs deciding before we make decisions, it suggests what's worth a strategy before we develop a strategic plan. If boards are not involved in this generative thinking, they're not governing fully" (cited in Bridgespan Group, 2009). Making this transition is key to successful entanglement[3] in the community and maximizing public value. It also means that a Generation 4 PAC is "re-thinking success" more substantially than in the past. The Generation 4 PAC is organized to maximize its impact and outcomes rather than simply generate activity and output. The Generation 4 PAC sees itself as more than just a venue. It is not defined by traditional theaters and concert halls or even its physical location; rather, its branded content can be found throughout the community in schools and hospitals and digitally around the world. Clearly defining success is becoming the primary responsibility for contemporary boards of directors. It is critical that they take this responsibility seriously.

The successful Generation 4 PAC has many different roles, ensuring that the community is served with the broadest possible arts and cultural opportunities. As illustrated in Figure 2.5, this "next generation" PAC is a sophisticated community resource. It is a public value generator, offering programs and services that enhance the capacity of the arts and

*Figure 2.5* The Many Roles of a Generation 4 Performing Arts Center
Illustration by Skye Gould

cultural organizations within and around them, and it develops content and programs to supplement gaps and explore new opportunities.

The Generation 4 PAC is

- **Home** to the traditional performing arts. The Generation 4 PAC provides a place for the production and presentation of traditional and emerging arts and culture programs in appropriate facilities.
- **Place/Brand.** The Generation 4 PAC is a destination, a recognized provider of first-quality activity on campus and off.
- **Incubator.** The Generation 4 PAC is an **enabler** of new content and emerging organizations, providing resources, facilities, technical support, and management guidance that facilitate success.
- **Educator.** The Generation 4 PAC is a place of learning and celebrates exploration, diversity, and inquiry. It recognizes opportunities in arts education and arts appreciation. The PAC collaborates to develop and offer programs that provide access for youth, the underserved and lifelong learners.
- **Innovator.** The Generation 4 PAC **encourages** risk and exploration while managing exposure through strong governance and by developing leadership skills, tools, systems, and financial resources that support innovation.
- **Partner.** The Generation 4 PAC recognizes that collaboration is an effective strategy to achieve shared goals. It invests resources in identifying and enabling partnerships.
- **Thought Leader.** The Generation 4 PAC is a leader in enabling continuing evolution of the sector, arts forms, business models, delivery systems, and audiences. It **advocates** for change and support.
- **Showcase.** The Generation 4 PAC **confers** legitimacy on a diverse array of programs by providing a platform for presentation and exhibition of the new, the different, and the traditional.

## Generation 5—What's Next?

Arts center boards of directors and executives are looking forward and wondering what's next? How do they remain vital institutions, contributing to their community and building public value? The past president of the Music Center of Los Angeles County, Stephen Rountree, noted in an interview that "to be successful, we must engage a broader public. We need to make our centers more diverse, informal, looser, funkier, participatory and younger" (S. Rountree, personal communication, January 9, 2014). To that end, PACs need to recognize new competitors and new opportunities. Chicago's Millennium Park is, in many ways, a performing arts center without walls, hosting performances and engaging artists and audiences. Recognizing this reality, The Music Center partnered with Los Angeles County to program and operate the first new civic park built in a half a century, Grand Park,

which is immediately adjacent to the Center. A logical extension of their skills as property managers, the park also draws on the Music Center's skills as a partner, programmer, and marketer. Most important, it creates new points of contact with potential audiences it might not otherwise see on its Generation 1 PAC campus.

In Montréal, leaders of the Place des Artes took advantage of the construction of a new home for the Orchestre Symphonique of Montréal to also redevelop subterranean pedestrian corridors into L'espace Culturel (or cultural space), where the center now provides hundreds of free and informal programs each year. Marc Blondeau, president of Place des Artes, calls this space "a haven for culture—you are touched, exposed, you experience something different than anywhere else in the city" (M. Blondeau, personal communication, January 2014). Each day 35,000 to 40,000 commuters pass through L'espace Culturel and are touched by the performing arts center in new ways that do not necessarily include attendance at a traditional performance.

Howard Herring is the president of the New World Symphony (NWS), a training institution for aspiring professional musicians, which operates the innovative New World Center designed by Frank Gehry in Miami Beach. Herring notes that he is challenged to find "new forms of delivery and to reach new audiences constantly" (H. Herring, personal communication, January 2015). To accomplish that his organization is experimenting with new presentation formats, whether live simulcasts on a 7,700 square-foot projection wall facing an adjacent park, short lunchtime concerts, concerts that include discussion, or high-speed Internet 2 connections to schools and master artists around the world. NWS is constantly looking for ways to expand its reach and sees its facility as a means to an end, as a tool it uses to engage the communities it hopes to impact.

In 2016, under the leadership of Deborah Rutter who joined the center as its CEO in 2015, the John F. Kennedy Center for the Performing Arts made a move beyond Generation 4 as well. It announced Q-Tip as its first artistic director of hip-hop culture, clearly demonstrating the breadth of its transformation. The center said in a press release that "Q-Tip will establish a dynamic, new program that will stretch across all disciplines, bringing the historic roots, contemporary expressions, and transformative power of Hip Hop to the [Kennedy] Center and local and national audiences" ("Q-Tip Appointed . . .", 2016, p. 1). *The Washington Post* noted the Kennedy Center's appointment of Jason Moran, a jazz pianist, who became the center's artistic director for jazz in 2014 and postulated, "A collaboration between Moran and Q-Tip? That seems like another no-brainer. Let's cross our fingers?" (Richards, 2016).

Performing arts centers across North America are immensely successful enterprises. They serve millions of live audiences each year. They provide access to the performing arts for youth and lifelong learners in the classroom and in the studio with teaching artists and masters. They are thoughtful and

deliberate about building public value and becoming entangled in civic life. They are rapidly becoming the central platform for creativity, conversation, and engagement in the dynamic cities of the twenty-first century.

## Acknowledgments

The author gratefully acknowledges the time and invaluable insights shared by the many performing arts center CEOs who have agreed to be interviewed over the years and who are cited in this chapter. The author also acknowledges the research assistance of Liz Davis, Megan Friedman, Kate Scorza Ingram, and Martha Wood, all from AMS Planning & Research, who supported the preparation of this chapter.

## Notes

1 Including free and subsidized admissions to Overture Center's programs, community galleries, and scheduled free performances, as well as the activity of the center's resident companies.
2 Now relocated to the University of Maryland.
3 See also Nine Essential Innovations, at http://ams-online.com/nine-essential-innovations/

## References and Further Reading

An arts center for New Jersey. (1997, October 16). *New York Times*. Retrieved from: http://www.nytimes.com/1997/10/16/opinion/an-arts-center-for-new-jersey.html
Arsht Center. (n.d.). "Jazz" program landing page. Retrieved from: http://www.arshtcenter.org/tickets/series-genres-arsht-center/jazz/
Ballon, H. (2003, June 8). Ideas & trends: Culture clash; how the arts transformed an urban landscape. *New York Times*, n.p. Retrieved from: http://www.nytimes.com/2003/06/08/weekinreview/ideas-trends-culture-clash-how-the-arts-transformed-an-urban-landscape.html
BAM150 Timeline. (n.d.). Brooklyn Academy of Music 150 Year Timeline. Brooklyn Academy of Music (BAM). Retrieved from: http://www.bam.org/media/476258/BAM%20150%20Timeline.pdf
Belcher, W. (2013, March 18). Straz Center, Tampa's cultural crown jewel, turns 25. *Tampa Bay Times*. Retrieved from: http://www.tbo.com/arts_music/straz-center-tampas-cultural-crown-jewel-turns—488681
Blumenthal, R. (1999, June 1). An urban journey from slum to cultural Acropolis. *New York Times*. Retrieved from: http://www.nytimes.com/1999/06/01/nyregion/an-urban-journey-from-slum-to-cultural-acropolis.html
Bridgespan Group. (2009). Governance as leadership: A conversation with William Ryan. The Bridgespan Group, "Building Leadership". Retrieved from: http://www.bridgespan.org/Publications-and-Tools/Nonprofit-Boards/Resources-for-Board-Members/Governance-as-Leadership-William-Ryan.aspx#.V1g_jfkrIdX
Broadway League. (2016). Statistics—touring broadway. Retrieved from: https://www.broadwayleague.com/research/statistics-touring-broadway/
CAMI History. (n.d.). Columbia Artists Management Inc. Retrieved from: http://www.cami.com/?topic=history

Chait, R., Ryan, W., & Taylor, B. (2005). *Governance as leadership: Reframing the work of nonprofit boards.* Hoboken, NJ: John Wiley & Sons, Inc.

Fitzgibbon, J. (n.d.). Portland Paramount Theatre/Arlene Schnitzer Concert Hall. The Oregon Encyclopedia. Retrieved from: http://www.oregonencyclopedia.org/articles/portland_paramount_theatre_arlene_schnitzer_concert_hall/#.V0msPfkrLSc

Foulkes, J. (2014, September 11). Lincoln Center, the Rockefellers, and New York City. Rockefeller Archives Center, Research Report Fall 2005. Retrieved from: http://juliafoulkes.net/?p=252

Fowler, L. (2014). NJPAC report to the community 2014. New Jersey Performing Arts Center. Retrieved from: http://njpac.s3.amazonaws.com/doc/Report-for-year-2014-041215-flip-low-res.pdf

Frampton, K., & Cava, J. (1995). *Studies in tectonic culture: The poetics of construction in nineteenth and twentieth century architecture* (pp. 247–295). Cambridge, MA: MIT Press.

Jackson, M., Kabwasa-Green, F., & Herranz, J. (2006). Cultural vitality in communities: Interpretation and indicators. Urban Institute. Retrieved from: http://www.urban.org/sites/default/files/alfresco/publication-pdfs/311392-Cultural-Vitality-in-Communities-Interpretation-and-Indicators.PDF

Johnson, T. (1960, November 19). Letter to Mr. George Judd, Jr. Retrieved from: http://archives.nyphil.org/index.php/artifact/c1c3842f-0b14–45f2-b59e-661c15aaeb92/fullview#page/7/mode/1up

Kavanagh, S. (2014). Defining and creating value for the public. *Government Finance Review*, 57–60. Retrieved from: http://www.gfoa.org/sites/default/files/GFROct1457_0.pdf

Moore, M. (2013). *Recognizing public value.* Boston: Harvard University Press.

Newman, D. (1977). *Subscribe now!: Building arts audiences through dynamic subscription promotion.* New York City: Theatre Communications Group.

Overture Center for the Arts, Community and Economic Impact Study. (2009, November). AMS Planning & Research Corp. Highlights.

Overture Center for the Arts 2011/12 Report to the Community. (2012). Overture Center for the Arts. Retrieved from: http://files-overturecenter.s3.amazonaws.com/b94a5311a5b96060ff60cb067414248b/1112oca_annualreport.pdf

Overture Center for the Arts 2014/15 Report to the Community. (2015). Overture Center for the Arts. Retrieved from: http://files-overturecenter.s3.amazonaws.com/c61e6015e22f4116a3701226aa9410dc/1516annualreportfor1415l.pdf

Overture Center History. (n.d.). Overture Center for the Arts, History: Our opening act. Retrieved from: http://www.overturecenter.org/about/history

PACStats. (2014 Report), AMS Analytics.

Patel Conservatory History. (n.d.). Straz Center. Retrieved from: http://www.strazcenter.org/Education-Outreach/Patel-Conservatory/About-Us/History

Playhouse Square History. (n.d.). A message from Art Falco, CEO and President, Playhouse Square Foundation. Retrieved from: http://www.playhousesquare.org/about-playhousesquare-main/history

"Q-tip appointed the center's first artistic director for hip hop culture; hi-ARTS partners for new hip hop culture series." (2016, March 8). Press Release. The Kennedy Center for the Performing Arts, Washington, DC. Retrieved from: http://web.kennedycenter.org/~/media/Files/KC/Press%20Releases/2016%20March/PressReleaseKennedyCenterAnnounces20162017seasonofHipHopCulture

Randall, K. (1992). *Lincoln Center for the Performing Arts: Cultural visibility and postwar urbanism* (Unpublished doctoral dissertation). Columbia University, New York City. Retrieved from: https://clio.columbia.edu/catalog/1670222

Report of the proceedings of a conference . . . concerning the question of the establishment of an opera house in Sydney, Public Library, Sydney, 30 November, 1954. Qtd

in Sydney Opera House History. (n.d.). Sydney Opera House History 1954–1958. Retrieved from: http://www.sydneyoperahouse.com/about/house_history/1954_1958. aspx

Rich, A. (n.d.). Philharmonic hall opens today and with it a new era for city. *New York Times*. Retrieved May 21, 2016, from: http://timesmachine.nytimes.com/ timesmachine/1962/09/23/93836109.html?pageNumber=84

Richards, C. (2016, March 8). Q-tip is the Kennedy Center's fist artistic director of hip-hop culture. *Washington Post*. Retrieved from: https://www.washingtonpost. com/news/arts-and-entertainment/wp/2016/03/08/q-tip-is-the-kennedy-centers-first-artistic-director-of-hip-hop-culture/

Roberts, M. (2011). History of the 1970s. Teaching Cleveland Digital. Retrieved from: http://www.teachingcleveland.org/images/pdf/publicpolicybook/history1970s%20 final.pdf

Sara. (2011). From the slum to the center: Robert Moses and the creation of Lincoln center [Web log post] American Civilization. Retrieved from: http://sghistory. blogspot.com/2011/04/lincoln-center-robert-moses-and.html

Schonberg, H. C. (1960). The Lincoln Center vision takes form. *New York Times Magazine*. Vol. CX(37,775). pp. 156-158, 297, 387, 388. New York.

Smith, R. (2014, October 26). Inventors, immigrants helped Cleveland lead an economic revolution 100 years ago. Cleveland.com Business. Retrieved from: http:// www.cleveland.com/business/index.ssf/2014/10/when_cleveland_rocked_to_a_ sta.html

Statement of Values for the Sydney Opera House National Heritage Listing. (1995). Australian heritage database. Retrieved from: http://www.environment.gov.au/ cgi-bin/ahdb/search.pl?mode=place_detail;place_id=105738.

Sydney Opera House History. (n.d.). Sydney Opera House History 1788–1953. Retrieved from: http://www.sydneyoperahouse.com/about/house_history/1788_ 1953.aspx

Tierney, J. (2014, December 11). How the arts drove Pittsburgh's revitalization. *The Atlantic*. 28th para. Retrieved from: http://www.theatlantic.com/business/ archive/2014/12/how-the-cultural-arts-drove-pittsburghs-revitalization/383627/

Tommasini, A. (2007, February 4). Miami Vivace: New arts center opens its arms. *New York Times*, AR15, NY ed. Retrieved from: http://www.nytimes. com/2007/02/04/arts/music/04tomm.html?_r=2

Vankin, D. (2014, November 14). Dorothy Buffum Chandler was the driving force behind the music center. *LA Times*. Retrieved from: http://www.latimes.com/ entertainment/la-et-cm-ca-music-center-buff-chandler-20141116-story.html

Waldman, B. (2012, January 1). The (old) Metropolitan Opera House. Untapped Cities: Architecture, Arts & Culture, New York. Retrieved from: http://untapped-cities.com/2012/01/18/the-old-metropolitan-opera-house/

Wirth, R. (2011, March). The curtain rises on consent decree modification in the theatre industry: United States v. Shubert. *Cardozo Arts & Entertainment Law Journal*, 2(91). Retrieved from: http://www.cardozoaelj.com/wp-content/ uploads/2011/03/Wirth-2-1.pdf

# 3 Trends in the Development and Operation of Performing Arts Centers

*Duncan M. Webb*

Much has changed in the decade since I published *Running Theaters: Best Practices for Managers and Leaders* (Webb, 2004). This resource shared practices and points of view from forty North American performing arts center (PAC) leaders on topics ranging from programming, audience development, and fund-raising to the particular challenges of managing historic and campus-based theaters. In rereading the book, I am struck by the passion of the facility managers, their embrace of the complexity and challenges of running a performing arts venue, and their general confidence about the future. In the early 2000s, some concern was expressed about government funding and audiences for the traditional (i.e., Western European) performing arts disciplines. But the general sense of this accomplished set of managers was that the future would unfold in reasonable ways and that they would be able to find their way forward.

Now, in 2016, performing arts center leaders are still gamely trying to program, manage, and sustain these large and complicated buildings and organizations. In order to update the data from over 10 years ago, I selected and surveyed some senior leaders to ask whether it is getting easier or harder to manage a performing arts center and how they might be responding to the new opportunities and challenges of the job. What became apparent from the ten surveys I received back (the respondents are listed in the Acknowledgments section at the end of this chapter) is that while some see the job as being harder, they understand why this is the case, and they are pursuing strategies designed to mitigate new challenges. One key strategy that all respondents emphasize is the importance of having more of an outward focus in their work.

This chapter explores diverse aspects of change in the management and operation of performing arts centers and describes ways in which current leaders are now applying their new outward focus in pursuit of mission and long-term sustainability. The analysis begins with an overview of changes underway among performing arts audiences, and briefly profiles emerging trends in arts funding, as well as major structural shifts in the operations of performing arts centers. Then, the chapter turns to a series of recommendations for how performing arts center leaders might proactively respond to these changes.

## Changes in Performing Arts Audiences Sizes, Characteristics, and Participation Rates

Every five years or so, the National Endowment for the Arts (NEA) publishes its *Survey of Public Participation in the Arts (SPPA)*, the most recent one in 2012. This report highlights significant audience participation trends relevant to performing arts centers, such as the following:

- About one third of adults attend live performances or visit museums or galleries each year, and in the last 20 years, participation within traditional arts disciplines has remained relatively flat. However, from 1982 to 2012, the percentage of adults attending arts events has declined from 39 percent to 33 percent. This decline in levels of participation has been mitigated only by increases in the total adult population.
- Attendance at traditional performing arts programs in formal venues has been largely replaced by participation in a broader set of cultural and entertainment venues, including attendance at outdoor arts festivals, films, and other forms of live music, as well as significant increase in consumption of the arts through electronic media.
- Participation in the traditional performing arts (jazz, classical music, opera, musicals, plays, ballet) among adults under the age of 40 has consistently declined from 1992 to 2012.
- Participation varies tremendously by demographic characteristics such as gender, race, age, and education. Educational attainment is by far the best predictor of arts attendance. The propensity to attend arts events among those who have completed college is far greater than for those who have finished high school. With each advanced level of educational attainment, there is an increased probability of arts participation. Age also matters, but not nearly as much as education; older people tend to participate more in the arts, but only to a point.

With the changing demographics of America's communities, it is also important to understand arts participation trends among minority and immigrant populations. Analysis of the NEA's *SPPA* suggests that Hispanic populations have higher rates of attendance at informal arts events (craft fairs and festivals, outdoor arts festivals, visits to historic sites and parks) than do White populations. Research also indicates that immigrant populations are often highly engaged in art forms connected to their cultural identity. Participation in these art forms, however, tends to take place outside of formalized cultural institutions, in places like churches and community centers (National Endowment for the Arts, 2012).

However, there are problems surrounding the ways in which arts participation is currently being measured. A recent article titled "Minding the Gap: Elucidating the Disconnect between Arts Participation Metrics and Arts Engagement Within Immigrant Communities" (Novak-Leonard,

O'Malley, & Truong, 2015) points to the inadequacy of the SPPA in measuring minority and immigrant participation in the arts, due principally to the fact that many people participate in a range of arts activities that are not reported. This means that we aren't asking the right questions in order to get the full picture of arts participation. But even with only a partial understanding of immigrant and minority participation, a lot of time and energy are being invested in increasing the diversity of performing arts audiences. We're trying to move from audiences that resemble a box of Q-Tips to audiences that look more like a box of crayons.

Despite good intentions, there is a lack of understanding about what motivates minority audiences to attend the performing arts. For example, several examples (such as Los Angeles Philharmonic, Los Angeles Opera, and Nashville Symphony Orchestra) illustrate that merely the appointment of a Latino music/artistic director does not automatically result in any significant growth in Hispanic audiences. Instead, examples provided by organizations such as the Broward Center for the Performing Arts (Broward County, Florida) demonstrate that "cracking" an immigrant/minority market (in this case, Brazilian) does not come from the booking of specific artists or entertainers. Instead, in this case, it was through a multiyear effort to engage the Brazilian community in the life of the building that worked—through one-on-one meetings with community leaders, group sessions out in the neighborhoods, programming plans developed with key representatives, and promotion of events both by and for the community. This community engagement process was unquestionably hard work, but it paved the way to a new set of relationships and a strong sense of the performing arts center being relevant and responsive to its changing community.

## Changes in Audience Behaviors

Performing arts center managers have been experiencing many significant trends in the consumption of the arts and how audiences choose to participate. Summarized in the following, these trends suggest the need for proactive responses on the part of performing arts leaders, which are outlined later in this chapter.

### Less Time and Less Planning

We are all increasingly busy and less likely to make a significant investment of our precious time into any activity, especially when we are asked to make that commitment well in advance of the event. We live in a world of shortened planning horizons, meaning a decline in advance commitment. This has led to the propitious decline in subscription ticketing, as individuals are less willing to commit early and are more likely to keep their options open until the last moment. This also means that there are more consumers now

who are willing to pay more later—the perceived premium of flexibility and the "on-demand" lifestyle.

### The Demand for More Stimulation

All consumers, and particularly younger ones, are acclimated to multisensory engagement. They are watching, hearing, and reading simultaneously (so they believe). This means that they have higher satisfaction thresholds and expectations for immediate rewards from the experience.

### The Demand for Convenience

Audiences are also seeking convenience, as in all aspects of life. There is less tolerance for events that have "hardships," such as uncomfortable seats, poor concessions service, or bad traffic. This pushes facilities and presenters toward excellent customer service and influences other factors that affect the experience, from parking to the after-show drink.

### The Diffusion of Cultural Tastes

Because of advances in information and communication technologies, people are now interested in a much broader array of programs. This means both fragmentation and diversification of artistic tastes, both narrowing and broadening at the same time. Eric Fliss, managing director of the South Miami-Dade Cultural Arts Center, speaks of audiences now having "expectations that are higher and broader," meaning that they are seeking programming at a high level, but that they also expect performing arts facilities to offer a broader range of programs (personal communication, January 2016).

### The Paradox of Choice

All consumers are now faced with an extraordinary range of choices. They are hungry for filters and enablers, people and services that will help them get past the paralysis brought on by too many choices. Word of mouth—a piece of one-on-one advice from a credible source—is the strongest filter. But people are also looking for other filters and influencers, which can be understood as "curators" who can help them make their arts participation decisions.

### Risk Versus Reward

Because of the cost (time and money) of participating, audiences are generally less willing to take risks and more willing to pay large sums for a guaranteed "home run" experience. This is evidenced by the blockbuster

phenomenon and super-premium price points on Broadway. It is also consistent with a pervasive trend toward "trading up" and the rise of VIP culture, where there is an attempt to create an illusion of exclusivity, status, and prestige. The challenge is that the more everything becomes accessible, the more some people want to be separate—which suggests demand for value-added, premium arts experiences.

## The Social Experience

Research suggests that what is drawing audiences to the arts today is the opportunity for a social experience, as opposed to the more traditional attraction of intellectual stimulation associated with the performance. The good news is that this is a clear competitive advantage since the shared social experience is not available to those at home. The challenge is that presenters and facilities must deliver much more than what is on the stage, creating an environment in which the social elements of the experience are supported.

## The Role of Media

We are seeing lower consumption of traditional media and a correspondingly reduced role that it plays in driving arts participation. There is fragmentation of the media and the absence of the critical voice to help audiences make purchase decisions. At the same time, there is a proliferation of personal communications technologies and online word-of-mouth tools, including Facebook and the like. These tools are critically important as a means for consumers to spread word of mouth in a viral way, and they are even more important for the cultural suppliers to build a community of friends and supporters in a world where consumer loyalty is largely a thing of the past.

## Theaters for Audiences

Today's theaters are grand buildings, meant to inspire awe and reverence. We are corralled into the theater like sheep, told to pay attention, and then pushed back out and sent on our way as soon as the performance is over. In contrast, artists for audiences built the theaters of centuries past. Over time, the audience has been silenced or "sacralized" as part of an effort to reshape cultural interaction, partly along class lines. This was particularly evident in the United States, where the insecurity of new wealth (from colonial days to the Gilded Age) transformed the arts experience into an opportunity to display one's cultivation and good manners. Even after the emergence of the nonprofit arts sector in the 1960s and the beginnings of multiculturalism, audiences have not regained virtually any control over the arts experience (Conner, 2008).

As Richard Pilbrow discusses in detail in his chapter in this book, we are building better theaters today than we were in the 1950s and 1960s. Gone are the dreadful municipal or civic auditoria, the fan-shaped halls that placed audiences miles from the stage, all facing in the same direction. Yet still, as Conner (2007) suggests, "the intellectual and emotional distance between public arts producers and the average cultural consumer has never been greater" (p. 90). The challenge and opportunity for performing arts leaders are to provide audiences with the opportunity to experience the arts to the full extent possible, involving the quality and value of the experience on an emotional, intellectual, and even spiritual level (Brown & Novak-Leonard, 2013). This persistent challenge involves better informing and preparing the audience, which is a role for the physical space, for programming and curating, and for the activities surrounding the performing arts event.

## Changes in Uses and Users

According to the 2014 *Arts Index* report by Americans for the Arts, as of 2012 there were roughly 91,000 arts and culture nonprofit organizations in the United States, a 20 percent increase from the past decade. In addition, there was a 14 percent increase in the number of working artists from 1996 to 2012 (1.99 to 2.18 million). Rocco Landesmann, past head of the National Endowment of the Arts, landed in a big pot of hot water when he suggested that we have a supply problem—as in too many arts groups. These days, foundation heads and other arts leaders would all agree privately on the problem, but they won't say it publicly. But the fact remains that the growth of the sector over the past two decades has stretched audiences and funders beyond capacity. However, despite the persistent and unsustainable growth in the nonprofit arts sector, there are also some positive trends on the supply side of the field.

### Changes in Definition

Communities are embracing a broader definition of culture, which means going beyond the traditional idea of Western European performing arts to embrace other cultural traditions and other forms of creative expression that are more inclusive and accessible. This trend also means the inclusion of many forms of creative expression that were once thought to be inferior or not worthy of presenting in a performing arts center. Put another way, Willie Nelson used to be called an outlaw. Today he's a performing artist.

### Everyone's an Artist

There is tremendous growth in active arts participation, meaning that more people are searching for and finding ways to express their personal creativity, whether that means joining a choral group, learning how to paint, or

participating in cultural activities reflecting their heritage. This is evidenced by higher rates of personal and amateur participation in community theatre groups, choirs, dance and movement classes, art and music classes, and more.

### Education and Outreach

Arts programs are under pressure in many schools as budgets come under stress and as more emphasis is placed on academic performance and test scores. At the same time, there has been significant growth in the number of education programs developed and delivered directly by arts organizations and facilities. These programs augment school-based programs and play a significant role in improving the vibrancy and sustainability of the nonprofit sector. Bill Reeder, dean of the College of Fine Arts at George Mason University and responsible for performing arts centers in Fairfax and Manassas, Virginia, speaks of "the ground game of facility programming, which for us means the fundamental importance of getting school kids in the building" (personal communication, January 2016).

### The Economics of Presenting

Many performing arts centers that were conceived to be the home of a set of local organizations are now active as presenters. Robyn Williams, executive director of Portland's 5 Centers for the Arts, notes that "we started presenting in order to diversify our business base and not be too reliant on one type of business" (personal communication, January 2016). Touring live entertainment is expensive, but the supply of product on the road is great, and facilities have many productions to choose from. A lot of this has to do with profound changes in the music industry, with recording revenues way down and artists increasingly forced to make their living through live performance. The other significant change, which creates new risks for promoters, is that the rise and fall of particular artists are very unpredictable and often meteoric. This has led to the emergence of more festival-based programs, which give promoters more flexibility to present the artist of the moment at events and facilities booked far in advance.

## Changes in Performing Arts Funding

Baumol and Bowen's *Performing Arts: The Economic Dilemma* was first published in 1968. Their theory was fairly straightforward—the problem in the performing arts sector is that because there are no productivity gains associated with the creation of the work (i.e., it takes the same time energy to rehearse and perform a Brahms *Requiem* today as it did when it was first performed in 1868), and because costs always increase over time and earned revenue growth is limited by a range of market forces, we are doomed to

fall further and further behind, essentially forcing the more aggressive pursuit of contributed income just to balance the budget. And the problem is progressive, meaning that every year we fall a little bit further behind. This phenomenon has come to be known as the *cost disease*. Indeed, we have observed over the past five decades how, with no productivity gains, the costs to create the performing arts have risen much faster than the costs of producing other goods and services. Even with the very best skills, training, resources, and motivation, performing arts managers cannot fix this problem.

However, there are two strategies that can be used to address the persistent challenges brought about by Baumol and Bowen's cost disease. The first strategy is to let organizations come and go in more realistic ways, the way commercial sector companies come and go. However, the laws around nonprofit governance make it very difficult to close up shop. And the prospect of a failing arts organization often leads to a desperate and emotional campaign to "Save our (insert organization name/type here)." The second strategy is to modify our thinking that nonprofit arts organizations should be stable, permanent entities with all of the attendant infrastructure and overheads. Performing arts organizations may need to organize more like the film and television industries, with smaller full-time staff and lower base operating costs.

Arts organizations have been and will continue to be reliant on contributed revenue from both public and private sources. With regard to government funding, though, we are now operating in a political environment in which direct support of the arts is controversial and difficult to justify, given the small percentage of adults who attend the performing arts and all of the other priorities facing different levels of government. Securing public funds for support of the arts will likely not become any easier in the years to come, particularly given the coming call on pensions from retiring public-sector workers.

On the private side, we have a fully developed philanthropic sector led by skilled marketers, technologists, and communicators. The bar has been raised for arts fund-raisers due to increasing competition from sectors like education, the environment, and health care. In addition, the new generation of philanthropists are much more proactive and engaged in their causes, expecting to be given the ability to direct the organization and the use of their funds in a much more personal (and often intrusive) manner.

The good news in the world of arts funding is that we have become much better at raising money from the public and private sectors when it is indirectly related to the arts. For example, there is funding to revitalize an old theater on Main Street when it is tied to a larger economic development plan. There is education funding available to arts organizations whose programs can be proved to improve test scores. And there is Health and Human Welfare funding delivered to organizations and facilities that play a role in healing, strengthening, and unifying communities. In order to secure this

funding, we must be able to clearly demonstrate the connections between community problems and arts solutions—teaching community leaders that the arts should be viewed as a tool for helping communities advance.

## Changes in Operators and Operations

Another important shift in the sector is how and by whom performing arts facilities are being operated, with the emergence of for-profit companies offering to manage facilities on behalf of local government and the managers of larger performing arts centers offering to program and manage additional performing arts venues in the same region.

Many cities around North America have become open to outsourcing government functions as a cost reduction tool, and this option seems to be coming up more often as it relates to the operation of a city-owned theater or PAC. The question of outsourcing appears to be raised when the facility and/or the city has had a bad year. The advocate for outsourcing tends to be an elected official with only a limited understanding of the complexity of operating a performing arts center.

Outsourcing management of a performing arts center is not simple, but several competent operating companies have become more aggressive in their pursuit of theater operating contracts. Firms like SMG, Professional Facilities Management, and Spectra (formerly Global Spectrum but still part of Comcast Spectacor) are now more visible in the marketplace. In addition, managers of existing performing arts centers are increasingly willing to sell their programming, marketing, and facility management skills for additional facilities in the same market area. This can be viewed as a positive trend, whereby successful facility managers are extending their skills and resources to other buildings when they can prove competence, efficiency, and the ability to operate each facility in the best interests of that community.

Success in outsourcing—whether the operating company comes from the commercial or nonprofit sector—is often a function of the quality and care put into the bid and the contracting process. Cities must be very careful to have their goals and expectations translated into a positive working relationship. Pursuing outsourcing does not necessarily reduce the city's financial commitment to the theater, as an outside operator will demand a fee for services, as opposed to paying rent.

Another interesting PAC development is the trend of universities to be more engaged in their local communities. Historically, colleges and universities were not willing to use, program, or even operate facilities off the traditional campus. But as these institutions become more externally focused, there seems to be an increasing willingness to bring audiences, users, and facility management skills off the campus and into the community. Recent examples include Emerson College taking over the Paramount Theatre in downtown Boston; Southern Oregon University and Jefferson Public Radio operating the historic Cascade Theatre in Redding, California; and the deal

that put the Theatre Department of George Brown College into a series of restored distillery buildings in downtown Toronto.

Despite the impact of Baumol's cost disease on artists and producing arts organizations, performing arts facility managements are achieving significant productivity gains through technologies associated with back-stage operations, front-of-house operations, ticketing, marketing, and general administration. Bruce Macpherson, managing director of the Eismann Center in Richardson, Texas, succinctly assesses the benefits and challenges of technological trends as follows:

> Email, social media, and host of other IT and high tech tools make communication with patrons, clients, artists, agents, staff, boards, etc. so much easier and certainly faster. Ticketing systems for online purchasing are considerably better now than they were a decade ago. The reports that come from the data collected by the ticketing systems are also much improved. Scheduling software for our venues is much improved. These programs capture not only event details, but staff assignments, invoicing, and payments received. Technology has also made stage operations much better. My lighting technicians are able to focus lights and program our moving lights with their iPad or iPhone, and save cues to the light board. Time involved is far less than what it took to do all of this a decade ago. And the same can be said for sound and monitor systems used for shows.
>
> These changes also create some new challenges that in some ways make the job harder. The speed of communication has created an expectation of getting answers sooner to questions asked by patrons, agents, clients, and others. It creates a higher volume of multi-tasking to keep ahead of the online and email inquiries that every member on staff receives daily. On the technical side, stage equipment is enhanced and improve upon so frequently that replacement of equipment is needed just to stay current with software and other stage support needs, even if the existing equipment is functional. This also means more training for staff so they may be proficient in the use of the equipment. AV has become part of performances on a much greater level. The number of shows touring that we present now have AV needs that exceed anything we ever saw a decade ago. We're still trying to catch up with this trend and are looking to purchase better projectors, larger screens, and refitting our stages to better support the AV needs of client rentals and touring shows. In many ways, these challenges are actually good things to be dealing with.
>
> (personal communication, January 2016)

Finally, with regard to operations, the issue of safety and security has come to the forefront of PAC managers' attention. The recent terrorist attack in the Bataclan Theater in Paris was horrific and has prompted many theater

managers to think more about security for artists, audiences, and staff. Kathleen O'Brian, CEO of the Tennessee Performing Arts Center, describes security as "an increasingly more challenging issue and expense that we all face. We are well aware that we could be a target for anyone wishing to inflict harm" (personal communication, January 2016). In this book, Patrick Donnelly's chapter discusses safety and security issues within venue operations in more detail.

## Responding to Changes

Many of the trends facing the performing arts sector and performing arts facilities are challenging, but there are proactive steps that can be made. Before addressing these recommendations, however, it may be helpful to describe an all-too-familiar scenario that has played out for performing arts centers in several communities.

### *Avoiding the PAC Death Spiral*

A group of community leaders gets together one day and decide to pursue the development of a performing arts center. Perhaps these leaders believe that such a thing is needed to validate their coming of age as a community. Or they see their local arts organizations struggling in high school gyms and churches and declare that those groups and their audiences deserve better. Or maybe they hear that a neighboring city is building one, and they turn green with envy.

Whatever the motivation, this group gets organized, raises some money, does a study or two, and then approaches key funders to see if the funding is there. Their case for support is generally some combination of supporting the cultural development of the community, attracting great artists for local audiences, enhancing quality of life, and other good things.

If the funding is there, a project is pursued, and some years later there is a grand opening featuring world-class performing artists who extoll the virtues of the building and the community from the stage on opening night. After the dust settles, management gets to work operating the building, trying to accommodate local arts groups with limited financial resources, selling tickets to touring cultural programs and generally keeping the budget busy and the budget balanced.

It all goes well for a few years until a recession hits and the building runs into some budget challenges due to lower rental income from local groups, reduced corporate sponsorships, and lower ticket sales from touring performing arts groups. The executive director is under pressure from the board to fill the budget gap, so a decision is made to redirect the annual presenting program. Paul Taylor Dance and the Tokyo String Quartet are dropped in favor of Kathy Griffin and the Oak Ridge Boys. The immediate payoff is positive, as those shows sell more tickets. But there are rumblings from the funding community, particularly those donors who were initially

sold on the center as a home for symphony, opera, ballet, and theatre. So, the annual campaign for the following year is down by 20 percent, which causes another budget shortfall.

The executive director, under pressure again, advises the local ballet company that their traditional December dates for the *Nutcracker* won't be available this coming year so that the building can book the touring Radio City Music Hall Christmas Show. That show solves the budget for the year, but even bigger problems emerge as the ballet is forced to cancel its next season without the *Nutcracker* cash cow, and the funding community shows its increasing displeasure with another 20 percent drop in gifts to the annual campaign.

Now our poor executive director is really under the gun, and all those business leaders on the board are calling for more responsible "business decisions" that will surely put things right. So, additional cultural tours are replaced with commercially oriented acts, and a couple of education programs are canceled to reduce the level of daytime activity in the building to save some staff and maintenance costs. You can guess how that goes over with the funding community as the dream of a Center for the Performing Arts becomes a reality focused on touring popular entertainment, with aging rock and rollers staggering around the stage trying vainly to remember the name of the city to shout out.

You see where this is going. Too often, the promises made to fund a performing arts center are unrealistic in terms of the economic challenges of maintaining the buildings. The situation is made much worse as staff and boards abandon whatever mission they might have had in order to balance that year's budget. In fact, there are some situations in which early promises made to funders doomed the operation of the building before it even opened. It seems implausible, but think of the capital campaign chair and fund-raising consultants trying to write a case statement for key local funders. They know that a pitch based on creating a new venue for the Oak Ridge Boys won't get them very far, as opposed to one focused on bringing world-class artists and great art to their hometown. And that sort of pitch aligns well with the interests of some architects, acousticians, and other specialists seeking acclaim (and higher fees) for designing and building a world-class building to support all of that world-class programming.

So, what are some constructive responses to the challenges of running a performing arts center? **Simply put, the goal of PAC leadership is to build connections and value to drive participation and support.** This goal can be approached through a series of steps, outlined next.

## Focus on Communities

Successful performing arts centers are succeeding because they are paying attention to what is going on in their communities and determining how best to respond. In essence, this is the venue's value proposition to the community. Most cultural facilities were developed with minimal consideration for their

potential role in economic and community development. But now, successful buildings are deeply engaged in this effort and are able to respond to the different challenges that arise in their various communities. As a whole, the arts sector is now doing a much better job of articulating the value of the arts to individuals, communities, and society. The key here is that we are finding the language, the arguments, and the examples that connect the arts to the core issues and challenges of a community. Philip Morris, the CEO of Proctors Theater in Schenectady, New York, suggests that "if you are engaged in community and connectedness, then complexity grows and that makes things harder. I guess we could choose to sleep as the world moves forward, but we'll be quickly less relevant" (personal communication, January 2016).

## Anchor Cultural Districts

One of the best things to happen in the arts sector has been the emergence of cultural districts as an alternative to the development of cultural palaces. We are moving away from the idea of facilities that include everything to the concept of districts, where cultural facilities are distributed in an urban core. Some PACs see these secondary facilities around them as competition, which is a mistake. There is an opportunity for the PAC in a developing district to play the role of anchor and unifying force, coordinating the branding, promotion, and programming in the district. Proctors Theater in Schenectady, New York, and the Overture Center in Madison, Wisconsin, are two good examples of large facilities providing the leadership necessary to animate a larger downtown area, motivated by an enlightened self-interest.

## Make the PAC a Destination

The next generation of performing arts venues must be 24/7 buildings, open all the time with informal programming and an atmosphere that is buzzing and welcoming. This is a major shift for performing arts centers, which are used to coming alive an hour before a show, preparing for fancy people to come to a fancy performance. That's over. We can no longer justify palaces for the arts that glorify Western European art forms with an aura of exclusivity and reverence. For several years, performing arts centers have been enlarging lobbies and adding informal spaces, where food and drink are available for sale over expanded periods. Perhaps the next step is to open up the performance space itself as a place to meet and socialize even when a performance is not in progress.

## Return More Control of the Experience to Audiences

Why shouldn't audience members decide how they want to experience the performance? Can we break down the traditional boundary between public space and the performance space in such a way that audiences can move

more freely into and out of the live experience? Omnivore cultural consumers are accustomed to the way they engage in the arts in clubs, cabarets, and some cinemas. Certainly there is less latitude for some disciplines given the occasional need for near silence and for clear views of the stage, but it is time to establish a new set of norms for civil behavior in the theater. This does not mean having to listen to each other's cell phone calls during the performance. But we do have to encourage a greater level of engagement and eliminate the sense that audiences are sheep in a pen.

## Help Audiences to Prepare for and Process the Experience of a Live Performance

Tom Webster, who programs and manages facilities for the University of Montana, emphasizes that our key selling point is that nothing beats a live performance, which we then build around to create a bigger and more impactful experience (personal communication, January 2016). Encouraging patrons to meet on-site for a drink before or to discuss the performance after creates a more complete experience, adds value to the event, and provides an environment conducive to social interaction. Many facilities now host artist talk-backs before and after performances. But there are also other ways to improve audience readiness and understanding.

Can we create public spaces in performance halls that more closely resemble the old Town Square, where citizens congregate and socialize and where ideas are discussed and debated? Can we expand the time in which audiences are welcome in the space before and after the performance? Can we enhance food and beverage opportunities such that audiences are inclined to stay and talk? And can we suggest to audiences that what they think and feel about a performance actually matters? Think of how powerful that might be as a means to build that connection with the audience!

Part of the answer lies in the physical space, but we must also use electronic media and social networking to help audiences prepare for and process the experience of a performance. Some organizations do a terrific job now of preparing/informing audiences of a coming event, such as the New York Philharmonic, which has recently introduced a free iPhone application through which patrons can purchase tickets but also listen to recordings and podcasts. And others support and enable the feedback loop through forums for bloggers and tweeters, although these seem to be thinly veiled viral marketing efforts rather than honest attempts to help audiences express themselves.

## Make Facilities and the Experience More Attractive to Younger Audiences

A lot of the ideas proposed above pertain to this challenge—returning control of the experience to the audience, creating destinations, and helping audiences prepare for and process the performance will do much to increase

participation on the part of younger audiences. We have to create destinations where young people choose to congregate. They are not making plans weeks or even days in advance. It's at 7:30 p.m. when the text messages are flying, asking where to meet and what to do. So, our performance venues must provide that place to meet and those things to do, even if it's not buying a ticket to the 8:00 p.m. performance. And along the way, we must replace the subscription-based model of advanced commitments of time and money to an on-demand model that allows all of us (but particularly younger audiences) to choose the time, place, and cost of their leisure-time activities.

Also interesting to young people is the idea of combining cultural forms. We live in the time of the shuffle function, where hip-hop fades into baroque, which fades into Reggae-ton. Those distinctions don't matter to young audiences. This is not about dumbing down the product to suit a younger or less attentive audience. However, we do need to package the program in more interesting ways that throw out the old boundaries of forms and genres.

Finally, we need to bring a strong customer service orientation to the facility and its staff. Norbert Mongeon of Professional Facilities Management, which programs and operates some very fine theaters around the country, believes that "the event drives audiences to the facility, but it is the overall experience they have there that will bring them back" (personal communication, January 2016).

### Find Community Problems to Solve

The wonderful role that performing arts centers can and should play in helping communities move forward does not happen by itself. It takes a substantial effort to match community challenges to cultural development tools. The key to success in this regard is the outward focus on the community to identify challenges, the consideration of tools that the PAC might have to offer, and then convincing other elements of community leadership that PAC venues can play a role in solving larger problems. Good executive directors spend an increasing amount of time in this effort, and it is to be expected that the future will require even more time and effort in community engagement, with additional contributions coming from senior staff and volunteer leadership. In fact, the role of the board of directors in connecting the PAC to other areas and concerns in the community can and should be a critical function.

### Measure the PAC's Success

Many city-owned performing arts facilities are operated by private non-profits, and in this structure, there is often tension regarding how the facility is being operated and how much the city is investing annually to sustain operations. The major challenge is most frequently the different language and tools that the city owner and the private operator of the cultural facilities use to define success of the venue. Cities (and elected officials) care

about things like economic development, effective management, positive media coverage, and happy taxpayers. Building operators (and their boards) tend to be more concerned with booking great acts, ticket sales, expense controls, and fund-raising events. So, it is often difficult for the owner and operator to agree on what it is that they want from the building—what their common definition of success is and how it can be measured moving forward. It is imperative to clearly articulate the entity's mission. What is the purpose of the building and the value it delivers to the community? And how should it be operated in order to achieve that purpose?

Lance Olson, who now manages the Spruce Peak Performing Arts Center in Stowe, Vermont, is

> concerned that the industry and related funding community is focusing on externalities, more than on the industry's distinct value. In fact, those externalities represent the tyranny of indiscriminate measurement. We value what we measure, but things that are hard to measure may be even more valuable. We can measure the possible viewing numbers of our Facebook ads, the cost per appearance, and to some degree return on investment. We experience less specificity in measuring the outcomes related to catalog distribution. Yet the catalog is one of our few remaining long-form information outlets, and it expresses our mission, vision and values. We can measure the guests through the door and the number of events in a year. But the outcomes are why we're important to the life of our community, [which are] much harder to quantify.
>
> (personal communication, January 2016)

In these cases, PAC leaders may wish to adopt more formal tools for strategy implementation and evaluation. One popular approach is the *Balanced Scorecard*, a strategy implementation tool developed by Harvard Business School professor David Niven (Niven & Mann, 2003). When used in the corporate and government sectors, the Balanced Scorecard tends to become extremely complicated and cumbersome, but there are three basic principles worth embracing in our world:

1   You can only move what you can measure: This is to say that it is important to find quantitative measures in order to track progress.
2   Don't just measure money: The Balanced Scorecard proposes four perspectives as the basis for measuring progress—audiences, internal processes, employee learning and growth, and financial. And there are good things to measure in all of these areas.
3   Find things to measure sooner: Too often we're only measuring things that take too long to become apparent. For example, if the goal is to strengthen the board, don't just measure the number of people added or their giving. Find leading indicators of progress, such as the number of people invited to join and the hours invested in board training.

Such tools are widely used in the public sector, and they are very effective ways to monitor progress and measure success in government-owned facilities. But they are often a stretch for nonprofit managers, volunteer boards, and government owners, who struggle to agree on goals, measures, and—even more basically—what success means in a performing arts center. Here the work is to find a common language in order to define success for all those inside and outside the building.

## Conclusion

So there's some bad news and some good news for the sector. The bad news relates to declining audiences, economic challenges for those producing content, and the hard work of raising money in both the public and private sectors. But the good news includes the rapid growth and development of arts education and outreach, new opportunities for active arts participation, new approaches to programming and our improving ability to express a strong value proposition to the communities we serve. Our favorite facility managers recognize these new challenges and opportunities and are generally optimistic about their ability to find a way forward.

The conundrum is that as much as we can make performing arts facilities safe, secure, inclusive, compelling, and sustainable, we can't control what's going on around them. The demography of North America is changing rapidly. Economic and political forces are swirling around the arts and how they are supported. And then there's the accelerating pace of technological advancement. So our future depends on our ability to observe and respond to external forces and trends, working relentlessly to make sure that performing arts facilities are relevant and valuable to individuals, communities, and society.

## Acknowledgments

I would like to thank those original contributors to *Running Theaters* who were kind enough to provide their views on the current state of affairs, including Eric Fliss, Bruce MacPherson, Norbert Mongeon, Philip Morris, Kathleen O'Brien, Lance Olsen, Randy Vogel, Tom Webster, and Robyn Williams. I would also like to thank all those who read and commented on *Running Theaters* over these past 10 years. It was a great adventure writing the book and a great education that has made us better consultants.

## References

2012 Survey of Public Participation in the Arts—Home I NEA. (2013, September 26). Retrieved June 1, 2016, from: https://www.arts.gov/sites/default/files/2012-sppa-feb2015.pdf

Baumol, W.J., & Bowen, W.G. (1968). *Performing arts—the economic dilemma.* Cambridge, MA: MIT Press.

Brown, A.S., & Novak-Leonard, J.L. (2013). Measuring the intrinsic impacts of arts attendance. *Cultural Trends, 22*(3–4), 223–233. doi: 10.1080/09548963.2013.817654

Conner, L. (2008). In and out of the dark—a theory about audience behavior from Sophocles to spoken word. In S.J. Tepper & B. Ivey (Eds.), *Engaging art: The next great transformation in America's cultural life.* (pp. 103–126) New York: Taylor & Francis Group.

Niven, P.R., & Mann, S.V. (2003). *Balanced scorecard step-by-step for government and nonprofit agencies.* New York: John Wiley & Sons.

Novak-Leonard, J.L., O'Malley, M.K., & Truong, E. (2015). Minding the gap: Elucidating the disconnect between arts participation metrics and arts engagement within immigrant communities. *Cultural Trends, 24*(2), 112–121. doi: 10.1080/09548963.2015.1031477

Webb, D.M. (2004). *Running theaters: Best practices for leaders and managers.* New York, NY: Allworth Press.

# 4 Programming the Performing Arts
## Balancing Mission and Solvency

*Tony Micocci*

## Introduction: To Produce, Present, or Rent?

At the core of the missions of most performing arts centers (PACs) are the performances that appear on their stages and related artistic and community activities. While the public may not always know by what means the shows appear—nor is it always important that they do—the approaches taken are of vital importance to the PAC managements, their organizational structures, and their finances. This chapter explores the programming options available to PAC managers, and the rationale for and implications of each of these options.

To begin, it may be helpful to clarify that there are essentially three ways that PAC programmers obtain shows for their audiences: (1) they *produce* new shows for their stages; (2) they *present* shows produced by outside entities, based locally or elsewhere; and/or (3) they *rent* their stages to third-party producers and presenters (in the music industry often referred to as *promoters*). The programming toolkit can also be expanded with variations on these core three options to encompass *hybrid producing*, *hybrid presenting*, and *renting variations*, which are profiled in Box 4.1.

The word *produce*, for purposes of this chapter, means to create new shows or new productions of existing shows, involving creation costs that include hiring casts, directors and designers, and paying for intellectual property rights, rehearsals, scenery, and costume construction. The productions themselves might be entirely new creations, adaptations from underlying sources such as books or films, or remounts of previous works. The key delineator is that they are newly built productions with all of the up-front costs and the uncertainty of the quality of the results assumed by the producer. In contrast, *presenting* involves the PAC bringing in shows that someone else has produced, and for which has borne the creation costs. These shows often have the added advantage to the presenter of having been tested for audience appeal and critical response in other markets. *Renting* implies the existence of a separate entity that is the presenter or producer, with the PAC a passive landlord in the process.

This chapter explores the reasons that a PAC might choose—or be forced into—one or a combination of these programming options, and what the associated ramifications might be on the PAC.

## Box 4.1   An Expanded PAC Programming Toolkit

### Hybrid Producing

#### Co-Producing

The PAC may have opportunities to share risk, responsibility, and potential reward with other institutions in the producing of shows. A key element is that the PAC puts something of value into the creation, which could be money or perhaps the use of rehearsal rooms, production equipment and time on stage with stagehands to realize the lighting and staging. As a *co-producer* the PAC will have the opportunity of financial return from future engagements of the show.

#### Commissioning or Co-Commissioning

This can look at lot like co-producing in that the PAC is putting something up towards the costs and resources needed to create a new production, but differs in that it does not have the opportunity of future financial return. PACs that are successful in commissioning new productions have often found financial contributors that are interested specifically in supporting the PACs' involvement in new artistic creation. The motivation for this is more elusive than hope of financial return as it has more to do with the image and status of the PAC, both locally and within the national and international arts community. Such creative involvement can attract donors, and a PAC with a reputation for originating exciting new productions can be a source of pride for a city seeking a strong cultural identity.

### Hybrid Presenting

#### Co-Presenting

As the name implies, the PAC might share the costs, risk, and return of presenting specific shows with one or more organizations, ideally ones with complementary resources. An excellent example of this is a PAC joining forces with the local ballet company to co-present an out-of-town touring dance company. The PAC has the venue, and the ballet company has the trust of and access to the dance audience, two core components of a successful presentation.

#### Block Booking

By banding together with other presenters in the region and collectively bargaining for the performance services of a show or artist for a regional tour segment, a PAC may reduce its expenses and expand promotional opportunities. The cost savings may go beyond discounted artist fee. If, for instance, the artist is flying in but can be transported on the ground once in the region, the high cost of the flights might be split among the group and a shared deal made with a regional bus charter company. Cooperative advertising by the presenters can also be possible in regional media, which may also give more editorial attention to shows appearing in multiple markets than in only one.

Many states and regions have presenter associations set up to facilitate block booking, and funding sources that underwrite the cost of presenting by multiple area presenters.

## Opportunity Booking

The term *opportunity booking* applies to receptivity by an artist or a show's booking agent of specially discounted terms as an incentive for the PAC to present on a particular date or dates in the middle of a tour on which the artist would otherwise be inactive. Having committed the costs of artist's salary, per diem, and accommodation, the tour organizer may opt for reduced income on an otherwise "dark" date as preferable to greater financial loss. The challenge to the PAC is that such opportunities inevitably are offered quite late in the booking and advertising process, after the tour organizer has explored all other options, and the PAC's marketing team will have to work on short notice.

## Renting Variations

### Resident Company Rental Relationships

Many PACs have *resident producing companies*, often the local symphony, ballet, and/or opera companies, to which ongoing commitments are made to provide performance homes. Indeed, the missions, architectural designs, and fund-raising rationales for PACs' establishment may have been based in part on these anticipated relationships. These are often rental relationships, but with unique stipulations that may include long-term venue commitments, priority scheduling, marketing support, and discounted rental rates.

### Exclusive Programming Relationships

Falling generally into *rental*, but often with a *co-presenting* component, this relationship most commonly applies in commercial programming areas of pop music, comedy, and Broadway. A PAC might award exclusive programming rights in these genres to genre-specific presenters or promoters and agree to not rent to competing promoters unless the latter have reached agreement with the promoters holding the exclusive agreements. In exchange, the PAC seeks to obtain access to a caliber of artist or production not otherwise available to the PAC directly and be guaranteed a minimum number of shows brought in by the promoter each year. Conversely, a promoter might agree to guarantee a PAC the first option on shows he or she may have available for the market or even to program in the market *only* at the PAC in exchange for favorable rental terms, marketing support, and priority scheduling access.

This chapter focuses on the management of performing arts centers, whether nonprofit or commercial or, in some cases, governmental agencies, recognizing that the managing companies are often not the same as the owners of the real estate. Management companies may also seek to achieve cost

efficiency by managing and programming more than one facility in a community, and in some cases, venues in more than one city.

Variants noted but not included in the scope of this chapter are theaters owned and operated by religious, social, or community organizations; by academic institutions; and by producing organizations. Producing institutions that own their own venues, such as the Goodman Theatre in Chicago and the Center Theatre Group in Los Angeles, would not be performing arts centers under this chapter's definition of the term as their primary mission is producing. Our focus is on exploring programming within independently operated PACs that achieve their programming through some combination of renting and presenting and only occasionally some producing.

## Performing Arts Center Programming Models

For most PACs, while commitments to provide ongoing performance homes to civic institutions such as the symphony and ballet may be of high importance, an even higher overarching *raison d'être* is to have their stages lit with productions that fit within the overall artistic missions and to have audiences coming in the doors, with business models that are financially viable and sustainable. The recent folding of opera companies in both Baltimore and New York for which PACs had dedicated space and time serves as a reminder that the buildings may well outlast the producing institutions. Accepting this as the primary mandate, PAC leaders can approach programming options as tools to achieve those ends—not as ends in themselves.

Not only will the programming models vary among different PACs, but it should also be noted that the mix of approaches may vary over time. In the classic case of Lincoln Center in New York City, at the outset each of the component venues was built for a specific existing producer, which would move from its previous home—an opera house for the Metropolitan Opera, a concert hall for the New York Philharmonic, a suitable theater for the New York City Ballet and Opera—and the original plan involved only a small amount of presenting by "Linc, Inc." It was only years later that the organization established more robust programming operations to undertake presenting and even some commissioning and producing, for many of the reasons discussed in this chapter. Conversely, PACs with initially strong presenting programs are sometimes compelled to pull back to more renting, often after experiencing unacceptable financial losses from higher risk presenting.

A *facility-use survey* will normally have preceded the construction or significant renovation of a PAC. A professional consultant generally conducts the survey with three goals in mind:

- First, to justify and lay the groundwork for capital fund-raising for the construction or renovation by demonstrating both (a) the need for new

or enlarged performing spaces by existing local producing organizations such as ballet companies and orchestras, by outside community and commercial promoters, and for shows available to the PAC itself to present and (b) that sufficient audience demand exists or will exist to attend these performances.

- Second, to recommend an optimal operational and program model for the PAC.
- Third, to inform decisions on seating configuration, capacities, and production capabilities, based on anticipated use and market demographics.

Performing arts center managers are well advised to study the facility-use surveys, even though they may have been conducted years prior and well before the managers were hired. At best they will serve as road maps for program planning. In some cases, the study results were predicated on a community expansion that has not been realized. Sadly, also, there are numerous examples of overly optimistic use surveys driven by well-meaning community leaders desirous of building cultural monuments. These often rely on wishful "if we build it, the performance calendar will somehow get filled" forecasts, with unrealistic rental, financial, and attendance expectations, and no financial plan to support presenting. Indeed, a nationwide study published in 2012 determined that a surprising number of new arts facilities built over the prior two decades had been built without fully developed and viable programming and financial plans in place (Woronkowicz et al., 2012). Boards will tend to hold management staff responsible for program delivery and fiscal stability and to believe in the veracity of the use surveys despite how much the environment may have changed or overly optimistic the surveys are. For this reason, it is important for managements to be aware of expectations their boards may be holding from those early use surveys and to work on changing those expectations if needed, possibly by commissioning updated use surveys.

## Strategies for Programming

Setting aside producing, which is rarely undertaken by the organizations managing performing arts centers, presenting demands the most resources and incurs the highest risk among programming options. The decision as to whether and how much the organization will undertake presenting should be made as early as possible after assessing the programming mix and quantity that will result from renting.

Most performing arts centers will start program planning with rental use by local producing organizations. Emphasis will be on organizations with the financial, marketing, and programmatic stability to reliably and consistently deliver programming and solid audiences throughout the season and over the years ("resident companies"). Noting the Lincoln Center example,

these may include the important civic institutions—the local opera, ballet, or symphony, for instance—which were integral to the rationale to construct or renovate the PAC in the first place. Financial supporters of those institutions may well have been crucial in the funding of the PAC, with attendant use expectations (*ex officio* representation of these civic institutions on the boards of the PACs, and vice versa, is not uncommon).

The second step in programming may be an exploration of commercial programming options. This may involve renting and presenting, and generally involves three areas: touring Broadway productions—at least one prime Broadway series is now considered *de rigueur* in most American cities—comedy, and commercial or "pop" music (while the word *pop* is sometimes used to refer to a specific subset of commercial music entertainment, in this chapter it used synonymously with commercially viable music). While these each work somewhat differently in the process by which booking dates are set and in the nature of the presentation deal structures, they share the expectation that their performances can generate profits without financial subsidy.

The renters or tour producers of commercial music might be local, regional, or national music promoters. Pop music can involve a range of relationships along the rental-to-full-presentation spectrum. Broadway touring engagements, on the other hand, generally require fee-guaranteeing local presenters: the PACs or other entities. Broadway and pop music are fields undergoing national and international consolidation, discussed in greater depth later in this chapter.

The third step in programming will be an assessment of demand for occasional rentals by local institutions that are not necessarily able to make consistent commitments of full-season programming but that can be important both as revenue generators to the PAC and to deepen community relations. Local dance and music school showcases are not uncommon, as well as non-arts events such as political election debates, product launches, bodybuilding championships, and religious services. Rentals by area schools for graduation ceremonies can be important to building community relationships that have importance well beyond the events themselves. (It is not uncommon for a PAC to offer a local nonprofit rental rate that is lower than commercial rates.)

### Presenting

The biggest decision the PAC must make, significantly affecting both operational structure and financial risk, is the degree to which it will present. At its best, presenting can provide the PAC with control of program content, marketing image, and calendar balancing. It can delight audiences and provide the PAC access to negotiating for the artists to undertake workshops and community outreach aligned with the PAC's mission, as well as to attend PAC donor receptions. It can provide sponsors a venue through ads, program and website credits to tout their support of the arts and, through

special ticket access, to socialize with clients. With a dose of good luck, it has the potential to generate surplus income for the PAC.

At its worst, presenting can generate unexpected financial losses, artistically offend segments of the community, and create divisiveness within the organization over who is to blame for failure (there is never any lack of claimants for presenting success!).

Some performing arts centers seek to program only based on venue rentals. This approach allows for a leaner organization with lower overhead, and assuming the rental demand is sufficiently robust, there is less financial risk involved. Many PACs that might have initially operated as rental landlords do end up presenting, however, driven in part by insufficient rental demand. But there are other more proactive reasons for PACs to consider presenting. Such reasons have to do with the PAC's control of factors relevant to its image and role in the community, as well as artistic balance and achievement of mission.

The first good reason to present has to do with the *institutional image*. While it is not unusual for a performing arts center to have, as a condition in rental contracts, constraints on how the PAC will be reflected in promoters' advertising (e.g., use of PAC logo, standardized ticket access information), there is a limit on the degree to which the PAC can take public credit for presenting shows brought in by renters or control where and how advertising dollars are spent. For the PAC this can be a blessing if a show is unpopular or not of high quality, but painful if a stellar success for which the PAC would like to take credit. There can be significant value to the PAC, especially in ongoing fund-raising, to be seen not just as "the place that shows happen" but also as "the organization that makes shows happen." Presenting even a limited series of high profile shows spaced in the calendar among the rentals allows the PAC consistent public messaging entirely within its marketing control.

Second, as hinted at earlier, hand in hand with institutional image is control of *artistic quality*, recognizing that to a large degree the average ticket buyer identifies a theater or PAC with what appears on its stages, regardless of who presents. If a PAC is not able to attract renting organizations that bring shows of consistently high standards of quality, this may contribute to a decision by the PAC to initiate presenting. For example, the annual bodybuilding championship or third-rate Broadway remount may pay good rent, but if those emerge as dominant on the calendar, are these *really* the purposes for which so much money was raised to build or renovate a world-class PAC? Without the ability to present, a PAC's programming is completely at the whim of renters.

Additional reasons to present pertain to ensuring the quantity of performances needed, a balance in the types of performing arts offered, and a consistent schedule of events. The combination of rentals by both local civic organizations and commercial promoters may simply not fill up enough of the calendar to satisfy public demand, or may leave significant gaps in the PAC's activity calendar. This can put the PAC in the position of paying staff

during low-use or inactive periods and risking the PAC falling off a fickle public's radar.

For the PAC programmer, calendar balance is matched by content or genre balance. There may be a good local orchestra appearing regularly in the PAC on a resident company rental basis, and perhaps a theatrical production company, but no dance being offered in a city that enjoys dance and expects to experience it in the PAC. Also, while national touring Broadway productions may be available to come to the community, the shows' producers will generally require an active risk-taking presenter to bring them in. In both these examples, if the PAC leadership feels these artistic genres are important to the overall program mix, it may do well to assume the role of presenter in order to get them.

The last two arguments for presenting have to do with *mission* and *money*. Many nonprofit performing arts centers are granted their tax status based on a commitment to education, which will be embedded in their missions, and most have dynamic activity in this area including school outreach, adult education, and other community interaction with artists. As presenters, they have a straightforward process for negotiating some amount of artist educational outreach activity into the engagement contracts. As a landlord only, the PAC has little ability to seek such activity of visiting artists and is at the whim of the presenter in such matters.

Regarding money, while the risk of loss looms over presenting, there is also a reasonable chance to end the year's presenting activity with what is often euphemistically referred to in the nonprofit world as *excess income over expense*, noting that any such profit under nonprofit law returns to support the organization. With economies of scale to be found in areas such as bulk advertising and hotel room bookings, and the spread of ticket income risk among a "portfolio" of presented shows, up to a point the prospect of achieving a surplus may actually increase with more presentations in each season. And on the fund-raising side, the value of negotiating access to the artists to appear at donor receptions following the performances can be high.

## Expanded Resources for Presenting

A presenting organization will, by the nature of the added effort involved, require additional resources—especially staff, whether contracted on a per-show basis or on regular salary—compared with a rental-only facility. This will show up in four areas of operations in particular:

### Production Planning and Control

Whereas a rental facility will have a technical director responsible for providing the needed electricity and other production services to the incoming show team, and to safeguard the PAC's equipment, the role is more complex

if the PAC is the presenter. A PAC that is both venue and presenter will assume full responsibility for advance planning and preparation for shows' needs, and for providing required equipment, stage crew, and production supervision on-site.

### Marketing

The event advertising responsibilities of a rental operator are comparatively minimal, with the presenter responsible for budgeting, design, and ad placement. As venue *and* presenter, that will all fall to the PAC.

### Artist Support and Coordination

Depending on the nature of the touring show coming in, the advance and on-site care and feeding of the artists can be significant—again becoming the responsibility of the PAC if also the presenter.

### Fund-Raising

The presenter will be responsible for seeking contributed underwriting or promotional sponsorships as may be needed. If the PAC is a nonprofit, already seeking general operating or other types of contributed support, presenting sponsorship can add considerably to the demands on the development department.

## Cultural Versus Commercial Presenting

For purposes of this chapter, *cultural presenting* refers to the presentation of artistic work that due to an imbalance in presenting costs relative to public demand can be expected to require a financial subsidy to present. The archetype of this might be symphony orchestra presentation, as well as *avant-garde* theatre and ballet productions (with the exception of *The Nutcracker*). In contrast, *commercial presenting* in the context of PACs refers to presenting in areas such as Broadway productions, commercial ("popular") music, and comedy wherein the ticket revenue is anticipated to more than exceed the costs of presentation.

In the United States, the tax-exempt, nonprofit organization is often referred to by the name of the section of federal tax code most commonly applied to cultural institutions: 501(c)3. Most cultural institutions, including PACs, operate as nonprofits. Because culture is not specified in Internal Revenue Service guidelines as a qualifying criterion for this status, PACs' missions often include education: to provide cultural enrichment and edification to their communities through programming and education. That being said, since the 1940s, legal precedent has established performing arts institutions to qualify as nonprofits, provided the bulk of their programming emphasizes work selected for artistic merit rather than mainstream commercial viability.[1]

## Mitigating Risk in Presenting

A successful ongoing presenting institution will do all it can to mitigate the enhanced risk that accompanies presenting. Concrete actions to do so include the following:

- Building up and sustaining a risk reserve fund, which can also aid cash flow when needed.
- Developing and maintaining an effective Constituent Relationship Management (CRM)–based marketing structure, nurturing a loyal audience and establishing the PAC as a trusted "art and entertainment guide" in the community.
- Selecting programming with care and sensitivity to the market, approached as a (hopefully) balanced risk portfolio.
- Balancing presentations with rentals.
- Pursuing block booking and co-presenting partnerships where feasible.

## International Presenting Considerations

Additional considerations need to be taken into account when presenting international artists. Among the most common and significant are the following:

- Stringent post-9/11 visa requirements for entry into the United States have made the visa petition process more complex, and in some cases forced the cancellation of planned tours. Research into the international tour history of the artists—notably their previous activity in the United States—and carefully prepared visa applications as early as permitted are important to success in this.
- The incremental overhead costs affecting tours of non-U.S. artists in areas such as international transportation, freight, and visas can heighten the pressure on securing a minimum number of tour engagements required in order for a tour to proceed. As a result, presenters may face the uncertainty of committing to participate in a tour that is subject to cancellation if sufficient additional dates are not procured. Transparent communication between presenters and the booking agent and clearly agreed upon deadlines for finalization are the key to successful outcomes.
- Currency fluctuations can play a significant role in international presenting. Ideally the U.S. presenter will secure an agreement that establishes a U.S. dollar fee cap to avoid surprise as a result of exchange rate changes between the time of contracting and of the engagement.
- Special U.S. government tax withholding requirements apply to fees to be paid to foreign artists (in addition to withholding by some states on fees to be paid to any out-of-state artist). The United States has tax treaties with many countries, searchable online, and the tax burden can often be reduced or waived with advance filing with the U.S. tax authorities.

Agencies representing international artists will usually take responsibility to guide on issues such as visas, international transportation and freight, and taxation issues (though the first presenter on a tour may be required to act as the visa petitioner). It is important for presenters to clarify with the agents early on the responsibilities that each will assume in these areas.

## Festival Programming

An overview of PAC programming options and strategies is not complete without a look at the increasing prevalence of festival programming, both nonprofit and commercial. While festivals vary considerably, characteristic of festivals is a critical mass of multiple events, chosen based on some theme, presented over a defined period within a limited geographic area. Festivals usually involve multiple venues; PACs with more than one performance space can often stage effective festivals entirely within their campuses. Citywide festivals epitomized by those in Edinburgh, Avignon, and cities throughout Australia have tremendous cultural and economic impact on their communities.

An appeal to festival programming on the artistic side is the opportunity to introduce new artists and productions to audiences who will approach a festival often with more open and exploratory attitudes than they will for a single event or subscription series. The extreme are *fringe festivals*, where, by definition, the shows represent new and often provocative artistic work.

From a structural standpoint, well-planned festivals can offer opportunities for synergistic marketing. And while the logistics of presenting multiple shows in a short time can involve significant resource challenges, some economies of scale can be achieved in areas such as accommodation block booking and short-term staff hiring.

Commercial music festival examples are well known, looking no further than Bonnaroo, Coachella, and the New Orleans Jazz Festival. Leading U.S. examples of nonprofit-produced festivals include Spoleto USA in Charleston, North Carolina, the Jacob's Pillow Dance Festival in Massachusetts, and the San Francisco International Festival. Excellent examples of PAC-specific festivals can be seen in New York with Lincoln Center's Mostly Mozart, White Light, and Lincoln Center Festivals, and the Brooklyn Academy of Music's Next Wave Festival.

## Historical Context: Performing Arts Presenting From the Late 1970s to Today

An understanding of programming approaches benefits from a look back over several decades of evolution in attitudes, expectations, and practices in this field. Performing arts presenting has come to operate on a continuum between high-risk esoteric cultural shows and commercial entertainment. A historical overview of the development of diverse national tour presenting

models will help provide understanding and appreciation for these seemingly dichotomous approaches.

In the late 1970s, presenting was generally a straightforward process wherein performing arts centers offered performances to well-heeled, established audiences. The generational disconnection reflected in Vietnam War protesting and the hippie movement was not yet impacting the model—the younger generation turned out in force for commercial music concerts in larger and larger arenas, and for the occasional effort at cross-generational productions such as the musical *Hair*, but for the most part did not participate in the PAC presenting process.

PAC presenters generally chose programs from lists offered by a few large booking agencies. These agencies offered established fare, chosen for salability based to a large degree on either renowned institutional brands (e.g., Broadway hits, Ireland's The Abbey Theatre, the Moscow Circus, the Tokyo String Quartet), established accolades such as winners of the Van Cliburn International Piano Competition or Grammy Awards, or raves from the New York press—especially *The New York Times*.

It was rare that an artist or show would tour the United States without appearing first in, and receiving critical acclaim from, New York City. And New York presenters were cautious in their choices. The divide was extreme between Manhattan's established "uptown" (Carnegie Hall, Lincoln Center, Broadway theaters) and a "downtown" largely invisible to all but the *cognoscenti*. While exciting new art was being shown at smaller lower Manhattan venues such as La Mama (founded in 1961), Dance Theatre Workshop (1965), and The Kitchen (1971), such productions rarely toured the United States. The New York City forces involved in producing and presenting the newest work were not yet integrated into the agency-dominated national tour–booking scene, and the agencies themselves were only beginning to dip their toes into representation of contemporary work from artists other than classical masters. Difficult as it is to imagine today, the commitment in the early 1970s by the venerable Columbia Artists Management to take on tour representation of the modern dance companies of Alvin Ailey and Martha Graham was considered a radical move!

Broadway shows had toured for years, but the significant national branding of "Broadway" under the Broadway League leadership of Jed Bernstein was years in the future (Robertson, 2006). Broadway became a mainstay of PACs' season offerings, often able to generate excess income over expenses that provided subsidy for cultural programming. (It is notable that in many cases, often by design, PACs have the optimal venues in capacity and production capability for Broadway shows in their communities.)

In this era of presenting, the commercial music field was divided regionally and was dominated in the largest cities by legendary promoters such as Ron Delsener and Bill Graham who controlled both venues and artist exclusive performance rights in touring territories. It was a turbulent business environment, with younger promoters in smaller communities

nipping at the heels of established giants. Significant groups such as the Beatles, Rolling Stones, and Grateful Dead had set upper end benchmarks for music acts performing in arenas and even stadiums, and PACs were considered to be midsized venues (2,000–3,000 seats) in a dynamic food chain with clubs at the lower end. The aggregation of the field into oligarchic national and even international control by a small number of behemoth companies such as Live Nation and AEG Live was decades in the future.

## The "Next Wave" of Presenting

By the early 1980s, for reasons having to do with demographic and societal changes well beyond the scope of this chapter, the post–World War II paternalistic presenting model of established brands spawned an antithetical movement of lasting significance to PAC program thinking. The result was cutting-edge artistic work moving out of intimate venues to large production scale and an appeal to new audiences. Ironically, it took a 150-year-old performing arts center in a New York City borough other than Manhattan to lead this revolution!

If there is one overarching lesson to be learned from the Brooklyn Academy of Music's initiative profiled in Box 4.2, it is that sometimes it is the bold and unexpected move that wins the day. It is a marketing truism that if asked what they would like to see on stages, audiences can only answer based on what they have already experienced. What BAM did was leapfrog ahead, and assume the role of initiator, guide, and instructor, inviting those who were prepared to go on a journey into the new and unknown to do so in the context of Next Wave.

BAM's new model provided a challenge and inspiration to many PAC leaders in small and large communities nationwide to view their programming more proactively as taste leaders rather than only followers. If one thinks of the programmatic role of an enlightened arts institution as a balance between offering what it perceives the public to already know and want, and pursuing an educational mandate to introduce the public to new art and artists, the effect of BAM's Next Wave was a shift in the direction of the latter. BAM's initiative had an impact on the touring and presenting eco-structure that continues today and anchors the new art end of the PAC programming spectrum.

The first lesson for PAC leaders was the public attention such programming can generate for their institutions. Almost overnight, BAM was recognized in media and the performing arts world in the city, nationally, and internationally. The public visibility and sense of excitement were the subject of envy, even among established Manhattan arts institutions. Visitors and residents learned just how simple it actually was to ride the subway to BAM and discover its fantastic facilities—indeed, the location across the river from Manhattan enhanced the exotic appeal to many. The message was that provocative, attention-getting programming can generate attention

## Box 4.2    Case Study—The Brooklyn Academy of Music's *Next Wave*

After attempting without success over some years to establish a successful program model to fill the 2,100 seats of the Brooklyn Academy of Music's (BAM) Opera House, BAM's president persuaded his board and staff to support a commitment to dramatically new work of large scale, promoted initially in series format. The launch of the Next Wave Series in 1981—dubbed the Next Wave Festival in 1983—in the heart of Brooklyn, prompted one of the most fundamentally transformative trends in the modern history of performing arts center programming, with impact globally and among the American theatergoing public. The scale of contemporary productions, previously unknown to the American public, coupled with the location—Brooklyn at that time was far from the sought-after cultural destination it has since become—offered challenges that would have easily deterred a less bold leader.

As the BAM website states,

> BAM's Next Wave Festival has permanently changed the artistic landscape, featuring breakout performances and landmark productions. Using a name that plays on the New Wave in French cinema, BAM president and executive producer Harvey Lichtenstein launched a series entitled "The Next Wave/New Masters" in November 1981 with four productions: three dance works, plus Philip Glass' new opera *Satyagraha*. A more ambitious program followed in 1982, including a two-evening performance work by Laurie Anderson entitled *United States: Parts I-IV*.
>
> The success of these first two years helped propel a bolder and riskier program in the years to come—one that has defined BAM and an entire generation of artists. In October 1983, the Next Wave Festival was launched, which spotlighted exciting new works and cross-disciplinary collaborations by promising young artists. The Next Wave was groundbreaking for taking works that had previously been shown in downtown lofts and small "black box" theaters and presenting them in the exquisite 2,100-seat BAM Opera House (now the BAM Howard Gilman Opera House), a renovated 1,000-seat playhouse (the Helen Carey Playhouse, later converted into BAM Rose Cinemas), and the flexible 300-seat Lepercq Space.[1]

Early successes led to one of the most landmark undertakings in American theater history: the complete adaptation of an entire theater for a production of *The Mahabharata* by director Peter Brook in 1987 at enormous cost and risk. As *The New York Times* reported,

> During its three-month run, *The Mahabharata* played to 97 percent of capacity, with box-office receipts of $1.5 million, and generated a torrent of media attention. Harvey Lichtenstein, the president of the academy, said yesterday that he was delighted with both the production and the theater. "The public that saw *The Mahabharata* was terrifically responsive," he said, "and every artist who has seen the theater, from Teresa Stratas and Pierre Boulez to Laurie Anderson, wants to work here." "*The*

*Mahabharata* has been very important to BAM," Mr. Lichtenstein added. "Peter Brook is one of the most distinguished, if not the most distinguished, director around, and this is a culmination of his 40 or 50 years in the theater. The rebuilding of the Majestic was really Peter Brook's idea, and I hope that BAM could be his New York outpost."[2]

Speaking of the festival, producer Joseph Melillo said,

This project was created to solve a cultural problem, which was that there was not a facility in America devoted to presenting large-scale works of contemporary, nontraditional performing artists. The opera houses of Germany and France were wooing away American artists with the opportunity of creating works on a grand scale.[3]

Through a combination of bold program choices, expert marketing, and timing, overnight BAM's Next Wave Festival became *the* event to experience in the hippest circles of the America's most culture-rich city, with bold-faced names and media in high gear. Both funders (led by the Philip Morris Companies) and the audiences came, and the Festival became what the French term a *succès fou!* (a riotous success).

1　http://www.bam.org/programs/next-wave-festival
2　http://www.nytimes.com/1988/01/05/theater/transforming-a-brooklyn-theater.html
3　http://articles.philly.com/1987–10–13/news/26214240_1_avant-garde-festival-music-s-next-wave-festival-armitage-ballet

for PACs in their communities well beyond appearances by the established classics.

A second lesson from BAM for PAC managers/programmers nationwide was that it is possible to reach a heretofore-uninvolved younger generation with contemporary programming appropriately marketed. Presenters came to realize that, when chosen and promoted with care and flair, daring new programming could break traditional molds and appeal to expanded audiences drawn to the exploration of the new rather than to nostalgia for the old.

A third lesson was an awakening to the power of presenters as customers in the touring ecosystem. In the 1980s, a generation of programmers came to recognize that presenters, as end buyers of touring "product" (an industry term for touring shows), had more influence on the choice of shows that toured the country than had ever been realized, *and* in some cases the artists could tour successfully without appearing in New York first! This meant that regional PAC presenters no longer needed to wait either for booking agencies to include the shows on their touring rosters or for New York presenters to decide to present them. Coalitions of PACs

interested in particular artists shunned by established booking agencies could reach out directly to the artists or show producers and arrange tours. Presenters increasingly traveled to bellwether showcase events such as the summer festivals in Edinburgh (International and Fringe) to seek programming directly.

A fourth area of impact was on the appeal to an expanded array of presentation underwriting sponsors, many of whom are eager to communicate with the active younger generation to which such programming appeals.

Admittedly, within the New York City market BAM had the benefit of early and timely staking out of large-scale contemporary programming. Its closest next market competitor, Lincoln Center's excellent summer festival, did not launch for another 15 years. More recent institutions offering large-scale contemporary performances, such as the Park Avenue Armory and the new Hudson Yards project, were in the future. In the intervening time, BAM was able to solidify its high-profile position in the city, add venues for expanded programming range, and lay the groundwork for the revitalization of the area of Brooklyn now called the *BAM Cultural District*. Next Wave established a lasting identity among a younger audience throughout New York City, on which BAM has been able to capitalize for other programming and to build robust educational activity.

### Tour Booking Structural Changes

Along with evolved presenter attitudes and sense of their roles in their communities, the tour booking business structure changed as well. A new breed of booking agents came on the scene with an interest in provocative contemporary work. These agents often see their roles as going beyond simply selling a package to presenters, to include assembling co-commissioning arts centers and funders, and facilitating presenter involvement in the creation of new work. In line with these changes, significant booking conferences produced by organizations such as the Association of Performing Arts Presenters, the Canada-based CINARS, and the International Society for the Performing Arts began offering versions of what are commonly referred to as *pitch sessions*, akin to venture capital presentations in the corporate world: artists with new projects in development are invited to pitch to presenters with potential to support project completion and to present.

The National Performance Network (NPN) was launched in 1985, made up of presenters of all stripes nationally—including some performing arts centers—sharing commitments to support and present new work for their stages. In addition to facilitating communication among such presenters in choosing works to be supported, NPN serves as a redistributor of grant funds from national foundations that recognize the importance of supporting the creation of new work *and* ensuring its public presentation.

Early in the new century, the Under the Radar Festival and globalFEST were established in New York to coincide with other significant booking conferences taking place in January, specifically as showcases for new artists and productions from around the world, and new showcase-oriented "festivals" continue to spring up.

## Commercial Programming: The Opposite End of the Spectrum

In direct contrast to *cultural programming* (as illustrated by the mission-driven BAM Next Wave example), *commercial programming* focuses on financial profit that is expected and aggressively pursued by all involved in the process—the artists, agents, and local presenters. As might be expected, issues of competition and control, and the nature of deals are quite different. While PAC managers should continue to view commercial programming through the filters of quality, artistic balance, risk, and affordability, they will and should approach this area of programming with the goal of generating surplus revenue.

The agents, managers, producers, and promoters of a commercial *product* will be looking at the PAC—at least for pop music and comedy—as one in a range of venue options within a market, and the PAC presenter may find itself bidding against both outside promoters and competing venues in the same market. Other than the issue of venue suitability for the incoming shows, the PAC's success in attracting these productions will be based primarily on the economics of presentation in the PAC, the PAC's marketing capability, its ticket sales history with similar artists, and geographic location and venue date availability in relation to the tour "routing."

For performing arts centers, commercial programming almost invariably involves one or more of three genres: Broadway musicals, commercial (commonly referred to as "popular" or "pop") music, and comedy. There are elements of all three that are similar, but the booking processes, timetables, and deal structures may vary considerably.

### Broadway

Assuming that a PAC has a main stage with full backstage production capability, including good truck loading access, an orchestra pit, and over-stage fly system, with roughly 2,000- to 3,000-seat capacity, the venue is ideal for touring Broadway productions.

First national Broadway shows generally go into venues for full- and multiple-week engagements, and due to the large scale of personnel, scenery, and equipment on the road, geographic routing is critical for these tours. Coupled with the presenters' needs to announce their series early for subscription sales, the scheduling of Broadway shows often takes priority in

the PAC's calendar development process, and must be secured before most other venue use can be committed.

At the high end, involving new shows coming from New York, control of the Broadway touring business is increasingly concentrated with little growth in the number of first national Broadway shows offered in any given season. The dominant player at this level is Broadway Across America, owned by Key Brand Entertainment, Inc., which through venue agreements controls top-flight Broadway tour presentation in approximately 40 of the largest markets in the United States. With this capacity, it dominates access to many of the most desirable shows as they prepare to tour. The recent purchase of the American regional venue management company, ACE Theatrical Group, by the London-based international venue operator and producer, the Ambassador Theatre Group, reflects a further significant consolidation on an international scale, noting that Broadway shows often move between New York and London's West End.

There are also producers of secondary productions, both unionized and non-unionized, generally offering shows the second and subsequent times on tour and to smaller markets. Not all such producers are based in New York. The Broadway League maintains an online list of all Broadway shows touring at any given time in hundreds of American cities.

### Commercial Music Concerts

Compared with its ideal size for touring Broadway shows, typical PAC main stages will be considered rungs on ladders in the commercial music world, and small for those musicians whose popularity is pushing them to play arenas. Unlike Broadway, as well as civic institutions such as symphony, ballet, and opera, which book fairly far in advance to allow for subscription sales, commercial music tends to book engagements much closer to the performance dates, often tied to the release of new recordings. An advantage to PACs is that these can fill unused dates after the Broadway and local user needs are accommodated. Conversely, the challenge for presentation of such artists within heavily subscriber-dependent marketing models is the frequent inability to secure engagement commitments in time to include them on early subscription offers (this is the same issue as *opportunity bookings* described in Box 4.1). Many PACs address this scheduling/marketing conundrum by offering as a subscriber perk early notice and purchase opportunity for late-booked shows. Of course, much of this music appeals more to a younger demographic less likely to subscribe, plugged into social media, and accustomed to responding quickly to short lead show announcements.

A continuing trend toward national and even international concentration of the commercial music industry among a few large conglomerates bears noting. Organizations such as Live Nation and AEG Live have, through direct investments in shows, acquisition of regional companies

such as the House of Blues and Bowery Presents, and control of major festivals, become industry powerhouses. In some markets they hold what amounts to near monopolies through a combination of, to varying degrees, exclusive control or dominant bidding power for the shows or artists, control of the booking agencies arranging the tours, exclusive programming agreements with key venues, and relatively recently in the case of Live Nation, controlling interest in the widely used Ticketmaster ticketing system.

### Comedy

For comedians, audience intimacy is of great importance. The 2,000–3,000-seat PAC main stage is probably the largest size venue in which a high-drawing comedian will perform, with many preferring smaller venues or clubs even if it involves multiple shows in the same evening. Technical demands to load in and set up the comedy show are often extremely simple and offer considerable flexibility. For instance, a comedian can appear on the set of a play or opera on a dark night of a run.

## Conclusion: The Future of Performing Arts Center Programming

The second decade of the twenty-first century is a period of tremendous change in the patterns by which Americans experience culture, with a shake-up of the established order that can be viewed as both troubling and exciting. The forces of economic uncertainty for many, demographic changes, and the advance of technological entertainment buffet the presentation of live performances in confusing and unpredictable ways. Running in parallel are societal trends that include a growing distrust in established institutions, and competition for charitable funding by societal needs viewed by many as more essential than art and culture. Independently owned and operated performing arts centers, with responsibility for maintaining expensive physical infrastructure but without benefit of municipal or academic economic protections, are in many cases the most exposed.

In this current environment, leaders of America's performing arts centers may strategically approach programming by implementing basic recommendations discussed throughout this chapter and summarized in Box 4.3.

As addressed in other chapters in this book, attendance at live performances is often as much about the overall *experience* of attending—from parking to pricing to patron services and everything in between—as it is about the performance on the stage. Unlike commercial promoters who are often focused only on ticket sales to the next event, programmers at institutions in which the goal is to attract and retain repeat visitors must hold a vision that extends well beyond the next show. To the degree that PAC managers are also involved in the facility management and patron services, they are encouraged to view these as interrelated parts of a whole. In short, programming involves

**Box 4.3   Summary of Recommendations for Managing PAC Programming**

1   **Consider All Programming Tools**
    Think of renting, presenting, and even producing as tools to achieve the end result: quality, balanced, well-scheduled programming.

2   **Start Planning with Rentals** and Resident Company Relationships
    Start with rental relationships, especially the organizations that can deliver reliable, full season series, and introduce culturally aware audiences to the PAC.

3   **Explore Commercial Options**
    Research the commercial options and the PAC's venue suitability for the capacity and production needed for touring Broadway productions.

4   **Develop Sustainable Marketing Capability and Customer Loyalty**
    A strong internal marketing engine for all events appearing at the PAC, regardless of who is presenting, strengthens the PAC's negotiating hand both for rentals and presentations and allows for PAC brand control.

5   **Plan for the Risk Involved in Presenting**
    If presenting is in the long-term strategic plan, recognize the risk involved and plan for it early. Depending on the *commercial* versus *cultural* programming balance planned, consider establishing a separate corporate entity for this purpose.

6   **Consider the Bigger Picture Role and Identity of the PAC**
    Consider the position of the PAC, not only within the community but also nationally and even internationally. Consider the factors of community relevance and community pride in the programming vision. And work to create a sustainable sense that time spent in the PAC is a *must* in everyone's routine activities and lifestyle.

*both* wise choices in show selection *and* contextualization of the performance as an appealing educational and lifestyle experience for the patron.

Two major trends can be witnessed in America's performing arts centers that point toward future trajectories in PAC programming. First, a new generation of arts managers is bringing an entrepreneurial spirit and fresh thinking to the core value of connecting culture and community in live experience, and aligning the corporate structures, resources, missions, and physical facilities to those ends. This generational shift comes at a time when arts leaders are increasingly recognizing that the nation's cultural institutions and their staffs, boards, and community relations must reflect the community's ethnically, racially, and gender diverse populations or they will not survive. New management approaches to community relations are increasingly supported by technology, especially Internet-enabled social media and sophisticated Constituent Relationship Management and data-tracking software.

Second, as the identification of the PAC's communities broadens, a shift is taking place in performing arts centers' identities from being bastions of

culture to being urban connective nodes. Indeed, renewed civic and govern-mental interest in the revitalization of urban centers, where many PACs are located, has the potential to align with and generate support for the goals of PACs to be effective community-based cultural catalysts.

With the performance and educational programs always at the core of the missions, it is crucial for tomorrow's PAC managers to understand the range of their programming options. This chapter has offered basic management strategies and a conceptual foundation for PACs to effectively program the performing arts in our communities—while remaining solvent.

## Acknowledgments

The author wishes to express gratitude to Joseph V. Melillo from the Brooklyn Academic of Music for the valuable insight he contributed to this chapter and his singular contribution to the field.

## Note

1 An excellent detailed discussion of this qualification is provided in http://itsartlaw. com/2014/05/27/visiting-the-non-profit-side-on-qualifying-for-501c3-status-as-an-arts-organization/.

## References

Milward, J. (1987, October 13). Next wave: An avant-garde festival grows in Brooklyn. Retrieved May 11, 2016, from: http://articles.philly.com/1987–10–13/news/26214240_1_avant-garde-festival-musics-next-wave-festival-armitage-ballet

Robertson, C. (2006, July 2). We all got together and put on a . . . brand. Retrieved May 11, 2016, from: http://www.nytimes.com/2006/07/02/theater/02rober.html?r=2

Takis, B. (2014). Art law visiting the non-profit side: On qualifying for 501(c)(3) status as an arts organization. Retrieved May 11, 2016, from: http://itsartslaw. com/2014/05/27/visitng-the-non-profit-side-on-qualifying-for-501c3-status-as-an-arts-organization/

Woronkowicz, J., Joynes, D.C., Frumkin, P., Kolendo, A., Seaman, B., Gertner, R., & Bradburn, N. (2012). *Set in stone: Building America's new generation of arts facilities, 1994–2008*. Chicago: Cultural Policy Center, University of Chicago. Retrieved from: http://culturalpolicy.uchicago.edu/sites/culturalpolicy.uchicago.edu/files/setinstone/pdf/setinstone.pdf

Yarrow, A.L. (1988). Transforming a Brooklyn Theater. Retrieved May 11, 2016, from: http://www.nytimes.com/1988/01/05/theater/transforming-a-brooklyn-theater.html

# 5   Magic of Place

## An Unrecognized Revolution in Theater Architecture

*Richard Pilbrow*

At the heart of the performing arts center (PAC) will lie a theater—a theater that may be for music, for drama, for ballet, for opera, for musicals, for popular entertainers, or for a rich mix of entertainment and culture. How can you ensure that the heart of your PAC will inspire, uplift, thrill, and connect with your community? For generations, theater space had evolved based upon considerations not of sight and sound alone but upon a fundamentally different principle: a theater was a place of communication between people. An audience did not passively sit, look, and listen: it participated in the performance—the experience was shared—with actors and audiences interacting together. Theaters were a place in which music, song, drama, or dance could be viscerally conveyed, where ideas, passions, exhilaration would be irresistible. All cultures around the world originally developed theaters that brought their audiences into such a dynamic relationship. However, after World War I and throughout the twentieth century, the vital importance of the three-dimensional relationship between the living performer and lively audience was lost. Cinema-style fan-shaped auditoriums with endless rows of seats facing a proscenium stage produced barren, overlarge, often-cavernous spaces that seem to defy the kindling of human emotion. Over time, a very small number of theater design consultants and architects began to realize that to restore the "magic" into theatre, a fresh understanding of the three-dimensional theater spaces of our ancestors was needed. This chapter discusses ways in which exciting theater design and supportive architecture can make a community's theater space something special indeed—a lively, thrilling heart of the modern performing arts center. A great performance onstage will always help, too!

## Shakespeare 400 Years Young

Shakespeare at 400! A worldwide celebration. In the entirety of human history there has never been such a legacy. Emperors, kings, and popes may come and go, but this poet dramatist has become the world's most revered playwright and an icon of the English language. What does he have to do with the modern American performing arts center?

Clearly, Shakespeare was a genius for all time—along with Beethoven, Bach, Mozart, and even the Beatles. But unlike these others, Shakespeare was also a true man of the theatre. He helped to create modern theatre and the modern theater building as a place to tell stories, as a place to transport their fellow men and women, as a place that could gather all types of people within a rich and diverse society into a thrilling and evidently timeless relationship. His plays triumphed over time and space, and the form of theatre that he and his fellow actors created still resonates with us today.

Mystery surrounds the detailed designs of the first theaters to be built in England, but the principles were clear. They were spaces in which the actor strode upon a platform stage placed within a courtyard that was surrounded by galleries. The total London audience in 1580 has been estimated at about 5,000 a day, out of a total population of about 140,000. This audience, with new theaters being built, doubled in size in 30 years.

In 1642, Puritans banned the theatre for its incipient "naughtiness," and theatre flourished as never before or perhaps since. Dramatists such as Christopher Marlowe, Ben Jonson, Beaumont and Fletcher, and others kept theaters spinning and attracting enormous audiences from a wide cross section of the public. By what seems to be more than a coincidence, in Spain during the same period, Cervantes, Lope de Vega, and Calderon prolifically filled theaters known as "Corrales," which were courtyards with balconies surrounding a platform stage. Molière, Racine, and Corneille delighted audiences in France through the eighteenth century in similar spaces.

## The Unknowing Sixties

My professional career as an assistant stage manager began straight from drama school when I walked through the stage door of Her Majesty's Theatre in London's Haymarket. My ambition since my early teens had been to be a stage manager, an occupation that Edward Gordon Craig had described as a "Master of the Art and Science of the Theatre." At 22 years old, I loved theatre and thought I knew it all. I had no idea who had passed through that stage door before: Beerbohm Tree, Ellen Terry, Bernard Shaw, Noel Coward, J. B. Priestley, or who had trodden the boards of earlier His/Her Majesty's on the site: Congreve, Betterton, Sheridan, even George Frederick Handel. And the premieres: Shaw's *Pygmalion, Chu Chin Chow*, Priestley's *The Good Companions*, and *West Side Story*. I little dreamed that as a producer I would later add to that roster Bock and Harnick's *Fiddler on the Roof* and Sondheim's *Company*, both with Harold Prince.

One of the wonders of our world of theatre is what a small world it is. Every part of today is built upon what our ancestors did before, and our own future is a product of the past. I believe in recalling the battles that those from the past went through to build the world of theatre that we inhabit today. Stories around the campfire fascinated our ancestors millennia ago and the cultural need for storytelling continues to be ignited through

theatre. Great changes in theatre and in architecture have occurred since the late nineteenth century, but the Depression and World War II broke any vestigial remains of continuity. And, subsequently, much has been forgotten about theater architecture from the period between the 1930s to the 1980s, particularly from the 1960s. This chapter provides important historical context to understand contemporary theater design and the theater consulting profession.

## A Potted History

After the forced closure of the theaters, the restoration of King Charles II in 1660 brought theatre back to England. The playhouses that reopened were now indoors, yet built upon those theatre principles that had existed in the more famous outdoor theaters of Shakespeare's time. The new theaters of the day were small in size but continued in the courtyard tradition, small rooms packed with spectators surrounding an apron stage. For three centuries, theaters in major cities slowly grew and the proscenium grew in importance. Actors continued to play *within* the audience space on the "pro-scenium"—which actually means *in front of* the scene. The constant lively and dynamic relationship between performer and surrounding audience continued as the highest priority. Only during the mid-nineteenth century did the actor complete his retreat into the scenic environment behind the proscenium arch, which now became a frame behind which the world of illusion was encouraged, while the auditorium was plunged into darkness.

Outside the major metropolitan cities, theaters continued to be small, multi-level, and intimate courtyard spaces where actors and surrounding audiences could come together. This pattern existed throughout Britain and was transported to the United States, where contrary to popular myth, it become the model for all early American theater buildings. Theaters everywhere grew in size and complexity in the nineteenth century but retained their wraparound form. The horseshoe-shaped Italian Opera House had become the world's model both acoustically and theatrically, the penultimate example of which is the Paris Opera House, designed by architect Charles Garnier in 1875.

A new form of theatre was to be developed by composer Richard Wagner in the Bayreuth Festspielhaus within the next year. Wagner, both a musical and political revolutionary, was determined on a new form of theatre to glorify his musical-dramatic operas. All seating must face the stage, his orchestra must be unseen, the music emerging from a "mystical abyss," and a double proscenium arch making the onstage spectacle seem more remote and mysterious, while the potential distraction of people seated in side boxes was banished.

Since Wagner, few other opera houses have been built following his example. But the latter years of the nineteenth century coincided with new movements in dramatic theatre, movements that reacted against the overlarge

bombast of popular theatres of the period, filled with melodrama and spectacle. A new spirit of serious playwriting in the works of Ibsen, Chekov, Shaw, and others needed new, smaller theater spaces. The play "director" was starting to replace the actor/manager, and the "Little Art Theatre" movement caught on across Europe, England, and America, bringing new experiments in a simpler theater architecture that coupled Wagner's frontal concentration of seating with experiments in removing the perceived barrier of the proscenium frame.

In parallel, the commercial theaters of first England and then America matured during the later nineteenth and early twentieth centuries. Initially, their development was driven by actors and managers, later by theatrical entrepreneurs, who all knew what they wanted. The development of intimate theaters was kindling for the excitement for the maximum number of paying spectators. Theatre people hired specialist architects, in the United Kingdom such as the most prolific, Frank Matcham. In the United States, others such as Rapp & Rapp, J.B. MacElfatrick (known as "the father of American theatre architecture"), Thomas Lamb, Herts & Tallant, and Herbert J. Krapp, became specialist theater architects.

Commercial considerations placed these theaters on tightly constricted sites. The London stage was usually narrow (about 30 feet proscenium width), with a horseshoe-shaped auditorium and several deeply overhung balconies and horizontal side boxes. In contrast, the later Broadway-style of theater space employed a wider proscenium (about 40 feet), an auditorium with one or two balconies close to the stage, and on either side, several boxes stepping down toward the stage—a ubiquitous American feature. Boxes filled an important role: they acted as an umbilical cord, figuratively joining the performer onstage to all levels of the auditorium. Theaters built for making a profit were maximizing the number of paying customers into the tightest possible site, which consequently made them intimate spaces capable of optimizing the generation of excitement.

Then the world was shaken by the upheaval of cinema. Many live theaters closed. Cinema demanded frontal sightlines to a flat screen that was initially quite small and showed only black-and-white flickering movies. To enrich the cinematic experience, architects embellished the enlarged auditoriums with traditional side boxes, often overtaken by massive and lavish decorations such as Moorish palaces or Spanish haciendas. In the early twentieth century, two powerful influences—the Wagner-led frontally seated "Art Theatre" movement and the cinema—were joined by a third, the development of modern architecture.

In reaction to the rich ornamentation of the pre–World War I age, a new purity—the "Bauhaus"—swept away decoration, reducing space interiors to their functional essence. Practical considerations, the newly emerging art of acoustics, and the modern architectural movement combined with a drive that was less class-conscious and egalitarian to make all audiences dutifully face forward toward the ubiquitous—if ever more distant—proscenium arch stage.

In *The Theatre of Today*, published in 1914, Hiram Kelly Moderwell wrote with passion about the newly emerged "ideal art of theatre." He dismisses with "utter contempt" the ordinary horseshoe theaters that "make the stage partly or wholly invisible," with "wretched acoustics" contributing to an evening of "torture." He hailed the new Wagnerian theater in which "there shall be no bad seats; there shall not even be any worse seats." His "amphitheatre playhouse has all its rows nearly parallel to the proscenium and its floor rising at such an angle that every spectator can look clean over the head of his neighbor in front. This became the new democratic playhouse" (pp. 31–32).

The Goodman Theatre in Chicago (1927) was a deliberate copy of the Wagner-inspired Künstler Theater of Munich. Fifty years later, enthusiasm for the frontal auditorium began to wane. With hindsight, in such a house there were far too many bad seats—almost all those more than halfway back—and the lack of encircling audience made the theater seem more an antiseptic lecture hall than a theater.

## The Ubiquitous Fan—Izenour and the Engineered Rational Theater

The overwhelming competition from the movies buried much theatre and vaudeville activity and many theaters, but perhaps its most pernicious influence was upon the design of the theaters that were built between the 1930s and the 1970s. Wagner's frontal theater, the new "art theatre" form, and the movie palace combined to support the design of the fan-shaped "auditorium" with blank sidewalls, so-called perfect sightlines, and at most a single balcony. The so-called rational theaters advocated by the famous American theater engineer, George Izenour, offered "engineered" sightlines, but resulted in spaces now perceived as alien to exciting human communication.

So by the 1960s, there were "rules" for theater design. A proscenium theater was preferred. It had to have frontal seating with so-called perfect sightlines, megaphone shaping for optimum acoustics, ideally placed in a single tier—or at most on two levels seeking social equality, no "snobby" side box seating for the glamorous show-offs. From the 1930s through the 1970s, these rules prevailed. Cinema-style theaters proliferated everywhere. Architects and theatre people alike seemed to forget that the paramount principle of theater design had involved creating a sense of unity among our audiences—unity and participation between performer and spectator, a "participant" in the creative event rather than a passive onlooker.

## A Learning Experience

In my youth I found the routine as an assistant stage manager on a long-running show to be a mind-crushing disappointment. The actors onstage had the stimulation of the audience's response, but to my impatient young

imagination, backstage was drudgery. My lifelong dream had turned sour. What next? A chance encounter introduced me to the concept that in the United States, a new profession of lighting design existed. Lighting had been my schoolboy hobby . . . maybe I could be a lighting designer in Britain.

In 1959, with absurd recklessness I started my new company, Theatre Projects. Soon the company seemed to light almost every show in London, and some landmark productions as well. Innovation took me to New York as a scene projection consultant. Meeting the legendary Broadway producer/director Hal Prince, I became his partner in London and for 25 years became a mainstream West End producer, with such London premiers as *Fiddler on the Roof*, *Company*, and *Cabaret*.

Theatre Projects rapidly expanded, providing production, lighting, sound, and backstage services, and then entered the field of theater consulting. In Britain, few theaters had been built since the 1930s, and so architects and theatre people had forgotten how it was done. The phone began to ring as people engaged in theater design projects wondered if we—as backstage specialists—might be able to help. Then, a miracle. Sir Laurence Olivier invited me to be his lighting designer for the new National Theatre Company at the Old Vic. As planning for the new building on the South Bank began, I joined the building committee and later was appointed the theater consultant to work with the architect Denys Lasdun. This astonishing elevation was accompanied by commissions for the new Royal Shakespeare Company theater at the Barbican and the replanning of a renovated Royal Opera House!

By now we had been involved in several of the new English regional theaters that were mushrooming under a benevolent Labor Government in the 1960s. Initially, we gave advice to architects about backstage planning. The National Theatre was a quantum leap forward in our responsibility. Yes, I felt that our new theaters were more efficient and their stages allowed new possibilities, but something was still missing. As a lighting designer, I worked around Britain and on Broadway; as a producer, I presented shows across the West End, all in late-nineteenth- or early-twentieth-century theaters. These other theaters seemed miracles of compression, theaters that seemed to bring the actor and the audience into lively juxtaposition. In comparison, our new socially aware, technically adroit theaters were simply boring.

My transformation began as I became a producer. *Fiddler on the Roof* ran for five years in my original West End home, Her Majesty's Theatre. My favorite place to watch was from an upper stage box, from which I watched the audience rather than the stage. The extraordinary power of hushed silence, the flicker of a tear being suppressed by a weary businessperson, the ripple of laughter that might spin through every level of the house. The Audience. Now, at long last, I realized what brought theatre to life.

When I joined the National Theatre Building Committee late in 1966, I studied all the past records of earlier deliberations. What sort of theater

should the National build? After 120 years of dreams, there was only confusion. Thrust stage, open stage, theater in the round, proscenium . . . the powerful personalities on the committee argued back and forth . . . seldom consistently. Denys Lasdun had seized upon a "new" idea, a variant of the thrust and open stage, within an almost ancient Greek-style auditorium. My job was to design the stage itself and introduce the necessary technical facilities to promote Sir Laurence's dream of an open stage playing in repertory with "full scenic capability." The second theater to be built in the facility seemed so simple: it was to be a proscenium stage. Everyone "knew" what that meant as Lasdun described it—it was to be "Theatre of Confrontation." Audiences sat facing a proscenium stage. For working in repertoire, I planned and equipped it with a highly variable proscenium and divided "German-style" wagon stages. Seemingly, we had all forgotten four centuries of evolution in theater architecture.

## A National Theatre

Several years ago, an e-mail arrived from a young English friend named Rob Halliday, who is both a lighting designer and a highly skilled control board programmer:

> Hi . . . So, I know it's not your favorite theatre in the world . . . But (have I ever confessed this to you before) I am a National Theatre junkie. And having spent the day working in and around the Olivier, including getting to some backstage bits I've never been to before, I just have to comment on what an incredible job you did on the place all those years ago—much of it still there and still working! I do love the Olivier, particularly when it has the right show in it.
>
> (personal communication, 2009)

It is true that I am not big fan of either of the two large theaters. I was so young at that moment when our National Theatre was first designed. I simply did not understand the essentials of theater design—and, truthfully, neither did the blue-ribbon building committee. The Olivier Theatre feels gigantic, and it is. With only 1,100 seats, its volume is actually greater than the 2,400-seat Theatre Royal Drury Lane. Forty years later, the Olivier Theatre can be the most exciting space on earth for large, outgoing productions, but it can be overwhelming for other more modest ventures.

The Lyttelton resulted from a theory expounded by Lasdun: a proscenium theater was a theater of "confrontation." A good proscenium theater is just as much a place to bring audience and actor together as is any other form. The almost-straight seating rows of the Lyttelton, the bare concrete side walls without a humanizing population of people, the single too-high and remote balcony—all contribute to its being a cinema-style space. I wish we could all have created something livelier and more

human in scale that might more easily lift the hearts of performer and audience alike.

I am proud of much of our contribution: the overall planning, the workshops, dressing rooms, rehearsal rooms, the stages, and their equipment, which was perhaps a decade in advance of its time. But in the late 1960s, I did not know the paramount importance of emotion and intimacy. I did not understand that, in a theater, it is not enough to see and hear. Our audiences must feel. In the communion of audience and artist, reactive energy from the audience fuels the performer. In designing the National, we all so passionately sought the perfect theater that we ignored the lessons of the past that were all around us in the West End. My central design mission grew from the understanding that theater architecture must pull us all together. We need to make the room feel small so that the performer seems large.

## The Cottesloe (Now Dorfman) Theatre

I invited my friend, Iain Mackintosh, to join me at Theatre Projects (TPC) as a theater consultant in 1972. He joined me after many years running a touring theatre company that had played each week in a different venue around the world. He had come to recognize that some theaters "worked" while some did not, regardless of their seat count. Some theaters more easily "sprang to life" for the actor and audience than others.

Iain's arrival coincided with a major upheaval at the then emerging National Theatre. Directors had changed, and as a condition of accepting the new job, the new director had persuaded the board to allow the studio theater, which had been "mothballed," to be restored to the project. On a Friday, I was asked whether TPC could quickly come up with a new design. I turned to Iain, and on Monday he brought me some scruffy drawings. The decision makers somewhat grudgingly accepted our design input, and the Cottesloe was born. The development of the Cottesloe was to prove pivotal for Theatre Projects. Its huge success led to Iain's coining the phrase *courtyard theater*, which describes a balconied space surrounding a central area that can be flexible to allow variation of the actor-audience arrangement. The courtyard theater—intimate, flexible, yet capable of the epic—became a model of theater design that has swept the world.

## Returning to Tradition: Densely Clustered, Intimately Spectacular

The restoration of the Theatre Royal Nottingham in 1976 was the next landmark of importance for me. It transformed a dilapidated Victorian auditorium into a wonderfully theatrical space. For the gala opening, the English comedian Ken Dodd gave a stand-up comedic performance, and

the audience members on three levels were beside themselves with delight. The excitement hit me like a lightning bolt. Our groping toward three-dimensional theaters, seeking intimacy and immediacy, was totally how our grandfathers had designed all their theaters! The old-fashioned, often somewhat-decayed, theaters of the West End, the British provinces, and indeed Broadway all shared these virtues. Enwrapping balconies and boxes brought all the audience around the room into a tight embrace of the actor, and all shared together the immediacy of each moment.

This sparked my *eureka* moment! Those sometimes tired, tatty old theaters that I had often scorned, in which I both had lit and produced theatre for years, were the key to rediscovering how to build theaters in the future. Theater design has deep and rich traditions that date back to the days of Shakespeare. This tradition was to be our inspiration in designing theatre for the future.

## New Theaters—Another Revolution

There is no one sort of theater. There are theaters for music (a concert hall is simply a theater for a symphony) for drama, for opera, for dance, and for musical theatre. There are tiny, informal theaters for fringe performance, and there are mighty theaters for water-based spectaculars. Theaters may come in many sizes and are built to satisfy many requirements, such as the needs of an artistic enterprise, urban renewal, civic pride, and national prestige. Theaters intended for one purpose may legitimately be employed for another, but the demands of the art form are strict. The theater for a future performing arts center must be careful considered. Yet, all theaters intended for live performance—live actor and lively audience—share a single feature: they are places of human communication.

## America Beckons

Through the 1970s, I finally understood that designing theaters for the future required a revolutionary approach: we had to take inspiration from the rich traditions of the past. Theater design was not a mechanical process concerned only with sightlines, acoustics, and technology. The magic that could be found in all the great theaters of the past was something more subtle and complex. Theaters had to be places of emotional intimacy, of meeting, of thrilling communion.

At the time, this idea was not something that was being considered in the United States. George Izenour, who had been responsible for many technical innovations, had been the prophet of the "engineered theater." Rejecting any interest in the past—except as proof that these stupid old theaters had terrible sightlines—he preached the absolute necessity for frontal sightlines and the absurdity of side boxes, proselytizing that new technology was the

key to a new theater. He endorsed the frontal, fan-shaped auditorium that had emerged in the 1930s and had set the tone for the entire country and its theater consulting profession. When it became clear to me that he was mistaken, I saw that Theatre Projects might, after all, have a role in influencing theater design in America.

There were, however, some signs that a different attitude did exist. In New York's Lincoln Center, designs for both the Metropolitan Opera and the New York State Theater had stemmed from a conflict between architect and theatre—and theatre had won. Both began as fan-shaped auditoria but became opera house–style spaces, inspired by tradition. In 1985, architect Benjamin Thompson designed the Ordway Center in St. Paul, Minnesota. At the client's request, La Scala (Milan's classic horseshoe-shaped opera house) inspired it. Perhaps the climate was now right in the United States for a new approach to theater design.

## Three Theaters on the Northern Prairie

We began in Calgary, Alberta with an arts center to include a concert hall and several theaters. For the Concert Hall, with acoustician Russell Johnson we created a classic "shoe-box" hall that would possess outstanding acoustics but that was capable of adjustment for enhancing every kind of musical performance. The flexible platform would allow many forms of other events. Theatre One (The Max Bell) was to be a modern space for drama, with 750 seats on three wraparound levels. It was based on tradition, yet with modern surprises: a proscenium stage with great flexibility to serve as an orchestra pit, forestage, or extended thrust stage. By sliding in or out the forestage boxes, the size and scale of the whole front of the auditorium could be changed. Theater Two (The Martha Cohen) was for Alberta Theatre Projects. This room was of extraordinary intimacy and flexibility. Four hundred fifty seats tightly clustered in a semicircular courtyard, in which everything could, and might happen: conventional proscenium stage, thrust stage, arena, and flat-floor environmental theater. Thirty years later, this complex, now named Arts Commons, continues to thrill.

After Calgary, to Toronto. The St. Lawrence Center, which opened in 1970, was an open-stage, concrete venue that drove actors and directors to despair. Its stage and auditorium lacked the virtues of Lincoln Center's Beaumont while sharing its vice of trying to combine both thrust and proscenium. It succeeded as neither.

Our solution concentrated 896 theatergoers in less than two-thirds of the area they had occupied in the original. This greater intensity was achieved by wrapping a second layer of audience (complete with triple side boxes in the tradition of architect Thomas Lamb) around the lower orchestra. This return to a traditional multilevel house yielded a fascinating by-product.

Although it held more people, the theater was itself smaller. Because the site was fixed, the lobbies grew as the auditorium shrunk. The old lobby, little more than eight feet wide, contained no audience amenities. The new, enlarged space, on two levels, added a café, a bookshop, and bars—bringing a truly new income stream to the company. "Back to the future" creates not only better theaters but also more financially viable ones.

## Portland, Oregon

Portland, Oregon, requested an arts center combining a renovated movie palace converted into a richly decorated concert hall, and two new theaters. Barton Myers's design for the 900-seat proscenium theater (Newmark Theatre) was striking: the columns forming the proscenium and support-ing the "crown-style" lighting bridges appeared to be cast iron, inspired by the bridges spanning the river that runs through the city. The balconies were a rich, polished wood, and the ceiling above was painted like a night sky. The polished wooden balconies reflected the English West End inti-mate tradition and Barton possessed an uncommon instinct about how to make a space feel more theatrical. The smaller space (Winningstad Theatre) was to be a courtyard, finished in rich red tones, that provided a flexible environment.

*Figure 5.1* Newmark Theatre, Portland'5 Centers for the Arts

Photo Credit: Jason Quigley, courtesy of Portland'5 Centers for the Arts

*Figure 5.2* Winningstad Theatre, Portland'5 Centers for the Arts

Photograph courtesy of Portland'5 Centers for the Arts

## The Ahmanson Theatre

Gordon Davidson, the longtime head of Los Angeles' Center Theatre Group at the Music Center, asked me to transform the Ahmanson Theatre into an attractive theatrical space. We developed a scheme to transform this ugly 1967 frontal auditorium—all painted black, with ski-slope side seating— into a modern Broadway theater. We brought each of the two balconies' three rows closer to the stage, curving them and adding step-down boxes to either side. Twenty percent of the audience was to be brought closer to the stage, the entire room made smaller, but with the same seat count. Charlton Heston was a member of the board. Excited about our proposal, he gave us a glimpse of his Moses performance: "A miracle, you can turn this dreadful space into a vibrant theatre!"

## The Multipurpose Hall

By the 1980s, multipurpose halls had a bad reputation. The popular saying was that "multipurpose means no purpose." These fan-shaped venues tried to serve symphony, ballet, opera, musical theatre, and popular

entertainment, but, in truth, they were not really good for *any* type of performance. However, the classic opera houses of Europe were all "multipurpose." They staged opera, ballet, musical theatre, and symphony, yet they were also wonderfully exciting theater spaces for their audiences. They might be our models.

The Blumenthal Centre in Charlotte, North Carolina, was the first multipurpose hall assignment for our American team. This was to be architect's Cesar Pelli's first theater with acoustician Larry Kirkegaard. It proved a dramatic contrast to Charlotte's existing black, fan-shaped Ovens Auditorium. The new theater was described as being designed in a contemporary European horseshoe arrangement for an intimate atmosphere and world-class acoustics. After Charlotte, other multipurpose halls followed, several with Cesar Pelli. The Aronoff Center, in Cincinnati, wanted a monstrously large 2,700 seats. We determined to develop the most intimate-feeling 2,700-seat house on the planet. With a wide seating plan that brought as many seats as possible close to the stage, and a proscenium zone so large that it seemed to engulf the hall, we succeeded.

Other multipurpose projects that combined three-dimensional, multi-tier auditoria with modern flexibility—inspired by tradition—included the Benjamin & Marian Schuster Performing Arts Center, in Dayton, Ohio,

*Figure 5.3* Muriel Kauffman Theatre, Kauffman Center for the Performing Arts

Photo Credit: Tim Hursley, courtesy of Kauffman Center for the Performing Arts

2003; the Overture Center for the Arts, Madison, Wisconsin, 2006, and the gloriously festive Muriel Kauffman Theatre (architect Moshe Safdie) in Kansas City, Missouri, 2011.

## Drama Theaters

Kevin Rigdon, the designer and a member of the Steppenwolf Theatre Company of Chicago, asked for assistance on a new theater. Since Steppenwolf's reputation as an archetypal American theatre group was so strong, they needed to have an equally strong *American* theater to match. The Broadway playhouse is uniquely different. Shaped by the plot ratio of New York City, the majority are wide and comparatively shallow. The balconies are (by English standards) very close to the stage. Finally, at either side, boxes step down toward the stage. The close-up balcony and stepping boxes are, to me, emblematic of American theatre. It was this American-style theater that I proposed to Kevin. Echoing Steppenwolf's urban, gritty aesthetic and the Chicago urban landscape, the theater would be built in raw concrete with steel balcony fronts. Designed by John Morris, a Chicago architect, the 520-seat theater opened in 1991 to instant success.

The Goodman Theatre Company in Chicago had been founded in 1927 when the art theater was strongly influenced by Wagner: a frontal theater focused upon the stage, with no frivolous side-box seating. The site on Chicago's lakefront severely restricted the building's height. The theater was sunk underground; its single-level auditorium was only slightly raked, and the stage had no fly tower. It was a hard stage for stage designers to work with, and the deep proscenium and long narrow wooden-paneled auditorium created a space that was even harder to act in. This was indeed two-room theater with little relationship between actor and audience.

In the heart of Chicago, two old theaters—the Selwyn and the Harris—lay derelict. Here was a real opportunity for two new theaters: a proscenium main stage and a smaller, flexible courtyard. With Kuwabara Payne McKenna Blumberg Architects we developed a two-level, 800-seat proscenium house and a 500-seat courtyard theater. The larger proscenium space was all-new construction, while the courtyard was built within the walls of the old Selwyn. The larger is a handsome two-level theater with two levels of boxes to either side, which was something of a hybrid between Edwardian English and the wider Broadway American theater. The courtyard theater, a two-level space wrought in rough-sawn timber, possesses all the usual flexibility in its central arena.

## Broadway Babies

Dan Sullivan, then artistic director of the Seattle Repertory, had long been dissatisfied by his main stage, the Bagley Wright Theatre, which had opened in 1983. It was a building of the old school: a two-level frontal auditorium

facing a proscenium stage. Where boxes should have been was a "tech-zone"—all black scaffolding, stage lights, and loudspeakers. Even worse, the balcony was excessively high, perhaps due to acoustics, perhaps because the designers simply wanted the control rooms to have a great view. In any event, the audience was split in two—some upstairs and some downstairs. Dan wanted a proper second stage, a small theater with fewer than 300 seats and an exceptionally intimate theater as well.

I suggested that even with such a tiny seat count, a two-level Broadway-style theater might be appropriate. Dan loved the idea and the Leo Kreielsheimer Theatre was built (with architects Callison Partnership). The 286-seat Broadway-style proscenium theater has orchestra, balcony, and side-box seating. It is complete with a stage and state-of-the-art technical facilities—in miniature. Actors feel that they can touch every member of their audience . . . and they almost can.

The Broadway model provides fine theatre at the other end of the scale too. The Walt Disney Theater (architect Barton Myers) of Dr. Phillips Center in Orlando, Florida is a 2,600-seat version of such a space, as is the massive 3,400 Dolby Theatre (previously the Kodak, architect David Rockwell) in Los Angeles, which is seen on one night every year during the Oscar Ceremonies by more human beings than perhaps all the theatergoers in human history! Broadway "intimacy" wins again.

*Figure 5.4* Walt Disney Theater, Dr. Phillips Center for the Performing Arts

Photograph courtesy of Dr. Phillips Center for the Performing Arts

## Flexible Theatre (Derngate, Cerritos, to an Arts District)

Despite my passion for theaters of the past to guide us into the future, I have never proselytized for "old-fashioned." Our theaters must be of the future. They must be intimate and thrilling spaces in which to experience theatre, but they must be flexible and technologically capable of providing the opportunity for directors and designers to explore the future of stagecraft. Every courtyard theater possesses such intrinsic intimacy and flexibility.

The Derngate Theatre (1983), in Northampton, England, proved that such flexibility and intimacy was possible on a larger scale—with up to about 1,600 seats. Utilizing air-palette technology to move large banks of seats, as well as multilevel towers of encircling boxes, its incredible utilization (390 performances a year) had demonstrated its practicality—and popularity.

The City of Cerritos, in California, needed a performing arts center that was different. In the Los Angeles area, another single-purpose hall seemed pointless, so we proposed an enhanced Derngate, with up to 2,000 seats. Barton Myers was selected as the architect. However, there was a problem: Northampton in the United Kingdom had never experienced an earthquake, but in California everyone awaited the "big one" and building codes for earthquake-proof buildings were stringent. In the United Kingdom, the seating towers that weighed about 8 to 10 tons moved on air casters, but when stationary, were fixed solidly to the ground by gravity. This was unacceptable in California, where the towers had to be anchored to the ground at all times and, even when moving, had to have hydraulic jacks that would lock solidly in the event of an earthquake. This was a huge complication. Everything had to be made far larger and heavier, and the complexity of locking moving objects in an emergency was not easy.

Eventually, the problems were solved. Barton designed a magnificent building and, as ever, he made the interior look rich, warm, and quite marvelously theatrical. Cerritos worked. In 1993, we opened in arena format, with Frank Sinatra—at a very advanced age—exerting his customary magic. The theater—really five theaters in one (arena, symphony hall, opera house, smaller drama theatre, and flat-floor hall)—proved a huge success.

## Arts District to Opera House

In Dallas, a massive concept evolved: an arts "district" took full flight after nearly 30 years of gestation. The superb acoustic Morton H. Meyerson Symphony Center opened in 1989, then the Winspear Opera House (Foster and Partners/TPC) and for the Dallas Theatre Center, the Wyly Theatre (Rem Koolhas/TPC) in 2012. The Wyly astonishes. The world's most flexible courtyard, the surrounding galleries can both move horizontally to change the aspect ratio of the space, but may also be flown out vertically leaving a

vast empty space—an entirely removable theater! Other opera houses that have rediscovered the intimacy of tradition, sophisticated modern theater technology and outstanding architecture have included the Den Norske, Oslo (Snohetta/TPC); and the thrillingly intimate 1,200-seat Glyndebourne Opera (Hopkins Architects/TPC), in Sussex.

## Multipurpose Space

In an ideal world, different types of performance would merit differently designed spaces. The requirement of classical music can differ widely from, say, drama. Outside the largest cities, the once-maligned multipurpose hall remains a necessity for many communities, and experience has shown how such a hall can succeed. Different art forms are best suited to audiences of a certain capacity, but for all, a room that seeks to amplify human scale is mandatory. An oversized auditorium can depress rather than support all but the most amazing (and famous) performers. Remember that your new theater should be active as many days of the year as possible, hopefully for many years. Oversizing your theater may adversely affect the audience's enjoyment long into the future.

And, there are limits to what a theater can do. A room intended for small-scale drama will not work for a touring musical superstar. Generally, the seating capacity of a house is almost impossible to manipulate. Experiments have tried to close off parts of an auditorium for smaller events, but these are seldom successful. The overall volume required by the larger event can destroy the fundamental human scale required. Within such limits, skillful acoustics and theater design that are dedicated to creating that human-scale, three-dimensional "house" for people's interaction will work. Smaller will always be better, lively will always be more appealing, and warmth will always attract.

## Design Through Teamwork

Everybody seems to know what an architect does. You can wave a wand, and he or she will surely bestow miracles on your community: a paradise of human-scale urban environments to enrich modern living. So we hope! Speaking perhaps less sarcastically, people also seem to instantly recognize the contribution of the acoustician, the person who makes a room sound wonderful.

Those building a new theater or concert hall know that they need one of each of these professionals. Nobody really seems to understand what a *theater design consultant*—as we at Theatre Projects term ourselves—contributes: "Why do we need a theater consultant? What does he or she do?" Everybody assumes that the theater consultant is the technical expert, the person who is brought in to recommend the stage equipment after the building is complete—the person who provides the "technical wallpaper" stuff.

Well, this was true in olden days, but times have changed. The reader will have followed TPC's development since the National Theatre: the success of the company despite the comparative barrenness of the two large auditoria, the success of the smaller Cottesloe/Dorfman, my discovery of the joys of intimate theater after the experience of the Theatre Royal Nottingham, and the retreat of the fan-shaped auditorium before the advance of the new/old flexible, intimate, three-dimensional theater space.

As theater consultants, we have brought to the client and architect many years of experience and awareness of the ancestry of theater architecture. We consult on the fundamental human nature of the theatrical experience, but also of the actual day-to-day practice of stagecraft. We translate for the architect the arcane terminology of the stage. We represent the artists, craftspeople, administrators, and, most important of all, the audiences of the future. For the renowned Philadelphia Orchestra, one of our clients described Theatre Projects as "the conscience of the project." We earnestly hope this is true.

Over the years, I have come to believe that no *individual* could be a theater design consultant. There are too many skills required: architecture, psychology, economics, technology, art, and more. With Theatre Projects, we built a team that had in-house theater designers, technicians, administrators, actors, singers, architects, and engineers. This team learned to speak the languages of both architecture and the construction industry.

## Finding a Theater Designer?

No architect is going to create your theater alone. History carries no record of an architect, new to the world of theatre, succeeding. We theatre folk know instinctively that great performances will be the product of teamwork. In the case of the extraordinary complexity of a theater building, this will be teamwork between two very disparate worlds. Architecture is permanent, while theatre is ephemeral. Concrete and steel compete with playwrights and actors. Theatre depends upon human relationships. The architecture of theater is to create a home for lively interaction—a framework for participation.

The theater designer must bring to his client and the chosen architect in-depth experience of theatre, ideally in many of its richly diverse manifestations—drama, musicals, dance, opera, music, and so on. Experience backstage is also important, as is every department of the "business" of performance. But experience alone will be insufficient, as the performing arts are in a state of constant flux. Everywhere people seek more intimate and less formally structured environments. As technology abounds, the personal becomes even more irresistible. The further impact of new technologies will be profound. It is increasingly urgent to have the ability to look around the corner to envision ways in which new technologies can be utilized to enhance human interconnectedness. Experience of past practice will have to be supplemented by imagination.

How can you identify the right theater design team? A first step must be to experience firsthand your potential designers' buildings, see performances in them, talk to existing users, find out the facility's virtues, and discover its inevitable problems. Does the theater *work*, practically, technically, and aesthetically? Can the "spirit of theatre" take flight in this hall? The twentieth century is rife with tales of misunderstanding between the two disparate worlds of theatre and architecture. Often the best of intentions get lost in confusion. Fine theaters of human scale for performers and audiences will only result from the closest collaboration, and from a deep-seated concern for the only outcome that finally matters: lively, vibrant performances to thrill our audiences of the future.

## Postscript: Beyond the Auditorium

The place where the actor meets the audience is fundamental and central to the performing arts center experience. The feeling of "sense of place" provides a place to gather and sense of belonging. Theaters must be economically built, as the arts cannot afford unnecessary maintenance or even cleaning. Architectural folly is simply not affordable. A theater is a place of life. Theatre folk refer to "The House" meaning the auditorium. It needs warmth, liveliness. Our audiences need food, drink, and places to congregate. They need to have places to mingle, and even perhaps to fall in love! A performing arts center needs to be a year-round, all-hours place of liveliness, entertainment, education, and sheer fun. Let your performing arts center be the most vibrant and popular place, and the heart of your community.

## Reference

Moderwell, H.K. (1914). *The theatre of today*. New York: John Lane and Company.

# 6 Building Performing Arts Centers

*Joanna Woronkowicz*

## Introduction

Performing arts center (PAC) construction is a relatively new phenomenon, especially when compared to other types of cultural building. It was not until the last decade of the twentieth century that the PAC, as we know it, began to proliferate in cities across the United States (Woronkowicz, Joynes, & Bradburn, 2014). Prior to this time, only a few major PACs existed, and even those were built relatively recently in the latter half of the twentieth century. Some of the earliest PACs include Lincoln Center, which was built sometime around 1960 in New York City, and The Kennedy Center, built in 1971 in Washington, D.C. Therefore, in describing the history of PAC building in the United States and learning from the experiences of others who have gone through the building process, it is only a matter of 20 or so years that is especially relevant.

The leaders of new performing arts center projects—in other words, those who initiate projects and/or serve as decision-makers throughout the process of planning and building—are not necessarily executive directors or managers of the arts; much of the time, these people are mayors, city managers, board trustees recruited specifically for construction projects, and other types of high-powered officials. Therefore, this chapter attempts to address the myriad types of project leaders who are on the frontlines of new performing arts center initiatives. The goal of this chapter, then, is for leaders to be able to apply the information to a variety of situations and/or perspectives both inside and outside of the arts and culture sector.

This chapter is organized into two parts: Part 1 provides a description of PACs and PAC building in the United States. The data in this part come from a study of cultural facility building between 1994 and 2008[1] from which several other publications were produced.[2] Part 1 includes the definition of a PAC used in the study and an overview of PACs' two main types of operating structures. This part of the chapter also includes a description of cultural and performing arts center construction in the United States between 1994 and 2008. Part 1 concludes with discussing the motivations for building PACs, particularly those PACs built between 1994 and 2008. Part 2 of the

chapter is of direct relevance to PAC project leaders, in that it addresses several best practices for managing the process of planning and building. This part also includes a section on the current methods of estimating demand for new performing arts center projects, these methods' flaws, and improved strategies that can be useful to leaders deciding whether or not to build. The chapter concludes with a summary and directions for future exploration in regard to building PACs.

## Part 1   An Overview of PACs and PAC Building

### *What Is a PAC?*

In this chapter, performing arts centers are defined as spaces that host Broadway tours and/or multidisciplinary performance acts (e.g., comedians, pop concerts, dance groups, theater groups); cultural art centers primarily focus on performance centers, dance theaters, opera houses, symphony halls, concert halls, and auditoriums. PACs, in this context, are usually owned and/or operated by a nonprofit performing arts organization. However, many PACs are also owned and/or operated by colleges and universities, or local and state governments. Furthermore, many PACs have collaborative structures such that multiple entities, perhaps from different sectors (e.g., public and private), share in the responsibilities of owning and/or operating the facility.

The characteristics of the average PAC are the following:

> [They are] multifunctional, often massive facilities that [combine] the production amenities of theaters, symphonic concert halls, and stages that [are] designed to accommodate everything from large choruses and classical musicians, ballet and modern dance companies, popular recording artists, full-scale Broadway musicals, and even magicians. They also [incorporate] user amenities like VIP and donors' lounges and flexible public spaces designed for conferences, private parties, weddings, bar mitzvahs, and other special events.[3]

That being said, the PAC by nature takes various forms. It is precisely the flexibility in hosting various performance and non-performance groups that make PACs attractive to leaders to build.

Compared to other types of cultural facilities (i.e., museums and theaters),[4] modern-day PACs have several other characteristics that make them unique. First, PACs are in general larger than museums and theaters. Among PACs built between 1994 and 2008, on average, a PAC's final square footage was about 216,000 square feet, whereas the final square footage for a museum and a theater was approximately 180,000 square feet and 84,000 square feet, respectively. PAC projects are also more complicated to build; they take longer and are typically more costly than museums and theaters.

They also tend to have higher budget escalations than museums. Estimates of PAC project duration show that, on average, a PAC project takes a little over 10 years from the time the planning group starts exploring the idea for the project to opening night. Museums, on average, take a little over nine years, and theaters take slightly over seven years. From the time the budget is decided on by the board to the final cost, PACs, on average, increase their cost by 64 percent, compared to 46 percent and 88 percent for museums and theaters, respectively. While PACs and theaters tend mainly to increase costs due to additions of technological amenities, museums do from architectural and design specification additions. Since technology steadily and rapidly improves, often what PAC and theater project leaders think they need is already out of date by the time the planning and construction process has run its course.

### Resident Versus Nonresident PACs

From an operating perspective, there are essentially two models of performing arts center organizations: resident and nonresident. In deciding on an operating model, most PAC leaders choose a combination of both; however, for the sake of simplicity, this section describes the models separately. The former model refers to center organizations that act as a home to an exclusive group of local performing arts groups. A resident performing arts center organization is not only responsible for the operations and maintenance of the center's facility, but it also serves as a coordinating body to the facility's various "resident" organizations or companies. Functions of the resident performing arts center organization include providing space and time for each resident company to utilize the facility (e.g., maintaining the calendar, designating office space), furnishing technical assistance, and partnering on marketing and fund-raising initiatives, including special events, with each of the resident organizations. Resident performing arts centers typically have contractual obligations toward their resident companies to provide a minimum number of dates on the calendar in any given year. Or, vice versa, resident companies are required to perform in the center a set number of days/nights. Therefore, the resident PAC is partly dependent on its companies in providing an important revenue source. Resident companies are independent nonprofit organizations usually of 501(c)3 status. Therefore, each company has its own staff and board, its own budget, and public service mission. Nevertheless, resident companies can have representation on the PAC organization's board and thus have influence over the center's management and policies. Among resident PACs built between 1994 and 2008, the average cost was around $137 million,[5] these facilities took almost 12 years to build, and budget escalations were around 64 percent.

In contrast to the resident PAC, the relationship between a nonresident PAC and an arts group is significantly more "arm's length." A nonresident PAC tends to be known as a "presenting" organization, in that it works

with a variety of local and touring performing arts and non-arts organizations on what tends to be a short-term contractual basis. Therefore, nonresident performing arts center organizations usually have no long-term contractual obligations to provide a set number of dates for companies to utilize the center's space. The PAC organization sets the programming for the center by curating what types of groups will use the facility. Thus, it is not uncommon to see everything from Broadway musicals to popular concerts to community events take place at nonresident performing arts centers. Among nonresident PACs built between 1994 and 2008, the average cost was approximately $49 million; these facilities took a little over eight years to build, and budget escalations were about 62 percent.

There are several variations of the resident and nonresident PAC models. For example, some PACs function as both presenting and performing arts organizations by combining an array of different types of contractual agreements across a spectrum of organizations. It is common to see a PAC serve as a home to the local symphony or ballet while also renting out space to Broadway touring groups. The type of arrangement that works best for each PAC is that which not only satisfies the goals of the organization but also maximizes revenue.

When deciding to build a new PAC facility, it is important to consider what type of operating model the PAC organization will utilize. Will the PAC be primarily a resident PAC that serves as a home to one or more arts organizations? Or will the PAC be primarily nonresident and function more as a rental house? If the PAC organization will be both resident and nonresident, what proportion of the performing arts center organization's activities will be performing versus the proportion of activities that will be presenting? Will the proportion change over time (e.g., the PAC will function as a presenting organization immediately upon opening and slowly move to becoming a full-time performing organization), or will the proportion remain static? All of these are important questions for leaders of PAC initiatives to answer before deciding to build.

## PAC Building in the United States Between 1994 and 2008

According to building permit data from McGraw-Hill Construction, Inc., 364 PACs were built in the United States between 1994 and 2008. Among these PACs, approximately 162 (45 percent) were new PACs with completely new governance structures (as opposed to PACs built or renovated for preexisting performing arts organizations). PACs made up 50 percent of the total number of cultural building projects built throughout this period and 54 percent of the total cost of cultural facility building. It is estimated that the number of cultural facilities built between 1994 and 2008 was 725 and the total cost summed to between $24 and $25 billion. Therefore, PAC construction alone totaled around $13 billion and new PAC construction around $6 billion between 1994 and 2008.

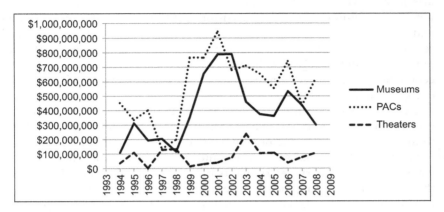

*Figure 6.1* Total Cost of Cultural Building between 1994 and 2008

Source: Woronkowicz et al. (2012).

Note: 2005 USD.

PAC building mirrored trends in aggregate cultural building between 1994 and 2008. Among all types of cultural facilities projects, spending dramatically increased from 1994 until 2008 and peaked in around 2001. Among PACs, spending on construction increased by 400 percent between 1998 and 2001 and continued to increase until at least 2008.

PAC building was especially pronounced in the southern region of the country; from 1994 to 2008 the southern states combined made up approximately 39 percent of total national PAC spending.[6] In addition, PAC building took place in primarily smaller cities: 60 percent of the total cost of cultural building that took place between 1994 and 2008 in cities with fewer than 500,000 residents was devoted to PAC building. Fifty-eight percent of the total number of cultural building projects during this period were PACs in small cities.

## Motivations for Building

Why the surge in cultural building, not to mention PAC building at the turn of the twenty-first century? At least anecdotally, the period around the turn of the twenty-first century seemed like the perfect time to build. Between 1990 and 2000—the decade in which much of the planning and building took place for many PAC projects—the United States experienced an unprecedented rate of economic growth. In fact, this period would ultimately be described as an era of "irrational exuberance."[7] From 1970 to 2000, U.S. gross domestic product increased pretty consistently by about 3.5 percent per year. Population growth and education levels were also steadily increasing during this time (Woronkowicz et al., 2014) As such,

arts leaders who were contemplating the perceived needs and opportunities for the cultural sector were accustomed to living in a climate of strong and steady economic growth. Given the strength of the economy, it seemed reasonable to expect that undertaking substantial long-term financial commitments would be relatively low risk. No one expected, however, that the economic growth the nation experienced in the 2000s would dramatically change course as it did in 2008.

Recent research on the determinants of cultural building at the metropolitan statistical area (MSA) level corroborate anecdotal evidence and add to an understanding of the determinants of cultural building. Increases in population, educational attainment, and median household income levels were the three primary determinants of cultural building in MSAs across the United States during the study period. Furthermore, the level of cultural capital stock in an MSA was positively associated with total per capita cost of building. In other words, MSAs with more preexisting cultural facilities also spent more on cultural construction, likely because of the cost of maintaining and replacing facilities (Woronkowicz, 2013).

There are social factors that also caused cities and cultural leaders to invest in building new PAC projects. One of the major reasons so many PACs were built during this period relates to the aspirations of leaders to have their cities be recognized on the national (and international) stage. Many PACs were designed as symbols of how a city and its residents envisioned itself and what vision they were projecting into the future. Part of this had to do with the cultural development of communities, and another part had to do with cities' economic development. Just as America's oldest and most prestigious cultural institutions were built in major industrial cities at the turn of the twentieth century in order to compete with one another for cultural capital (Conn, 2011), cities across the United States that built PACs at the turn of the millennium embarked on these projects to demonstrate that they deserved and were capable of offering cultural events that rivaled other cities in their region and across the country.

Perhaps this is why PAC building occurred in the way that it did as part of a "spill-over" effect. It was not uncommon during this period to see one city propose and start building a PAC and shortly thereafter see a neighboring city or region also start their own PAC project. The Adrienne Arsht Center in downtown Miami, built in 2006, came after the David A. Straz Jr. Center for the Performing Arts (initially the Tampa Bay Performing Arts Center) in Tampa Bay in 1987, the Broward Center for the Performing Arts in Fort Lauderdale in 1991, and the Raymond F. Kravis Center for the Performing Arts in West Palm Beach in 1992. The Luther F. Carson Center for the Performing Arts in Paducah, Kentucky, built in 2004, came after the RiverPark Center in Owensboro, Kentucky, built in 1992. Currently in the process of building, the Steven Tanger Center for the Performing Arts in Greensboro, North Carolina, followed in the footsteps of the Durham Performing Arts Center (DPAC) in Durham built in 2008.

The economic development of cities, regions, and towns was and is a major reason for building PACs. As part of modern arts economic development (AED) strategies, local politicians and city leaders believed investing in PACs would increase new business creation and tourism. The multifunctional nature of PACs made them an ideal facility type for attracting visitors with a spectrum of artistic interests that ranged from popular musical entertainment to more obscure genres like jazz. Frequently, it was a city mayor who led efforts in creating a new PAC. A few examples illustrate this: Mayor Ed Rendell of Philadelphia led the charge in building the Kimmel Center and was even part of the reason the project morphed from being a purpose-built concert hall for the Philadelphia Orchestra to being a multiuse space for a plethora of cultural groups; Mayor Bill Bell served as a major advocate for building DPAC; Mayor Jim Brainard of Carmel, Indiana was the driving force behind building the Palladium, a $180 million PAC largely built with public funds. All of these mayors had economic development as goals for pursuing these PAC initiatives. The strategy of using cultural facilities as part of AED is certainly not new (Ashley, 2015), but using PACs as part of this strategy was exemplified during PAC building in recent times.

## Part 2   Management of PAC Projects

### *Best Practices for Building*

Among PAC projects, and cultural facility projects more generally, there emerges a set of "best practices" from observing the processes other projects have gone through. Rather than describe in detail these processes (which differ slightly between resident and nonresident PACs), this section highlights prominent themes among new PAC initiatives that suggest a specific course of action for future projects.

First, passion is a prerequisite for any cultural facility project, including a PAC project. Be it passion for an art form, the needs of a community, or an organization and its future, passion is what inspires individuals and a community to support a PAC project. While there is definitely a need for rational decision-making in deciding whether or not to build a PAC (the next section discusses this in detail), and in managing the project's processes, very rarely do new PAC projects arise from an entirely rational and systematic process of decision-making. More often, a city or arts leader has a grand vision for a new facility and uses his vision to inspire others to support the project. This is how the Kimmel Center for the Performing Arts—built in 2001 in Philadelphia, Pennsylvania—came about when Riccardo Muti, the past music director for the Philadelphia Symphony Orchestra, and the late Stephen Sell, former executive director of the orchestra, made the case for a new concert hall.

Not only is passion a prerequisite for garnering support for a PAC project, but it helps sustain a project throughout. PAC projects are inherently

complex, in that they tend to involve multiple bodies working together, require great skill in overcoming bureaucratic hurdles, take a very long to time to complete, not to mention are expensive. Furthermore, the leadership groups that manage PAC projects are often composed of high-powered individuals with strong personalities and opinions on how to accomplish project goals. Given the complexities of new PAC initiatives, there will almost always be conflict at some time throughout the project timeline. For example, when the city of Las Vegas took a ferocious hit during the Great Recession in 2008, not surprisingly, the planning and building process for The Smith Center (TSC) for the Performing Arts slowed down considerably. Were it not for the passion for the TSC's leaders to building "a living room for Las Vegas," likely the PAC would not have opened in 2011. A leader or leaders who can remind the project-planning group of the initial passion that inspired the idea for the project can help motivate project leaders to move forward. In other words, new PAC projects that retain a "passionate advocate"—a leader whose role is to inspire others—from the start of the project to its completion will benefit as a result.

An effective project leadership group is at the core of any successful PAC project. There are many conceptions of how to structure project leadership; for example, The Kauffman Center for the Performing Arts in Kansas City, Missouri, utilized a small (seven people) planning committee that was responsible for the entirety of project planning; the Adrienne Arsht Center for the Performing Arts had multiple larger bodies each addressing different aspects of project planning. PAC projects are by nature collaborative, in that they tend to involve multiple entities (e.g., nonprofit organizations, local governments, economic development groups, foundations, etc.). In the case of resident PACs, multiple performing arts organizations are invested in the project's outcome and the planning process as a result. While each group serves a valuable function in the project's planning and building process, it is important that there be one (small) primary leadership group responsible for decision-making. Otherwise, decision-making can become muddied and ultimately slow down or complicate the overall process of getting a PAC built. In the case of the Adrienne Arsht Center, for example, having multiple large decision-making bodies partly led to major timeline delays and a budget increase of over $200 million.

The composition of a project leadership group is just as important as its size and responsibilities. Attorneys, finance executives, developers, and artists are important types of people to have on a PAC project planning team; these types of people have experience with the functions required to bring a PAC project to completion. Equally (or more) important is having a person (or persons) familiar with planning and completing construction on a PAC facility, and having a person with experience operating a PAC venue. Performance facilities have a unique set of design specifications that only a person who has worked and/or operated one before can fully understand. The same is true with architects; PAC projects that use architects who have

designed performance facilities before encounter fewer problems related to facility functioning. This is precisely the reason why the executive leadership team at the Goodman Theater in Chicago, built in 2000, encouraged its board to hire a lesser known architect with theater design experience instead of a more prominent architectural firm. In the end, the facility must function well for its audiences and its artists, and not just be a monument to its city or organization.

Budget and scope increases are par for the course in performing arts center projects; therefore, having a business plan that clearly lays out the initial vision for the project (and that the project leadership team follows) is key to controlling the amount of project amendments (and cost increases) that take place. The first step in creating a business plan is to identify the need for the project, or the problem that that project is attempting to fix. This involves studying and becoming familiar with the market a PAC project is envisioned to serve. For example, perhaps a significant portion of community residents is traveling long distances to attend performing arts events. Built in 2008, DPAC in Durham, North Carolina, caters to audiences all over the region. About 5 percent of DPAC's audiences come from 50 miles away in Greensboro. Part of the impetus for building the Steven Tanger Center for the Performing Arts in Greensboro (scheduled to be completed in 2017), then, was the fact that Greensboro residents had to travel long distances to attend performing arts events.

Whatever the problem or need is that stimulates the idea for a PAC project, clearly stating it in a business plan reduces the tendency of leaders to agree to morphing the project into something else as a result of pressures from stakeholders. Initially planned to be a concert hall for the Philadelphia Orchestra, the Kimmel Center for the Performing Arts became a much larger endeavor when the board of the Orchestra espoused the mayor's vision for a multiresident company performing arts center as the anchor for downtown redevelopment. With the mayor's support also came additional funding, and since project fund-raising, at that point, had leveled off, the board agreed to transform the concert hall into something much bigger, costlier, and with a much more complicated operating model.

After the fact, when a project is complete, a business plan can also help limit the amount of "revisionist narrative" that takes place—when the initial idea for the project is supplanted by what has become the current circumstances of the PAC, for better or for worse. If the project's purpose and function significantly change from the time of conception to operation, it is often the case that those who were involved claim that new PAC, in its current form, is what is was always meant to be. In Chicago, the Harris Theater for Music and Dance was initially built to serve as a home to small and midsized local performing arts organizations. Years later, the PAC functions more as a presenting house bringing in touring groups from across the globe in order to sustain itself financially and respond to what audiences were saying they wanted. As in the case of the Harris Theater, often PACs change

their goals based on current demands in the marketplace; nevertheless, in order to learn from the experiences of past projects, and to understand how and why an organization's goals may change, being honest about its trajectory is key. Therefore, in addition to being knowledgeable about the market a PAC is to serve before embarking upon a project, PAC leaders can benefit by staying attuned to changes in the marketplace after the PAC is built in order to adjust programming, or its mission.

Given the dynamics of performing arts audiences, arts funding, and other social, economic and demographic trends in the United States, changes to a PAC organization's initial purpose, functions, or mission are inevitable. From the standpoint of building sustainable PACs, it is a mistake, then, to build static facilities that prevent performing arts organizations from being able to respond to the world around them. This involves building PACs with flexible designs, such as retractable concert hall seating, modular spaces, and outdoor performance spaces, in order to be able to alter the mix of programming to appeal to a variety of audiences. These types of spaces not only offer new revenue opportunities, but they also provide longevity to the facility by preventing a facility from becoming outdated too fast. The New World Center in Miami Beach integrated both retractable concert hall seating and outdoor space where audiences can watch performances broadcast on the building's façade. These two design elements have attracted audiences to the New World Center's events that likely would not have otherwise come. "Black box" spaces, like BAM Fisher at the Brooklyn Academy of Music, National Sawdust in Brooklyn, and the Studio Theater at the planned Tateuchi Center in Bellevue, Washington, are becoming much more commonplace among new PAC projects. Especially when coupled with other types of performance spaces, black box spaces provide a range of alternatives for PAC programming besides that which is designed for a traditional proscenium space.

### Estimating Demand

From a demand perspective, there are essentially two reasons why new PACs are built (1) to respond to increased demand for performing arts events from consumers (i.e., audiences) and (2) to help stimulate demand for performing arts events by consumers (i.e., audiences). The methods for estimating demand in both respects are not without their challenges. Furthermore, the consequences for inaccurately estimating demand can be extremely dire. For example, leaders at the Adrienne Arsht Center for the Performing Arts underestimated the new PAC's operating expenses and overestimated its projected revenue. As a result, the PAC ran a $2.5 million deficit in the first eighteen months after opening. Luckily, Miami-Dade County was willing to help bail out the struggling PAC with a $4.1 million bailout package (in addition to $3.75 million the county already provided in annual operating subsidies) and a wealthy benefactor (i.e., Adrienne Arsht) donated an additional $30 million to help save the center.

The feasibility study is often the method used to estimate demand for new PACs. As the name implies, these studies attempt to evaluate the possibility of building and operating a new PAC based on projections about audience demand, donor capacity, community interest, and competition from other venues. Consultants generally conduct these studies in the early phases of a PAC planning process. A completed feasibility study will offer predictions for what will happen under different circumstances (i.e., conservative, midrange, optimistic).

The inherent flaws of the methods used to conduct feasibility studies contribute to the gross misestimation of projected revenues and expenses for new PAC projects after they are completed. Among cultural facilities built in the United States between 1994 and 2008, including PACs, the majority of projects inaccurately projected both future revenues and expenses for the facility after the project was completed. Specifically, 54 percent of projects had lower revenues than projected, and 59 percent had higher expenses than projected. One of the reasons feasibility studies fail to accurately estimate demand is that they tend to rely on nonrepresentative data on audiences. For example, a feasibility study will include a survey of current performing arts audiences but fail to ask a broader population that could potentially provide insight into how audiences may change in the future. Feasibility studies are also notoriously bad for calculating risk, such as evidence of fiscal instability in a potential resident performing arts organization's history. Not only do feasibility studies tend to neglect evaluating whether resident companies can actually afford to pay rent on a new facility's space and whether rental payments will cover the costs of operations, but many studies cite a history of fiscal instability among resident companies as rationale for building a new a PAC in the first place. The idea that a new facility can somehow rescue the failing performing arts organization by enticing audiences to come experience a new space has repeatedly been shown not to work in practice (e.g., the Florida Philharmonic and the Concert Association in Miami). Therefore, new resident PACs that build for financially healthy performing arts organizations will have a better chance of succeeding.

On a broader level, demand for PAC projects is difficult to estimate because PAC projects in and of themselves are unpredictable. As Duncan Watts (2011) explains,

> There are two kinds of events that arise in complex social systems—events that conform to some stable historical pattern, and events that do not—and it is only the first kind about which we can make reliable predictions (p. 162).

Feasibility studies try to make predictions about events that are inherently unpredictable. The outcomes of a performing arts center initiative can be influenced by a whole host of factors, including project leadership, political events, and demographic and economic shifts. In other words, because the

future itself is uncertain and impossible to control, the outcomes of PAC projects cannot be accurately forecasted. Furthermore, new PAC projects tend to be dramatic departures from the past or current conditions. Project goals are often ambitious, and the projects are designed to create nonincremental change. Therefore, feasibility studies that try to extrapolate based on past experiences are often inaccurate in predicting the future.

New PAC initiatives are frequently pursued with objectives of increasing demand for performing arts audiences, as well as for economic activity in areas surrounding a new facility. In this instance, demand is not necessarily known *ex ante* (the goal of a feasibility study), but demand is calculated *ex post* most commonly by using methods to conduct an economic impact study. First, it is worth stating that there is currently scant quantifiable evidence that cultural facilities projects can stimulate demand. Anecdotally, there exist multiple accounts and case studies of new PAC projects "transforming" disinvested regions and downtowns[8] (i.e., the Bilbao effect), but in terms of actual quantifiable evidence of the catalytic impact of new PACs, there is still a major gap in the literature that purports new PAC projects have these outcomes. Nevertheless, the potential for a new PAC to create waves of economic activity through increased tourism and new business development is often used as a tool of persuasion among PAC leaders to help generate support from donors, foundations, and local governments.

Second, despite the wide use of economic impact studies in the arts to quantify *ex post* demand for PAC projects, and arts and cultural amenities more generally, the methods used to conduct these studies are often so fuzzy that the results are not to be trusted. Economic impact assessments of PAC projects "total up the money invested in and spent by [PAC] facilities . . . and compute the resulting jobs, tax revenues, and total expenditures, using multipliers" (Markusen & Gadwa, 2010, p. 381). Many times a PAC project will involve conducting an economic impact study *ex post* to illustrate to the community that the PAC project was worth the investment. For example, after building the Holland Performing Arts Center in Omaha, Nebraska, Omaha Performing Arts Society (OPAS) commissioned two economists from the University of Nebraska to conduct an economic impact study of the Holland Center and OPAS's other facility in the greater metropolitan area. The study argued that OPAS generated a $128.5 million impact in the form of salaries, restaurant meals, hotel stays, and other goods and services in the region—results that OPAS continue to use to advocate for support.

The methods used to come to these results are not without their flaws. First, these studies fail to take into account the "substitution effect" of making a new cultural investment (i.e., building a new PAC). In other words, whether arts and cultural spending is simply displaced or redistributed from spending in other sectors. Second, arts economic impact studies tend to overestimate the amount of wealth arts investments bring in from outside of a region (i.e., export-based industry; Seaman, 2000). Third, these studies fail

to acknowledge that nonprofit arts expenditures are largely publicly subsidized and that nonprofit arts organizations, by being exempt from paying taxes, also contribute to foregone tax revenue (Markusen & Gadwa, 2010). Finally, by focusing on instrumental outcomes such as jobs and spending, arts impact studies neglect to consider the intrinsic public benefits of the arts, such as the ability of arts organizations to "entertain, educate, inspire, and provoke" (Sterngold, 2004).

Given that demand for PAC projects is difficult to estimate, what can project leaders do to help decide whether a project will have a successful outcome? In other words, how can leaders answer the question, "Should we build?" Fortunately, there are resources project leaders can use to learn strategies for overcoming challenges of conducting feasibility studies (also known as cost-benefit analyses or CBAs). PAC projects are one form of infrastructure project that uses CBAs to inform decision-making; sports arena, transport, and other types of mega-projects are also subject to this form of analysis. Since mega-projects are typically almost entirely funded by public money, and often at amounts much higher than PACs (think billions), the CBAs that are conducted for mega-projects are often subject to great scrutiny. Therefore, the methods to conduct CBAs are constantly being rethought and improved upon in order to be able to produce more accurate results. Fortunately for PAC project leaders, this means that the resources to learn how to conduct a good CBA are at one's disposal.[9]

In regard to overcoming the inherent uncertainty that goes along with predicting whether or not a PAC project will be a success, one strategy that leaders can use is to garner as many perspectives as possible on the likely trajectory of the project. Rather than rely on one single opinion—or on one consultant—leaders of PAC projects should consult with as many people as possible and combine their diverse opinions in order to make an informed decision. These people can be experts in PAC construction or the performing arts, those knowledgeable about local conditions, or even just smart people with accumulated experience—but the goal is to assemble a large set of differing opinions so they can be systematically reviewed and synthesized.

Finally, strategies that can help safeguard the investment a community, a city, or a set of leaders will potentially make in building a PAC can be implemented in the early decision-making stages of a project—before the decision to build has been made. New performing arts center initiatives, like all cultural facility projects, tend to move along very quickly and for that reason are difficult to stop once the decision to build has been made. In other words, PAC projects are like bobsled races: "once the gate goes down, it's almost impossible to put on the brakes" (Woronkowicz et al., 2014, p. 107). Therefore, taking ample time to evaluate the possibility of a project, before planning for its construction, helps ensure that leaders have considered all of the possible best- and worst-case scenarios that can unfold. For PACs that were built between 1994 and 2008, those that were the most successful engaged in very long preplanning phases. Or devising strategies that

protect funders' initial investments—like the leadership team at The Smith Center did when they put the board's initial contribution for the new PAC in escrow—can all help alleviate the anxiety around whether or not the right decision was made in response to asking, "Should we build?"

## Conclusion

In addition to following the best practices described above in regard to planning for and building a new PAC project, leaders of new PAC initiatives will also benefit from trying to overcome what psychologist, Daniel Kahneman—a specialist in decision-making, judgment, and behavioral economics—calls the "planning fallacy." This term refers to when leaders' decisions are characterized by optimism and overconfidence that one's plans will work out in the manner one has predicted they will. Leaders of PAC projects tend to focus on what a successful outcome will look like, instead of all the ways the project could possibly be derailed. Kahneman (2011) argues that the tendency to succumb to the planning fallacy is very much ingrained in human behavior, therefore, difficult to override. PAC project leaders are often very successful men and women who are accustomed to making decisions based on their own experiences and that of their collaborators. This type of "inside knowledge" does not take into account what statisticians call the "base rate"—or the distribution of projects that did not go as planned. One way to mitigate the planning fallacy is to gather data on as many similar projects in order to be able to understand the range of different experiences people go through. Being aware that 91 percent of newly constructed PACs went over budget, 73 percent of PACs went over by at least 50 percent, and 40 percent of these projects took longer than originally planned can help PAC leaders overcome the planning fallacy. Furthermore, tempering optimism by carefully investigating all of the things that can go wrong, and planning for when they do, is another way to help mitigate the planning fallacy.

In sum, new PAC project initiatives were an especially prominent type of cultural building project in the past few decades, and they continue to proliferate among cities in the United States. The flexibility these types of facilities offer communities seeking to embed the arts in their regions make PACs an attractive type of cultural building project for city and cultural leaders. As this chapter has highlighted, new PAC projects are not without their complexities. They tend to be very large and complicated in their design and functionality. As a result, PAC projects take several years to plan for and to build and often experience significant budget overages. Nevertheless, city and cultural leaders continue to include PAC projects as parts of their regional economic development plans. From examining the projects built in the recent surge in cultural building, not to mention PAC building, lessons emerge regarding the most effective methods to plan and build. However, new PAC building is still risky, in that forecasts related to project demand

are near impossible to predict. It is likely cities and cultural leaders will continue to build new PACs, despite their risks, but hopefully with guidance from past project experiences in mind.

Without the data to quantify the level of PAC building since 2008, it is tough to say whether the surge in PAC building the United States saw at the turn of millennium has slowed or whether PAC building is still as prevalent as it was over a decade ago. There are plenty of examples of large PACs either having been built or in the process of building in cities throughout the nation (e.g., The Dr. Phillips Center for the Performing Arts in Orlando, Florida, which opened in 2014, and The George S. and Dolores Dore Eccles Theater in Salt Lake City scheduled to open in 2016). At least according to media accounts of recent PAC projects, it seems like the trend to build PACs has moved away from building large, traditional performing arts spaces—where audiences initially enter a PAC through an expansive lobby and watch a performance in a proscenium-style theater— to building smaller, flexible spaces that may break the conception of the "fourth wall" (as described earlier). Cities are even proposing temporary PACs that pretest levels of market demand (see, e.g., the temporary PAC that was proposed in Kennewick, Washington, as a first phase of a master redevelopment plan for the city) before investing in permanent facilities. This trend toward building more flexible performance spaces may have come as a result of the number of PACs built prior to the 2008 economic recession that experienced substantial financial difficulties. In sum, the sense is that in planning and building performance spaces for the future, city leaders and arts managers have begun to think about new models to reduce the risk that failed PAC projects can incur to their organizations and community.

Regarding new PAC building, there is still a lot to discover. PAC leaders still do not know whether or not PACs are the most effective means by which to share space among a group of performing arts organizations. There may, in fact, be more cost effective ways to collaborate on space— ones that reduce the amount of overhead that new PAC facilities tend to generate. For this reason, and others, PAC facilities may soon become an outdated type of cultural facility project. Given the changing dynamics of arts participation, especially trends in experiencing arts events in both non-traditional and informal settings, it is likely that PAC facilities (and facilities in general) will face challenges in attracting audiences. However, just as it is difficult to predict the outcomes of a PAC project, it is impossible to know with certainty that audience demands for performance space will drastically change in the coming years. Similar to the recent resurgence of vinyl records among music enthusiasts, the traditional performance space may once again become the preferred mode of participating in the arts. Since it is impossible to predict the future, cultural and city leaders who decide to build new PACs can only try to limit the amount of risk they undertake with building a PAC and follow the guidance of those who came before them.

## Notes

1 See Woronkowicz et al. (2012) for a description of the study and its results.
2 See, for example, Woronkowicz (2016), Woronkowicz (2013), and Woronkowicz et al., (2014).
3 Woronkowicz et al. (2012)
4 In this context, museums are defined as traditional art museums, ethnic museums, history museums, historical societies, and organizations and cultural art centers that focus primarily on exhibiting art. Theaters are defined as single-use performance spaces such as those with their own resident companies. Theaters, in this context, are typically known as "producing theaters."
5 All monetary figures are reported in 2005 USD.
6 Regions are defined by the U.S. Census Bureau. See https://www.census.gov/geo/maps-data/maps/pdfs/reference/us_regdiv.pdf for a map of regions and divisions of the United States.
7 This quote was brought to popularity by Alan Greenspan (former Federal Reserve Board chairman) in his televised speech on December 5, 1996, to the American Enterprise Institute.
8 See, for example, Strom (2002) on the urban development impact of the New Jersey Performing Arts Center, and Birch, Griffin, Johnson, and Stover (2014) for multiple case studies including The Adrienne Arsht Center for the Performing Arts, The Kimmel Center, and the Woodruff Arts Center.
9 See, for example, the work of Hugo Priemus, Bent Flyvbjerg, and Bert Van Wee (2008).

## References

Ashley, A.J. (2015). Beyond the aesthetic: The historical pursuit of local arts economic development. *Journal of Planning History, 14*(1), 38–61.
Birch, E.L., Griffin, C., Johnson, A., & Stover, J. (2014). *Arts and culture anchor institutions as urban anchors: Livingston case studies in urban development.* Philadelphia, PA: Penn Institute for Urban Research, University of Pennsylvania. Retrieved from: http://www.penniur.upenn.edu/uploads/media/Arts-Culture-Anchors-August-2013.pdf
Conn, S. (2011). *Do museums still need objects?* Philadelphia: University of Pennsylvania Press.
Kahneman, D. (2011). *Thinking, fast and slow.* New York: Farrar, Straus and Giroux.
Markusen, A., & Gadwa, A. (2010). Arts and culture in urban or regional planning: A review and research agenda. *Journal of Planning Education and Research, 29*(3), 379–391.
Priemus, H., Flyvbjerg, B., & van Wee, B. (Eds.). (2008). *Decision-making on megaprojects: Cost-benefit analysis, planning and innovation.* Cheltenham, UK: Edward Elgar.
Seaman, B. (2000). Arts impact studies: A fashionable excess. In G. Bradford, M. Gary, & G. Wallach (Eds.), *The politics of culture: Policy perspectives for individuals, institutions and communities* (pp. 266–285). New York: New Press.
Sterngold, A.H. (2004). Do economic impact studies misrepresent the benefits of arts and cultural organizations? *The Journal of Arts Management, Law, and Society, 34*(3), 166–187.
Strom, E. (2002). Let's put on a show!: Performing arts and urban revitalization in Newark, New Jersey. *Journal of Urban Affairs, 21*(4), 423–435.
Watts, D. (2011). *Everything is obvious—once you know the answer: How common sense fails us.* New York: Crown Business.

Woronkowicz, J. (2013). The determinants of cultural building: Identifying the demographic and economic factors associated with cultural facility investment in US metropolitan statistical areas between 1994 and 2008. *Cultural Trends,* 22(3–4), 192–202.

Woronkowicz, J. (2016). Is bigger really better? The effect of nonprofit facilities projects on financial vulnerability. *Nonprofit Management & Leadership.* doi: 10.1002/nml.21209

Woronkowicz, J., Joynes, D.C., & Bradburn, N. (2014). *Building better arts facilities: Lessons from a U.S. national study.* New York/London: Routledge.

Woronkowicz, J., Joynes, D.C., Frumkin, P., Kolendo, A., Seaman, B., Gertner, R., & Bradburn, N. (2012). *Set in stone: Building America's new generation of arts facilities, 1994–2008.* Chicago: Cultural Policy Center, University of Chicago. Retrieved from: http://culturalpolicy.uchicago.edu/sites/culturalpolicy.uchicago.edu/files/setinstone/pdf/setinstone.pdf

# 7 Ownership and Governance of Urban Performing Arts Centers

## Patricia Dewey Lambert and Robyn Williams

## Introduction

As discussed in all the chapters of this book, virtually all performing arts centers (PACs) are community-based and serve the public interest. For senior executives of performing arts centers, mandates for venue management include diverse responsibilities like supporting local resident companies, programming additional performing arts presentations for the community, and engaging in community education and outreach initiatives. Senior staff responsible for overseeing the day-to-day management and operations for the PAC report to some kind of governance entity, which may or may not be the same entity that actually "owns" the PAC facility. A community's performing arts center is accountable to the public, but the primary over-sight—that is, the *ownership and governance*—of the center can take many different organizational forms. Decisions made in establishing the structure of ownership and governance of the PAC—the *umbrella organization*—will significantly influence decisions made in establishing the structure of man-agement and operations of the PAC.

Unfortunately, far too many performing arts centers are built or reno-vated without civic leaders paying adequate attention to how the center will be structured, programmed, and run after the building project is com-plete. Without plans for ownership, governance, and management carefully thought out early in the PAC project, many of these institutions end up in significant financial difficulty not too long after their doors open.

This chapter builds on the prior chapters of this book to focus specifically on assessing models of performing arts center ownership and governance in America's communities. This is one of the most complex aspects of PAC leadership. However, carefully considered decisions regarding ownership, governance, and management oversight are absolutely crucial to establish-ing an organizational infrastructure that will provide and sustain success. When Patrick Donnelly provides insight into executive leadership of opera-tional functions of a new PAC in Chapter 8 of this volume, he often refers to the significance of the umbrella organization that provides oversight. This umbrella organization is composed of all the entities—and there may be

several in a highly complex organizational structure—that provide owner-ship and governance of the PAC.

In fact, urban performing arts center oversight can be composed of several distinct layers. The PAC facility will be owned by an entity, which may or may not manage the PAC. Community oversight of the PAC may be provided by a different entity. And day-to-day operations of the PAC may be provided by one of these entities or by another group. Each of these entities may be any number of organizational types structured as a public (government) entity, a nonprofit organization, or a hybrid of the two. In practice, the structure of this oversight is unique to each community.

This chapter offers insight into decisions, choices, and options for establishing or modifying the ownership and governance structures of an urban performing arts center. While these structures will be relevant to PACs in communities of all sizes, a sample set of major metropolitan PACs was selected for analysis in this chapter. This sample set (profiled in Table 7.1) was purposively selected for its comparability and its benchmarking relevance across the field. After introducing diverse types of PAC ownership and governance, this chapter integrates information collected from senior executives in the sample set through questionnaires and interviews to describe umbrella organizations in practice. This discussion then leads to a deeper analysis of these models of ownership and governance—as well as their hybrid forms—and posits criteria for assessing which model might be best suited to the local community.

## Decisions That Determine Models of Ownership and Governance

When a community begins to consider building, renovating, or revitalizing a performing arts center, civic leaders must make a set of important decisions regarding the intended mission and goals of the PAC. This set of decisions may shift over time as the needs of the community change. To be a successful and sustainable PAC, the ownership, governance, and operations structures of the PAC must both result from and reflect these core planning decisions. A general decision-making framework is provided in Figure 7.1.

To begin making decisions about the ownership, governance, and management structure of the performing arts center, the first matter to clarify is *who* will have the authority to make these preliminary decisions. Who are the key stakeholders in and champions of this project? Is a set of private community leaders or a governmental entity driving the planning process? Is the performing arts center to be within a small community or a suburb, or is it to play a major role in an urban downtown infrastructure? Who will benefit the most from the PAC, and who will oversee its role in the community?

The second set of preliminary decisions has to do with *why* the performing arts center project is being undertaken. What are the economic, social, and cultural needs driving the intended investment in the PAC? How will

*Considerations for Primary Oversight Structure*
Direct, arm's-length, or independent ownership and governance?
Scope and separation of ownership, governance, and management?
What form of ownership and governance?
Public, nonprofit, or hybrid organization?

*Why?*
Urban Planning & Development Goals + PAC's Role in a Cultural District
Economic, Social, & Cultural Goals

*PAC Mission, Goals, and Funding Mix*
Resident vs. Nonresident?
Produce, Present, or Host?
Cultural vs. Commercial Programming?
Intended Revenue Streams?

*Who?*
Decision-Makers
Stakeholders
Champions
Beneficiaries

*Figure 7.1* Determining the Umbrella Organization of a PAC
Illustration by Stephanie McCarthy

the PAC contribute to urban planning and development goals? Is the PAC intended to represent the cultural heritage and artistic expression of a nation or region or a specific cultural identity? Is the PAC to be positioned within a college or university—and if so, what is its role within its larger community? The respective set of stakeholders and decision-makers will vary in each of these scenarios and the PAC planning committee is wise to structure its decision-making process to include diverse voices and perspectives.[1]

Further decisions to be made have to do with the intended role of the performing arts center in the community. Is the PAC to primarily serve as a home for local nonprofit and community-based arts organizations; that is, will it support resident companies? Is it to bring popular and inspirational performing arts touring productions to the community; that is, will it be a nonresident organization? To what extent is the PAC intended to anchor a cultural district or serve as part of other urban revitalization plans? Does the theater to be renovated hold historic preservation significance? Are there key economic and social goals to be addressed by the PAC in its planned location?

The next set of decisions has to do with the intended breadth of programming to take place in the community's PAC. Will the entity *produce* any of its own work—that is, will it fund and create its own artistic work, utilizing its own artistic, administrative, and production personnel? Most urban PACs are intended to either *present* work of outside producers (which includes local resident companies) or *host* other performances by renting their facilities to third-party producers and presenters. If the PAC is meant to be a *presenting* or *hosting* organization, does the community desire an emphasis on arts and culture programming or commercial entertainment or a mix of these? What are the intended revenue streams for the PAC, and to what extent will income from hosting touring productions and other ancillary revenue streams be used to subsidize the PAC's use by local arts groups? As discussed by Tony Micocci in Chapter 4 of this volume, opportunities abound for the PAC leadership to make conscious decisions regarding programming—including *hybrid producing*, *hybrid presenting*, and *renting variations*. It is imperative for civic leaders to intentionally consider this mix of programming options in the early phase of PAC building, renovation, or revitalization in order to assess the financial viability of the PAC.

When considered within a framework of solid strategic planning practices, decisions on the questions listed earlier will lead to clarity on the performing arts center's mission, main goals, and intended funding mix. An explicit articulation of the PAC's intended role in the community (especially within a cultural district) and within the local performing arts ecosystem should be in place prior to considering the next set of key questions that have to do with ownership, governance, and management.

The next set of decisions made by civic leaders will connect the PAC mission and goals to a congruent structure of ownership and governance. Who will actually *own* the facility and take care of maintaining and repairing this community asset throughout its lifetime? What entity will maintain oversight

over the management, programming, and operations of the PAC? First, a clear decision must be made on whether or not—and to what extent—the community wishes to distinguish ownership and maintenance of the PAC from its operations and programming functions. Should the PAC be directly owned and operated by the community, or should it be operated at arm's-length? Should it be operated separately from a city's public administration or within a division of the city, region, or state government? Should it be purely a public, government-run organization? Should the PAC be run as a nonprofit organization with a governing board of some kind? Or should the PAC be owned and operated in some kind of a hybrid or mixed organizational form?

Ultimately, how does a community determine the ownership and governance structure that is best suited to the local context? As discussed in this chapter, the first step is to reach decisions on the PACs mission, community goals, programming, and realistically anticipated funding streams. Decisions surrounding the mission of the PAC must be made first, as should the determination of the extent to which the PAC should have the ability to be entrepreneurial in its operations. The structures for ownership, governance, and operations must be congruent with these decisions to allow for both mission realization and revenue generation. Figure 7.2 illustrates a range of options for structuring the PAC umbrella organization.

With reference to Figure 7.2, the spheres of PAC ownership and PAC governance often overlap—to varying degrees—to constitute what is ultimately the "umbrella organization," providing primary oversight over the PAC. This chapter provides examples of three major types of ownership and governance that can be found among America's urban performing arts centers. Namely, the PAC can be run by or as a 501(c)3 nonprofit organization, it can be run by or as a cultural district or a cultural center, or it can be run by a division of a city, state, county, or region's government. Within these three major types, further variations exist as determined by the extent to which the community has decided to distinguish the ownership and governance of the PAC from its day-to-day management, programming, and operations. When governed as a nonprofit, the PAC can be owned and operated by a community nonprofit, or it can be publicly owned but operated as a nonprofit. When owned and governed within a cultural district or cultural center, the PAC's venue operations frequently (but not necessarily) take the form of an independent nonprofit within the larger entity. And when the PAC is owned and overseen publicly, the PAC can still be operated as an independent, arm's-length nonprofit that reports to the government, or the PAC can be run within a department or a division of the government. An additional option, which is beyond the scope of analysis in this chapter, is for the umbrella organization to contract with an outside entity for the PAC management and operations.

The interplay between PAC ownership, governance, management, and operations models is exceedingly complex. Communities have a wide array of models to choose from in structuring oversight of their performing arts

**Umbrella Organization**

*PAC Ownership + PAC Governance*

by/as
Nonprofit
Organization

by/as
Cultural District or
Cultural Center

by
City, County, State, or
Regional Government

The PAC is owned and operated by a community nonprofit.

The city or region owns the PAC, but an independent nonprofit operates it.

The PAC is often operated as an independent nonprofit within this entity.

The PAC is operated as an independent nonprofit that reports to government.

The PAC is operated as or within a department or division of government.

*PAC Management and Operations*

*Figure 7.2* Options for Structuring the PAC Umbrella Organization

Illustration by Stephanie McCarthy

center, and in practice, the organizational form ultimately selected can be further modified to meet the specific needs and desires of the community. The resulting fascinating array of hybrid structures and functions provides a fertile ground for study.

## Overview of Ownership and Governance Models

The ownership, governance, and management structures of performing arts centers throughout North America and internationally vary tremendously. This chapter is delimited to analyze models of ownership and governance of major metropolitan performing arts centers in the United States. Based on relevant published scholarship, a review of organizational documents and other information, and data collected through questionnaires and interviews with senior executives, this chapter provides insight into existing models within a sample set of urban PACs. This sample set was selected to represent a range of "typical" metropolitan PACs.

In the United States, a "typical" set of PACs is composed of venue management organizations that serve a large urban region. These PACs may run one venue or multiple venues, and can be further differentiated by budget, programming, and education programs, along with other community engagement initiatives. The funding of these organizations varies significantly in the categories of government support, nonprofit funding streams, and for-profit revenues (as well as various combinations of these funding streams). The governance and local politics associated with the PAC also vary enormously. In identifying a "typical" set of PACs for this study, the authors selected a set of major, multifacility PACs in cities of a comparable size, with venues of a similar size, and with a similar resident company mix. Table 7.1 provides an overview of the sample set.[2] This table provides the location, PAC name, primary function of the PAC, oversight entity's name, and a listing of each PAC's venues and main resident companies.

Analyzing information publicly available on the sample set's organizational websites reveals both similarities and differences in venue ownership, governance, organizational structures, administrative functions, programming, and activities. A glance through the mission statements illuminates many common goals for these PACs. Many organizations discuss the importance of fostering economic and cultural development; indeed, a major priority for many of the sample PACs is the explicit contribution to urban revitalization through cultural planning and development. The original goal for some performing arts centers was to build a great home for one (or more) of the city's major arts organizations—such as the symphony orchestra, opera company, ballet company, or theatre company—but all PACs in the sample set now promote a wide range of performing arts events. Key concepts that emerge in many of the PAC mission statements include an emphasis on civic vitality, strengthening community, enhancing the vibrancy of the city center, promoting cultural tourism, historic preservation, strengthening

*Table 7.1* Sample Set of Major Metropolitan PACs

| City | PAC Name (primary function) | Oversight | Venues (seats) | Main Resident Companies |
|---|---|---|---|---|
| **Cincinnati, Ohio** | Aronoff Center for the Arts (*presenting*) Music Hall (*presenting*) | Cincinnati Arts Association | Procter & Gamble Hall (2,719) Jarson-Kaplan Theater (437) Fifth Third Bank Theater (150) Music Hall: Springer Auditorium (3,516) | Ballet Tech Cincinnati Cincinnati Ballet Mamluft&Co. Dance Cincinnati Music Theatre Cincinnati Playwrights Initiative Contemporary Dance Theater Exhale Dance Tribe Fifth Third Bank Broadway Cincinnati Opera Cincinnati Pops Orchestra Cincinnati Symphony Orchestra May Festival Chorus |
| **Cleveland, Ohio** | Playhouse Square (*presenting*) | Playhouse Square | Allen Theatre (2,500) Hanna Theatre (566) Ohio Theatre (1001) State Theatre (3,200) | Cleveland State University DANCE Cleveland Great Lakes Theater Festival Tri-C Jazz Festival Cleveland Play House |
| **Denver, Colorado** | Denver Performing Arts Complex (*hosting*) | Division of Arts and Venues, City and County of Denver | Ellie Caulkins Opera House (2,225) Boettcher Concert Hall (2,679) Temple Hoyne Buell Theatre (2,884) | Colorado Ballet Colorado Symphony Orchestra Opera Colorado Denver Center for the Performing Arts |

(*Continued*)

*Table 7.1* (Continued)

| City | PAC Name (primary function) | Oversight | Venues (seats) | Main Resident Companies |
|---|---|---|---|---|
| | | | Garner Galleria Theatre (200) | Colorado Children's Chorale |
| | | | Helen Bonfils Theatre Complex (which includes four theaters and a ballroom) (3,000) | Denver Young Artists Orchestra |
| | | | | Denver Film Society |
| | | | Chambers Grant Salon (700) | |
| | | | The Studio Loft (750) | |
| | | | Nathaniel Merrill Founders Room (30) | |
| | | | The Galleria (1,000) | |
| | | | Sculpture Park (6,000) | |
| **Houston, Texas** | Wortham Theatre Center (*hosting*) | Houston First | Alice and George Brown Theater (2,405) | Houston Ballet |
| | Jones Hall for the Performing Arts (*hosting*) | | Lillie and Roy Cullen Theater (1,100) | Houston Grand Opera |
| | Miller Outdoor Theatre (*hosting*) | | Jones Hall (2,900) | Houston Symphony Society for the Performing Arts |
| | | | Miller Outdoor Theatre (1,700 fixed; 4,500 lawn) | |
| **Los Angeles, California** | Performing Arts Center of Los Angeles County (dba The Music Center) (*hosting*) | County of Los Angeles | Ahmanson Theatre (2,000) | LA Philharmonic |
| | | | Dorothy Chandler Pavilion (3,197) | LA Opera Center Theatre Group |
| | | | Mark Taper Forum (750) | LA Master Chorale |
| | | | Walt Disney Concert Hall (2,265) | |

| City | PAC Name (primary function) | Oversight | Venues (seats) | Main Resident Companies |
|---|---|---|---|---|
| | | | W.M. Keck Children's Amphitheatre (350) Redcat Theater (operated by CalArts) (270) Music Center Plaza (2,000) Grand Park (12 acres) | |
| **Portland, Oregon** | Portland'5 Centers for the Arts (*hosting*) | Metropolitan Exposition Recreation Commission | Keller Auditorium (2,992) Arlene Schnitzer Concert Hall (2,776) Antoinette Hatfield Hall: Newmark Theatre (878) Dolores Winningstad Theatre (304) Brunish Hall (200) | Oregon Ballet Theatre Oregon Children's Theatre Oregon Symphony Orchestra Portland Opera Portland Youth Philharmonic |
| **Pittsburgh, Pennsylvania** | Byham Theater The Benedum Center for the Performing Arts (*presenting*) | Pittsburgh Cultural Trust | Byham Theater (1,300) Benedum Center (2,800) | Pittsburgh Opera Pittsburgh CLO Pittsburgh Ballet Theatre PNC Broadway Across America Pittsburgh Dance Council CD Live Pittsburg International Children's Theater Cohen & Grigsby Trust Presents First Night Pittsburg |

(*Continued*)

*Table 7.1* (Continued)

| City | PAC Name (primary function) | Oversight | Venues (seats) | Main Resident Companies |
|---|---|---|---|---|
| **St. Paul, Minnesota** | Ordway Center for the Performing Arts (*presenting*) | Ordway Center for the Performing Arts | Main Hall (1,900) Ordway Concert Hall (1100) | The Minnesota Opera Saint Paul Chamber Orchestra The Schubert Club Flint Hills International Children's Festival Target World Music and Dance Series |
| **Seattle, Washington** | Seattle Center: Marion Oliver McCaw Hall (*hosting*) | Seattle Center, City of Seattle | Susan Brotman Auditorium (2,900) Nesholm Family Lecture Hall (380) | Pacific Northwest Ballet Seattle Opera |
| **Seattle, Washington** | Seattle Theatre Group (*presenting*) | Seattle Theatre Group | Paramount Theatre (2,807) Moore Theatre (1,800) Neptune Theatre (800) | KeyBank Broadway Silent Film Series International Music Series Dance Series Seattle Rock Orchestra Nights at the Neptune Community Arts Series |

creativity and the arts in society, arts education, and encouraging a rich cultural identity.

From the missions and goals, a variety of ownership and governance structures emerges. The key choices that seem to be made by each entity are threefold. First, is the PAC to be directly owned and operated, or run at arm's length, or structured as an organization independent from the city's public administration? Second, is the PAC to be primarily a public (government-run) organization, a nonprofit organization, or some kind of

quasi-governmental or mixed organizational form? And third, does the city wish to distinguish ownership and maintenance of the facility from leadership required for the management, operations, and programming of the facility? The resulting organizational structures selected to provide ownership, governance, and management are highly complex and hybrid public, nonprofit, and for-profit models.

The three major forms of community ownership of PACs in the sample set are (1) the PAC is run by/as a nonprofit 501(c)3 organization, (2) the organization is run by/as a cultural district or a cultural center, and (3) the PAC is run by a department or division of a city or government. That said, multiple variations and hybrid forms of community ownership exist within the main types and subtypes. One significant commonality among all of these types is the frequent positioning and promotion of the PAC within a cultural district or theater district, whether or not the PAC is actually overseen by this entity.

## *The Nonprofit PAC*

Upon examining the four PACs in the sample set identified as nonprofit organizations, one finds two distinct subtypes. The Seattle Theatre Group and the Ordway Center in St. Paul function essentially as independent, nonprofit community presenting organizations, with a significant emphasis on community engagement and education. These two entities both own and operate their venues. As an example of this type, The Seattle Theatre Group (STG) owns the historic Paramount Theatre and leases the historic Neptune and Moore Theatres (which are privately owned by families). The STG is governed by a 19-member board of directors, to which the executive director reports. The executive director, in turn, oversees a management staff of eight, and 521 staff members total across its three venues. The governing board of STG is racially, ethnically, and professionally diverse, committed to the organization's mission to serve as "The People's Theatre" of Seattle. STG receives some public subsidy, but is mainly self-reliant on its own earned and contributed revenues in meeting its $40 million annual operating budget. This business model of a standard nonprofit 501(c)3 organization is very familiar in the professional performing arts sector. Josh LaBelle, executive director of STG, notes that he finds it easy to participate in the community as a nonprofit organization, since nonprofits are often seen as friendly, community-focused entities. In addition, nonprofits can band together to get things done, can leverage their fund-raising capabilities to help fund capital and other operating needs, and can focus their efforts on serving the community through "programming things that matter." LaBelle also notes that some aspects of the nonprofit business model can be stifling to the STG but that any perceived constraints can also be viewed as an opportunity for the organization to innovate (J. LaBelle, personal communication, April 19, 2016).

In contrast to this "pure" nonprofit business model, the Cincinnati Arts Association manages and operates two major PACs, but the venues are owned by the city of Cincinnati. In Cleveland, Playhouse Square was explicitly renovated and developed as a cultural district. It is a nonprofit organization but operates in close partnership with public administration as the Cleveland Theatre District. In this first type of PAC (PACs that are set up by or as nonprofit organizations), the relationship between the public and private sector in each municipality and the intricacies of hybrid models of ownership and operation of the performing arts venues require additional exploration.

## *The Cultural District/Cultural Center PAC*

The second major type of community ownership is the PAC that is run by or is a cultural district or cultural center. Two excellent examples of this type exist in Pittsburgh and Seattle. In Pittsburgh, the Byham Theater and the Benedum Center for the Performing Arts are both owned by the city of Pittsburgh and managed by the Pittsburgh Cultural Trust. The PACs were renovated as part of a massive urban redevelopment initiative that established the Pittsburgh Cultural District, which features fourteen new cultural facilities among other projects. In contrast, the McCaw Hall in Seattle is owned by the City of Seattle and operated by Seattle Center. Seattle Center is a large 74-acre campus that is home to more than 30 cultural, educational, sports, and entertainment organizations. While the formal ownership and operation of these PACs in Pittsburgh and Seattle is, respectively, a cultural district and a cultural center, the venue operation of each is organized as an independent nonprofit. Further, it is difficult in these cases to identify how and to what extent the governance of the cultural district is overseen by the municipal government. In each case, the ownership, governance, and management models are complex public/nonprofit hybrids.

McCaw Hall in Seattle, home of the Pacific Northwest Ballet and the Seattle Opera, offers insight into the complex structure of this form of PAC ownership and governance. This PAC hosts approximately 350 to 400 events per year, including resident and nonresident company performances and corporate events in its 2,900-seat main auditorium, as well as small events and meetings in the hall's various lobby spaces, and corporate events, lectures and similar events in the hall's 380-seat lecture hall. These events generate approximately 375,000 patron visits annually.

The former general manager of McCaw Hall, Chris Miller, explains that McCaw Hall is owned by the City of Seattle, and managed by the Seattle Center, in accordance with a 25-year operating agreement between the city and the hall's two resident tenants, Pacific Northwest Ballet and Seattle Opera. This operating agreement provides the two resident companies— in partnership with the city—a significant role in and responsibility for determining the hall's operating policies, staffing, service standards, annual

operating budget, and long-term capital replacement/major maintenance budget. The executive directors of the three entities (Ballet, Opera, and Seattle Center) constitute the McCaw Hall Operating Board, and the Hall has a small "core team" of resident employees (who are City of Seattle/ Seattle Center employees) who have responsibility for the hall's general management, event booking/sales, theatrical production management, event servicing, patron services, and basic facility maintenance. Other administrative and facility management/maintenance functions are performed by various campus-based Seattle Center employees.

McCaw Hall operates on a $4.3 million annual operating budget, which is a separate "enterprise" fund within the Seattle Center's approximately $38 million budget. Per the operating agreement, the city contributes a specific amount (approximately $580,000 in 2015) from its General Fund to the hall's budget, and the balance is earned income from nonresident events, reimbursed labor revenue, catering and concessions commissions, ticketing commissions, per-ticket facility-use fees, and so on. The Ballet and Opera annual use fees are calculated to "fill the gap" of approximately $1.3 million between these earned revenue sources and the hall's operating expenses. The hall maintains an accumulated reserve (i.e., a "rainy day" fund), and an ongoing capital renewal/major maintenance fund to replace capital items in the hall, such as carpet, theatrical lighting, sound system components, and the like (C. Miller, personal communication, April 5, 2016).

The Seattle Center McCaw Hall example provides insight into an administrative structure that blends public ownership, oversight, and management with a highly collaborative public–nonprofit hybrid form of governance, management, and operations involving three separate institutions (the venue and two separate resident companies). Each of these institutions possesses its own governance and management personnel, and these efforts are aligned through an operating board that represents all three entities. The city owns and maintains the PAC, and provides extensive staffing and support for this responsibility through the Seattle Center (which manages the PAC), but the three entities that compose the PAC operating board have extensive governance (financial and policy) oversight and responsibilities. The result is a complex business model where it is virtually impossible to distinguish what is a public responsibility versus what is a private nonprofit responsibility.

## The Governmental PAC

The third form of community ownership is that of venues that are owned by a city, county, or state, where the PAC is run by a department or division of a city, county, or state government. This organizational form has multiple subtypes, which seem to be driven by the level of direct or arm's-length operation the city determines is appropriate, as well as a frequent urban planning goal to support the development of a cultural district.

In Los Angeles, The Music Center is owned by the county but oper-
ates as a large nonprofit performing arts organization, governed by a board
of directors. The administration of Portland'5 Centers for the Arts reports
to the board of commissioners of the Metropolitan Exposition Recreation
Commission (MERC), which is a subsidiary of Metro, an elected regional
government. In Portland, the venues are owned by the city and are posi-
tioned at the core of a downtown cultural district. In Houston, the Wortham
Theatre Center is owned by the City of Houston and is overseen by Houston
First (an arm's-length agency of the city that reports to its own governing
board) and is promoted as part of the Houston Theatre District. In Denver,
the PAC is located at the heart of the Denver Theater District, an urban
development initiative of the city's Scientific and Cultural Facilities District.
The Division of Arts & Venues of the City and County of Denver own and
operate the Denver Performing Arts Complex. This third form of PAC com-
munity ownership (and its many hybrid forms) appears the most complex
in distinguishing governance, reporting lines, and public/nonprofit manage-
ment systems.

The first example in this group is The Music Center in Los Angeles. The
County of Los Angeles owns the facility and leases it to a nonprofit organi-
zation called the Performing Arts Center of L.A. County (dba "The Music
Center"). Howard Sherman, executive vice president and chief operating
officer of this PAC, explains that in this contractual relationship, the county
provides funding for a majority of the operating costs (such as building
maintenance, housekeeping, landscaping, ushers, front-of-house staff, and
security). The Music Center is a 501(c)3 that is run with a president and
chief executive officer (CEO) reporting to the board of directors. The four
theaters of this PAC are largely filled by resident company performances.
These four independent nonprofit organizations—L.A. Philharmonic, L.A.
Opera, L.A. Master Chorale, and Center Theatre Group—have long-term
leases with The Music Center that have very favorable terms and condi-
tions that allow these organizations to fund-raise for the art on the stages
as opposed to the operational needs of the facility. In addition to presenting
the work of resident companies, The Music Center also presents a season of
dance and an array of free, public programming, and it offers its venues for
lease to short-term tenants.

In Los Angeles, the county chose to own the facility but to set up a sepa-
rate organization to run the venues. The county government provides
$30 million annually to fund security, maintenance, utilities, and day-to-day
operations (everything except programming and education) of the center.
The Music Center conducts its own fund-raising campaign to raise $8 to
$9 million per year to help fund specific center programming, education,
and marketing efforts. According to Sherman, this hybrid public–private
partnership works well in that public dollars pay for "non-sexy stuff like
boilers and chillers," and private support pays for the arts programming,
which is "the soul" of the center. The annual operating budget of the PAC is

$60 million, but the county provides half of this up front annually to cover basic operations expenses (H. Sherman, personal communication, May 25, 2016).

The second example in this group is Portland'5 Centers for the Arts, which operates three venues that serve as the homes for the Oregon Ballet, Oregon Symphony, Portland Opera, and numerous other nonprofits. The buildings are owned by the City of Portland and governed through an intergovernmental agreement with Metro, an elected regional government that serves three counties. The Metropolitan Exposition and Recreation Commission (MERC) appointed by Metro is a seven-member board that represents the three counties, the City of Portland, and Metro. MERC provides budget and policy oversight for the Portland'5 venues, as well as the Oregon Convention Center and Portland Expo Center. Final budget approval resides with Metro.

Portland'5 has an annual operating budget of approximately $14 million. The City of Portland provides $854,000 for maintenance. Portland'5 also receives about $2 million annually in transient lodging tax. Both of these subsidies grow annually by the consumer price index (CPI). The balance of the operating budget is made up by earned revenue from both hosting and presenting events.

As an enterprise fund, Portland'5 is expected to live within its means and either break even or contribute surplus dollars to its renewal and replacement fund. This quasi-governmental hybrid allows Portland'5 to be entrepreneurial in its business practices but also allows shared services with Metro (HR, IT, Legal, Finance), as well as shared services with the other MERC venues, which helps control operating costs. This governing model works quite well as it allows a high level of administrative support services at a reasonable cost with the flexibility to operate like a business. However, Portland'5 is still a public entity and must follow state budget and spending laws, which can be somewhat more restrictive and time-consuming than in the private sector. However, this requirement does provide a great deal of transparency in its operations, which builds trust and confidence.

The third example in this set is the performing arts venues in Houston, Texas, operated by Houston First. The City of Houston owns the PACs, but an entity named Houston First is responsible for the operation, maintenance, and programming of the venues. Houston First was originally a department of the city, but it recently moved away from direct city oversight and was put under the governance of a separate 13-member governance board. This quasi-public (arm's-length) agency's official title is Cultural Services, Inc., but the group adopted "Houston First" as its working title for branding purposes. The board of Houston First sets policy and approves the budget, although final approval of the budget comes from the City of Houston. Houston First receives public subsidy through annual allocation of 7 percent of the city's lodging tax. The venues overseen by Houston

First—Wortham Theatre Center, Jones Hall for the Performing Arts, and Miller Outdoor Theatre Center—then build budgets to request specific allocation of public operational funds on an annual basis.

Mario Ariza, chief operating officer of Houston First, sees this quasi-public, hybrid governance model as working very well for entrepreneurial activity and negotiating purchasing and contracting. Employees are much more empowered and have more accountability than when they held civil service positions, and the entity as a whole can now be much more goal-focused and efficient. Houston First is the largest arts property owner/manager in the city and is deeply involved in local conversations around cultural policy and facilities, downtown development, investment in the Houston Theatre District, and development of arts incubator spaces. This quasi-public organization is seen as the "go-to" organization to help other local arts organizations, as it provides facility support and other forms of grant support to local producing and presenting companies. Nonetheless, in Houston, ownership by the City and governance oversight by Houston First are distantly separated from day-to-day management of the specific performing arts center (M. Ariza, personal communication, May 26, 2016).

The fourth example of a highly complex hybrid public–nonprofit model of ownership and governance can be found in the Denver Performing Arts Complex (DPAC). This complex is owned and operated by the city and County of Denver, and overseen specifically by the joint city/county Division of Arts & Venues. In addition to the DPAC, the Division of Arts & Venues oversees and manages Red Rocks, the Coliseum, the Colorado Convention Center, and the McNichols Building. According to Mark Najarian, venue director for Arts & Venues, City and County of Denver, Red Rocks serves as a "cash cow" in helping to subsidize the DPAC and the Convention Center.

Within the Denver Performing Arts Complex, the Division of Arts & Venues owns and manages the three largest venues (The Ellie Caulkins Opera House, Buell Theatre, and Boettcher Concert Hall) along with outdoor events on the Galleria and in Sculpture Park. In total, the DPAC is composed of 14 venues (see Table 7.1), one of which is the Denver Center for the Performing Arts (DCPA), which is a separate 501(c)3 nonprofit organization that operates a portion of the DPAC (the Bonfils Theatre Complex and the Garner Galleria Theatre). The DCPA is an autonomous producing arts organization that also presents Broadway touring productions in the DPAC. Mark Najarian says that the goal of the DPAC is to activate spaces and use commercial products to subsidize local organizations that support more community-based programming. Overseeing its 14 venues—in addition to the other public venues managed by Arts & Venues—allows for shared expertise, shared revenue streams, and leveraged resources. Najarian notes that the business model "feels like a governmental agency/commercial/nonprofit blend" as a hybrid business form that has the ability to be entrepreneurial.

As a whole, the DPAC maintains an annual operating budget of $11 million, funded largely by a seat tax of 10 percent of gross ticket sales. Surplus each year goes into the reserve, which can be invested in capital projects once required levels of the reserve are met. Denver's arts organizations are supported by the Scientific and Cultural Facilities District sales tax, which is also administered by Arts & Venues. In Denver, significant governmental ownership, resource streams, and oversight structures position the Denver Performing Arts Complex to play a key role in urban planning and development initiatives (M. Najarian, personal communication, April 18, 2016).

The major performing arts centers in Los Angeles, Portland, Houston, and Denver provide great insight into the diversity of business models and organizational forms that communities can utilize to own, govern, and manage their venues. In many of these cases, the facility is owned by the public, but oversight provided by PAC's umbrella organization can take the form of an independent nonprofit (like The Music Center in Los Angeles or the DCPA within the Denver Performing Arts Complex), as an arm's-length oversight agency (like Houston First or MERC in Portland), or as an actual division of the government (like Arts & Venues that oversees DPAC).

In these examples, the selected business model follows funding streams as well as the mission of the PAC and its role in urban development. But from a leadership perspective, how does one reconcile the diverse business models that together manifest the entire oversight of a performing arts center? In many communities, the facility is publically owned and maintained but is governed by some kind of governmental–nonprofit hybrid organization and is actually operated and programmed by an entity reliant on some mix of public funding, contributed revenue, and earned income. It follows that the PAC senior executive must possess the ability to work seamlessly across public administration, nonprofit management, and for-profit business models. The next section of this chapter presents a framework for a community to systematically consider optimal business models for its PAC to address local expectations for ownership, governance, and management.

## Determining the PAC's Ownership and Governance Model

To be successful and sustainable as an institution, the ownership and governance model selected for a performing arts center must follow the mission, goals, and mix of revenue sources planned for the PAC. After all, form follows function—not the other way around. It is also important to remember that the leadership team of the PAC is constantly balancing the oft-cited "triple bottom line" of financial, artistic, and public benefit. The relative balance of these goals will influence the selection of the umbrella organization's structure, as will the political climate of the community and the availability of public funding. Even among governmental PACs, the expectation for securing earned revenue is very high. For example, for many members

of our sample set, roughly 90 percent of the PAC's annual budget comes from earned and contributed revenue sources. In addition to fund-raising efforts, the PAC staff will need to engage in an array of revenue-generating programming and ancillary activities (see Table 1.1 in this volume), and so the business model of the PAC will need to allow for this.

As many authors in this book argue, community expectations for the programming, events, and activities that take place in and around the performing arts center are changing. Senior executives interviewed for this chapter noted that PAC board compositions are changing to be more diverse and reflective of the local community as PACs expand and broaden their offerings to meet wide-ranging community needs. Balancing the goals of financial solvency, artistic excellence, and public engagement most frequently plays out in an arts organization's programming selections. Many PACs that were historically renting organizations are now beginning to invest in presenting and producing performing arts, and executives expect that activity in PAC presenting and producing will generally continue to increase over the next 5 to 10 years.

In addition, the umbrella organization selected for the PAC needs to provide for managers to proactively engage with the numerous municipal goals (public benefits) that may exist for the performing arts center, such as the following:

- To contribute to urban regeneration and/or revitalization
- To enhance the vibrancy of the city center
- To strengthen the community's quality of life
- To promote access, inclusion, and participation in the arts
- To provide homes for resident arts organizations
- To strengthen the local arts and culture sector
- To facilitate the integration of the arts sector within the wider community
- To contribute to historic preservation
- To promote cultural tourism

In addressing the triple bottom line, performing arts centers are increasingly being overseen as a community resource. Our key informants for this chapter spoke of the important role of their PAC as a catalyst for urban development and cultural planning, often serving as the lead organization to help other arts organization in the community. Major metropolitan PACs are deeply engaged in cultural policy advocacy, planning, and economic development initiatives. And in terms of programming, urban PACs are moving toward community-focused programs (such as festivals and other large-scale programs) and are expanding their focus on presenting, producing, and education initiatives in what are seen as increasingly competitive markets.

As Howard Sherman put it, "there is no such thing as a definitive model" for a performing arts center's umbrella organization (personal communication, May 25, 2016). In practice, the ownership, governance, and management structures for a PAC will likely take on some kind of a hybrid

or mixed organizational form. Scholarship on hybrid organizations at the blurry boundaries of the public, nonprofit, and for-profit domains is rather thin and even scarcer as applied to the arts and culture sector. That said, the growth in arts entrepreneurship and social enterprise has led to consideration of hybridity in arts organizations across the for-profit/nonprofit divide, especially in pursuit of "flexible management models" (Marsland, 2005). Indeed, most research on hybrid models focuses on entities that combine elements of nonprofit organizations and for-profit businesses, such as social enterprise or nonprofits with income-generating activities (Billitteri, 2007; Haugh, 2005; Tuckman, 2009). More useful to PAC civic leaders may be resources that explore hybrid organizational forms termed Public-Private Partnerships (P3) or the Fourth Sector (or For-Benefit Enterprise).[3] Particularly important to hybrid organizational considerations for a performing arts center are that community-based PACs are typically both market-oriented and mission-centered and that they serve distinct public goals.

There are some key considerations that civic leaders may wish to keep in mind in mapping out the opportunities and constraints that the selected ownership and governance structures will inevitably provide to the ongoing management and operations of the facility. Figure 7.3 provides a conceptual framework for these choices.

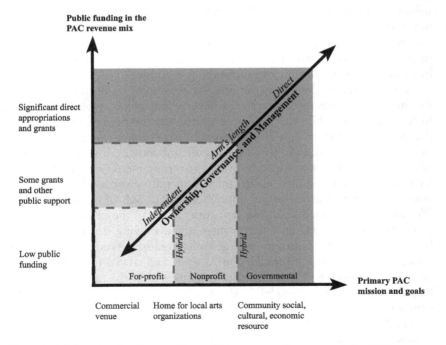

*Figure 7.3* Mapping the Ownership and Governance Structure of the PAC

Illustration by Stephanie McCarthy

To explain Figure 7.3, the two primary considerations for civic leaders in identifying their PAC's placement along a continuum of governmental, nonprofit, or for-profit business structures (and all hybrid or mixed structures) are (1) the primary mission and goals of the PAC and (2) the amount of public funding expected to be provided annually for support of the PAC's operations. The PAC mission and goals may range from being a commercial venue that books tours and profit-generating entertainment, to serving as a home for local arts organizations, to being envisioned as a key community amenity and economic resource. Similarly, the PAC may have access to little or no public funding, some grants and other public funding streams, or significant direct appropriations and grants.

Civic leaders can use Figure 7.3 to thoughtfully consider the ownership, governance, and management business models best suited to their local PAC's needs. For example, if the PAC is expressly meant to serve as a crucial social, cultural, and economic resource in the community, and the owner (city, county, region, state) intends to commit significant direct appropriations and grants to support ongoing PAC expenses, then the PAC will most likely utilize a direct governmental form of ownership and governance. On the opposite end of the spectrum, a PAC that is expected by the community to be a private, commercial endeavor with no public funds provided to support it will need to take the form of an independent for-profit business. Most urban performing arts centers lie between these extremes, with their business structures requiring a blend of governmental, nonprofit, and for-profit models. Many of these are hybrid or mixed models, and specific revenue-generating activities within the PAC are structured as one (or more) of these business models within the organization as a whole.

To illustrate, the facilities (the individual venues) of Portland'5 Centers for the Arts are directly owned by the government (the City of Portland). So, in terms of ownership, the PAC is positioned at the upper right end of the diagonal line in Figure 7.3. The governance structure, however, is composed of several entities that are in various positions moving down the diagonal line in Figure 7.3 as arm's-length, hybrid governmental/nonprofit structures. Metro, an elected regional government, officially governs the PAC, but it does so through an arm's-length appointed board (MERC) that oversees the PAC at a more detailed level. The daily operations of the management of the PAC take place largely as a nonprofit—again, moving down the diagonal line. However, certain programming and operations (such as commercial concerts, private facility rentals, concessions, and so on) take place largely as for-profit revenue generation mechanisms within the larger PAC governance and management model. In short, when carefully considering the mission and intended revenue streams of an urban PAC, civic leaders should also understand that these considerations lead to a specific range of options in determining the business model(s) of the organization and its activities.

To conclude, central to balancing the PAC mission and revenue generation mix are a set of systematic decisions, discussed throughout this chapter, that have to do with the community's decision to operate the PAC directly,

at arm's length, or independently. Major business forms that the PAC may adopt are as a for-profit entity, as a nonprofit organization, or as a governmental body. In addition, the PAC may utilize different business forms for different parts of its operations. The PAC is often positioned to some extent within a cultural district or a cultural center, and hybrid ownership and governance forms frequently appear at the intersection of governmental and nonprofit structures or at nonprofit and for-profit structures. The diverse programming and ancillary activities of a PAC may be positioned throughout this spectrum, and the business model of the PAC will need to allow for successful community engagement and revenue generation within each area of this spectrum. This topic begs further research.

Ultimately, each community must make its own decisions regarding ownership and governance of its performing arts center. But an umbrella organization structure matched to the strategy of the organization (in terms of its mission and funding streams) is absolutely crucial to organizational success.

## Acknowledgments

The authors gratefully acknowledge the participation of senior executives affiliated with the sample set of performing arts centers in field research conducted for this chapter: Mario Ariza, Jamie Grant, Josh LaBelle, Chris Miller, Mark Najarian, and Howard Sherman.

## Notes

1 See Joanna Woronkowicz's detailed discussion of best practices for building in Chapter 6 of this volume.
2 All data included in this table come from information available online, and senior executives representing all PACs included in this chart were offered the opportunity to edit their organization's listing in this chart in the spring of 2016.
3 An internet search on any of these terms will yield an array of scholarly articles, reports, websites, and international resources on each of these topics. See www.fourthsector.net/ for a particularly helpful starting point.

## References

Billitteri, T.J. (2007). Mixing mission and business: Does social enterprise need a new legal approach? *Nonprofit Sector Research Fund of the Aspen Institute.* Retrieved from: https://www.aspeninstitute.org/sites/default/files/content/docs/pubs/New_Legal_Forms_Report_FINAL.pdf

Haugh, H. (2005). A research agenda for social entrepreneurship. *Social Enterprise Journal, 1*(1), 1–12.

Marsland, J. (2005). *Flexible management models.* Ottawa: Canada Council for the Arts. Retrieved from: http://canadacouncil.ca/~/media/files/research%20-%20en/flexible%20management%20models/flexiblemanagementmodelsbyjmarsland march302005.pdf

Tuckman, H.P. (2009). The strategic and economic value of hybrid nonprofit structures. In J.J. Cordes & C.E. Steuerle (Eds.), *Nonprofits & business* (pp. 129–153). Washington, DC: The Urban Institute Press.

# 8 Managing Venue Operations for a Newly Opened PAC

*Patrick Donnelly*

As construction or heavy renovation begins on a new performing arts center (PAC), two countdown clocks commence: one for completing the building project on time and one for operating the venue fully when its doors open. The first clock is comparatively visible, with progress known to the community and outside world as they watch the project unfold. The building grows, the quantity of workers and materials around the site changes, and the media notes it all because of the ease of telling the building's story. The second clock, the operations clock, ticks farther from the public eye. The decisions about how to run the venue, with choices for equipment, personnel, software, and business policies, do not have the same visibility. But those choices matter as much to the successful completion of the PAC as laying the bricks and installing the plumbing. This chapter aims to prevent the second clock from being an afterthought for the PAC's principal administrator and staff. It will examine several topical areas that drive the success of a venue, areas that fall outside of the scope of the architects and general contractors who lead the construction team. These topics include furniture, fixtures, and equipment (FFE); security and insurance planning; scheduling policies; housekeeping standards; public relations; and parking services. If the leader of a new or newly renovated PAC fails to get ahead of these, they will consume inordinate amounts of time to remedy, and may detract from the public's perception that the venue opened properly.

## Calling the Tune: Umbrella Organizations

The *umbrella organization*—the ownership, governance, and management model—of a new or newly renovated PAC greatly influences how resources get organized to support the building, including those key topics listed earlier. The assets available to operate the venue scale out differently for different umbrella organizations, given that the PAC may be owned by a city government, a county government, a university, or even a Fortune 500 company. To illustrate, a new PAC opening on a college campus can call upon the already-existing custodial, facility maintenance, and security units to coordinate and provide services in the new building. To the extent that

colleges regularly bring other new buildings on line, the PAC is not starting from scratch in these areas. A venue created by a stand-alone organization, by contrast, will need to establish custodial, building maintenance, and security staffing on its own. Each oversight structure—umbrella or not—comes with benefits and liabilities, for the quality of what the umbrella organization contributes cuts both ways: some things become easier, and some things become more complex. Municipal employment regulations, or the obligation to source contracted services through a public bid process, opens the doors to some business practices and closes some others, usually with minimal discussion. Working within the safety culture of a company that operates large industrial sites brings another flavor. A PAC's umbrella organization, therefore, will inform each of the topic areas that follow.

## Countdown: Furniture, Fixtures, and Equipment

The design team for a performing arts center project includes a group of architects, engineers, and senior consultants who work with the owner's representative to plan and deliver the building on time and on budget. (That team, in turn, relies on a general contractor to carry out the work that they collectively specify.) As the design team lays out the construction scheme, the attention that they give to the FFE needs follows a top-down planning model. Their broader view regards the project as a whole, with emphasis on elements that are building-wide: aesthetic choices for seating that tie spaces together, backbone connectivity for communication systems, and production gear that the facility shares across performance sites. This 30,000-foot view provides great value to the overall design, for it matches the resources of the venue to the scale of the project. Importantly, the design team creates this broader view through a combination of experience with other projects, and through planning studies with the owners and anticipated users of the new venue. They make the bigger picture match the project goals.

The designers do not serve as facility operators; they can only deflect small things as they map out the larger FFE needs of a new venue. Because of this, building construction typically uses the concept of project-provided FFE and owner-provided FFE. That is, the construction team will design and provide some FFE, while the manager of the new or newly renovated PAC carries the obligation of specifying, purchasing, and installing some portion of the FFE needed in the building. The dividing line of who provides what will vary from project to project, and any umbrella organization involved will influence where the line lands. While design teams commonly arrange for auditorium or theater seating in the performance space, the venue owner will often coordinate office and administrative seating using its own resources, for example. Due to this shared responsibility, the written scope of the construction project will spell out, in some detail, what FFE the design team will provide. While the venue manager can request modifications to the design team's portion of FFE, the cost implications of those

requests generally make them suspect relative to controlling overall project expenses. Of course, the design team knows that the PAC owner has budgeted for some acquisitions, and will often encourage the PAC owner/venue manager to solve smaller FFE items on their own. Because owner-suggested modifications tend to come from beneath the 30,000-foot point of view that the design team uses, this design team response can be appropriate.

Venue owner preplanning for FFE inventory can only go so far. It works with two-dimensional drawings of spaces and relies on experience linked to other PACs, not the new one at hand. Despite the work done in advance, the venue staff will take possession of the building, and undergo a discovery phase of what resources they have and what seems to be missing. The discovery phase lasts months, through the lead-up to the venue's grand opening, and through a period of event operations that allow the staff to determine the most expedient ways to get work done. Invariably, the venue will acquire more furniture, will change up information technology connectivity, and will match its equipment inventory to immediate needs. This will happen in the context of (1) a construction budget that is winding down, if not already completed; (2) an operating budget for Year 1 that depends heavily on modeled data rather than historic data; and, lastly, amid (3) the need for drafting capital maintenance and replacement plans. Calling the FFE discovery phase convenient, in light of the surrounding circumstances for getting the PAC up and running, approaches a cruel joke.

Venue managers cannot avoid this period of FFE research and acquisition for a newly opened or renovated PAC. They can defer acquisition for financial reasons, but it's a deferral only: the pressure from staff and clients to operate the building well will not abate. People will keep asking for the resources they do not have at hand. (Depending on the nature of what is missing, clients might point out that some competing venues possess the resources they want.) Getting ahead of this by attempting to make comprehensive FFE decisions before the building opens results in decision-making in a partial vacuum, for without the firsthand operating knowledge of the new PAC, the venue manager drifts between the 30,000-foot level of the building's design team and the minutia of event details and line-level staff.

Rather than fight the process of allowing staff apart from the principal administrator to map out FFE requirements from the building, venue managers must plan for it. They should identify a period for researching asset needs and solutions, match that period to the construction and start-up operating budget, and feed anything not solvable during the months of countdown and initial operation into capital planning for the venue in Years 2, 3, and further of operation. Timetable and financial resources for this planning will match the situation, expectedly: what a new or newly renovated building of 500,000 square feet requires differs from a new venue of 50,000 square feet.

The venue's staff spends inordinate countdown hours manipulating the resources that they already have; unearthing yet more to do leads to more

hours spent and more hard costs for the project. Despite the awkward time-table for those conducting the FFE discovery process, the work itself can be enjoyable. Opening a new or newly renovated PAC resembles solving a puzzle; collaborating to solve the puzzle and concluding the project allows staff a modest role in the design and operation of the building. For venue professionals, that discovery process carries great experiential rewards.

Capital replacement and maintenance planning during the countdown present an opportunity with a limited incentive. The ability to document equipment sources, pricing, and to estimate replacement costs in Year 1 will never be better: the information about current FFE inventory is recent, centrally stored, and can be explained or clarified by the individuals who specified, acquired, and installed it. Access to that information will only decline as the grand opening moves farther into the past. Conversely, the newness of the FFE inventory points to few replacement needs in the immediate term. When staff are busy pulling the shrink-wrap and other packaging off of new equipment, their attention naturally goes to making it all work well, not to how best to replace it in 3, 5, or 10 years down the road. The countdown clock gives everyone more pressing things to do in Year 1 than map out capital planning downstream, including insuring against loss.

## Countdown: Security and Insurance

In the twenty-first century, the protection of guests and property sits at the front of most venue managers' minds. Threats to groups of people assembled together in various corners of the world appear in the media almost every week, with differing causes and consequences. How threats play out in venues often links back to the preparedness of the team leading the assembly event. For the principal administrator of a new or newly renovated PAC, how best to care for the venue and the audiences who visit it requires effort well in advance of opening the building's doors. Foresight into what might happen, and planning for those possibilities, strengthens the service ethic of the venue team in preventing harm to life and property. Understanding the risks surrounding a new building will require thinking through guest relations differently, knowledge of the details of the venue's neighborhood, and transferring any risk assumed by carrying insurance sized to the task.

New real estate and new event types beget new insurance requirements. By taking on physical assets in the form of a building and its equipment, the quantity of insurable property increases. The insurance provider (be it a traditional, pooled-risk underwriter or a self-insuring, umbrella organization) will evaluate the new PAC in order to issue coverage that corresponds to the new assets. Quantifying the materials that form the asset list, for both their current value and their replacement value, takes time. Using the information from the construction budget readily at hand, a modest effort will translate it into dollar amounts for purposes of indemnity. The venue team, however, will need to help the insurer understand the unknown or uncertain items

not contained in the construction budget, particularly the owner-acquired FFE and the activities that the new PAC will host. As noted previously, the venue operator will likely install equipment and other assets later in the construction cycle, perhaps after the doors of the building have opened. Capturing those assets in the insurance evaluation matters greatly to secure the financial health of the building. Additionally, periodic asset reevaluation, as acquisitions continue, will keep the carrier abreast of updates that can influence the volume of coverage required to repair or replace materials that the PAC owns.

The quantity and types of activity that occur in the new building will also drive insurance levels needed by the venue. For example, suppose that the renovated PAC includes generous coatroom space that the principal administrator plans to emphasize for purposes of creating ancillary revenue. Checkroom holdings insurance can transfer the risk related to accepting patron property for temporary safekeeping, in those circumstances where that property gets damaged or goes missing. If the venue intends to increase its food and beverage offerings, the quality of insurance for these new offerings should also undergo evaluation. Higher sales targets for alcohol and more food inventory moving through a kitchen change the risk profile for patron or employee mishap. Some new or newly renovated PACs open their doors without their event client base fully defined. While a core set of activities formed enough of a nucleus to conceive and execute the construction project, the PAC's business plan contains the expectation that venue staff will populate the calendar with other, as-yet-undefined event types. The insurance coverage selected by the venue must scale to match the plausible range of events and activities that it will host (Conte & Langley, 2007).

The general coverage that the venue carries will also influence the level of insurance the venue requires of its business clients. The protection types and levels that renters and other customers demonstrate to the PAC through submitting a certificate of insurance (or TULIP participation, where the client participates in the insurance coverage possessed by the venue for a fee) links to the underlying insurance needs of the building. Some renters or large-name touring artists may require the venue to carry an enhanced level of coverage during the course of a rental or tour event; the PAC's carrier must be able to respond in accord with these requirements in order to win that rental or touring business.

Admission control standards for entering many assembly venues have changed to include screening for unwanted or dangerous items. PACs have adopted screening standards that mimic these larger changes, albeit at a slower pace: to the extent that PACs seat fewer patrons than stadiums or arenas, or host higher risk events less frequently, they screen patrons less. But a new or newly renovated PAC can attract more events with a different risk profile, and some of those events may require patrons and staff to undergo bag inspections, pat-down searches, to walk through metal detection devices, or to check in with a security officer at the stage door. For a

traditional PAC audience, these screening measures can seem foreign or out of place. Some patrons may view them as invasive. The process for introducing security screening to an organization or audience base that has little experience with such procedures requires great delicacy and planning. But perception aside, it can lead to a safer event through reduced risk of harm to life or property.

Planning for enhanced admission controls generally follows a three-part continuum: (1) select the screening process appropriate to the event; (2) explain the selected process to all stakeholders—patrons, staff, rental clients, the venue's governing body—before, during, and after the screening happens; and (3) train staff on the chosen process so that each patron experiences near-identical entry transactions. For the principal administrator of a new PAC, the second part with stakeholders will consume the most time and can partly influence the screening methods that the venue eventually deploys. While the renter or touring event will specify some screening obligations as part of their contract with the building, the venue manager will have latitude in how to implement or augment them. They will have to consider how often special admission controls get used in the building, and whether any advantage exists for using baseline screening for *all* events warrants the effort and expense required. (Some venues require all guests, independent of the event type, to walk through metal detectors as a condition for admission, for example.) While the goal of becoming efficient at and minimally disruptive with screening motivates all venue managers, preparing guests to undergo it requires local solutions and support from the governance group of the PAC.

The question of who will provide screening services for the venue may already be answered: If an umbrella organization owns the new venue, it may possess infrastructure for securing buildings and public gatherings, at least to some extent. The venue operator would expectedly work within those resources to plan the admission control needs of the new PAC. Developing safety and security procedures where event types can swing from student recitals to presidential candidate debates requires access to a range of security resources, from labor pools that can grow and shrink with event needs, equipment that can supplement what the building already owns, and a planning team that can focus outside the four walls of the venue while supporting the activity inside at the same time. These resources perforce require working relationships with contract labor organizations, and with local law enforcement agencies, and some familiarity with state or federal organizations that have larger legal jurisdictions.

The newness of the building or the renovation can be a good time to introduce operating procedures like enhanced admission screening. Patrons do expect to encounter new things because of the construction project and the changes it brings; how they enter the venue can be one of these new items. But the process has to work well, like all the other attributes of the PAC. What makes sense for the nearest professional sports venue cannot be

cut and pasted onto an audience of opera patrons—that would overlook the nuances specific to a PAC setting.

A new or renovated PAC does not open its doors in a static environment. While construction continues, the property near the site regenerates according to its own life cycle. Structures are bought and sold, nearby buildings get repurposed, and neighbors come and go. What occurs in that adjacent property changes, contracts, and expands. The proximity of this activity to the PAC forms part of the risk-assessment radius for the venue manager to evaluate when planning safety and security. If the venue sits next to a manufacturing site, the risks of that site become part of the PAC's risk. Does the manufacturer locally store raw materials that require special handling (oil, compressed gas, industrial chemicals)? Or perhaps that empty lot nearby was a brownfield with waste from previous businesses that still pollutes the soil. That service provider down the street from the venue regularly works on topics of political controversy. Do they attract protest groups, or offer opportunities for possible vandalism or sabotage? A railroad line runs 100 meters from the PAC's back door, with trains moving along it seven days of the week. What freight types dominate that rail traffic, and might they induce added risk into the neighborhood?

Of course, the range of activities that transpire on the neighboring property might change five years after the venue opens its doors. Ownership can shift, and the spaces can adapt into different business models, introducing different risks or safety concerns into play. The community center that provided daytime services for an indigent population, despite its good work, had brought a level of petty theft and vagrancy to the area around the PAC. But the community center closes its doors and becomes part of a restaurateur's portfolio. The new clientele keeps late hours, creates pressure on parking resources, and brings a level of intoxicated driving to the area not known before. The venue will need to adapt its security protocols in light of these changes.

Knowing what occurs in the PAC's neighborhood can start the risk-planning process, but getting to know the neighbors and their risk-management concerns will help the venue to prepare more fully. The principal administrator must encourage the venue's staff and the area neighbors to discuss security planning and risk management collectively; he or she might need to facilitate this communication. Community policing districts form because area property owners choose to collaborate and meet common goals, for example. Information sharing in this context can function like a tide that lifts all boats.

Good safety and risk management improves venue operation: it helps to protect a PAC's reputation, while preserving the continuity of service delivery for event clients. Importantly, enacting security and insurance protocols demonstrates a professionalism that wins community confidence and repeat business for the venue—a genuine concern for a nascent assembly spaces (IAVM, 2007).

## Countdown: Public Relations and Grand Opening

The newness of a construction project inherently drives media interest—a PAC coming online is current, visible, and very likely entails a commitment of public resources as part of the project. Local journalists and their readers thrive on stories with potential community impact, and performance venues readily show that potential. Year 1 of operation for a new or newly renovated PAC functions as a public honeymoon, of sorts. The community brings an elevated level of interest to the venue, and the facility correspondingly attracts greater media attention than will be the norm in the future.

Not all PAC projects sail smoothly through news coverage leading up to grand opening or in Year 1. The wise venue manager prepares in advance to respond to media stories and lines of questioning that do not flatter the venue's image. Construction timetables, project funding, and which organizations use the facility consume much of the negative journalism given over to a new venue. The public will generally pose questions about parking and personal safety when they make their attendance decisions, for they want convenience, and they want to go to and from the building without perceived risk to person or property. Per the sections of this chapter, the principal administrator and the venue team will have good answers to these questions, and well-developed plans for providing quality services and general safety and security for attendees. The ability to talk through these plans, artfully, as a method for answering the public questions, forms the requisite approach to responding to and managing the media. The individual spokesperson who represents the venue greatly shapes the success of the messages. In the words of a seasoned principal administrator, the venue must carefully (1) select who speaks, (2) train who speaks, and (3) tell everyone else who speaks (Singer, 2014). Consistency of message and standard sources of distributed information enable a PAC to direct the conversation toward the outcomes it wants to attain—or wants to contain, as the case may be.

The in-house staffing model for the PAC typically carries the resources to handle the operations-based and event-based media conversation. To the extent any slack exists, either the umbrella organization or contracted media consultants provide guidance. Countdown-specific media plans always include local and regional news outlets. Depending on the scale of the building project, pursuing national media coverage might form part of the countdown strategy. Short of the new venue's location falling in the radius of an oversized metropolitan area, the resources needed to make an effective push for a cultural project at the national level must be contracted from out of town. Establishing the balance between the on-staff communications leader and any contracted communications leader requires thoughtful discussion and some negotiation. If the new PAC belongs to an umbrella organization, some of the "contracted" support may readily be available during the construction phase. For example, that umbrella group might have been handling PR for the project before the staff communications leader joined the

team. The umbrella organization likely does not have assembly facilities or the larger cultural sector as a principal area of focus. They may require persuasion to influence the type of communication needed to meet attributes of counting down the project.

New or newly renovated PACs can do wonderful things for a community. But not all community members will see it that way. During the course of project planning and execution, questioning voices will make themselves heard on a variety of potential topics. Some of the topics will be legitimate queries, some will be idle chatter, and some will convey competing interests. Yet each will require venue management to anticipate, plan for, and respond to these community voices—and to allocate the resources to manage the conversation efficiently (Woronkowicz, Joynes, & Bradburn, 2015).

The tone and content of the project detractors can evolve in relation to where the project cycle falls at any moment. Some will function as early detractors during the planning phase and some as countdown detractors during construction. Once the building opens its doors, organizations and patrons with some degree of firsthand experience with the venue will join the conversation. While topics will come and go once the venue commences operation, the general areas of comment and query, for purposes of planning, include the following:

1   *Funding detractors*—primarily concerns about using public monies to support the project dominate here. Public financing can happen in a range of ways, and in varying magnitude. Land for the construction may be provided at lower than market cost, or allocated in lieu of another use that holds some public interest. Local government may allow some kind of tax abatement for the location of the new structure that comes at the expense of property tax revenues for the community. The umbrella organization may choose to provide annual operating support for the new building. In projects that receive majority-private funding, a large funder might shift its resources away from current commitments to the new venue; that may cause hardship for other peer organizations in the community.

2   *Design detractors*—the outward appearance of the new building may unsettle some. It might not "fit" with the aesthetics of the surrounding neighborhood. It might not include adequate new parking space in the design scheme, putting pressure on other parking resources that nearby properties count on for their own activities. The magnitude of the project might introduce foot traffic into the area beyond desirable levels. Conversely, the interior layout and resources of the venue might not perfectly match what the user organizations think best suits their own interests, in terms of assembly spaces, FFE, administrative office space, or optimal compliance with the Americans with Disabilities Act. The selection of nonlocal architects or nonlocal construction firms to lead the project may generate resentment with local companies that bid but did not win the work.

3   *Programming detractors*—new or newly renovated PACs almost always generate some public discussion that Year 1 and beyond will cause a plethora of new events to descend upon a community. Those events might compete with existing entertainment venues and cultural organizations to their detriment. Or the balance of programming in the new venue will not match a perceived need voiced by some segment of the community. A perception of favoring "commercial" entertainment over local nonprofit organizations frequently makes the rounds.

4   *Access detractors*—the ability to stage events at the new or newly renovated building often wins attention. Resident or tenant organizations will be viewed as gatekeepers to calendar access who cause the venue to preclude other groups from using it. The newness of the building will influence the cost of renting space for events, likely making it more expensive than other facilities in the market. Some potential users will lament that they have been priced out of the building. Other rental venues in the community, seeing the higher price point that the new PAC commands might adjust their own rates upward. Offering big-name performances in the building, particularly as part of an inaugural season or two, will push average ticket prices higher and create perceptions of the venue as not affordable for all people.

Different individuals or organizations, depending on their motivation and resources, may represent more than one line of questioning from above. Venue managers must mind how vocal the detractor chooses to be, and which attributes of the building earn unfavorable comments. They should evaluate the topic on the lengthiness it suggests: a construction delay most likely is temporary, where difficulty parking can extend well past grand opening into Year 1. The venue team then develops responses and messaging to suit the circumstances. They should anticipate queries from multiple directions at any given time; the response tactics will need to repeat during the course of the project, owing to the same questions arising from different sources across the project duration. Again, this messaging should flow through the designated spokespersons for the PAC.

Occasionally, public criticism points out a genuine operating challenge for a venue. But it is usually stating the obvious. Because of the team of designers and consultants involved, public foresight is rare—the professionals cover most of the bases in their planning. Criticism as the building opens, or after it runs for a period of some months—that is, criticism in hindsight—has the longer life span.

## Countdown: Scheduling Policies and Calendar Data

As noted earlier, opening a new or newly renovated assembly venue generates attention from potential clients. The media covers the construction, then kickoff or gala events inaugurate the rooms, and for a time, usage inquiries

for the new PAC arrive at an abnormal pace. Good policies for handling schedule requests must meet those inquiries, via a team that anticipates the unusual call volume, and leverages it for the best interests of the organization. A system for holding schedule and client data—usually software—must also be up and running, to capture details for reasons of future customer relations. A percentage of the calls generated by the newness of the venue will be less than serious (and some will be frivolous). But the ability to filter these, given the newness of circumstances, will not be fully developed within the staff until they hear the inquiries. Proportionally, the increased call volume will raise the number of requesters whose ideas are declined; how the venue team handles this in the earliest stages of a new PAC can shape client perception and longer term success of the facility. The principal administrator will need to balance saying yes to rental inquiries in order to distribute financial risk across clients and across time on the event calendar. This delicate equilibrium keeps many people happy and the venue budget in good order.

Part of the new building's calendar management plan will likely involve larger schedule commitments to key tenant organizations. Few PACs operate their calendars without some hierarchy of user priorities to guide which activities hit the calendar first. Some priorities can be contractual, with resident or tenant organizations guaranteed early access to dates; other priorities may be less formal in agreement but tightly sequenced in practice. While some level of financial favoritism can accompany priority access, that's not uniformly the case with all clients. For many venues, bulk buying, in terms of quantity of dates consumed, more strongly correlates with favorable pricing than scheduling hierarchy does. A new or newly renovated PAC that opens its doors with revised or brand-new scheduling priorities should anticipate a period of adaptiveness on the part of client organizations. For example, changing the decision deadline for calendar commitments may alter established business practices for the tenant groups: where they could wrap season planning up 18 months prior in years past, having the same work completed 30 months prior will pose new challenges for them. They might not get it right the first time or two, to which the venue will need to respond, and perhaps adapt. It's fair to say that in the initial couple of years, the PAC will also be learning how to best allocate calendar time across performance priorities and nonperformance requests from the community—cocktail receptions, seated dinners, and life events (weddings, bar mitzvahs, memorial services). Repeat clients do not all decide to become repeat clients of the venue in Year 1—they need opportunities to try out the PAC and gauge whether it matches their requisites. Venue schedule management must encourage first-time users with an eye to retaining them for future events, as with any product cycle (Donnelly, 2011).

Candor about binding, contractual priorities can aid the venue team with managing inquiries from prospective renters. While openness about such obligations won't eliminate complaints from other renters about matters of priority access, it does answer the question definitively about what is

scheduled first. (Written agreements with tenant organizations and explicit scheduling policies facilitate these conversations.) Steering clients away from requested but unavailable days into alternate, open days does require care on the part of venue team. As a problem-solving exercise, it can build good will between the parties, as they collaborate to find agreement on what can work for both. But PACs will inevitably decline usage requests for reasons other than availability—and those conversations require great diplomacy to conduct well. In some instances, the requesting organization will lack the wherewithal to execute the event fully. They may fail to meet the financial or insurance requirements that the venue mandates, or they may lack the raw experience as event planners to secure the talent and carry out the marketing campaign to hit sales targets. Importantly, their date request may interfere with the PAC's ability to promote its own events. For a principal administrator, delivering the "no" message in such circumstances requires contextual knowledge and coaching of venue staff. And there are other scenarios that demand similar tact. Some usage inquires may push the PAC to insulate preexisting events from competition, through date protection. For example, a touring version of *The Nutcracker* that visits the venue just prior to the local company's annual *Nutcracker* production may harm the local client's ticket sales. In this case, the venue, to preserve the relationship with the annual client, may decline to rent to the tour, or decline to rent to the tour until after the local company finishes its show run. Alternately, an inquiry might entail an event with security needs that the venue cannot readily meet or cannot meet while keeping pricing competitive. When an event demands extensive admission screening requirements, plus resources to manage any exterior counter-events generated by the first event taking place, costs and safety concerns quickly mount (Mahoney, Esckilsen, Jeralds, & Camp, 2015). Or the political nature of a request, along with the pricing and operating concessions that the requestor makes to bring it to the venue, may threaten the tax-exempt status of the PAC. All of these scenarios could legitimately enable the venue to pass on scheduling the event. Yet fielding these circumstances in the context of an umbrella organization makes evaluating them and declining them all the more complex. In most cases, simply saying no and expecting the requestor to quietly accept it is wishful thinking. How "no" gets delivered matters enormously, especially during a venue countdown cycle with a very public face.

## Countdown: Parking and Transportation

Many PAC employees, volunteers, performers, and patrons will rely on personal motor vehicles to arrive at the new or newly renovated venue. They will require places to leave most of those vehicles while they are inside the facility. Since their comparatively smaller seating capacity (next to arenas and stadiums) makes PACs less likely to own or operate lots and garages, new PACs commonly plan to use external parking infrastructure. The feasibility study for

the construction project will have tallied the available parking resources within a walking radius of the new venue, and when an outright shortage of parking inventory exists, the project will attempt to ameliorate it. But the study will not have mapped out comprehensive information about which organizations own and operate those parking facilities, nor will it have built relationships between those lot owners and the venue staff. It will not have analyzed how the event schedule in the new PAC aligns with contractual obligations that those parking resources already carry with area businesses and other established clients. The principal administrator must use the venue team to sort through these details and to develop a fuller picture of what PAC staff and guests will encounter when attempting to park on an event day, on a nonevent day, and when any neighboring facilities host assembly events that introduce parking demands of their own.

Some events, by nature of their patron and performer vehicles, will strain parking and transit resources. Few PACs can accommodate 20, 30, or more school buses at a time; back-to-back performances for schools can snarl traffic for a neighborhood. Historic venues often lack loading docks suited to modern transport, forcing them to use lane or street closures in order to take event equipment in and out. Similarly, touring performers sometimes arrive with a large number of vehicles—more than the loading dock can accommodate. The venue, as host of the event, will be expected to offer solutions for these circumstances. Such outsized transit challenges require coordination with municipal government, to accommodate curbside parking that likely stretches beyond the perimeter of the building. Traffic police may be a necessary part of events where so many irregular vehicles need to drop off and pick up groups of passengers. Knowledge of which departments issue street closure permits and how best to schedule officers will enable the principal administrator to prepare well for venue clients as the countdown to opening continues (Cooper, 2014).

Fuller-service PACs will wrestle with the questions of combining ticket and parking transactions. For reasons of patron convenience, and to help ensure patron access to prime parking inventory, parking vouchers sold through the venue box office appeal to many building managers. Coordination between the venue and the garage to carry out the service, however, can take repeated and extensive effort. The garage and its staff do not work in the ticketing business, making the concept of scanning barcodes or tracking admission foreign to them. Nor do they operate with a budget line for the technology required to optimize data collection on arrivals and so on. Perhaps the new venue forms only a small part of the parking operator's client base—that is, they actively serve other parkers at the same time venue clients arrive at the garage. Even if an umbrella organization links the garage and the PAC together, they tend not to report to the same entity in the organizational hierarchy. Reaching full operational accord between the two requires a good amount of time, and operational efficiency often lags the agreement.

PACs that serve subscription audiences, or that want to differentiate themselves from other venues in the marketplace, will contemplate whether to offer a valet parking service to their ticket holders. This can be a welcome option for patrons who enjoy convenience or face mobility challenges. It can also provide a modest ancillary revenue stream for the PAC, usually small enough to not raise concerns through unrelated business income tax. Few umbrella organizations or garages regularly provide valet service, leaving the venue operator to fend for themselves in researching and contracting for a valet parking company. New PACs and other assembly venues rarely want the liability of valet operations themselves, for the chance of damage to cars can become expensive to insure. (Per the security and insurance section earlier in this chapter, it is an activity ripe for risk transfer to a third party.) But the PAC sits at the center of coordinating the service between the valet operator, the garage operator, and the patrons who consume the service. Valet parking staff no more work in the ticketing world than garage staff, making the concept of presold services through the box office unusual to them. But the valet team and the garage team do understand parking goals and can effectively plan some parts of their operation. The venue manager must facilitate good communication between the leadership of each entity—garage, valet, box office, and ushers.

While the trend toward online ticket transactions continues to grow, a sizable number of patrons still visit the box office during normal business hours. To enable this, convenient, short-term parking for a few cars enables patrons to conduct their transactions with minimal transit hassle. Not all venues can accommodate this, perhaps due to an urban setting where on-street parking for private cars is nearly impossible or perhaps due to the distance between the nearest parking structure and the box office itself. (Delivery vehicles working in city environments also face this challenge, though they practice how and where to drop off materials on a daily basis. The venue operator should weigh the security considerations of street versus loading dock delivery services—some items benefit from less public view, e.g., trash and recycling containers). Patron drop-off locations for guests with disabilities, given the demographic band of many arts attendees, also beg attention at new or newly renovated PACs.

Communication between the parking operator, the patrons, and the venue must develop to a level of good frequency and good quality. Getting there will take work, for most garage operators are not accustomed to the level of attentiveness that PACs wish to give their patrons. Indeed, event parking might be entirely new to their garage focus, if they normally service weekday business or collegiate parking customers. Demands on parking resources obviously vary with event attendance levels. Those demands can swing widely if other events near the new or newly renovated PAC eat into the general parking inventory. The venue team can best help attendees and staff by sharing situational parking information prior to events. Just as media outlets report on the state of roads during rush hour, the PAC can

communicate with ticket holders and employees by e-mail or other methods on what to expect and when to allow for "extra time" to navigate traffic pressures.

Parking resembles storage in a new building—you can always use a bit more. And patrons and renters tend to view parking needs as the venue's problem to solve. Maintenance issues for lots and garages may not belong to the PAC, but in the public's eyes, they do. While that can be a reasonable point of view for some venue settings, PACs in the heart of urban areas operate with a different parking scenario. Like other urban businesses, they fall to the mercy of their surroundings. Madison Square Garden in New York City, for example, has the advantage of being located at a transit hub, but does not—and realistically cannot—offer patrons and renters many parking options.

## Countdown: Housekeeping and Maintenance Standards

It goes without saying that a new or newly renovated PAC will need cleaning, maintenance, and repair services. Those services will come either from the umbrella organization's resource pool or through a team that the venue manager assembles through a combination of employees and contractors. Planning for building services generally emphasizes finding a match between the minimum number of full-time cleaners and technicians needed for daily work plus the right ramp-up in staff for event days when the venue hosts greater numbers of people. A set list of work and tasks to accomplish influences the discussion of planning new facility services, but the emphasis falls more on the driver of cost—that is, labor—than it does on supplies or overall housekeeping and maintenance standards.

Yet criteria for venue cleaning and maintenance, from a policy perspective, rarely get more attention than vague statements that convey an expectation for keeping things looking nice. That pushes the resource planning decisions further down the chain of command—closer to where the work gets done, which can be good, but at the loss of the chance to consciously decide cleaning and maintenance targets prior to the opening of the building. For a new or newly renovated PAC, missing the opportunity to ponder and thoughtfully select housekeeping or maintenance standards with an eye toward larger organizational goals puts the venue in the position of adopting business practices that might not match money and mission.

The Association of Physical Plant Administrators (APPA) has charted the topic of cleaning and maintenance philosophy in a format that allows senior building managers (including PAC leaders) to evaluate the range of service planning levels available to pursue. This resource, provided in Table 8.1, can help sift through budgetary requirements and operating goals to make the strongest policy decisions for the new or newly renovated building as it prepares to open. Is the new PAC meant to be a showpiece facility, with the highest visibility? Or will comprehensive stewardship and an aggressive maintenance plan meet venue needs and stakeholder expectations? For new

Table 8.1 APPA Level of Care Matrix, Edited

| TOPIC AREA | LEVEL OF SERVICE | | | | |
|---|---|---|---|---|---|
| | Showpiece Facility | Comprehensive Stewardship | Managed Care | Reactive Management | Crisis Response |
| **Maintenance Mix** | All recommended preventive maintenance is scheduled and completed on time. Emergencies are infrequent and handled efficiently. | A well-developed PM program, with most done at a frequency slightly less than defined schedule. Occasional emergencies due to building system failures. | Reactive maintenance dominates due to system failures, especially during peak times. Higher rates of emergency generate reports to senior administration. | Preventive maintenance work consists of simple tasks that are completed inconsistently. | No preventive maintenance performed due to more pressing problems. Reactive maintenance to worn-out systems is norm. Good emergency response because of skills gained in reacting to frequent system failures. |
| **Preventive Maintenance vs. Corrective Maintenance** | Approaching 100% | Between 75% and 100% | Between 50% and 75% | Between 25% and 50% | Under 25% |
| **Service & Response Time** | Able to respond to virtually any type of service; immediate response | Response to most service needs occurs inside of seven days. | Services available only by reducing maintenance, response time inside of 30 days. | Services only available by reducing maintenance, with response times of one year or less. | Services unavailable unless directed from higher administration. Emergency responses only. |

(Continued)

Table 8.1 (Continued)

| TOPIC AREA | LEVEL OF SERVICE | | | | |
|---|---|---|---|---|---|
| | Showpiece Facility | Comprehensive Stewardship | Managed Care | Reactive Management | Crisis Response |
| **Service Efficiency** | Maintenance activities appear highly organized and focused. Service calls receive immediate responses. | Maintenance activities appear organized with direction. Service calls are responded to in a timely manner. | Maintenance activities appear to somewhat organized, but remain people-dependent. Service calls are variable and sporadic. | Maintenance activities appear somewhat chaotic and are people-dependent. Service calls do not get timely responses. | Maintenance activities appear chaotic and without direction. Equipment and building components are routinely broken and inoperable. Service calls do not get timely responses. |
| **Aesthetics, Interior** | Like-new finishes | Clean, crisp finishes | Average finishes | Dingy finishes | Neglected finishes |
| **Aesthetics, Exterior** | Windows, doors, trim, exterior walls are like new. | Water-tight, good appearance of exterior cleaning | Minor leaks and blemishes, average exterior appearance | Somewhat drafty and leaky, rough-looking exterior, begs for painting. | Inoperable windows, leaky windows, unpainted, cracked panes, significant air and water penetration, poor overall appearance. |
| **Aesthetics, Lighting** | Bright & clean, attractively lit | Bright & clean, attractively lit | Small percentage of lights out, generally well lit. | Numerous lights out, some missing diffusers, secondary areas dark. | Dark, many shadows, bulbs and diffusers and hardware missing; cavelike. |

| TOPIC AREA | LEVEL OF SERVICE | | | | |
|---|---|---|---|---|---|
| | *Showpiece Facility* | *Comprehensive Stewardship* | *Managed Care* | *Reactive Management* | *Crisis Response* |
| **Building Systems Reliability** | Breakdown maintenance is rare, limited to vandalism and abuse repairs. | Breakdown maintenance is limited to system components short of mean time between failures. | Building and system components periodically fail. | Many systems are unreliable. Constant need for repair. Backlog of repair needs exceeds resources. | Many systems are nonfunctional. Repair instituted only for life-safety issues. |
| **Facility Maintenance Budget as % of Current Replacement Value** | Greater than 4.0% | 3.5% to 4.0% | 3.0% to 3.5% | 2.5% to 3.0% | Under 2.5% |
| **Customer Satisfaction** | Proud of facilities; have a high level of trust for the facility managers | Satisfied with facilities; complimentary of facilities staff. | Accustomed to basic level of facilities care; generally able to perform mission duties. Absence of pride in physical environment. | Generally critical of cost, responsiveness, and quality of facilities services. | Consistent customer ridicule, mistrust of facilities services. |

Source: A. Shouse (personal communication, July 7, 2010).

buildings that belong to umbrella organizations, the larger maintenance phi-
losophy of the umbrella group may well make the choice for the venue. But
evaluating the range of options during the countdown to Year 1 at least
allows for a planning discussion that allocates resources to meet governance
expectations and operating needs.

A new or newly renovated PAC will open its doors with aesthetic items
largely in fine shape, save perhaps for landscaping that needs a cycle of
seasons to settle in to place. Of course, no new venue will open its doors in
crisis mode. The goal is to keep it from sliding into that condition.

The relative visibility of the building—it is intended for public assem-
bly, after all—can tilt the discussion to the higher end of the chart. But if
umbrella resources point to a different philosophy, the venue manager will
have to work within that context. To not consciously weigh these choices
effectively delegates the decision downward, without much thought to
resource implications for the venue.

## Carrying the Tune: Venue Staff

The decisions, tasks, and relationships outlined earlier require great effort
before the new or newly renovated PAC opens its doors. Few of them will
fall into place naturally. The principal administrator cannot complete this
work without assistance, for each topic will require sustained attention dur-
ing the countdown and more still attention after opening. There must be
other persons present to whom the venue manager can delegate a portion of
the work as the building prepares to operate. This staff will need to join the
organization with a lead time proportionate to the tasks at hand: FFE dis-
cussions clearly take place during the design and construction phase; pub-
lic relations goes in tandem with funding the project; populating the event
calendar and modeling financials cannot occur successfully a mere 60 days
prior to grand opening. A venue without a team in place during these phases
will suffer in Year 1 for a lack of attention in these areas.

The challenges to making preopening staff hires are legion. Without nor-
mal income sources flowing yet, the added payroll expense for a PAC in the
construction phase can be difficult to shoulder. Given the larger funding
context of finding resources for construction, making the case for operating
personnel may strain project owners and supporters. Invariably, the princi-
pal administrator will be asked to defend a plan to staff up well before the
grand opening, against a tone of "what are those people doing, if the build-
ing is still a construction site?" And defend it they must, in order to ensure
a smooth countdown and Year 1 for the PAC.

The planning culture of any umbrella organization involved with the
venue will influence when staff positions may advertise and when hires can
join the team. Of course, the outlook of the umbrella group on these time-
table matters may not be rooted in opening assembly facilities. If shared ser-
vices for the new PAC form a portion of the operation model—the umbrella

parking division, the maintenance/custodial division—the long-term work will, expectedly, reside in those other units. But the preexistence of those other service units does not ensure that the countdown tasks outlined in this chapter will receive attention or resources from them in good measure. While others may call the tune, the venue team must carry the tune and see things through.

## Conclusion

Principal administrators of a new or newly renovated PAC will readily give attention to planning ticketing services, managing tenant expectations, wrangling food and beverage issues, and completing the capital campaign for funding the project. Those topics all warrant attention and lots of it. But operational success for the PAC also relies on some less visible planning, to give the staff the resources that they need, and the clients and patrons the services they expect. This chapter has outlined those countdown items from a senior management point of view, to enable both leadership of and effective delegation of that planning. The topics are significant enough to the success of the new venue that direction and regular verification from the principal administrator will need to occur.

Once the new PAC opens its doors, these planning details will appear obvious—in hindsight. But distractions during the countdown will make it difficult for the venue team to work on them aggressively. For purposes of helping the project, the principal administrator should visit and revisit the following questions as part of preparing to open:

1  What umbrella organization structures will the project navigate through? How will those influence the planning and execution of tasks leading up to Year 1 of operation?
2  What process will determine owner-specified FFE for the project? Who on the venue team will help evaluate and identify needed resources? What timetable will guide this?
3  What sequence of meetings with the insurance carrier and important neighboring property owners will most help project planning? How can the venue's security staff most benefit from this knowledge?
4  Who will work as a media or public spokesperson for the venue? How do we train those persons, and vet important issues with the PAC's governing body?
5  What rental inquiry review procedures will the venue team use? When do decisions come to the principal administrator? What hard criteria will define whether or not to accept an event request? How can the scheduling priority policy help the overall business model?
6  Who on the venue team owns the relationship between parking resources and the PAC? How best can possible problems and bottlenecks be identified during the countdown phase? Which organization will lead public messaging about event-day parking resources?

7   What target level of facility care will guide the venue's housekeeping and maintenance teams? How best can the principal administrator translate those targets into actionable goals for staff and justifiable goals for the PAC's governing body? Which other buildings would make good benchmarks for these decisions?
8   What key staff positions will join the organization during the countdown phase? When should they be onboard, relative to the construction cycle and the grand-opening date?

As noted earlier, the countdown clock for construction will receive more public and stakeholder attention than any of these quieter countdown items. But the end of construction will create a vacuum for that attention, and everyone's gaze will shift to the topics of this chapter. The venue team must be prepared for this and be ready to respond.

## References

Conte, D., & Langley, S. (2007). *Theatre management: Producing and managing the performing arts*. Hollywood, CA: Entertainment Pro.

Cooper, D. (Ed.), & The Event Safety Alliance. (2014). *The event safety guide*. Delaware: Skyhorse Publishing.

Donnelly, P. (2011). Arts facilities—schedules, agreements, and ownership. In M. Brindle & C. DeVereaux (Eds.), *The arts management handbook* (pp. 13–37). New York: M.E. Sharpe, Inc.

International Association of Venue Managers. (2007). *Academy for venue safety and security handbook*. Coppell, TX: IAVM.

Mahoney, K., Esckilsen, L., Jeralds, A., & Camp, S. (2015). *Public assembly venue management: Sports, entertainment, meeting and convention venues*. Dallas, TX: Brown Books Publishing Group.

Singer, R. (2014). *Media relations*. Venue Management School Monograph #115. Wheeling, WV: IAVM.

Woronkowicz, J., Joynes, D.C., & Bradburn, N. (2015). *Building better arts facilities: Lessons from a U.S. national study*. New York: Routledge.

# 9  Managing Performing Arts Centers in a University Setting

*Lawrence D. Henley*

Performing arts centers (PACs) have long held an essential place on the campuses of American colleges and universities. Collegiate PACs serve a dual purpose. First, there is the more obvious mission of education, as university PACs serve as training centers (laboratories) for students matriculating in the school's theatre, music, opera, dance, and technical production programs. Second, and of equal importance, is that collegiate PACs also represent their institutions as an important gateway into the communities that they serve.

For these reasons, the motivations behind operational and financial decisions can be quite different from those of other types of PACs. A college PAC manager may make very different decisions based on the political situation, or development, recruiting possibilities, and the realities of the calendar and availability of venues at a given school. This chapter gives readers an overview of what those seeking a career in PAC management in a university will be likely to encounter once entering the field. Much of what follows is based on the author's experience and professional network in the field. The sections that follow examine the balance of influences and political power, fund-raising and development climates, financial infrastructure and inner workings, and types of events experienced in the collegiate setting.

## The Higher Education Context of Collegiate PACs

Within the borders of the United States are roughly 4,700 degree-granting institutions of higher learning, according to National Center for Education Services (https://nces.ed.gov). Of these schools, roughly two-thirds are four-year colleges and universities. Over 20 million full- and part-time students attend such institutions. While schools of higher learning are found in all reaches of the country, there is a tendency for the most highly visible institutions to be located in urban areas. However, many high-profile institutions can also be found in low-density regions. There are national and regional universities, both publicly and privately funded, private undergraduate liberal arts colleges, and technical/trade schools. In addition, there are scores of two-year institutions (junior colleges) that feature performing arts

programs. Colleges and universities come in all sizes. Some have multiple venues, while other have only a single performance space. Many are designated as graduate and research institutions, while many others emphasize undergraduate education. State-funded schools most often are part of a system of institutions within state borders. In addition, there are also roughly 2,500 non-degree-granting for-profit postsecondary institutions. Education is a most substantial American industry.

Many of America's most highly visible university campuses are located in major population centers. This is particularly true of the East Coast and Midwestern states. Incoming students with a high degree of occupational focus tend often to seek out major programs located in cities where they believe they're more likely to find employment connections after graduation. Prime examples of higher education–focused metropolitan areas are Boston (54 colleges and universities, including Harvard and Brandeis), Pittsburgh (68 colleges and universities, including Carnegie Mellon and the University of Pittsburgh), Chicago (119 colleges and universities, including the University of Chicago and DePaul), and Los Angeles (131 colleges and universities, including USC and UCLA).

As American cities expanded beyond their boundaries into bedroom communities and suburbia, higher education followed. With the nineteenth- and twentieth-century expansion and growth of metropolitan suburbs, the need quickly arose for providing education options to those living and working in those suburban areas, many as distant as thirty or more miles from downtown campuses. As a result, thousands of smaller universities, colleges, and community colleges dot the landscapes of outlying anchor communities. Satellite campuses of the major state universities also address the educational needs of perimeter towns. Conversely, it's also common to find satellite campuses of the larger rural or suburban universities in downtown areas.

Since the colonial era, universities have not only been viewed as the gateway for opportunity and the advancement of the nation's citizens but are also regarded by local, state, and federal governments as powerful and centralized economic engines for those communities fortunate enough to have one. Colleges and universities are created by governmental bodies and/or private trustee groups. In many cases, the successful regional communities that have secured a state university accomplished that amid stiff competition with neighboring municipalities who equally coveted an institution of advanced learning.

Many American universities were founded in rural and regional centers. The reasons for this were twofold. In most cases, this approach was mutually beneficial to both the individual states and the rural municipalities. On one hand, the states' initial intention was to build new schools in remote regions that were distant from capitals and population centers, the concept being to spread out higher education facilities to reach students least able to afford leaving their families and relocating to urban centers. On the other

hand, rural and agricultural communities sought to expand both their populations and economic bases by building universities, knowing that this is one essential key to economic development. As a result, many nonurban locations are better known for the universities they host than for other points of industry, agriculture, or local attractions. Prime examples of smaller cities with highly recognizable schools are Bloomington, Indiana; State College, Pennsylvania; College Station, Texas; and both Eugene and Corvallis, Oregon. Large states such as New York, Missouri, Texas, Wisconsin, and California have all developed large university systems with several campuses dotting their state maps. Many large urban areas have their own single or multiple college campuses (CUNY, CULA, etc.). Community and junior colleges are found in nearly every corner of the United States.

## Understanding the Governance Structure of University PACs

The two basic governance classifications of colleges and universities are publicly and privately funded institutions. Nearly all collegiate performing arts centers fit into the university's distinct governance structure in one of three forms: (1) The university PAC is publicly operated (local, city, or state government), (2) the university PAC is privately operated by a 501(c)3 not-for-profit organization, or (3) the university PAC is operated by a for-profit entity. However, in order to analyze diverse collegiate PAC governance structures, it is first important to understand in broad brushstrokes the differences between public and private universities.

Public university performing arts centers primarily receive their bedrock funding from state or local governments and student tuition, and the university is overseen by a publicly elected or appointed board of trustees, regents, or directors. In contrast, private university venues are mostly funded by private not-for-profit entities and (more heavily on) student tuition, and their oversight emanates from privately selected boards of trustees. There are also numerous for-profit educational institutions that do not fund or operate their own self-managed performing arts venues. Typically, this type of institution will operate out of an office building or "storefront" retail location, not provide athletic teams, and find that it is more practical to lease other local event facilities for their college ceremonies, meetings, or other large assembly functions.

In a private non-university setting, the chief executive officer or executive-level officer of the performing arts venue will typically report directly to a structured board. This top level of decision-making for universities is found with the individuals elected or appointed to the board, usually called *regents* or *trustees*. Typically, these are prominent, altruistic local area citizens who are successful in their own business or education-related endeavors. At a university, one generally finds additional reporting layers between the top-level PAC manager and the board. Here there are similarities with PACs

in a civic or municipal setting, where there are also likely to be elected or appointed officials near the top of the chain of command. In a university's management structure, the equivalent reporting structure would be to an academic dean, a vice-president, and/or a president or a chancellor.

Financial advantages and disadvantages exist with every university PAC reporting structure. Generally speaking, administrators at a vice-presidential level tend to have greater access to control of monetary resources, as well as a much louder say in how the resources are parsed and distributed at a given school. An academic vice-president could potentially have a better conceptual grasp than a finance officer of why the operations of their PAC are of crucial importance to the university. Then again, the finance administrator may have access to abundant resources. Reporting to a dean, especially a dean of the arts, should give the PAC the best odds of having a direct report that is truly aligned with the PAC mission; however, for some, there are also advantages in reporting to a vice president for community relations. There is no ideal reporting structure, and the personal character differences among individuals and institutions drive significant variance among governance and reporting systems. Individual managers may also carry their own preference on where they would like to report, although this is typically a decision that is not under the manager's control.

Operating any government-funded facility can be a highly political endeavor, but this truism tends to be heightened for university public assembly venue managers. Instead of employing a model where a performing arts center itself drives its own mission and goals, the collegiate PAC mission is far more likely to be set in accordance with the overarching mission and goals of the larger institution, or perhaps a division/subdivision of the institution. Such divisions might include academic affairs, university finance, university advancement, community relations and/or alumni relations, or an individual academic unit such as a college of the fine and performing arts, arts and letters, or arts and communications. In the university context, the PAC is subject not only to the will of its parent administrative bodies but also to the influence of the members of the political bodies that provide the campus its basic state funding and services.

Performing arts centers housed in private university settings may tend to be less subject to outside political influence, but serve distinct missions and goals that are more likely to be influenced by a board of trustees and the university president. In practice, both public and private university administrative structures bear a strong resemblance to the other. At the top level is usually a university president or chancellor. Reporting directly to the president is a "cabinet"—an assemblage of senior-level administrators, usually at the vice-presidential level. In this senior leadership group, there is usually a senior vice-president—the provost—who is the chief academic officer, accompanied by vice-presidents and vice-provosts for large areas of campus operations. University vice-presidents represent broad areas such as

finance and administration, student services, community and alumni relations, development, research, government relations, athletics, and more.

On the academic side, the next level of leadership can be found with the deans, who have been granted oversight over the various college disciplines within the university. Academic department heads (or chairs) report to the deans. Deans in the arts will be more likely to have at least some past experiences and familiarity with PAC operations. The leadership corollary on the administrative side will be the various directors of departments within their respective areas.

As with important pedagogical matters dealt with by teaching units across the campus, university governance leans heavily toward a committee system among the faculty and administrative staff. Extensive or moderate committee service is an ordinary, expected part of university life. Universities use their permanent and ad hoc committees to make recommendations or decisions on wide-ranging issues and concerns, and whether a blessing or a curse, committee work tends to be how most tasks are accomplished at colleges. The criticism, of course, is that arriving at committee decisions has a tendency to protract the length of time involved in getting things accomplished. Large volumes of committee meetings are time-consuming, and while mostly collegial, they can also become contentious or unproductive. The positive aspects of the university committee structure are that problems tend to be more thoroughly vetted, and the sense of inclusion and teamwork is greatly augmented. Working with a diverse staff collective from different areas of the institution can help to breed familiarity among departments and personnel. The committee process certainly helps to "build bridges" and promote good will. Committee decisions also tend to foster an impression of unity, suppress interdepartmental jealousies, and counter the viewpoint that a unit is acting as a "lone wolf," or a "rogue" department. Participation in this way serves to enhance the image of the PAC, making for a more positive and collaborative campuswide workplace. Still, committee work can, at times, be a frustrating process.

Within a university, there are a number of academic departments that can be viewed as opportunities for collaboration. Good relationships with key members of these departments, and with department heads in particular, can foster the sharing of ideas that can become joint efforts mutually beneficial to both parties. The artists and administrators in other departments that produce events generally appreciate the production and business assistance gained from interacting with the performing arts center's leadership and staff. This will usually help the PAC set forth a positive image, gaining publicity from collaborations, as well as improving its standing in the eyes of academic deans and other key leaders within the administration. It always helps for the PAC to be "part of the solution," as opposed to being viewed as part of the problem, however that might be perceived in a given institution.

## The Performing Arts Center's Role at Colleges and Universities

Colleges and universities have long played a significant role in the cultural life of American municipalities. Dating back more than a century, both small and large public assembly facilities have played an integral role in the lives of most college campuses and have provided their communities with either an additional cultural outlet or served as the primary local outlet until a major regional venue could be funded and built. Many smaller and difficult to reach communities rely on collegiate performance venues to provide experiences they would not otherwise receive. Local university centers can also be useful for large community gatherings, meetings, town halls, and other non-arts events.

While university performance venues are created first to serve their college campuses, university venues are also established with more in mind than simply serving their own students and faculty. Like independent performing arts centers, universities often measure success in terms of community impact, be it for city, county, or state. Most often, university performing arts centers are expected to engage their local communities, bringing the citizenry to campus in order to entertain, enlighten, facilitate communications, and enhance the image of the institution. The event bases of university PACs tend to look fairly similar to those of non-educational PACs. Campus event centers routinely host theatrical productions, industrial/corporate events, and classical and popular concerts in addition to lectures, graduations, music recitals, dance performances, business meetings, and political events.

Indeed, many university PACs are not merely seen as supplemental to major nonprofit venues, but rather on the forefront in their markets. Indiana University, the University of Missouri at St. Louis, and University of Nebraska's Lied Center all provide highly visible venues in their communities. In other metropolitan areas, such as the San Fernando Valley, Sonoma County, California, and Las Vegas, university PACs are one among a substantial host of local and regional venues. Often, the local college or university provides an outlet for underserved parts of communities.

University performing arts facilities are built with every intention of serving fellow campus units and departments. It is not an uncommon mandate for university PACs to offer deep discounts, subsidies, or gratis services for its campus users. Many of these PACs were (at least initially) conceived and created to support the performance programs of such units. Most colleges and universities run performance-based theatre, music, dance, and opera programs, which are, to varying degrees, incapable or ill equipped to solely operate the venues they need to sustain their performance and programming seasons.

College PAC organizations will typically play some kind of supporting role in the production operation of performing arts units at their institution.

Quite often, those departments are underneath the same academic or administrative umbrella. For the most part, these academic units will be Departments (or Schools) of Theatre, Music, and Dance. While the primary roles of these departments are pedagogical in nature, also inherent within their mission is the need to produce publicly performed plays, musicals, concerts, recitals, ballet, modern dance, and opera. These departments may require support with ticketing services, front-of-house staffing, marketing, public relations, or stage production staffing, equipment, and general expertise that can be provided by the staff of the PAC. Other university arts departments, such as art, film, and architecture may occasionally take advantage of PAC resources. Additional benefits offered by the PAC are facilities and resources for gallery exhibitions, video services, architectural planning, or other specialized functions relating to departments within the unit.

Whether or not the university PAC manager may view the funding levels provided by their universities as adequate, it is probable that the university's administration will nonetheless expect varying levels of preferential treatment to be granted for academic performing arts departments. These discounts and usage policies significantly impact the PAC bottom line. Examples of gratis services accorded to university departments include free or reduced facility rental fees, subsidized/discounted rates for any labor and equipment provided, preferential (priority) scheduling, and the expectation of marketing services. In many cases, the PAC will be entitled to half, less than half, or even nothing received in terms of billable reimbursements. These benefits to other departments are often "grandfathered" in, and the resultant financial losses will need to be offset by other revenue sources.

Like most non-university PACs, university PACs also serve or support local nonprofit arts organizations, resident companies, and fellow educational institutions. Most college PACs also welcome business from for-profit presenters and promoters. Indeed, non-university business is probably a budgetary necessity for most collegiate PACs. In addition to in-house academic producers and presenters residing in college performing arts centers, other local producing and presenting arts organizations are naturally drawn to university facilities, which they may find preferable to other available community venues. Such groups will often establish relationships with members of the university's administration in order to gain varying forms of resident status on campus. Generally, these groups are dance, theatre, and opera companies but can also include producers or presenters of film, architecture, and the visual arts. Such relationships can earn them reduced or waived rent and fees and discounted marketing or other staff services. Such arrangements may be expanded to offer free office or studio space on campus or cost waivers for utilities. Under these arrangements, many of the same privileges granted to producing academic departments may be offered to resident companies but most likely at lesser levels. In return, universities often find that there is value in the master classes, internships, and performance

opportunities that these resident companies can provide to their students. In addition, resident company performances tend to bring audiences to campus that might not otherwise visit. University administrators also enjoy mining the political value of relationships with influential board members and supporters of other external organizations.

Most colleges and universities also have policies that will allow their facilities to be rented out to local, national, and international arts organizations and to other commercial, governmental, and educational users. While renting groups are usually nonprofit 501(c)3 organizations, many for-profit commercial businesses, producers, and promoters also enjoy contractual relationships with education-based venues. Many local and federal government entities also need rental space for their activities. Other educational bodies, such as local school districts, also seek out relationships with university performance centers, enjoying brokered rates offered by university administrators who relish having primary and secondary students visiting and performing on their campuses.

Scheduling and competition for dates among university departments, resident companies, renters, students, and others nearly always represents a headache for PAC managers. It involves constant juggling, where a tenuous balance exists between booking more commercial activity in order to make budget, yet needing to accommodate lesser-paying entities. The specific scheduling priorities and policies of each university PAC will vary, but all generally share the same issues and problems with accommodating competing demands for the PAC calendar.

Many schools do allow venue management to enter into often-lucrative partnerships with outside promoters. These situations tend to reduce financial risk to the university but can also add challenges inherent in having a partner relationship. Co-promotion partners always have their own list of wants and needs and may not be understanding when it comes to some of the restrictions imposed on collegiate PAC venue managers by their institutions.

Partners and promoters will always seek to gain from the venue the maximum revenue split available. In other words, they will take whatever you're willing to give them (sometimes more!). From here it is a question of leverage, and the negotiation process can become rather like a game of poker or blackjack. In the words of songwriter Don Henley, "How Bad Do You Want It?" Every manager must decide what he or she is willing to give up to have the products and audiences he or she wants come into the doors of the venue. One manager might believe that a non-university partner or promoter has no right to a split of their merchandise or concession revenues for a given event, while another may decide it's a necessary addition to the venue package in order to keep a coveted event from playing elsewhere.

The beauty of the co-promotion deal, of course, is that the financial risk the event represents is shared by other stakeholders. Conversely, the facility could be settling for less revenue than it might otherwise have realized. As mentioned previously, there will always be serious cost and financial risk

involved in presenting the arts, and partnering to get the job done doesn't wholly change this fact.

## Programming and Funding Considerations for University PACs

Universities are intrinsically collaborative environments, and the performing arts both reflect and exemplify this orientation. From the standpoint of the collegiate PAC manager, it is essential to embrace the spirit of collaboration as the organization moves forward. Being viewed as an uncooperative partner, or exhibiting a lack of teamwork with academic units never reflects well on the PAC's philosophy or its operations. Working with faculty, staff, and students from across the university is positive for growth. In addition, collaborating with one or more academic departments will tend to strengthen funding arguments and academic support for the PAC.

Programming for university PACs is often a contentious area. It is often the expectation that university PACs present a season of performances that will bring the community to campus, and numerous schools have thriving performance series'. This is not only a part of the unit's artistic mission but also serves as an important public relations function and often supports the school's overall fund-raising goals. In order to be successful with programming, managers must have an appetite for risk, whether shared risk (the more that risk is shared, the better), or leveraged/calculated risk. It is also crucial for the PAC manager to have a talent for identifying the performances and events that local audiences will pay to attend.

In direct opposition to the need to be risk-aggressive are the financial expectations of the university. When operating as an administrative or auxiliary agent for a university, there is usually an expectation that the entity will comply with budgets and the need for positive fund balances. Those who have been around the entertainment industry well know that event promotion inherently contains an element of risk that correlates more to gambling than to strict adherence to budgets. Rare are the events that guarantee audiences will fill the house. The riskiness of presenting events can be offset by other funding and revenue sources. Along with tight calculation of the risk involved in booking the right programming for the collegiate PAC audience, venue managers must embrace and live with the fact that audience behaviors can change with economic downturns, cultural and generational changes, and additional factors that are often beyond the PAC's control.

For the most part, a university PAC will have access to the same events and event genres as non-educational PACs. If a university venue is capable of fulfilling the show requirements and the pricing fits the presenters' budget range, promoters and producers will pursue quality venues on a relatively even playing field. As with all locales, touring radius and proximity to like venues within a given market or region can play a major factor in which tours and events will go to what theatre. To ensure that promoters can

find venues, it is of critical importance for a college venue to make certain that they are listed in directory publications such as *Pollstar* and *Musical America*. However, if universities wish to be truly competitive with non-university centers in this touring and presenting market, it is essential to maintain, renovate, and innovate their PAC facilities, internal space flexibility, and corresponding technical capacities. The touring arts have changed significantly in recent decades. Heightened production demands, coupled with increased performer expectations have created greater demands from the venues that artists and agents most often select.

Another programming area for universities to consider is the content and the acceptability of new ideas. In recent centuries, universities have been viewed as bastions of free speech and laboratories for the cultivation of innovation and expression. One would tend to think of colleges as intrepid when it comes to pushing the envelope in terms of programmatic risk taking, and this is indeed the case at many schools. However, how far a university PAC or academic programmer is allowed to delve into the boundaries of what some consider good or bad taste will often depend on the local climate surrounding the individual institution. Some collegiate programmers may work for schools in major centers of population or artistic havens where the majority of minds are open to most anything. Other colleges may be situated in more conservative or religious states or communities where locals may take a dim view of offensive language, depiction of drug use, extreme political views, nudity, or other highly sexual content. All university PACs reside in campus situations where development and fund-raising efforts can be threatened when patrons react negatively to programming content. Each manager must learn the "lay of the land" when it comes to their regional community and institutional standards. Often, controversial content can be performed and, to varying degrees, accepted in difficult community situations through dexterous communications and public relations work. Programmers should always take care in this area, in that negative media attention tends to reflect on the entire institution, not the venue alone.

A critical question for the collegiate PAC will be, "Is our venue equipped to handle the most current, desirable, and lucrative events?" The expense of bringing artists to the venue, catering to their needs, and marketing them is not the only serious cost factor involved in housing great arts and entertainment. In general terms, the artist is usually looking to play the venue that provides the best service, technical, and artistic experience for their touring company and their audiences. Beyond location, determining which venues to perform in involves several considerations. Some of these are ease of production process and event intake, the quality of production assets available, and the ability of the venue and its staff to enhance the artist's performance/production. Is the venue state of the art? How close is a given venue to the standards the artist has set forth in their technical requirements? How well can staff adapt to the differing considerations for each event?

In today's economy, a new state-of-the-art performing arts facility with all of the latest trimmings can rival the cost of an athletic stadium with 15 times the number of seats. Stage lighting, acoustic attributes, professional audio, flexible staging, plush seating, and digital infrastructure all can add up very quickly. The reality is, however, that the level of venue support requested by producers and artists is rapidly advancing. In these areas, it can be a tall order for most universities to compete with the private sector. Financing for big-ticket items can be more difficult to procure, for reasons related to government budgeting, fund-raising, public purchasing regulations, and competition for resources among diverse areas within the university.

Working contractually with non-university or non-entertainment related entities is a reality for many university PACs. Contracting these events can lead to innumerable difficulties, especially when the events presented are not touring events. "One-off" single-performance community and non-touring events usually prove to be problematic in some way from a production management standpoint, but they still produce needed revenue. In these situations, PAC staff are often dealing with event representatives whose profession or expertise is completely unrelated to the business of event production, and quite often nonexistent. Many events that a university will be asked to facilitate will have nothing to do with the performing arts. Nonetheless, while these single events can be stressful and difficult to pull off, they do serve as a way to fill an empty date and enhance the bottom line.

Successful onetime events can also serve to position PAC managers and staff as an important campus resource. Universities will tend to call upon PAC managers—skilled experts in an important area of university life—for their advice and expertise with other special events the university produces. These events will not necessarily be presented in performing arts venues, but perhaps at the school's other venues such as arenas, outdoor locations, or even off campus. PAC staff may be recruited to work on local or national political events, ceremonial events (inaugurals, commencement, and honors ceremonies), school anniversaries, festivals, and more.

Creating and achieving the right balance in the PAC's calendar for the needs of the institution is possibly the manager's greatest challenge. In theory, at least, the university funds the academic operations set in practice by its own departments. Logically, those departments should have first right of refusal to use the venue. However, political allegiances, bias, and financial concerns may radically affect the process of determining who gets how much of the calendar at a collegiate PAC. Certainly, these venues are mostly created with student, faculty, and departmental use in mind, at least nominally. However, the funding in place to support the venue will not always be enough to pay the PAC's operational bills.

The calendar battle generally pits the needs of the academic units versus the PAC's need for earned income or a desire on the part of the institution to favor external groups and resident companies. In other instances, campuses

will skirmish over the number of dates allotted for popular forms of entertainment versus those dedicated to the arts and academic units.

Ideally, more than half of a university PAC budget will be comprised of state funding, which is also referred to as "hard" money. The best-case scenario for university PAC operations will have solid funding in place from their parent organizations in the form of annual renewable state-appropriated dollars. However, institutions that offer the arts this kind of stability tend to be the exception. The fortunate collegiate PAC manager will be the one who has a balanced financial foundation, consisting equally of hard money and soft dollars earned and/or contributed during the budget year. In reality, however, most university PAC managers are faced with the fact that they will be required to earn the greatest chunk of their budget dollars via the sale of tickets, ancillary merchandise, food and beverage sales, venue rentals, equipment rentals, advertising sales, and donated revenue (similar to privatized arts centers).

As with non-college PAC's, most university centers that also present the performing arts will, to some degree, rely on governmental and grant funding. National Endowment for the Arts grants, as well as grants from state and local arts councils, are considered essential by many in the arts, especially those who do produce and present. Like their community-based counterparts, many university PACs also glean support from private philanthropic foundations. In the university setting, the most common fund-raising models are run through an approving body, usually the institution's own foundation, development office, or office of research. Unfortunately, fund-raising wishes can lead to frustration when the PAC finds itself competing with many other university departments who are also looking for donated money, grants, and facilities from the same pool of donors.

In view of the way that most universities set up dedicated funding and giving opportunities for their PACs, it is reasonable to assume that such a funding model will only rarely be enough to fully support the PAC's annual operations. This propels the crucial need for university PACs to identify sources and earn additional revenues to meet operational expenses. Most university PACs will need to generate considerable additional ancillary revenues to balance out their annual budgets.

Indeed, the fund-raising process is just as essential to a university PAC as it is to privately operated PACs. Contributed revenues can help make up the difference between a challenging, hand-to-mouth existence and a thriving operation. Endowment support to supplement venue staffing, needed maintenance, operating, or programming expenses is a great thing, and can make or break the performing arts venue operation. Other development sources, such as annual gifts, contributions from estate planning, and even funding for internships or scholarships can go a long way to adding to the vibrancy of a university PAC. If the institution's administration and development officers truly act as partners with the PAC, the relationship can carry venues a long way toward supplementing the cost of annual operations.

Additional revenues can be earned from a variety of income sources but are mostly generated from event operations and/or presenting. As with other types of PACs, a list of examples will include numerous items such as revenue from concessions, food and beverage or catering operations, merchandising, ticketing sales and premium ticket packages, and many other items related to venue rentals.

## Managing University PAC Operations

One of the pitfalls of operating a nonacademic concern within the university framework is that the business of running an entertainment facility is largely alien to the way standard university departmental operations and budgets work. Events centers often require delivery of purchased items more rapidly than the rigid academic purchasing process tends to allow. There is also the need for a quick day of show settlements, disbursement of box office sales refunds, and artist check payments to consider. Payments to internationally based artists can be difficult. Mandated bid ceilings and processes are another concern for venues that might require delivery of specialized equipment in truncated periods. Regulations concerning staff travel reimbursements and institutional memberships may be additional areas where university processes can slow the reimbursement period.

The auxiliary campus departments that PACs work with for functions such as purchasing, payroll, and human resources generally have very little idea about what the performing arts center needs to accomplish, or how operating an arts and entertainment organization is different from the manner in which most "normal" campus business would function. If time allows, the process of educating university officials about the functionality, specialized equipment, atypical time frames, and terminology involved in the arts and entertainment business can be helpful. It is noteworthy, also, that there are great advantages of being university based, as the institution will often pay the majority, or at least part, of the cost for utilities and maintenance.

Many colleges believe that there is great value in having a PAC on campus, yet prefer to stay out the business of running such specialized venues. In some cases, even state-owned universities will opt to subcontract venue operations out to a private entity. This arrangement is attractive to many public schools because it carries with it the option of running the PAC without burdensome rules of a governmental bureaucracy. The downside, of course, is that while there may be less headache and red tape involved, there also may be a loss of control experienced by the institution. Less profitable events produced by academic units may be pushed aside in order to accommodate events that advance the bottom line.

Event staffing levels at a university PAC will vary in accordance with the needs of the event. Because union labor can be so costly, other options are generally preferred at universities. For public colleges and smaller institutions located in *right-to-work* states, a university PAC will be more likely

to operate without union labor, until/unless touring programming concerns dictate otherwise. University venues will often rely heavily on part-time hourly student and nonstudent labor, retirees, volunteers, or on a mixture of all of these demographic groups. Some universities conduct in-house student labor training programs for both front- and back-of-house labor. At universities, as in many theaters, staff turnover issues often lead to problems. Theatrical labor tends to be more transient than in other work environments, and by definition students remain on campuses only for a finite number of years. Many nonstudent workers are only biding time on a college campus until a higher paying private-sector opportunity presents itself.

Certainly, at large state-operated universities, officials and policies are set in place to govern the higher education system. Long-existing policies can be difficult to manage and have generally been created by individuals or entities with which the PAC manager will likely never come in contact. The college manager will be subject to employee classifications and labor laws that may work famously for most standard office and "nine-to-five" job descriptions but not at all well for theatrical employees, such as stage technicians, ushers, and box-office employees. Performing arts center employees work odd and extended hours that do not conform with the workaday world. Student labor may also be subject to restrictions concerning the number of hours that can be worked within a single week, to restrictions regarding work opportunities for international students, and much more. Also problematic are personnel rules concerning the permanence of state employees. Once probationary hurdles are passed through, these regulations can make discipline and dismissal a difficult and highly contentious proposition.

Salary structures and the frequency of pay increases at universities may also be determined by governing bodies, often in a manner that can be unrealistic or noncompetitive with local markets. According to the spring 2016 International Association of Venue Managers (IAVM) salary survey, most university PAC management salaries were reported as being significantly lower than their counterparts in other public and private institutions. In addition, campus employees may have their available weekly hours compressed by furlough mandates during budget crises and economic slumps. State-funded universities are by nature highly susceptible to changes in economic conditions. Mandated staff cuts or "freezes" on new hires during tough fiscal times can limit or strain productivity. In some cases, the PAC manager might be able to argue for variances or exemptions from certain labor and salary mandates, but more often than not, the bureaucracy will prevail.

On the brighter side, there is the matter of pay levels and job security for university managers and executives. Yes, on the downside pay levels for state university leadership tend to run at 10 to 15 percent behind municipal, federal, and private salaries. However, on the positive side, universities tend to provide better employee job security, owing in part to existing

legislated mandates. Obviously, this can be the proverbial double-edged sword. As a manager or an executive, you may be underpaid but also have above-average chances of enjoying an extended career at your public university. Conversely, so does the problem employee that you may want to see move on.

Marketing also tends to be another two-edged sword. There are both advantages and disadvantages to marketing both the PAC and its events in the university setting. Networking with other university professionals from different departments within the university can provide an important support system for marketers. Having the student body residing on campus along with the arts center can provide a built-in audience market. Universities often provide their marketers with a variety of Internet and printed calendars, social media, posting sites, ticket outlets, electronic signage, and other advertising opportunities. In addition, the campus arena or athletic department may also be of assistance (they, too, share a strong interest in penetrating into many of the same areas of the community). It is also possible that the university venue will qualify for "community betterment" advertising rates with news and media outlets.

Unfortunately, staff size and marketing budgets for a university performing arts center will tend to be limited compared to what would be found in other PAC settings. And while many factors are dependent on the characteristics of individual markets and institutions, university athletic and institutional marketing budgets and visibility often have a proclivity for overshadowing the performing arts.

## Contracting and Risk Management for University PAC Events

One of the key areas in establishing a business arrangement and protecting any facility from financial risk is the contract agreement. Whenever two parties reach a formal agreement to conduct business or projects, it is always best practice to capture the deal in writing. College PACs will find that their agreements are subject to changes and approval by university legal counsel who are employed either by their university system or by the campus itself. While assisting legal eyes can seem invasive at times, they are a wonderful business resource for the university PAC manager. In the best of worlds, the campus legal counsel assigned to review venue agreements will be at least somewhat familiar with entertainment law, which is a great offer of protection for the PAC.

Managers of a university PAC can spend an inordinate amount of time trying to nail down optimal contractual agreements. At most universities, attorneys and purchasing contract administrators can provide plenty of help. However, at times, their assistance might seem like too much of a good thing! Different legal and contractual advisors will tend to have different viewpoints, preferred contract terms and language, and their preferences

are rarely static. Their involvement may also protract the time it takes to get an agreement finalized. Contracts evolve and change with legal trends and with business developments, in general. Attorneys also tend to move around within the legal profession. Often the counsel a manager is dealing with today is not the same legal advisor that was the approver of key documents three to four years ago. And, of course, PAC administrators will have their own ideas, stipulations, and phrases for inclusion in the contract or policy. Nailing down the best "boilerplate" language for legal documents and policies can be elusive.

As with any business arrangement, negotiations in the entertainment profession are a two-party affair. Each side will seek to position the entities they represent with the most favorable bargaining position possible. Similarly, the positioning of a university legal advisor will usually be in direct opposition to representatives of the other party in one or multiple sections of a contractual agreement. Since the financial terms and technical rider are generally established prior to generating the contracts, the most common disagreements are in the other areas of the contract document: indemnification, liability insurances, worker compensation coverage, and protection of dates.

At state institutions, campus counsel will generally report to a higher level system counsel, who determines or approves legal policy for the entire state system. University and state attorneys may also insist on a change of venue if agreements could conceivably be called into question in court. Most entertainment agents are based in states such as New York, Tennessee, and California, where local laws favor the position of artists, entertainers, and their agents and managers. State university counsel often request the use of a purchaser-generated agreement, as opposed to using a document produced by representatives of the artist.

University PACs, like all performing arts venue operators, establish rules, regulations, and procedures to which their clients need to adhere. Sometimes, communicating these strictures verbally—in pamphlets and brochures or via the Internet—will prove insufficient to gain the full cooperation and attention of venue clients. It is good practice to include such matters in facility contracts, of which each page should be initialed by the signatory authorities.

Licensing is another business issue that can prove to be complex within educational institutions. Agencies such as ASCAP, BMI, and SESAC offer blanket institutional licensing for schools. Other local privilege licenses, such as licensing to serve alcoholic beverages, may have to be routed through a higher administrative office on campus. These licenses may be available only on a per-event basis.

For university PACs, liability insurance is a facet of operations that always requires careful attention. It can seem difficult for some rental tenants—especially smaller, more informal groups—to comply with the letter of the law as articulated by university risk-management officials. The PAC manager, as

the go-between, can feel "caught in the middle" of the expectations of risk officials and what the client and client representatives feel is reasonable. The institutional risk-management division will be the likely entity to establish required levels of insurance, as well as guidelines for how they are applied. Most state governments do not carry their own liability coverage. Instead, they establish their own self-insurance funds, and venue users often will not have the option of purchasing insurance directly from the venue. Self-insured government-operated venues will require nonuniversity users of their venues to list them as co-insured on the certificates of coverage.

Risk-management concerns are pertinent to campus safety. Although venue managers might share a belief that campus safety officers have a tendency to overthink these issues, inspection personnel have the best of intentions. Their job is to identify, assist, and help the venue manager address threats to employee and public safety. It is in everyone's best interest to adhere to safety recommendations and reports, but it can at times be difficult and expensive to operate under some of the more stringent stipulations that will be called for. The risk managers at an institution may find disagreement with facility technicians and staff on matters such as housekeeping of catwalks and electrical raceways, control booths, orchestra pits and trap rooms, storage and gear rooms, dressing rooms, offices, and more.

There will always be periods of conflict between collegiate PAC managers and university safety officials because some risk-management efforts can at times seem highly prohibitive to PAC operations. Typically, campus risk managers will not be familiar with how PACs operate and why they are a very different animal than a classroom or library facility. As with any preventative measure, excessive care to avoid accidents and injuries can seem onerous at times. The PAC manager should keep in mind that safety officials usually have the best interests of the staff, the university, and the public at heart. They can be of invaluable service, especially when they know that procedures have been adhered to. While frequent inspections can be a source of irritation to staff, they are a good way to keep overall safety precautions from slipping.

In any large institution, there is always debate concerning who at the institution is deemed the appropriate spokesperson or media liaison, especially when a crisis arises. Generally, university administrations will rely on staff communications professionals to fill this role. However, there are times when unexpected matters suddenly surface, and these designated campus communicators simply are not available. The PAC manager is wise to determine who the organization's go-to communicator will be before an emergency arises. At many institutions, the office of the school's overarching public relations official is predetermined to be the default spokesperson.

Another somewhat difficult characteristic of university operations is the need for essential services that are beyond the PAC's control. Other departments within the university may have campus domain over important services such as HVAC, electrical maintenance, custodial service, trash

collection, or grounds and landscape maintenance. The PAC manager has very little control over when services are performed or what they cost, but it can help to have a good relationship with key individuals in these departments. Of course, the PAC will be subject to rates established either by these departments or for the position classifications that those departments employ to get the work done. In addition, PACs are usually six and seven days per week operations, with many irregular shifts and work times. It is important to budget overtime payment for many services, especially on weekends. An alternative would be to subcontract privately with less expensive, more flexible companies off campus, assuming the responsible departments on campus can be persuaded to waive their first refusal rights for these tasks.

## In Summary

Managing a performing arts center in the university environment can be highly challenging but also highly rewarding. Those who enjoy and appreciate a youthful environment, and a place where discourse and diversity are an intrinsic part of their work, will likely be drawn to collegiate PACs. At times, colleges have the characteristic feel of living on an island or in a separate universe. Conversely, at times politics and bureaucracy can quickly negate the utopian vibe, and being dependent on university funding can lead to frustration. Some colleges maintain a strong dedication to the arts, but many more are less eager to support PACs at what they may view as being at the expense of other programs.

Throughout the United States, universities will always have need of arts venues for their own uses. However, looking to the future, universities will need to continue to find more resources in order for their PACs to remain competitive with private and government-owned venues. In terms of maintaining external programming, community outreach, and rental activity, continuing increases in competition from non-university venues will be a significant and persistent factor in collegiate PAC management.

While the university PAC functions to a great extent similarly to other types of PACs, the higher education context and the academic mission of the institutions within which they are housed call for a distinct managerial approach. This chapter has provided behind-the-scenes insight into what leading operations of a collegiate PAC entails, including approaches to managing governance, university relations, funding, programming, contracting, communications, risk management, and event management.

# 10 Impact of the Performing Arts Center on the Local Community

*Ann Patricia Salamunovich Wilson*

## Introduction

While there have been reports and studies highlighting the economic and fiscal impact of performing arts centers (PACs), a significant gap exists in current research that assesses the more comprehensive value of PACs in their communities. This chapter presents a framework and case study for analyzing the value of a performing arts center in three main categories of *public engagement value, economic value,* and *cultural value.* As depicted in Figure 10.1, this framework for analysis considers the value of the PAC to patrons, volunteers, and education within its public engagement value; the value to local businesses, to cultural tourism, and to anchoring an arts district within its economic value; and the value to resident companies, arts programs, and cultural advocacy within its cultural value.

To illustrate how this framework can be used across the nation to assess the value of the PAC to its local community, this chapter profiles its use in analyzing the comprehensive community value of Portland'5 Centers for the Arts, a major performing arts center in Portland, Oregon. Portland'5 was rebranded and renamed as such in 2013; its former name (also referenced throughout this chapter) was the Portland Center for the Performing Arts (PCPA). Portland'5 Centers for the Arts is one of the busiest performing arts centers in the United States, with almost 1,000 performances and over nine hundred thousand patrons annually. Portland'5 Centers for the Arts consists of five venues: the Keller Auditorium (seats 2,992), the Arlene Schnitzer Concert Hall (seats 2,776), the Newmark Theatre (seats 880), the Dolores Winningstad Theatre (seats 304), and the Brunish Theatre (seats 200). Its resident companies include the Oregon Symphony, Portland Opera, Oregon Ballet Theatre, Oregon Children's Theatre, and the Portland Youth Philharmonic. Portland'5 Centers for the Arts is managed by Metro, a regional governmental commission composed of representatives of several counties and cities in the Portland metropolitan region, and through the Metropolitan Exposition and Recreation Commission (MERC).

This chapter presents findings from an in-depth case study on the community value and impact attributed to Portland'5 Centers for the Arts; the

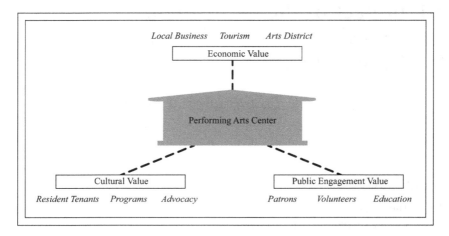

*Figure 10.1* Framework for Analyzing the Impact of a PAC on the Local Community

field research took place from 2013 to 2014. The author of this chapter conducted both quantitative and qualitative research, composed of literature review, document analysis, interviews, surveys, and observation as part of a master's degree study.[1] By presenting findings on the resulting identification and articulation of public engagement value, economic value, and cultural value of Portland'5 to its local community, it is hoped that other performing arts centers might develop similar studies in their own communities to build a fieldwide understanding of the importance of these institutions.

## Public Engagement Value in the Local Community

Metro and MERC are committed to implementing excellent cultural policy in the Portland and Tri-County community due to the many economic, civic, and educational benefits that organizations such as Portland'5 Centers for the Arts (Portland'5) provide. Indeed, a performing arts center plays a key role in both urban cultural policy and community politics. Cultural institutions such as Portland'5 provide such value to urban communities because "they point to the potential role and influence of individuals and organizations outside the traditional business and property-led coalitions, which the dominant approach to urban politics, regime theory, has tended to ignore" (Grodach, 2013, p. 84). A creative city composed of symbiotic relationships between civic leaders and institutions like Portland'5 has many positive assets derived from community supporters, partnerships, motivations, and actions. In the United States, among other cities, the *creative city* – movement can also be seen in Portland, and the regional government annually commissions an economic impact study of Portland'5 to demonstrate to the public the value of having such an organization in the community.

In 2013, Shaw investigated Portland as a specific example of a successful regional cultural policy. He posits that organizations such as Portland'5 Centers for the Arts improve the civic health and reputation of the community by

> (a) networking, or "making connections" between artists in Portland and other art centers around the world and (b) making place distinctions, or extending Portland's "foothold," securing the city's reputation "as a widely known destination . . . " In addition, the conversation implies a third strategy (c) making place, by which I refer to the building and development of art venues, supports, and infrastructure at the local level.
>
> (p. 237)

Metro/MERC views Portland'5 as a means to connect audiences (e.g., the community of Portlanders) with other perspectives, groups, presenters, and nationalities. The urban performing arts center provides a means by which to connect and engage the local community with the outside world—artistically, economically, and culturally. Furthermore, the management structure of the venues, which are owned by the city of Portland and managed by the regional government entity Metro, is evidence of cooperation and networking that transcends politics. Civic leaders understand that Portland'5 is an influential player in shaping the urban landscape of Portland, Oregon, economically and culturally for the people who live and work within the region. As stated by former Portland mayor Sam Adams, "PCPA is a vital resource for Portlanders that contributes significantly to the quality of life, culture, and the economy of our region" (as cited in Appendix A of the Portland City Auditor Report, 2011).

## The PAC as a Venue: Events

The executive director of the Portland'5 Centers for the Arts, Robyn Williams, notes that "compared to the industry, we are heavily occupied. The more dates with shows, the better we can hold down costs to some of our arts organizations. It actually allows us to support them more" (personal communication, January 30, 2014). Table 10.1 provides the average capacity of the 2012–2013 season by venue and type of event (this includes ticketed events but excludes the free or nonticketed events). The Schnitzer and Keller theaters had the highest capacity ratios. The "Popular" genre, which includes commercial rock shows and comedians, was the most heavily attended, followed by the Broadway series.

Additional data regarding events reveal the Portland'5 has a higher useday incidence per venue from 2009 to 2012 as compared with similarly sized performing arts centers in North America. Also, Portland'5 attendance has remained relatively stable over the past decade, ranging across the past

*Table 10.1* Average Capacity by Venue by Type

| *Average Capacity by Venue by Type (Calculated)—FY2013* | | | | | | | | | | |
|---|---|---|---|---|---|---|---|---|---|---|
| | B'way | Classical | Dance | Fam | Film | Opera | Pop | Thtr | Var | Total Cap. Rank by Venue |
| Keller | 61% | | 70% | | | 68% | 71% | | 62% | 64% 2 |
| Schnitzer | 88% | 59% | 60% | 68% | 51% | | 75% | | 52% | 65% 1 |
| Newmark | | 62% | 58% | 58% | 82% | 78% | 84% | 46% | 81% | 60% 3 |
| Winningstad | | | 22% | 50% | 34% | | 89% | 49% | 58% | 50% 5 |
| Brunish | | | | 41% | | | | 53% | 38% | 52% 4 |
| Average | 75% | 61% | 53% | 54% | 56% | 73% | 80% | 49% | 58% | 58% |
| Cap. Rank by Type | 2 | 4 | 8 | 7 | 6 | 3 | 1 | 9 | 5 | |

10 years from 769,000 (the low in FY2011) to almost 1 million attendees (AMS Planning & Research, 2013a; 2013b).

## The PAC as a Venue: Defining the Patron

One method to define the patron community is by using ZIP codes collected by the ticketing departments and agencies of a performing arts center. This can be complex to coordinate, as resident companies may not utilize the PAC box office. In the Portland'5 case study, data obtained on commercial, local nonprofit, and Broadway ticket sales provided a significant sample for analysis, representing 110,000 patrons out of the total 785,000 patrons in that year. In this sample, people from 21 different countries purchased a ticket, and 99 percent of patrons were from the United States, including 48 different states and 2 Armed Forces territories. Of the tickets sold, 76 percent were sold to residents of Oregon and Washington, and 63 percent of tickets were sold to residents in the metropolitan region's three counties. This audience willingness to purchase tickets to attend Portland'5 events demonstrates one measure of the public's valuation of the performing arts center.

## The PAC as Engaging the Community in a Breadth of Offerings

Portland'5 has seen a trend of expanded programming in the past several years in order to better engage the community and to provide more opportunities for access and inclusion. In addition to the standard fare expected at a performing arts center (e.g., ballet, opera, Broadway, comedy, symphony), Portland'5 has made a conscious effort to program many free community events and many events that do not center on the performing arts. In order

to reflect this focus on the Portland community and the breadth of art available to the community, a rebranding and renaming campaign was completed in 2013 to change the name from Portland Center for the Performing Arts to Portland'5 Centers for the Arts.

Portland'5 has increased many of its non-ticketed and free events in order to entice the Portland community to stop in and experience its venues in a less traditional format. The visual arts are represented through a popular revolving art gallery in the Antoinette Hatfield Hall Rotunda: "These exhibits serve the dual function of providing gallery space for professional as well as up-and-coming local artists and giving our patrons an opportunity to experience a diverse range of visual art" (Williams & Dresler, 2010, p. 11). The literary arts have a home through the Portland Arts & Lectures series, a popular client, and the Portland'5-produced "Poetry on Broadway" series. Free tours are offered on a regular basis. Additionally, business meetings, film shoots, wedding receptions, conferences, charitable events, blood drives, dance auditions, and many more activities have all been a part of the events calendar over the past several seasons (Williams & Woolson, 2007). Free performances are regularly offered through the *Noontime Showcase, Summer Arts on Main*, and *Music on Main* series'. All of these events attract a different type of patron than might traditionally be interested in entering the venue. It is hoped that, with familiarity, this person will return to purchase other event tickets and become a frequent attendee and supporter of the Portland arts scene.

In 2014, Robyn Williams noted that "Portland'5 is evolving, being more proactive about how we fill dates and providing a whole breadth of activities, whether it's paid tickets or it's a free event" (personal communication, January 30, 2014). Teri Dresler, general manager of Visitor Venues, similarly noted that Portland is "a more attractive city because we have a vibrant arts scene. We are able to offer a wide variety of activities for people with many different interests" (personal communication, February 28, 2014). Tamara Kennedy-Hill, Travel Portland director of community relations, agrees: "Portland'5 excels at having diverse shows and opportunities. Whether you want the symphony, Broadway, a youth program; it really provides, for our community, at various price points, various arts and culture experiences that you can be a part of in Portland" (personal communication, February 28, 2014).

### The PAC as an Arts Education Partner

Portland'5 is a key partner in providing meaningful arts education to the youth of the community. Robyn Williams explains how Portland'5 views its role as a community arts education partner:

> The primary thing we do is make things easier for those who are really in arts education; they have arts education departments and arts educators who work for them. We try to have policies in place that make

it easier for them to do their jobs, like the free summer camps that we offer in the summer, picking up more of the costs for events that serve children. . . . We partner.

(personal communication, January 30, 2014)

Metro and MERC view the support of arts education by Portland'5 as an important part of the organization's mission:

> Often missing from annual business recaps is the impact the arts, and the free arts experiences provided by the PCPA, have on our community's youth. I am particularly proud of the free access we provide to thousands of area students throughout the year, and while these programs are difficult to measure on a balance sheet, we know these investments return valuable future dividends for many years to come.
>
> (Williams & Dresler, 2011, p. 4)

In 2014, a survey instrument was sent to arts leaders in local organizations that work directly with Portland'5 to fulfill their organization's mission of providing quality arts education programming to the youth of the community. Survey responses confirmed the idea that an introduction to the facilities at a young age could de-mystify the experience for youth and could promote attendance and participation in arts activities later in life. These community arts education partners deeply value the collaborative support they receive from Portland'5. Through the family- and youth-oriented educational programming presented by Portland'5 and its user groups, the PAC is able to serve over 100,000 of the community's youth each season. Furthermore, after participating in the groups' Portland'5-based education programs, children continue in their arts engagement. One survey respondent noted that children who participate "continue in music as performers and they continue their interest in the arts overall in their schools after camp experiences, and often major in the arts in college years later." Other respondents noted a direct correlation between children "who see a show [at Portland'5] then sign up for classes or dream to perform on those stages." As evidenced by the breadth of education opportunities Portland'5 provides to the youth of the community and the importance it has to the groups who provide these programs, Portland'5 has an immense value in the community in its educational role in the local region.

## The PAC as a Provider of Volunteer Opportunities

The volunteer group(s) associated with a performing arts center not only provides value in the sheer amount of free labor and personnel costs saved but also offers a sense of community and empowerment to a large group of people from the region. Portland'5 has a robust Volunteer Corps of

over 600 people each season. The volunteers serve in different capacities, including working in the gift shop, welcoming patrons as greeters, performing administrative positions in the office, acting as tour guides, and ushering events. Each season, volunteers donate approximately 50,000 hours of work and save Portland'5 and its user groups over $600,000 in personnel costs (Williams & Woolson, 2007; see also Williams & Twete, 2009).

For the case study of Portland'5 Centers for the Arts, a Volunteer Program survey was administered by the Events Department. Survey responses indicated a high level of engagement and feeling of community within the Volunteer Corps. While many volunteers begin their work as a volunteer for the perks of seeing free shows, the vast majority of them continue—often for decades—due to the sense of camaraderie, feeling of worth, and genuine pride in Portland'5, even when required to pay for parking or to volunteer at events that may not be their first choice.

As demonstrated in this section, PACs that offer a wide variety of events, appeal to broad demographic bases, provide volunteer opportunities, and partner to ensure delivery of arts education contribute to a truly symbiotic relationship with its community and cultural sector. Additionally, healthy and vibrant PACs provide measurable economic benefits to their neighboring communities and urban areas. The next section of this chapter addresses the extremely important role PACs play in the economic health and vitality of their communities.

## Economic Value in the Local Community

A performing arts center has a clear, defined, and direct value for its community, a downtown cultural district, cultural tourism, the local economy, and peripheral businesses. This section demonstrates that the vitality and daily operations of Portland'5 have a very real monetary value to Portland and the tricounty metro region:

> PCPA's three unique venues contribute to the vibrancy of Portland's downtown core, its cultural identity and its economic stability. The region benefits from the on-going operations of the PCPA in a number of ways, including such tangible and intangible benefits as supporting a vibrant downtown Portland by attracting residents and visitors to local businesses, contributing to arts educational institutions including children's theatre, generating public awareness and funding of arts organizations, providing an alternative entertainment option for both residents and visitors, enhancing business for other area companies involved in related services purchased by arts organizations (e.g., advertising, transportation, printing, etc.), attracting in-kind and cash contributions from local arts supporters.
>
> (Williams & Twete, 2009, p. 10)

## The PAC as a Vibrant Arts Hub and Driver of Cultural Tourism

There is no question that Portland'5 Centers for the Arts serves as a significant attraction for both tourism and for the local tri-county region community. Tamara Kennedy-Hill, an expert in cultural tourism in Portland, states that "Portland'5 really is the center for the cultural district. It provides a central value of arts in our community, which makes it great for tourism." She goes on to explain that "the Schnitz is an icon of the city of Portland. It is a way to bring people not only from outside of Portland but within our own community into the downtown region. They are attracted to this arts district" (personal communication, March 4, 2014). Indeed, Portland'5 as an anchor of a vibrant cultural hub was an important idea that emerged during many interviews associated with this case study research project. Teri Dresler pointed out that Portland is a more attractive city due to its "vibrant arts scene with Portland'5 as the hub downtown" (personal correspondence, February 28, 2014). Kennedy-Hill concurs, noting that Portland'5 "provides a good hub and vibrancy for the region, especially the downtown area. People want to visit. I think it helps put Portland on a sophisticated scale" (personal communication, February 28, 2014). Gus Castaneda, chair of the Portland'5 Advisory Board and local hotelier, agrees that "Portland'5 keeps the energy of the area; it keeps [the neighborhood] safer and more vibrant" (personal communication, March 5, 2014).

As described previously, Portland'5 is an important asset in the city's cultural tourism portfolio. Kennedy-Hill clarifies that "it is the arts and the additional assets that make Portland a destination. . . . Portland'5 is really a part of helping expand what makes our destination a great and vibrant place to be" (personal communication, March 4, 2014). Over the past decade, there has been a significant and increasing amount of financial impact attributed to cultural tourism, and much of this is directly related to Portland'5. Travel Portland's consulting group, Dean Runyan Associates, Inc., reported that in FY2013 there was almost $120 million of Portland visitor spending related to cultural tourism, resulting in almost $40 million in cultural tourism–related industry earnings (Travel Portland, 2014).

## The PAC as an Economic Catalyst

As an organization, Portland'5 serves as an economic catalyst that has tremendous, direct, and real financial impact on the community of Portland. Williams and Dresler (2011) point out that "PCPA's performances are more than works of art. They stoke the economic engine that provides jobs, promotes local spending and contribute important tax dollars to state, county, and city coffers" (p. 2). Cheryl Twete, MERC interim director, agreed, noting that Portland'5 plays "a substantive role in our community's health and well-being by inducing spending, supporting local jobs and generating millions in tax revenues that, in turn, fund essential programs and services

upon which we all rely" (Williams & Twete, 2009, p. 3). A resident company executive director agreed:

> Yes, there's enormous value in people coming downtown. The performing arts are vital to the economic wellbeing of a city. People who are coming downtown to our performances, they are spending money on the max line, they are spending money in the parking garages, they are coming in early perhaps to do some shopping and then have a dinner at a restaurant, and then have a drink afterwards. We are one part of an enormous economic engine that keeps the lights on downtown, keeps downtown populated after 10 o'clock at night by people going to the theatres. That creates a safe environment for people who live here and creates enormous economic activity.
>
> (personal communication, March 19, 2014)

It is important to view a performing arts center like Portland'5 not just as an organization where the community can experience transformative arts and culture but also as business that creates economic opportunities for its 46 full-time employees, hundreds of part-time employees, peripheral businesses—including its resident companies and other user groups— surrounding restaurants and hotels, and the rest of the community: "Portland's performing arts center is an economic catalyst that is as important as any major company in our market" (Williams & Twete, 2009, p. 2).

Each year, Crossroads Consulting conducts an economic impact study for Portland'5 that explicitly details the very direct financial impact that the organization provides to Portland:

> In FY2013, the PCPA hosted 957 performances that attracted approximately 785,600 in total attendance. . . . This activity was estimated to generate $63.6 million in total spending which supported 680 full and part-time jobs and created $24.5 million in personal earnings. . . . Tax revenues generated from PCPA-related activities were estimated to be approximately $1.8 million in FY2013.
>
> (Crossroads Consulting Report, 2014, p. 1)

Crossroads further broke out direct spending related to Portland'5 operations, which totaled almost $38 million for the 2013 fiscal year. When adding the total of indirect spending calculated at roughly $26 million for the same period, the study calculated a total of $63.6 million in total spending for FY2013.

## The PAC as a Good Neighbor

Everyone contacted for the Portland'5 case study research conducted in 2013–2014 agreed that the presence and activities of Portland'5 are imperative to the success and life of the peripheral businesses, specifically

the surrounding restaurants and hotels that cater to the patrons and the performing arts groups. As Teri Dresler explained, "Portland'5 is a catalyst for economic activity. That neighborhood and the vitality of it is really interlinked with everything that is going on at Hatfield Hall and the Schnitzer and the Keller. You don't see a lot of people out on the street and frequenting some of those businesses unless there's something going on. That's why it is important to have Portland'5 functioning: the venues really do add to that vitality" (personal communication, February 28, 2014). Local hotel manager Gus Castaneda knows first-hand how important Portland'5 is to the surrounding businesses. "Portland'5 creates a tremendous economic impact. Many restaurants [and hotels] budget their revenues and sales around the events and activities. It's a major reason people go downtown" (personal communication, March 5, 2014).

These statements were confirmed through a survey of local business owners located within a half-mile radius of Portland'5. Greg Higgins, owner of the popular Higgins restaurant a block away from Hatfield Hall and the Schnitzer Concert Hall, proclaimed that he specifically chose the location of his restaurant due to its proximity to the performing arts center: "We chose this location specifically because the surrounding venues bring in high-end entertainment and a clientele with disposable income. We wouldn't change locations with any other restaurant in town. We'd be crazy to" (Higgins, as quoted in Williams & Dresler, 2010, p. 15). Chris Erickson, general manager of the Heathman Hotel, which occupies the location directly adjacent to the Schnitzer Concert Hall, echoes the importance of Portland'5 to his business: "PCPA directly benefits all 225 of the Heathman Hotel team members. The business we receive from PCPA . . . propelled us through the recession. These venues continually provide us with consistent traffic. . . . PCPA clearly has an impact on our economy" (as quoted in Williams & Dresler, 2010, p. 15). Similarly, in response to a survey instrument sent to local business managers, the co-owner and marketing director of a nearby restaurant called Pastini summed up the importance of Portland'5 by stating that "[Portland'5] is an incredibly important key to the success of Pastini's downtown location." All respondents to this survey agreed that Portland'5 is an economic catalyst in the neighborhood and positively impacts their business, and all respondents notice a drop-off in their business activity on days when no events are taking place at Portland'5. Certainly, as all these findings reveal, the urban performing arts center is a very good neighbor indeed.

## Cultural Value in the Local Community

In this case study, the cultural value of a performing arts center to its local community was investigated in the areas of the PAC's relationship to resident companies, its artistic programming, and its cultural advocacy work. It

was found that, in practice, these three areas are interconnected and cannot easily be separated for purposes of research:

> As a prominent member of the arts community, PCPA feels it has a responsibility to give back to the community. Providing affordable performance space to our non-profit user groups is one of the ways that we give back. Through subsidized rent, free performance space, discounted shows for school children and donated time from volunteers, we strive to provide space for groups that would otherwise be unable to perform in our venues. Our resident companies enjoy subsidized rent, while groups such as Metro Arts and Oregon Children's Theatre . . . are given free performance space for summer camps.
>
> (Williams & Woolson, 2007, p. 11)

However, the relationship between the leadership of performing arts centers and that of its resident companies is not always smooth, largely due to differing community perceptions and understandings of the scope and scale of support that the PAC is able to provide to local arts organizations. The balance between economic support for local arts groups and revenue generation—and the communication of this topic—is one of the largest areas of interest when examining the relationship between the performing arts center and its resident companies. For the case study of Portland'5 Centers for the Arts, the researcher interviewed the senior management of the PAC's resident companies: Oregon Symphony, Portland Opera, Oregon Ballet Theatre, Oregon Children's Theatre, and Portland Youth Philharmonic. This section of the chapter delves into the relationship between the Portland'5 and its resident companies, provides a detailed analysis of Portland'5's subsidy amounts of these organizations, discusses how Portland'5 balances the support of these arts organizations, and provides insight into the difference in perception between the venue and the organizations regarding the extent of this support.

## The PAC as Balancer

Experts all agree that a performing arts center faces challenges in balancing the events of their resident companies with those of commercial performances and events. Often, resident arts organizations occupy the majority of the venue calendar while paying the lowest rental rate. Webb (2004) notes that "one of the great programming challenges is the need to balance rental activities with touring programs" (p. 46). "The [facility must provide] the best possible mix of events for the community . . . [while] . . . soliciting events to meet the programmatic and financial projections of the facility" (Russo, Esckilsen, & Stewart, 2009, p. 50). These International Association of Venue Management experts go on to state that "priorities given to prime tenants or facility users can ensure a high level of event activity," but they

caution against giving these users exclusive rights in order to maintain enough calendar space to generate enough revenue to support these same users (Russo et al., 2009, p. 50).

In an interview, Robyn Williams suggested that Portland'5 maintains a good balance in its calendar, acknowledging that supporting the resident companies is important and has immense value, while maintaining that commercial business is important from both a financial standpoint and as a way to cater to the broadest population possible (personal communication, January 30, 2014): "The PCPA provides subsidized use of its venues to local resident and nonprofit arts organizations as well as space for popular commercial shows such as Broadway musicals and concerts" (Williams & Woolson, 2007, p. 8). During the 2013 season, the five resident companies occupied approximately 35 percent of the calendar and required 45 percent of total Portland'5 expenses while they accounted for just 15 percent of total revenue.

All parties interviewed for this case study were very aware of the precarious balance of PAC revenue generation needs versus PAC support of local arts organizations. Stan Foote, artistic director at Oregon Children's Theatre, simply stated that "they have economic goals they have to reach to stay in business; we have economic goals we have to reach to stay in business" (personal communication, February 4, 2014). Mary Crist, interim co-president and general manager of the Oregon Symphony, knows that the need to book commercial presenters is a reality, but feels that this impinges on the symphony's use of the Schnitzer. "The challenges come when pressures are put on Portland'5; their resources are limited and that has created some mutual challenges. I understand their need to be responsive to commercial promoters, but the promoters seem to want equal access to hall dates." Crist would "like to see the pressures removed from [Portland'5] so they have better support—whether it's governmental supports or through Metro—so that it really is viewed as a performing arts center for Portland-area performing arts as opposed to a generic venue for touring groups to come in" (personal communication, February 26, 2014).

Neville Wellman, director of finance and operations at the Oregon Ballet Theatre, values that resident companies get the first chance to book dates each season, but wishes that OBT didn't have to "compete for those dates with commercial promoters who come into town. . . . It is an economic reason, which I understand. They have their budget guidelines they need to meet each year, just like we do" (personal communication, March 7, 2014). Teri Dresler summarized the situation as follows:

> Within the city agreement is a defined mission for the theatres, and part of that mission is to subsidize the resident companies. There are some historic use patterns of the facilities by those resident companies

that . . . are becoming more and more challenging to the Portland'5 ability to generate commercial revenue when theatres are dark. That arrangement is based in history, but as we are driven by expenses to generate more revenue and get more aggressive with commercial business, we really need to fine-tune how much use people get for little or no rent for rehearsals and things like that, and how we make those adjustments without creating a negative impact on the resident companies. It is this really tight balance, this subsidy versus being more economical and efficient.

(personal communication, February 28, 2014)

To better understand this tight balance for performing arts centers, it is helpful to look at the resident companies' subsidized use by Portland'5 and the PAC financial value to them in detail.

### The PAC as Resident Company Supporter

Robyn Williams is proud that Portland'5 Centers for the Arts is able to heavily subsidize their resident company organizations so that they can continue to thrive in presenting their performing arts productions in the five venues:

Our job is to responsibly manage the venues. We try to accomplish this within the means that we have; making sure that these are well-maintained, beautiful venues; that all the different shows can come in and have the equipment that meets their needs, that they have the tools to produce their art. We provide subsidized use, very heavy for our resident companies but to all of our local non-profits, as well as having venues that are competitive so our commercial promoters find us to be an attractive market and can bring in those shows that the public wants to see.

(personal communication, January 30, 2014)

Gus Castanada agrees that Portland'5 provides immense value to its resident companies, noting that "Portland'5 definitely extends a large effort to accommodate the needs of the resident companies" (personal communication, March 5, 2014). Williams notes that it is very inexpensive for the resident companies to use the halls, a statement confirmed by the fact that daily rental rates for resident companies can be as low as $400 per day, while commercial promoters may pay up to $5,000 per day for the same hall and level of customer service: "The commercial users are not getting discounted rent. They pay the full-meal deal here, which they are accustomed to doing, and that money is used to help support the non-profit groups" (Williams, personal communication, January 30, 2014). But the PAC support to

resident companies and other local arts groups goes far beyond discounted rent. In an interview, Williams detailed many of the services Portland'5 provides for which costs are not recovered:

> We do all the customer service training. We provide volunteers at no cost to anybody. We do all of the uniforms and fire drills and the maintenance and all of the things that make the buildings good homes for them so that their audiences like to come here. We also spend money on theatrical equipment that enhances their art form; we buy sophisticated lighting systems for them and sound systems, staging, chairs, and so on. We own the symphony shell that the symphony uses—all of those components that if they were out on their own they'd have to pay for and maintain. When the boiler breaks down, they don't get billed for that; we pick up those extra costs. The buildings are getting old and a lot of equipment needs to be replaced, and they're not paying for that. By holding the costs down, that allows them to put money into producing their art form and enables them to hold down ticket prices at very low levels.
>
> (personal communication, January 30, 2014)

### Operational Expense and Revenue Analysis

A key strategy to accomplish the goal of subsidization and support for community arts organizations while maintaining a balanced budget within the current PAC strategic plan is to understand the business mix and current rates while developing profit-and-loss methodologies by user and venue. For this case study, the researcher undertook an analysis of the operational expenses and revenues of Portland'5 to determine an average "per use" rate for each of the five venues, as well as the total allocated cost of operating each venue during the 11-month period of July 2012 through May 2013 (see Table 10.2). These expenses were then allocated against the user-generated revenue during the same period. All data discussed in this section of the chapter were taken from the Portland'5 General Ledger Financial Data in the EBMS software. The following section presents findings and outlines the procedures, allocation methodology, and data sources of the analysis.

Table 10.2 indicates the average per-use cost of each venue and the total expenses associated with this venue over the 11-month period under review. The average per-use cost ranges from approximately $15,000 at the Keller Auditorium to approximately $2,000 in the Brunish Theatre. As stated above, the resident rental rates can be as low as $400 per day. A table listing the expenses allocated to users and the average per-use cost is provided in Table 10.3.

Table 10.2 Operational Expenses Allocated to Portland's Venues

*Operational Expenses Allocated to Venues*

| | Keller | | Schnitzer | | Newmark | | Winningstad | | Brunish | | Total |
|---|---|---|---|---|---|---|---|---|---|---|---|
| | Per Use | Total | Per Use | Total | Per Use | Total | Per Use | Total | Per Use | Total | Total |
| Overhead | 12,019 | 2,596,204 | 11,282 | 2,408,777 | 2,989 | 763,589 | 1,081 | 263,784 | 564 | 126,685 | 6,159,039 |
| Ticket Overhead | 487 | 39,953 | 487 | 27,284 | 487 | 40,196 | 487 | 54,084 | 487 | 103,785 | 265,302 |
| Utilities | 749 | 142,300 | 694 | 132,931 | 508 | 114,140 | 184 | 39,429 | 94 | 18,935 | 447,735 |
| Direct Stage Labor | Direct | 340,598 | Direct | 415,120 | Direct | 240,809 | Direct | 30,576 | Direct | 24,523 | 1,051,626 |
| Stage Labor Overhead | 382 | 82,585 | 358 | 76,400 | 97 | 24,892 | 38 | 9,327 | 19 | 4,205 | 197,409 |
| Stagehand Labor | Direct | 70,932 | Direct | 202,144 | Direct | 49,836 | Direct | 2,482 | Direct | 963 | 326,357 |
| Ticket Agency | 708 | 58,017 | 708 | 39,622 | 708 | 58,370 | 708 | 78,536 | 708 | 150,703 | 385,248 |
| Rental Equipment | 5 | 871 | 1 | 269 | | | | | | | 1,140 |
| Stage Equipment | 12 | 2,674 | 83 | 17,735 | 10 | 2,634 | 2 | 608 | | 89 | 23,740 |
| Sponsorship | — | — | — | — | 271 | 32,943 | 271 | 12,743 | 271 | 2,576 | 48,262 |
| Show Services | — | — | — | — | 20 | 4,600 | — | — | — | — | 4,600 |
| Depreciation | 478 | 103,282 | 655 | 139,928 | 197 | 50,403 | 85 | 20,752 | 39 | 8,724 | 323,089 |
| **Total** | **14,840** | **3,437,416** | **14,268** | **3,460,210** | **5,287** | **1,382,412** | **2,856** | **512,321** | **2,182** | **441,188** | **9,233,546** |
| *Total Use Days* | | 216.0 | | 213.5 | | 255.5 | | 244.0 | | 224.5 | 1,153.5 |

*Table 10.3* Operational Expenses Allocated to Users

*Operational Expenses Allocated to Users*

| User | Expense | Use Days | Average Per-Use Cost |
|---|---|---|---|
| Oregon Symphony | 2,058,816 | 139.5 | 14,759 |
| Tier 1—Commercial | 1,369,351 | 108.5 | 12,621 |
| Broadway | 1,156,136 | 69.0 | 16,756 |
| Portland Opera | 1,062,576 | 86.0 | 12,356 |
| Tier 2—Local Nonprofits | 869,580 | 280.0 | 3,106 |
| Oregon Ballet Theatre | 828,763 | 65.0 | 12,750 |
| Oregon Children's Theatre | 664,422 | 176.0 | 3,775 |
| White Bird | 359,575 | 32.5 | 11,064 |
| Singing Christmas Tree | 280,962 | 18.0 | 15,609 |
| Third Rail | 203,389 | 73.5 | 2,767 |
| Tears of Joy | 112,119 | 74.0 | 1,515 |
| Portland Arts & Lectures | 102,164 | 6.5 | 15,717 |
| Portland Youth Philharmonic | 74,045 | 5.0 | 14,809 |
| Jefferson Dance | 41,032 | 6.0 | 6,839 |
| Portland Institute for Contemporary Art | 32,423 | 13.0 | 2,494 |
| Metropolitan Youth Symphony | 18,196 | 1.0 | 18,196 |
| Total | 9,233,546 | 1,153.5 | |

Table 10.3 shows the total allocated expense by user, the number of use days during the 11-month period, and the average per-use cost. These data indicate that the Oregon Symphony was allocated the most operational expense due to their heavy occupation rate. Portland'5 expends an average of almost $15,000 per use day for the symphony. These data show that the symphony has a higher operational expenses allocation than all commercial and non-local nonprofit groups combined for the 11-month period under review.

Table 10.4 contrasts the user's revenue and expense over the 11-month period under review and highlights the subsidy amount and percentage per user. This list is sorted from most subsidized to least subsidized. These data show that all but three groups are subsidized by Portland'5. In sum, Portland'5 Centers for the Arts' resident companies as a group have the highest rate of subsidy percentage levels, with an average of 64 percent. Other local nonprofit groups receive subsidy percentages ranging from roughly 30 percent to 42 percent. It is important to note that through non-operating revenue (this includes contributed income, food and beverage net income, and income earned from activities not directly related to specific events), Portland'5 is able to operate in the black, with periodic net income of almost $400,000.

*Table 10.4* Subsidy Amount by User Group

## Subsidy Amount by User Group

| User | (Revenue) | Expense | Subsidy Amount | Subsidy % |
|------|-----------|---------|----------------|-----------|
| Oregon Symphony | (818,566) | 2,058,816 | 1,240,250 | 60% |
| Portland Opera | (281,248) | 1,062,576 | 781,328 | 74% |
| Oregon Ballet Theatre | (337,457) | 828,763 | 491,306 | 59% |
| Oregon Children's Theatre | (195,684) | 664,422 | 468,738 | 71% |
| Tier 2—Local Nonprofits | (500,643) | 869,580 | 368,937 | 42% |
| Third Rail | (72,531) | 203,389 | 130,858 | 64% |
| Singing Christmas Tree | (156,806) | 280,962 | 124,156 | 44% |
| White Bird | (237,711) | 359,575 | 121,864 | 34% |
| Tears of Joy | (24,202) | 112,119 | 87,917 | 78% |
| Portland Youth Philharmonic | (30,848) | 74,045 | 43,197 | 58% |
| Jefferson Dance | (34,912) | 41,032 | 6,120 | 15% |
| Portland Institute for Contemporary Art | (26,971) | 32,423 | 5,452 | 17% |
| Metropolitan Youth Symphony | (16,136) | 18,196 | 2,060 | 11% |
| Portland Arts & Lectures | (126,554) | 102,164 | (24,390) | –24% |
| Broadway | (1,419,500) | 1,156,136 | (263,364) | –23% |
| Tier 1—Commercial | (2,407,988) | 1,369,351 | (1,038,637) | –76% |
| Ticketing Incentive Award | (199,567) | — | (199,567) | |
| Earned Revenue | (40,914) | — | (40,914) | |
| Operating Totals | (6,928,238) | 9,233,549 | 2,305,311 | Net Operating Deficit |
| Non-Operating (Revenue)/ Expense *Beyond Scope* | (3,934,872) | 1,241,005 | (2,693,867) | |
| Tie-Out to General Ledger | (10,863,110) | 10,474,554 | (388,556) | Net Income |

### The PAC as a Community Arts Partner

Of the resident company managers interviewed, 100 percent in this case-study research project agreed that Portland's Centers for the Arts help them to fulfill their mission. Wellman notes that "The facility that Portland's offers us is what [Oregon Ballet Theatre] needs in order to present what we do as a ballet company" (personal communication, March 7, 2014). Foote agrees: "[Portland's5] helps us a lot. They help us serve our intended audience. . . . We get resident rates, that's important" (personal communication, February 4, 2014). A resident company director notes that Portland's5 fills a need in that "we need a venue for audiences to come to and experience the art form we produce" (personal communication, March 19, 2014). Crist appreciates

that "the consistency facilitates familiarity with our core audiences and our musicians; their needs are anticipated" (personal communication, February 26, 2014).

When resident company managers were asked to describe Portland'5, adjectives such as *essential, supportive, compromising, professional, service-oriented,* and *accommodating* were used consistently. Nouns such as *managers, believers, partners,* and *a home* were popular images, as well. Crist stated that "our relationship with Portland'5 is positive. We have an interest in mutually supporting each other" (personal communication, February 26, 2014). Wellman offered that "It is a very good relationship; a very supportive relationship on the part of Portland'5" (personal communication, March 7, 2014). One of the best descriptions was offered by Foote, when he shared that "our relationship with Portland'5 is like a good, healthy marriage. We talk about things. We are not afraid of each other" (personal communication, February 4, 2014).

However, in the research process, it also appeared that in some areas there was a slight disconnect in expectations and perceptions that could be improved with communication. A frustration about a perceived lack of communication was shared by several interviewees. Dresler shares this point of view, noting that she understands all involved are trying to run their businesses. She suggests that it would be beneficial for all parties involved to participate in "a facilitated session [to] really understand everybody's goals and objectives and limitations and figure out how to live better together. . . . Portland'5 and Metro need to listen and really let people talk to us about the stresses they have in trying to operate within our rules and regulations so that we can understand what they are up against" (personal communication, February 28, 2014). Furthermore, more explicitly sharing with the resident companies detailed information about the extensive benefits that they receive—as detailed in this chapter—may assist all parties in reaching more mutually acceptable compromises in terms of sharing dates, flexibility, and continuing the overall feeling of goodwill toward each other. It may be important for Portland'5 to remind its user groups that, yes, part of the mission may be supporting their art forms and helping them to thrive, but it also contains language about diversity of programming and ensuring adequate funding through a balanced mix of offerings. Historic use patterns may not necessarily reflect the updated mission and strategic goals as outlined in the 2012–2017 Portland'5 Centers for the Arts Strategic Plan.

In this case study, all resident company managers agreed that Portland'5 is vital to their organization's success. Without Portland'5, these organizations would have to "scramble" (a popular word choice when questioned) to find a new home capable of housing and supporting their art. Foote commented that "there is a need in the community for that space" (personal communication, February 4, 2014). Access to these buildings—these publicly owned assets—is of tremendous cultural value to these organizations.

## Conclusion

The purpose of the study discussed in this chapter was to determine whether Portland'5 Centers for the Arts provides community value to the city of Portland, Oregon, and its surrounding region. In this study, "community value" is composed of three themes: public engagement value, economic value, and cultural value. By methodically researching this question through field research comprised of document analysis, interviews, surveys, and observation, it was conclusively demonstrated that Portland'5 has immense value to its local community. In addition, by providing a high number of events per year, expanding free programming options, and broadening the scope of art presented within the venue, Portland'5 is guaranteeing a multigenerational and diverse audience and performer base. By increasing engagement and participation, Portland'5 also serves as an economic catalyst within the neighborhood and the city. Portland'5 is a committed partner to its user groups—specifically, its local, nonprofit resident companies—by providing subsidies and supporting educational programming.

The case study profiled in this chapter successfully measured—through both qualitative and quantitative methods—a broad variety of values, as described earlier, so that Portland'5 is able to represent itself and demonstrate to its governing entities why it is important and the valuable roles it plays in the community. The information generated through this study is important for communications to the City of Portland, which owns the venues, as well as for the Portland'5 user groups, its patrons, and the public at large. The research methods developed and implemented to assess Portland'5 Centers for the Arts' impact on the local community are fully replicable in other communities across the nation and internationally.

The relationship between a local community and its performing arts center is incredibly important to ensuring the vitality of both the center and the community, and that all public spaces are being assessed with regard to accessibility, engagement, and participation. Research in this area is useful for several parties. Performing arts center personnel may find it helpful for partnerships, branding, programming, development, and marketing. Government officials may find it useful when deciding whether to fund these centers and to understand how these centers support their nonprofit user groups and resident companies. Resident companies and nonprofit user groups can better understand how their venue supports their mission and complexities of the venue management business—and perhaps learn how to better navigate this framework for their own organization's benefit.

This case study, as a cohesive narrative of the Portland'5 impact on the local community, is a way to begin to communicate with the diverse constituencies and public offices to tell the story of the value a performing arts center brings to its community. Indeed, the case study process itself helped to facilitate conversations between Portland'5 and its user groups, its governing entities, its performers, its volunteers, its arts education groups,

its patrons, and many others. By opening the lines of communication, it is hoped that even more value can be generated through teamwork, collaboration, and genuine understanding of the different roles undertaken by each of the players. By beginning to document and quantify the value of a performing arts center to its community, one can begin to understand the importance of cultural institutions that serve as a foundation for a community. Communicating this value to local officials, regional governing entities, donors, local nonprofit groups, and the public is vital to ensuring the continued success of a performing arts center.

## Acknowledgments

The author thanks the key research partners for this study, particularly Robyn Williams, Jason Blackwell, Jeannie Baker, and Patricia Dewey Lambert, and gratefully acknowledges the valuable information provided in interviews and survey responses from a broad array of case study research participants.

## Note

1 The full master's research project is published online at https://scholarsbank. uoregon.edu/xmlui/handle/1794/17941.

## References

AMS Planning & Research. (2013a). *2012 PAC stats report: Prepared for Portland center for the performing arts*. Petaluma, CA: AMS Planning and Research.

AMS Planning & Research. (2013b). *Performing arts center stats: Benchmark and performance measurement report*. Petaluma, CA: AMS Planning and Research.

Crossroads Consulting Services. (2014). *Portland Center for the Performing Arts: Economic and fiscal impact analysis FY2013*. Retrieved from Metro.

Grodach, C. (2013). Before and after the creative city: The politics of urban cultural policy in Austin, Texas. *Journal of Urban Affairs, 34*(1), 81–97.

Office of the City Auditor, Portland, Oregon. (2011). *Portland center for the performing arts: Outsourced management good for city, but agreements and oversight need improvement* (Report #393, June 2011). Portland, OR: Audit Services Division.

Portland'5 Centers for the Arts. (2013). *2012–2013 Volunteer Program Appraisal Form* [Data file]. Retrieved from Portland'5 Centers for the Arts Events Department.

Russo, F.E., Eskilsen, L.A., & Stewart, R.J. (2009). *Public assembly facility management: Principles and practices*, 2nd edition. Coppell: International Association of Assembly Managers.

Shaw, S. (2013). Planned and spontaneous arts development: Notes from Portland 2013. In C. Grodach & D. Silver (Eds.), *The politics of urban cultural policy: Global perspectives* (pp. 236–248). London: Routledge.

Travel Portland. (2014). *2013 preliminary travel impacts for Portland metro (Clackamas, Multnomah & Washington counties)*. Dean Runyan Associates, Inc.

Webb, D.M. (2004). *Running theatres: Best practices for leaders and managers*. New York: Allworth Press.

Williams, R., & Dresler, T. (2010). Portland Center for the Performing Arts: State of the Stage 2009–2010. Retrieved from PCPA Internal V-Drive on June 18, 2013.
Williams, R., & Dresler, T. (2011). Portland Center for the Performing Arts: State of the Stage 2010–2011. Retrieved from PCPA Internal V-Drive on June 18, 2013.
Williams, R., & Twete, C. (2009). Portland Center for the Performing Arts: State of the Stage 2007–2009. Retrieved from PCPA Internal V-Drive on June 18, 2013.
Williams, R., & Woolson, D. (2007). Portland Center for the Performing Arts: State of the Stage 2006–2007. Retrieved from PCPA Internal V-Drive on June 18, 2013.

# 11 The PAC as Intermediary

## Models of Collaboration and Partnerships Among Local Performing Arts Organizations

*Gretchen D. McIntosh*

Local performing arts centers (PACs) have long exhibited shared service models with resident companies utilizing space for rehearsal and performance at a reduced rate and even working collaboratively to share cost on marketing and other back-office functions. Some local performing arts centers are becoming well known nationally for an expansion of the resident company model that offers a fully integrated administrative shared service network.

Examples of organizations sharing services are prevalent and continue to grow in number. Organizations depend on scarce and valued resources to function, including monetary or physical resources such as performance or rehearsal space, information or industry knowledge, administrative skill, and social legitimacy. Resources sought can also include labor force, board members, and audiences. All organizations acquire some of their needed resources from external entities. This need for resource acquisition offers challenges depending on the environment in which the organization functions, the availability of resources required, and the level of resources required.

The Woodruff Arts Center in Atlanta operates on a shared services model with the Atlanta Symphony that includes the provision of utilities, IT, human resources, finance, and development. McManus (2016) highlights another instance of a shared service agreement focusing on the newly signed deal between the Hartford Symphony Orchestra and the Bushnell Performing Arts Center and the outsourcing of all administrative functions of the orchestra to the PAC. The interorganizational ties between arts and culture organizations and the local performing arts center that are created via contract or informal agreement are varied and specific to the individual needs within the geographic environment of the organizations. This chapter identifies typical shared services in the performing arts and how the partnerships and collaborations to share services often take place with the community performing arts center at the center of these agreements, acting as an intermediary between needs and resources. As models of shared services are becoming more prevalent, it is necessary to understand these models and their possible impact on the creative ecology.

## Interorganizational Ties

Performing arts centers can be in collaborative agreements or interorganizational ties that are based on a variety of service provisions with varying degrees of interconnectedness between the organizations. Figure 11.1 offers a way to frame the different interorganizational ties that may be present in a cultural ecology between the local performing arts center and other arts or culture organizations. The interorganizational tie with the most interconnectedness between an organization and the local performing arts center is administrative shared services. The tie with the least amount of interconnectedness needed for service provision is ticketing.

Ticketing is a service provided by many local performing arts centers for multiple arts groups and small organizations. Small performing arts groups desire the access and ease of a mobile-enabled, web-based ticketing service for their patrons but are unable to afford the large expense on their own. The local performing arts center is able to offer use of the ticketing service

*Figure 11.1* Performing Arts Center/Organization Ties
Illustration by Stephanie McCarthy

for a fee to the arts group. Ticketing is often the most widely provided service and requires a low level of direct collaboration with an organization aside from basic program information and a contract regarding fees for use of the online purchasing system and box-office staff if applicable.

Marketing, accounting services, IT support, and fund-raising are service provisions often shared with the local performing arts centers by other arts and culture groups or organizations. Collaborative marketing agreements continue to increase in popularity as local performing arts centers provide marketing services for a contract fee. Marketing collaborations also allow for the advertisement of multiple arts events happening around the same periods to drive tourism. Websites and social media become active tools for collaborative marketing agreements benefiting the smaller organizations via the provision of service through a contract fee while helping to support the marketing/social media staff person(s) at the performing arts center.

Accounting services or bookkeeping and IT support are provided on a contract basis utilizing the expertise of staff from the local performing arts center to benefit other arts and culture organizations while providing a source of revenue for the PAC. Fund-raising services such as grant writing, event planning, donor research, and cultivation can be outsourced to the larger local performing arts center, providing the smaller arts and culture organization with access to highly skilled staff and hopes of increased return on investment. The provision of services related to accounting, IT, marketing, and development in organizational ties require more depth to the relationship between the organizations involved than ticketing alone does. In the provision of these services, some extensive knowledge about daily management, programming, and financials is necessary to effectively provide said services. In exchange for the contract fee to the local performing arts center, the smaller arts and culture organizations receive the provision of benefit that allows organizational energy and resources to be spent on other services such as programming or education and outreach.

Resident companies are the next level of interorganizational tie or collaborative agreement that may take place between the local performing arts center and other arts and culture organizations in a creative ecology. Resident companies often take advantage of service provision by the PAC but also utilize space in the PAC for a discounted price. Resident companies may be involved in a contract agreement with the PAC for ticketing, marketing, accounting, IT, and/or fund-raising but are a different type of tie because of their use of the performing arts center space. Resident companies are different from other venue space renters as they are often given priority in space use over the public rental of the venue and are often able to use the space at a deeply discounted rate. The resident companies are legitimized through their relationship with the local PAC and provide additional revenue opportunities for the PAC through programming and space rental on top of any other contract service fees.

Arts and culture organizations may be in an interorganizational tie with the local PAC through theater or venue management. This tie is not a full day-to-day management service contract, but can include management decision along with service provision involving marketing, accounting, fundraising, IT, and/or programming. A management contract may also be in place for purposes of remodeling or renovations for the theater or venue.

Administrative shared services between the local performing arts center and other arts or culture organizations can take many forms but are distinguishable from the rest of the interorganizational ties because of the depth of interconnectedness that results from active involvement in day-to-day operations of the organization outside of the local PAC. An administrative shared service contract may involve the provision of any of the previously mentioned services in conjunction with decision-making regarding programming and/or day-to-day management of the organization. This highly interconnected tie is becoming more popular as arts and culture organizations strive to manage scarce resources in their individual creative ecologies. The local performing arts center often situates itself as an intermediary between an arts and culture organization and the resources necessary to achieve financial sustainability, artistic creation, and fulfillment of community need through mission.

Partnerships between organizations are not new phenomena. As Vaughan and Arsneault (2014) note, organizational collaborations are formed to address resource scarcity in many forms and are a growing trend in the third sector. These interorganizational ties can address management and operational issues or the outsourcing of tasks, the need to acquire resources they are unable to access independently, the desire to access expertise, and the need to address pressures in the environment (Guo & Acar, 2005; Sowa, 2009).

The many advantages of interorganizational ties may include access to new and improved resources, technologies, and skills as well as systems or additional markets that may help an organization move into a more stable position in an unstable environment (Bretherton & Chaston, 2005). This pursuit of economic stability as a motivation behind collaborative or interorganizational ties is well founded in the literature (Mosley, Maronick, & Katz, 2012; Pfeffer & Salancik, 1978). Faced with a daunting financial future, a nonprofit may choose to cut internal staff to save money and seek a contracted service to fulfill the need or seek the provision of service in-kind. Meiseberg and Ehrmann (2013) found that an organization with high knowledge resources and experienced management were far less likely to seek entrance into a cooperative agreement such as an interorganizational tie. Organizations lacking in experienced management or other resources may seek to enter into an interorganizational tie to have access to these resources.

Interorganizational ties arise out of the same desire of outcomes for organizations that can often lead to mergers but do not require the same resources, circumstances, or formal organizational change. Coordination of organizations can take many forms including but not limited to collaborative

programming, advisory boards, trade associations, coordinating councils, and social norms. Guo and Acar (2005) state that the formality of the collaboration is influenced by the size of the organization in that smaller organizations struggle with greater resource scarcity and thus are more likely to enter into more formalized collaborations. Coordination depends on organizations making voluntary choices about linkages and allows for movement in and out of the interorganizational tie. In exploring how interorganizational ties with a local performing arts organization are structured, it is necessary to look at how certain choices remain voluntary, especially the ease with which movement may occur out of the interorganizational tie.

The reorganization, restructuring, reinvention or reengineering through interorganizational ties or collaborative agreements refers to changes in the organizational structure or how an organization approaches its tasks or goals. These tasks or goals can include processes, efficiencies, effectiveness, or other goals that can result in a change of the basic policies or roles of the organization. Sowa (2009) found that nonprofit interorganizational ties offer benefits to the provision of service and to the organization as a whole. Her finding suggests efficiency and survival as desired outcomes of collaborative ties.

Resource Dependency Theory offers coordination, or interorganizational ties, as providing four benefits for organizations attempting to manage interdependence, namely, information sharing, opened lines of communication, additional options for support or resources in the environment, and legitimacy (Casciaro & Piskorski, 2005; Guo & Acar, 2005; Pfeffer & Salancik, 1978). As the linkages, or interorganizational ties, help to reduce uncertainty through the provision of sought resources, they help to increase stability for the organization's exchanges in the environment. The stabilization is especially helpful for the smaller arts and culture organization in a tie with the performing arts center as the sharing of services allows for more predictability in operation.

To better understand how a local performing arts center shares services with arts and culture organizations, an overview of a current example in Columbus, Ohio, is offered. Six arts organizations in Columbus are part of an administrative shared service agreement with Columbus Association for the Performing Arts (CAPA). CAPA also shares services like ticketing, and marketing with many other arts and culture organizations in the local creative ecology of Columbus. This specific case highlights how interorganizational ties are defined, how they may come about, and how they connect the organizations. This case also helps to identify possible policy concerns with shared service models.

## CAPA, the Community PAC

The *Columbus Dispatch* has run multiple articles in the last few years highlighting the accomplishments of the Columbus Association for the Performing Arts (CAPA). The articles often cite how CAPA has saved an

organization through its management practices and cost-cutting procedures: "During the past ten years, the Columbus Association for the Performing Arts has gradually taken over most administrative duties of nine central Ohio arts groups" (Grossberg, 2013, p. 1). CAPA is now the largest arts organization in central Ohio and one of the largest arts organizations in the state. Columbus is thriving and being recognized nationally for its workforce and its economic policy. As a growing city, Columbus arts and culture opportunities abound, yet following the national trend, financial sustainability for arts and culture in the city remains a concern.

As national attention is directed at the CAPA shared services network as a sustainability model for arts organizations, little attention is given to the multiple variables that may be influencing the perceived success of the model. Information about CAPA and its administrative shared service network appears in newspapers, research reports and other literature. Field leaders are trying to locate what parts of the model are transferable. Blain Nelson, chairman of the board for the Dallas Symphony, is quoted in Grossberg's (2013) article: "There's no question we ought to look at Columbus and figure out what elements of that model might work in our community" (p. 2). However, Durst and Newell (2001) offer that the perceived success of a shared service model may not rely on excellent management practice but may involve particular environmental variables that contribute to the ongoing sustainability of the current structure.

CAPA was established in 1969 to renovate the Ohio Theatre located in Columbus, Ohio. The organization has grown to become one of the largest theater management groups in the state. Celebrating over 40 years in Columbus, CAPA offers multiple services to arts and culture nonprofit organizations as well as maintaining partnerships with the City of Columbus and the State of Ohio. CAPA owns, operates, and/or manages the Palace Theatre, the Southern Theatre, the Vern Riffe Center Theatres, the Lincoln Theatre, the Festival Latino, the Columbus Symphony Orchestra, McCoy Center for the Arts, the Drexel Theater, CATCO, Franklin Park Conservatory, and Jazz Arts Group in the Columbus area. CAPA also manages the Valentine Theatre in Toledo, Ohio, and the Shubert Theatre in New Haven, Connecticut. CAPA also provides venue space for over 20 resident arts groups and hosts the longest running classic film series in the nation. CAPA partners with schools and other local supporters to offer an educational series for Grades K to 8. This local performing arts center is a focal organization in the Columbus creative ecology.

CAPA is a presenting organization, offering varied programming in music, theatre, film, comedy, dance, and family entertainment. CAPA has a diverse funding structure, including revenue streams from venue rentals, ticket sales, event management, administrative service provision, and concessions, as well as contributed income. CAPA operates with a large staff of full-time and part-time employees.

## The Administrative Shared Service Network

CAPA outlines its administrative shared service network in its annual report:

> CAPA offers personalized back-office services to local arts organizations, providing a streamlined process for patrons while allowing the arts organizations to focus on continued, quality entertainment for their audiences. Service agreements are personalized to fit each organization's needs, but can include programming, marketing, publicity, ticketing, finance, human resources, IT, management, operations, and development.
>
> (capa.com)

The description from the annual report is included verbatim to highlight the priorities of CAPA in their shared service agreement and to offer CAPA's lens about the framing of the service. It is clear that CAPA creates unique relationships with each organization based on the specific needs of that organization. CAPA furthers the priority of quality entertainment. Although CAPA highlights the agreements as back-office services, the organization does offer programming and management services. Several of the organizations in the CAPA administrative shared service network take advantage of these offerings. In the provision of a large range of administrative services to other organizations through interorganizational ties, CAPA reports large savings for the other organizations and increased earned revenue for the performing arts center. A detailed look at the administrative shared services structures between CAPA and six other arts organizations in Columbus follows.

### CATCO

CATCO (formerly known as Contemporary American Theater Company) cites the shared service tie with CAPA as a unique model. The structure gives the responsibility of artistic programming, community outreach, and education to CATCO. CAPA staff is responsible for finance, marketing, ticketing, graphic design, and development. CATCO attributes this structure with eliminating $600,000 in liabilities over three years and helping to establish a balanced budget (www.catco.org). CATCO's shared service contract has evolved over time regarding contract fees and management structure. In 2003, Coyne reported the management contract with CAPA came with an annual fee of $100,000 to cover the business operations of box office, marketing, graphic design, and information technology services. Under the shared service model, CATCO reduced its staff from 28 to 7. For FY2007, the contract between CAPA and CATCO was renewed with a $10,000 per month fee.

## Lincoln Theatre Association

The Lincoln Theatre Association (LTA) owns the Lincoln Theatre. LTA's contract with CAPA gives management oversight to CAPA. The venue's programming, fund-raising, accounting, ticketing and marketing are provided by CAPA. All of the contact information for the Lincoln Theatre Association and email addresses for employees identify under the CAPA domain name, and LTA uses CAPA's street address for tax filings. LTA's public record financials reveal a detailed fiscal tie with CAPA. It is the fiscal responsibility of CAPA to pay all Lincoln Theatre Association employees with LTA reimbursing CAPA on a monthly basis for salaries paid. Although the Lincoln Theatre Association maintains its own 501(c)3 status, CAPA is responsible for the majority of day-to-day operations of the theater.

## Columbus Symphony Orchestra

The CSO self-reports the shared services with CAPA, explaining the depth of interconnectedness between the two organizations. CAPA is responsible for the Columbus Symphony Orchestra's administrative responsibilities, including finance, accounting, publicity, graphics, information technology, ticketing, and human resources (tcfapp.org). The chief executive officer (CEO) of CAPA is also listed as managing director and CEO of CSO. He is financially compensated by CSO in this position. The CSO has benefitted significantly in the interorganizational tie with CAPA through access to additional staff on CAPA's payroll, management expertise, and increased access to public funds.

The interorganizational tie between the CSO and CAPA is best represented in a media article from September, 2011. The article reviews an interview with Roland Valliere, then chief creative officer for the CSO. He describes the CAPA tie in detail:

> It functions much like a holding company. The Columbus Symphony's board continues as before, with its own committees, fundraising work, executive committee, but the CAPA board has ultimate fiduciary responsibility. There is a kind of cross-fertilization on the two boards, with two of our board members, including our chairman Martin Inglis, sitting on the CAPA board. Bill Conner wears two hats as President and CEO of CAPA and as Managing Director and CEO of the Columbus Symphony. He has management responsibility on a daily basis for the symphony.
>
> (Woodcock, 2011)

## Drexel Theatre/Friends of the Drexel

Details regarding the shared service agreement between CAPA and the Drexel are not as robust as the earlier examples. The CEO of CAPA is listed as the managing director for Friends of the Drexel but is not fiscally

compensated. CAPA provides executive oversight, accounting, fund-raising, and marketing services to the Drexel.

## Opera Columbus

Although recognizing CAPA's CEO as the fiscally compensated managing director and CEO of Opera Columbus on its website and in the annual report, Opera Columbus does not otherwise acknowledge its interorganizational tie with CAPA. When the shared service contract with CAPA was announced, Burns (2011) reported that CAPA, with a five-year contract, would take over Opera Columbus' back-office operations including finance, accounting, marketing, advertising, publicity, graphics, IT, ticketing, human resources, and daily operations.

## McCoy Center for the Arts

The McCoy Center for the Arts employs the CEO of CAPA as CEO of the McCoy, responsible for programming decisions and the supervision of daily operations. The McCoy details the agreement with CAPA in its FY2014 990, offering CAPA's role in the interorganizational tie as providing management, financial, and marketing services to the center. Unique in McCoy's description is the recognition that the center's board continues to provide oversight and strategic direction to both the center's staff and CAPA in its capacity as recognized management company. This is in contrast to the tie with the CSO. Weese's (2013) article adds that the CAPA service agreement positions CAPA to manage the McCoy venue, its theater operations, programming, ticketing, information technology, and financial services.

The complexity of the interorganizational ties detailed between CAPA and the other organizations offered can be explored in Figure 11.1. Although each organization is tied with CAPA in different ways, utilizing different levels of services, all of the organizations would be positioned in the administrative shared services circle, showing a close tie with the local performing arts center because of each organization's reliance on CAPA for day-to-day management.

## Outcomes-Based Decision-Making

Motivations to engage in interorganizational ties can be widespread but are outcome based. For example, creating a tie to contract accounting to reduce internal cost can be based on the outcome of reducing expenditures, an output related to the outcome of financial sustainability. A tie might be desired to increase access to easy to use and technologically advanced ticketing software. The desired output may be increased ease of use for consumers, possibly increasing ticket sales, also related to the fiscal outcome. The make/buy decision regarding organizational responsibility resides with

the organizational management. The CAPA case and the overlapping management brings to light details regarding administrative shared service networks that question if fiscal sustainability is the main desired outcome or if there additional factors to consider that not only explain the network's existence but also its continued growth.

Administrators are not only symbolic heads and responsive actors in the organization but also discretionary actors that assess environmental constraints and determine actions to modify the environment. Thus, administrators may be reacting to environmental constraints, like political influence, in making the decision to enter into a tie with CAPA. The strategic decision-making also may not be located in the traditional administration if that is not where the decision-making power is located. The board of the organization may be making the decision to enter into the tie either in absence of the manager or in spite of his or her presence, or the board, under the influence of another organization's board, may be making those decisions. Board influence across multiple organizations can be the catalyst to encourage a shared services model. Board linkages and individual board member affiliations create networks and coalitions that may work to manage the seeking of resources in reaction to the often complex external environments (MacIndoe, 2013).

As noted in the CAPA and CSO tie, individuals were present on both boards. Although this is not an unusual occurrence, it is significant to note in this case because of the deep interconnectedness of the two organizations. Organizations that enter into ties with CAPA may see their environment through information from the executive director or a board member that serves to highlight CAPA as the most viable option for resource attainment. Thus, CAPA becomes the center of the shared services network, acting as an intermediary in the local performing arts ecology between the organization in need of a resource and the resource or resource provision.

## Interdependence and Long-Term Concerns

Dependence of one's organization on another for resource access creates varying degrees of interconnectedness based on the resource concentration. Organizations are often encouraged toward interconnectedness because it makes actions more predictable. However, interconnectedness decreases the long-term stability of the environment. The more connected organizations are, the less adaptable to change they become (Pfeffer & Salancik, 1978). Organizations in the same geographic region sharing capital, markets, and labor are more likely to be more interdependent due to the scarcity of the resources. This assumption is especially interesting for the CAPA example because as the CAPA administrative shared service network grows, the interconnectedness of the tied organizations makes the organizations involved in the network less stable. Conditions of instability can be decreasing or stagnant budgets, decreased revenue streams, or the sharp contrast of resources

owned by one organization. One could question if the organizations within the CAPA administrative shared services network are less adaptable to change because of their geographic location and sharing of resources. If one of the organizations were to fail, there are many possible implications that failure would have on the larger network, including CAPA. Resource dependency assumes the longer an organization is interconnected, the more unstable it is. Therefore, CATCO in its tie with CAPA since 2003 would have the most to lose if CAPA were to fail. It may not be possible to determine the influence of a failure of another organization like Opera Columbus on the shared service network, but a failure of CAPA to continue may have a significant influence on the future sustainability of the rest of the organizations in the network.

Malatesta and Smith (2011) add that the lack of or availability of alternative suppliers is important in understanding how organizations decide to enter into organizational ties. With CAPA providing a majority of resources to these organizations through shared service contracts, it is important to identify the existence, if any, of alternative suppliers. Although there are multiple suppliers for accounting and marketing services via a collaborative agreement, CAPA is the largest performing arts organization in Columbus and the main provider of ticketing services. The lack of viable alternatives for the organizations may be influencing the tie with CAPA.

## Knowledge Centralization

When organizations are failing due to lack of fiscal sustainability, often the administrator becomes the visible and tangible target. The power structure within the organization determines the fate of the administrator and those with institutionalized power are less likely to be removed. When a new administrator is brought into the organization, possible new information and insight are also brought in. As most of the organizations that are engaged in interorganizational ties now have the same executive director as CAPA, this highlights a concern of knowledge being tied to a singular individual among multiple organizations. The day-to-day management of several organizations is under the decision-making of one individual. This concern extends to additional resource sharing centered on skilled individuals. One person providing marketing or fund-raising service to multiple organizations can provide highly skilled service, but this results in a lack of knowledge dissemination. Individual organizations are not benefiting from professionalism of employees, only converged ways of doing based on one person's knowledge and skill.

## Isomorphism

These complex arrangements of the CAPA administrative shared service network can influence the norms and practices of the organizations. DiMaggio and Powell (1983) state that, within a similar environmental context,

organizations will adopt the practices and structures of organizations similar in the field that are perceived to be more legitimate or successful, replicating function and procedures. This process is termed *isomorphism*.

Within the nonprofit sector, larger organizations with well-connected artistic directors or executives create the models for smaller emerging organizations, resulting in a tendency to minimize variance or diversity within the field. Although isomorphism does not necessarily improve efficiency, organizations are often rewarded for assimilation.

DiMaggio and Powell (1983) define institutional isomorphism as the homogenizing process of an organization by other surrounding organizations due to the competition for resources, power, and legitimacy. Institutional isomorphic change uses three types of mechanisms: coercive, mimetic, or normative. *Coercive isomorphism* results from political influence and an organization's search for legitimacy. Pressure is exerted on an organization by other organizations on which it is dependent, including governmental organizations. These organizations become centralized around environmental norms. *Mimetic isomorphism* is the result of uncertainty stemming from goal ambiguity or an uncertain environment. This results in the process of modeling or mimicking the appearance, structure, and or practices of another successful or well-received organization. *Normative isomorphism* results from professionalization. Isomorphism results in organizations being nearly indistinguishable from one another.

Concerns of institutional isomorphism are relevant to the CAPA model and other shared service agreements regarding knowledge concentration and aligned processes that may not be the most suitable for different organizations. Internal processes allow for a large amount of autonomy in decision-making that has a large effect on the overall management and operation of the organization. Yet, if processes become normalized due to convergence influenced by normative isomorphism, further reductions in autonomy can take place.

## Autonomy

In several of the organizations in ties with CAPA, the day-to-day operations have come under the oversight of CAPA and the CAPA CEO listed as CEO or managing director of the other organization. This may create a reduction in the autonomy of the organization because the same person is making decisions for different organizations. The convergence of processes through normative isomorphism would also be expected. As the CEO uses his or her expertise in the field, certain knowledge and process information would become the norm in the tied organization as he institutes processes and policies in day-to-day operations to align with his expectations. As the organizations strive for financial sustainability by adopting processes of CAPA, the organizations become normalized in striving for professionalism as prescribed by one individual.

As Bretherton and Chaston (2005) offer, a smaller organization is often more likely to have autonomy concerns and rightly so. Although no organization is autonomous due to the dependence on the external environment, the suggested discussion about autonomy offers the need to view the concept not as a dichotomy with all or none but as a spectrum. An organization makes somewhat autonomous decisions regarding programming. Yes, programming is limited by available resources, but the organization picks from the available to decide what to present/produce. In the decision-making of the organization, the autonomy exists within the parameters, yet it still exists. In the instance of a small organization in an interorganizational tie with a larger organization, the parameters within which the smaller organization makes its decisions may become increasingly smaller. This reduction of autonomy, sliding farther down the scale, is a concern regarding the shared services model. The literature is unclear at what point an organization loses most of its decision-making autonomy and thus its individualism and/or competitive advantage. Critical resources to the organization must be owned, developed, or appropriated, and under the control of the organization. Any other structure may impede the organization's sustainability or power in the interorganizational tie (Nienhueser, 2008). A more formalized relationship or contract for control of resources can result in higher instances of autonomy loss (Provan, 1984). Following this line of thought with the CAPA case, the other arts and culture organizations that are sharing services with CAPA may be experiencing a reduction in autonomy as their parameters of decision-making are reduced by the shared service contract.

Some critical resources that may be outputs from the interorganizational ties are already visible, including board members that sit on multiple boards in the network and the same executive director across multiple organizations. Attempted influence and control relies on the manager's ability to recognize present constraints on the organization in its environment. The manager's ability to influence others assists in the manipulation of the organization's environment. As seen in the CAPA case, one manager is responsible for multiple organizations in the environment. The influence of the main management organization, CAPA, may be more significant than the influence of the other arts and culture organizations being serviced in the agreement. Preece (2005) speaks of the possibility of arts organizations manipulating their environment through performing arts partnerships but warns that few are executed correctly and that opportunities for appropriate partnerships are rare. It is unclear yet if the CAPA interorganizational ties will have long-term benefits on organizational sustainability for all of the organizations in the shared service network, and there are many concerns regarding this model, especially direction of power and influence in the relationships between the organizations.

Power to influence in the exchange of resources comes in the occurrence of asymmetrical dependence. Some organizational behaviors, especially in the case of the CAPA model, may be under the influence of CAPA within

the interorganizational tie. The importance of the resource to organization operation and survival aligns with the influence position of the resource owner. In the case of shared marketing services, the organization that contracts for the service from the local performing arts center may not view marketing as a critical resource for operation. It is unlikely that the resource owner, the local performing arts center, has a large influence on the day-to-day decision-making of the other arts organization through the provision of marketing services. However, certain shared services, like day-to-day management of the organization including programmatic decisions, can be considered a critical resource for operation and may have influence on the arts organization not initially anticipated. Shared services, especially in day-to-day management provision, can result in extra-organizational influence by the resource provider. It is necessary to consider to what extent the shared service provided by the local performing arts center is important and critical to the operation of the focal organization and what influence the provision of that resource imparts. The large provision of service by the local performing arts center may have a significant influence on how the arts or culture organization carries out its mission.

## Misalignment of Revenue and Expense Structures

As processes converge within the shared service network based on common staff and resources, it is interesting to review financial structures of tied organizations to look for more alignment. CAPA's financial structure differs from the other organizations tied with CAPA. CAPA's revenue is largely based on ticket revenue, rentals, and management fees. In 2012, earned income accounted for 91 percent of the organizational revenue for that fiscal year. Ticket revenue was the largest percentage of earned revenue at 51 percent, but rental sales and management fees together accounted for an additional 40 percent of earned revenue. CAPAs main expenses are salaries and artistic expenses. Together, those categories account for 60 percent of CAPA's 2012 budget. The majority of CAPA's budget is going toward the provision of services and performances. The majority of their revenue also comes from the provision of services and performances.

These structures are in sharp contrast to the McCoy Center for the Arts. McCoy's budget is largely based on contributed revenue. Approximately 74 percent of McCoy's revenue comes from grants and contributions, with 5 percent directly from government support. Only 10 percent of McCoy's revenue comes from rental sales, even though it is highly advertised on its website and appears to be a priority service in its community. The expenses for the McCoy are pretty evenly broken out across advertising, artistic fees, salaries, occupancy, fund-raising costs, and the management contract with CAPA. However, when taking the outside fees for McCoy in the aggregate, it accounts for 65 percent of the center's expenses. The management contract with CAPA accounted for 17 percent of total expenses for the center

in 2012. This is the more typical structure for the organizations tied with CAPA: large reliance on contributed revenue along with large percentages paid in outside fees and occupancy. The difference in financial structures offers insight into why the organizations enter into collaborative ties with CAPA. The sharing of services with the larger local performing arts center increases stability in cost projection of expenses like accounting and marketing while providing access to highly skilled workers. However, the disparity in earned revenue highlights the dependence of CAPA on the tied organizations. As resource owner, CAPA, or any local performing arts center that is providing shared services, it is reliant on the selling of that resource to other organizations for its own sustainability.

## Conclusion

Shared services or interorganizational ties position the local performing arts center as an intermediary between resource and organizations in need of the resource. Sought resources are varied and can be monetary or physical resources like venue space for rehearsal, performance or events, education or industry specific knowledge, skills in administration or resource provision such as marketing, and professionalization or industry legitimacy. Audiences for performance attendance, volunteers, board members, sponsors, and social partnerships are also resources sought by organizations to gain competitive advantage. All organizations look outside of their physical and intangible boundaries to acquire resources, challenged by their immediate environment to obtain the needed resources. The availability of resources, the level of resources required, and the ability to influence the environment drive organizations to seek interorganizational ties to manage instability.

The shared services model provides access for many organizations to highly skilled labor and scarce resources while providing financial stability in multiple ways to both sides of the interorganizational tie. However, the tension between the tied organizations is clear. Concerns of autonomy, succession, long-term sustainability, influence, staff size reduction, knowledge centralization, and mission fulfillment complicate the evident surface benefits of a shared service model.

Extreme knowledge centralization is evident in the CAPA case. One person is responsible for the daily management of multiple organizations. Concerns arise as to the independence of each of the organizations tied with CAPA in decision-making regarding programming and mission fulfillment. All of the organizations in the CAPA administrative shared service network operate as separate 501(c)3s, but the levels of autonomy of the organization are questioned. As time continues with the interorganizational ties in place, it will be necessary to examine how day-to-day management decisions under the direction of CAPA create convergence in process and practice. This concern extends to any performing arts center that serves as the

main resource provider for multiple organizations. It is not clear at what point the tied organization begins to lose competitive advantage. However, as the staff necessary to operate a creative ecology decreases without continued knowledge dissemination, concerns regarding succession become prevalent. Shared service networks can negatively impact the education of workers in organizations in the creative ecology by significantly limiting access to opportunities for employment and professionalization. Knowledge reduction in the tied organizations can result in greater dependence on the resource provider, eliminating the possibility of moving back out of the shared service agreement. The organization in a shared service agreement with a local performing arts center can, over time, become completely dependent on the PAC for sustainability.

The CAPA case presented offers an extreme example of how organizations can enter into ties for resource provision. However, this example also highlights the possible long-term concerns with this type of model being furthered for industry sustainability. Not all of the structures of a shared service model are undesirable. As mentioned previously, significant benefits can be accomplished through the sharing of services. The concerns arise as one resource provider continues to grow as the only viable service. It is necessary to have multiple alternatives of service provision and ways for knowledge to be disseminated throughout the shared service network to ensure long-term sustainability for multiple organizations—not just the local performing arts center as resource owner.

# References

Bretherton, P., & Chaston, I. (2005). Resource dependency and SME strategy: An empirical study. *Journal of Small Business and Enterprise Development, 12*(2), 274–289.

Burns, A. (2011). CAPA taking Opera Columbus under its wing. Columbus Business First May 6, 2011. Retrieved from: http://www.bizjournals.com/columbus/news/2011/0505/CAPA-taking-Opera-Columbus.html

Casciaro, T., & Piskorski, M.J. (2005). Power imbalance, mutual dependence, and constraint absorption: A closer look at resource dependence theory. *Administrative Science Quarterly, 50,* 167–199.

DiMaggio, P.J., & Powell, W.W. (1983). The iron cage revisited: Institutional isomorphism and collective rationality in organizational field. *American Sociological Review, 48*(2), 147–160.

Durst, S.L., & Newell, C. (2001). The who, why and how of reinvention in nonprofit organizations. *Nonprofit Management & Leadership, 11*(4), 443–457.

Grossberg, M. (2013). Outsourcing of work to CAPA has paid off, group leaders say. Retrieved from: http://www.dispatch.com/content/stories/life_and_entertainment/2013/03/10/1-model-of-success.html

Guo, C., & Acar, M. (2005). Understanding collaboration among nonprofit organizations: Combining resource dependency, institutional, and network perspectives. *Nonprofit and Voluntary Sector Quarterly, 34,* 340–361.

MacIndoe, H. (2013). Reinforcing the safety net: Explaining the propensity for and intensity of nonprofit-local government collaboration. *State and Local Government Review, 45*(4), 283–295.

Malatesta, D., & Smith, C.R. (2011). Resource dependence, alternative supply sources, and the design of formal contracts. *Public Administration Review*, July/ August, 608–617.

McCoy. (2015). Retrieved from: tcfapp.org/PortraitView/PrintPortrait?portraitKey= 4172

McManus, D. (2016). Hartford's elephant in the room settles in as musicians cave. Retrieved from: http://www.adaptistration.com/blog/2016/01/20/hartfordse lephant

Meiseberg, B., & Ehrmann, T. (2013). Tendency to network of small and medium-sized enterprises: Combining organizational economics and resource-based perspectives. *Managerial and Decision Economics, 34*, 283–300.

Mosley, J.E., Maronick, M.P., & Katz, H. (2012). How organizational characteristics affect the adaptive tactics used by human service nonprofit mangers confronting financial uncertainty. *Nonprofit Management & Leadership, 22*(3), 281–303.

Nienhueser, W. (2008). Resource dependency theory-how well does it explain behavior of organizations? *Management Revue, 19*(1–2), 9–32.

Pfeffer, J., & Salancik, G.R. (1978). *The external control of organizations: A resource dependence perspective*. New York: Harper & Row.

Preece, S. (2005). The performing arts value chain. *International Journal of Arts Management, 8*(1), 21–32.

Provan, K.G. (1984). Interorganizational cooperation and decision-making autonomy in a consortium multihospital system. *Academy of Management Review, 9*(3), 494–504.

Sowa, J.E. (2009). The collaboration decision in nonprofit organizations: Views from the front line. *Nonprofit and Voluntary Sector Quarterly, 38*, 1003–1024.

Vaughan, S.K., & Arsneault, S. (2014). *Managing nonprofit organizations in a policy world*. Los Angeles: Sage Publications.

Weese, E. (2013). CAPA to manage New Albany's McCoy community center. Columbus Business First January 10, 2013. Retrieved from: http://www.bizjournals.com/columbus/news/2013/01/10/capa-to-manage-new-albanys-mccoy.html

Woodcock, T. (2011). A conversation with Roland Valliere of the Columbus Symphony. Retrieved from: https://necmusic.wordpress.com/2011/09/01/a-converations-with-roland-valliere-of-the-columbus-symphony/

# 12 International Horizons in Performing Arts Center Management

*Douglas Gautier*

## The Rise of the Asia-Pacific Performing Arts Center

While the geographic focus of this book as a whole is on the United States, creative and cultural industry scholars around the world are watching with great interest the current cultural facilities building boom in Asia. Performing arts centers (PACs) have for decades served as an important area of urban planning investment in North America and Australia, but this area of urban infrastructure development is relatively new to China and Southeast Asia.

Significant investment is underway across Asia in arts and entertainment venues and civic place making. This is evident in smaller provincial towns along with such major centers as Beijing, Hong Kong, Tokyo, Singapore, Seoul, and Taipei. Investment in infrastructure development has been massive (overall worth many billions of U.S. dollars), and there has been a parallel investment in programming to fill the venues. To provide some insight into the extent of investment in the People's Republic of China, National Center for the Performing Arts senior administrator Qiao Luqiang estimated in 2010 that some 20 new large-scale venues had been built in the prior five years. Since then the building activity has considerably accelerated.

Performing arts center leaders play an important role in the creative and cultural industries affected by dramatic economic and demographic shifts taking place throughout the Asia-Pacific region, a discussion of which goes beyond the scope of this chapter. In many of this region's nations, arts administration and venue management are in a very early stage of professionalization. Those responsible for overseeing cultural facilities frequently look abroad for administrative models, professional practice, and training. Professional networks and associations that support cultural managers throughout the region are growing, and Australia's arts leaders—who often serve as an important bridge between the Western Anglosphere and Asia—are investing significant time and resources to support these regional networks.

Within the Asia-Pacific geopolitical context that involves significant investment in cultural infrastructure, the Adelaide Festival Centre (AFC), in Adelaide, Australia, has become a recognized internationally focused leader

in the field of performing arts center management. This chapter describes how this performing arts center has come to establish itself as a prominent international arts leader, interlocutor, and collaborator, particularly in the Asian region. Ultimately, this case study demonstrates how an urban performing arts center can both support and lead its community's international relations priorities.

This case study of the Adelaide Festival Centre begins with providing a general context and history of the performing arts center, and an introduction to a strategic 10-year plan that the PAC began in 2006. The chapter then turns to a discussion of the festival programming focus of the AFC, profiling in detail the Oz Asia Festival. Whereas American PACs' involvement in festivals is generally limited to a minor focus on programming, PAC engagement with cultural festivals in many other nations of the world is a central focus of their activities.

An overview of the AFC organizational leadership, higher education partnerships, and engagement in Asia-Pacific professional associations follows, illustrating the organizational infrastructure necessary to provide international leadership in performing arts center management capacity building. The chapter describes the AFC's collaborative relationships with federal, state, and municipal government entities and then turns to an overview of the strong memoranda of understanding that the PAC has established with key Asian cultural organizations. Finally, the case study describes the AFC's crucial role in achieving the designation of UNESCO Creative City for Music for Adelaide, Australia. In sum, this case study provides insight into the planning and organizational infrastructure necessary for senior management of a performing arts center to effectively adopt international horizons in their vision, mission, goals, and operations.

## Adelaide: Australia's Preeminent Festival City

Adelaide (population 1.2 million) is the capital of South Australia, a state in Australia with a total population of 1.7 million. As the only Australian capital that was founded as a free settlement, an aspirational and liberal approach to arts, education, and society were central to the city's founding principles. Interestingly, the modern city was founded and planned by a soldier, artist, and surveyor, William Light, who was born in Penang as the son of the British governor there, Francis Light, and a Malaysian mother. This early history gives Adelaide a fundamental and tangible connection to Asia, which is becoming ever more important in the city's cultural dialogue and international positioning.

Since the late nineteenth century, the city has aspired to be a center of culture and learning. This has manifested in a number of ways, such as Adelaide being the first Australian capital to pursue the Edinburgh model of an international arts festival. The Adelaide Festival remains a strong brand and presence and has been joined by a fringe festival, which in this year

(2016) sold about 1 million tickets to a range of shows and venues across the city. There are now about 10 major festivals across the year that take place in Adelaide, a city whose size and layout make it particularly suitable for festival programming. In addition, the Australian Youth Orchestra was founded in Adelaide in 1949, and this ensemble is now consistently regarded as one of the best youth orchestras in the world. The Adelaide Festival Centre was Australia's first capital city arts center and the site for the first full set of performances of the Ring Cycle. In 2015, Adelaide was named a UNESCO Creative City for Music.

## History of the Adelaide Festival Centre

The AFC complex was opened in June 1973, several months ahead of the Sydney Opera House. The performing arts center consists of a 2,000-seat lyric theater that also serves as a concert hall, a 600-seat drama theater, a 400-seat black box space, a set of galleries, and an external amphitheater. The AFC also runs a 1,000-seat old Edwardian theater in the downtown area of the city. These venues are run by the Adelaide Festival Centre Trust, which provides with a full range of services: programming, marketing, ticketing, technical and staging support, education, sponsorship, and so on. The performing arts center contains the principal set of venues for the state orchestra, the opera company, various theater companies, and dance companies. It also is utilized by a range of commercial presenters and renters.

By early 2006, the Adelaide Festival Centre was a little over 30 years old, over 27 million dollars in debt, with significantly underutilized venues. At this point in its history, there was a lack of clear definition of purpose as to where as an organization it was going and what it wanted to achieve—particularly in relation to its role in the community and its international connections and profile.

The current management team came on board in May in 2006, determined and primed to achieve a number of clearly defined mid- and long-term objectives that had been agreed on by the board. First was the overall objective of making the center one of Australia's leading creative and cultural organizations once again. Key to this was and is a "program-led" approach, which propels the AFC to invest heavily in programming, marketing, and audience development. This core objective was to be based on a sound financial model with a view toward balancing operational annual budgets or better and getting the organization out of debt.

There were two other aims germane to the plan (and this narrative) and reflective of a much broader ambition in line with positioning the organization as a leader in its field. The first of these objectives was that the center would take the national lead with a comprehensive program of cultural engagement with Asia that would put it at the forefront of such engagement by an Australian cultural organization of scale. As part of this objective, the AFC would be set up as a hub for Australian/Asian cultural engagement

and exchange. Second, this activity would work in parallel with a push to make the AFC's activities more relevant to an increasingly multicultural Australian community, due to large-scale recent immigration from Asia. It is noteworthy that, after English, Mandarin Chinese is now the most spoken language in Australia.

These initiatives began at a time when, increasingly, the Australian community was in many ways acknowledging and relishing that it is part of the Asia-Pacific region—a shift in thinking that has manifested in terms of business, government, education, and travel contact. There is an acknowledgment, too, of the extraordinary outburst of economic activity in Asia (China, Japan, and Korea are among Australia's largest trading partners). This economic growth has involved a similar level of contemporary creative activity in the region. In addition, the use of culture as a facilitator of other business endeavors has been embraced by the South Australian government and allows the AFC to play a role as a good citizen in supporting the aims of the government and business community.

Many Australian cultural institutions and individuals still look most strongly to Europe and America for international cultural connections, but the identification with and curiosity about Asian culture in all its manifestation has begun—and has unstoppable momentum. The Adelaide Festival Centre has been one influencer in this trend, which has been an important role for both the AFC and the city.

Indeed, the leadership of the AFC view the institution as possessing a significant social responsibility to engage the power of the arts to celebrate diversity, promote social harmony, and help to create a place for Australia in the world. The presentation of performing arts, literature, film, and visual arts of Asian influence or origin has been embraced by mainstream audiences and is helping Australia's understanding of Asian culture, traditions, and language. The presentation of Asian cultural programs has also helped the AFC to connect with local Australian-Asian communities that have historically not participated in the center's activities.

## AFC's Decade of Program-Led Planning

The Adelaide Festival Centre's goal of leveraging programming to attract both the local community and foster international engagement is probably best demonstrated by the festivals that are run by the organization: the International Guitar Festival, Cabaret Festival, Children's Festival, and the Oz Asia Festival.

All four festivals have strong international collaboration agendas and achievements. With Guitar and Cabaret, the AFC has put well-known and talented Australian artists in charge creatively, and they have integrated strong international connections in programming. For instance, Barry Humphrey (aka Dame Edna Everage) has played a key role in programming the Cabaret Festival, and Australia's premier classical guitarist, Slava

Grigoryan, has served a similar role for the AFC Guitar Festival. In addition, the international dimensions and ambitions of Guitar Festival have been considerably grown by its formal association with the guitar festivals in Seville, Cordoba, and New York. Similarly, the international guitar competition functioning under the aegis of the festival has attracted worldwide attention and participation from many fine Asian guitarists. These international links are constantly reinvested in and maintained. For example, Slava Grigoryan is one of the main figures in a chamber music exchange initiative with the National Center for the Performing Arts in Beijing and music projects with our sister province of Shandong in China.

However, the program project which has had the largest and most focused impact on our international profile is undoubtedly the AFC's annual Oz Asia Festival.

## The Oz Asia Festival

The Oz Asia Festival began in 2007 and is now in its tenth year. This festival is regarded as the major Australian/Asian cultural engagement event in our country. The Oz Asia Festival is a comprehensive two-week festival involving the showcasing of contemporary and traditional performing and visual arts from across Asia, as well as collaborations between Australian and Asian artists and work from Australian artists of Asian heritage—that is, "Asia within Australia." There is also a significant amount of context work in seminars and discussion throughout the festival; for example, on the role of media, the teaching of Asian languages in Australia, and the opportunities and challenges of multiculturalism.

Ten years ago this project was seen as pioneering, and now—in light of Australians' changing view of their nation as being part of Asia—Oz Asia is regarded as timely and has well caught the mood and desire for a better understanding of and interest in Asia and our regional neighborhood. Indeed, this festival embodies the changing nature of the communities around us in Australia and the cultures that have come to be part of the mix.

The international stakeholders, friends, and collaborators for this festival have been central to Oz Asia's success and the growth of the AFC's international links and reputation. They are the following:

- *Asian Governments.* This network is established and constantly nurtured by us at national and provincial levels all across Asia and with the diplomatic representation of those countries in Australia. The AFC has come to be often sought out by Asian governments to facilitate Australian tours of visual and performing arts from their countries.
- *Asian Cultural Organizations.* Performing arts companies, centers, galleries, cultural agencies, and agents—AFC staff work hard to make sure the AFC and Oz Asia are an active part of these networks. AFC

managers take an active role in Asia-Pacific professional arts and entertainment associations and industry groups.

- *Politicians.* Politicians at home and abroad are increasingly engaged with the notion and possibilities of the Asia/Pacific Century and the value of cultural understanding within the region. Many prominent politicians in Australia and Asia have become champions for cultural exchange in the broader Asia-Pacific community. Several have become key partners and advocates for Oz Asia and its ideals. A number of Australian prime ministers and state premiers have been direct advocates for the Festival and its Asian engagement focus.
- *Business Sponsors.* Oz Asia has a range of corporate supporters big and small that are either Australian companies doing business in Asia or with Asian communities in Australia or Asian companies seeking to do business in Australia and/or raise profile and develop contacts in this market.
- *University Partners.* AFC collaboration in this respect extends to alliances with Asian-language departments, Asia-focused arts administration programs, and direct relationship with the several thousand Asian students studying at Adelaide's tertiary and secondary educational institutions.

The Oz Asia Festival started as a relatively small event, attracting around 20,000 attendees in its first year. In 2015, Oz Asia attracted over 230,000 attendees. It has become the flagship of the AFC's Australia/Asia cultural exchange program, and it has caught the imagination and the wave of sentiment and mood for engagement with Asia in our country.

Oz Asia is now the centerpiece of international engagement that is valued and trusted both in Australia and in Asia. This festival has enabled the AFC to be an interlocutor, advocate, partner, and innovator in a much larger set of international engagement projects and platforms in Asia. Some of these initiatives—profiled in the pages that follow—involve internships and exchange of personnel, province-to-province or city-to-city relationships, PAC-to-PAC or festival-to-festival agreements, involvement in pan-regional industry groups, partnerships with universities, and training and collaborations with international cultural agencies.

## Role of the AFC Board

The close working relationship with the AFC trustees or board has been a vital ingredient in the success of the ongoing process of identifying clear objectives in our international engagement program and working toward them. From day one of the program, management and trustees have been united in the view that the AFC should find practical mechanisms to extend its international profile and engagement, with a specific focus on Asia. Parallel to that was the view that this approach must be in tandem with a much stronger

commitment to multiculturalism, and fostering of our connections with the various and fast-growing ethnic groups that make up our community.

In considering these changes and how we should react to them, trustees and management acknowledged that our performing arts facilities and organization were designed over 40 years ago to mainly present the work of the Western European cultural tradition: symphonic music, ballet, opera, and English-speaking theater. We also agreed that while those art forms remain important, they should and must be supplemented by work and projects that provide accessibility to all ethnic elements of our community. This is critical if the AFC is to reflect and serve its community well and contribute positively to the maintenance and development of good civic society.

All three chairmen of the trustees since 2006 have supported our Asian engagement and multicultural involvement at home. One particular influence and inspiration in this regard was one of our trustees, Mr. Hieu Van Le. In the early 1970s, this gentleman—a boat person and refugee from the conflict in Vietnam—literally steered his refugee boat into Darwin Harbour. Hieu Van Le was appointed to the AFC Trust while serving as the chairman of the South Australian Multicultural and Ethnic Affairs Commission and as lieutenant governor of the state. He told me early on that when he first arrived in Adelaide, he and his family would walk past the AFC and admire it, but they didn't think it was for them or people like them. We have been determined to change that perception, and one of the first practical tasks he undertook for us as a trustee was to become a very active patron of the Oz Asia Festival. Hieu Van Le is now the governor of South Australia, no longer on our board but still a patron of Oz Asia. Influence and inspiration provided by extraordinary individuals have certainly helped the AFC on its way toward redefining itself at home and abroad.

## AFC Partnerships with Universities

Collaborations with the state's three universities have been integral to the Adelaide Festival Centre's international positioning strategy. These partnerships, profiled in the following, have been structured to be mutually beneficial for all the institutions involved. The AFC seeks to strengthen its educational role through strong university partnerships and is looking to the Lincoln Center/Juilliard School and the Barbican Centre/Guildhall School as models of synergetic relationships where the schools have an active presence in the performing arts center site.

### *University of South Australia*

The AFC has partnered with the University of South Australia's arts administration program to set up the Asia Pacific Centre for Cultural Leadership. This initiative is designed to foster those North–South connections and synergies that are growing within the Asian region, specifically in the

management of creative organizations. The aim is to develop formal links with other arts administration schools in the region, and a number of those affiliations are beginning to blossom. These affiliations are being linked with working cultural organizations in each location, to create academic/industry alliances that are particularly attractive to students. Furthermore, many of the Asian interns that come to the AFC are looking for academic accreditation for their time with us, either with this university or in association with a university in their home country. Locally, the Asia Pacific Centre for Cultural Leadership seeks to make young Australian creative leaders "Asia Ready," as many of them will work in Asia and be dealing with Asian colleagues and organizations as part of the growing Asia-Pacific Networks.

### Flinders University

Flinders University has always had a strong creative arts faculty, and there are many linkages between this university and the AFC. The most pertinent to this chapter is the AFC's work with the university's Indonesian department and, in particular, their *Jembatam* (*bridge*—in Indonesian) project. Indonesia is Australia's closest Asian neighbor, a culturally diverse and complex nation, and one with which Australians are very interested in understanding better and in encouraging cultural exchange and collaboration. A clear and successful outcome of this was the large-scale Indonesian content in the 2015 Oz Asia Festival, in which detailed contextual and interpretative material and events were provided to audiences in collaboration with the Flinders University under the auspices of the *Jembatam* project.

### Adelaide University

AFC's collaboration with Adelaide University has been twofold. First, the AFC has worked in collaboration with the University's Confucius Institute on many and varied initiatives focusing on China/Australia cultural exchange. Second, the director of the university's respected Conservatory of Music is the chair of the "Adelaide UNESCO Creative City for Music" advisory panel. The secretariat for this UNESCO affiliation is based with AFC, and we were the prime mover in winning this accreditation (discussed later in this chapter).

## Bob Hawke Fellowships and Internship Program

As outlined previously, the goals of the Adelaide Festival Centre's Asian engagement program have always been long term and with a view to building long-lasting working relationships with individual colleagues and partner institutions across Asia. The focus has been on developing relationships that might last working lifetimes and that can engender forms and possibilities of cross-cultural cooperation well into the future and across a

range of diverse genres. As the AFC's partnerships with universities attest, educational and professional development initiatives are key to achieving this goal.

To this end, the AFC promotes internship opportunities for young arts industry colleagues from all over Asia. These internships have been promoted through cultural institutions, performing arts and visual arts organizations, and universities in China, Korea, Indonesia, Thailand, Singapore, and Hong Kong. These internships have been funded in a variety of ways from Australian state and federal governments/agencies, by partner institutions in Asia, and by private philanthropists in Australia through our AFC Foundation.

It is crucial to reference the important role of influential and supportive independent advocates in developing an international leadership focus for the AFC. The outstanding example for the AFC early on the program was the willingness of a past prime minister of Australia, Bob Hawke, to put his name to a fellowship specifically for young arts administrators from China to intern with the AFC for up to nine months. Mr. Hawke was not only the first Australian prime minister born in South Australia, but also during his term of office he was a great supporter of engagement with China on all fronts. His identification with the fellowship and the recognition of his name in China and at home means a high level of respect and visibility for the project in China and increased interest from corporations, governments, and individuals in donating funds to keep the program active. Active it still is, and it remains a key part of the China component of the overall program, which has included fellows from the Shanghai Ballet, the National Center for the Performing Arts in Beijing, and the Arts Bureau of Shandong province. It is a platform and instrument that are valued by China's Ministry of Culture and Australia's Foreign Affairs Department, both of which have been actively involved with it at one time or another.

## AFC Membership in and Leadership of Asia-Pacific Professional Associations

As a key component in its internationalization strategy, the Adelaide Festival Centre has strongly engaged with two premier professional associations in the Asia-Pacific region and has sought to help grow Australian involvement in these networks. The AFC has also taken leadership positions with both of the organizations profiled in the following.

### *Association of Asia Pacific Performing Arts Centres (AAPPAC)*

The Association of Asia Pacific Performing Arts Centres has existed for over twenty years and consists of around fifty or so of the main performing arts centers in Asia-Pacific, in the main and capital cities of Korea, Japan, China, Philippines, Taiwan, Hong Kong, Malaysia, Singapore, India, Sri Lanka,

Thailand, New Zealand and Australia. In addition, the association includes a business circle of another 50-plus members who are interested in and do or want to do business with the network. This group includes artist's agents, performing arts companies, academics, government representatives, technical suppliers, and architects.

AAPPAC is by far the strongest and biggest pan-Asia-Pacific cultural organization in terms of numbers, reach, activity, and potential. Like all areas of activity in the Asia-Pacific region, the arts and cultural sectors are on a rapid growth curve, and there is significant investment in arts infrastructure, rapid building of new PACs, and the need to activate them with content and attract audiences and supporters. Accordingly, there is much potential for exchange of information and cooperation between AAPPAC members in such matters as programming, marketing, ticketing, sponsorship, technical aspects, design, and placemaking. There is also a strong mutual interest in developing the Asian touring network of member venues.

The AFC executive director (the author of this chapter) has served on the AAPPAC board for a number of years and was elected by members to chair the organization from 2013 to the present. This appointment has been a key opportunity for the AFC to further its international connections and engagement. Not only does the chairmanship involve consultation and contact with the leaders of the industry around the region on a regular basis with the AFC as an interlocutor and initiator, but it also involves consultation with the various governments and their cultural agencies.

The AAPPAC annual congress is a well-attended event and enables the host PAC to showcase their local arts developments to international colleagues. As part of our international ambitions for the AFC and our city, we won the right to host the AAPPAC conference in September 2016. At the time of writing this chapter, planning for this event is underway. A key theme at the congress will be the role of the arts in a multicultural society, a topic of interest to local and international delegates alike. This theme also firmly positions the AFC at the heart of a conversation about cultural institutions and their value in fostering good civil society at home and the importance of international cultural exchange and understanding to the region at large.

The Association of Asia Pacific Performing Arts Festivals and the Australia Council for the Arts have chosen to co-locate meetings in Adelaide to take advantage of the presence of so many heads of performing arts centers and associated cultural leaders. The Australia Council, for instance, will bring the representatives of 50 Australian performing arts companies to meet with AAPPAC members. In September 2016, all of these forums will happen against the background of the AFC's tenth annual Oz Asia Festival.

### Association of Asia Pacific Performing Arts Festivals (AAPPAF)

The Association of Asia Pacific Performing Arts Festivals was formed in 2004 and, although it is a smaller organization than AAPPAC, it is one that is instrumental in collaborations in programming and commissioning across

the growing Asian festival network. Increasingly, these festivals are interested in homegrown intraregional commissions. Again, the AFC has taken a leadership role with this organization, with the Oz Asia Festival director serving on the board. While our current Oz Asia Festival director has been instrumental in encouraging this organization to meet in Adelaide alongside the AAPPAC annual congress, I have in my role as AAPPAC chairman encouraged stronger links between the two organizations, particularly in the areas of programming, commissioning, and touring. In these areas, there is already much synergy between the festivals and the PACs, with the possibility of a great deal more. Again, it is central to the international engagement strategy for the AFC to have a seat at the table in these discussions and deals.

## AFC Strategic Collaboration With Governments

The Adelaide Festival Centre collaborates extensively with the three tiers of Australian government with regard to international cultural exchange. Increasingly, the AFC is seen by these governments as an important "go-to" agency in this regard, largely due to the organization's successful track record and strong connections, particularly in Asia.

### State Government of South Australia

This level of government is the AFC's major public funder and key public policy partner. Central to the international horizons of both the AFC and the state government has been the systematic inclusion of "people to people" exchange and cultural exchange within the framework of the broader positioning of the state, politically and economically, to regional partners across Asia.

It is important to remember that, in foreign relations spheres, the state of South Australia is the smallest mainland state of Australia in terms of population (1.7 million). The Australian states' cities with the main populations and profiles are in the east of the nation (Sydney and Melbourne). It follows that to create attention for Adelaide and South Australia with Asian neighbors and attract them to the possibilities of engaging with this State (in education, tourism, trade, investment, and so on), those responsible for promoting South Australia have had to seek points of difference and work very hard in promoting the region.

The best premiers or political leaders of the state in this regard have been those who are internationalists. Interestingly, the premier at the time of the building of the AFC was definitely in that mold, and the current premier has been an active and strategic evangelist for South Australia in creating relationships with a number of important Asian partners. He sees cultural exchange very much as part of building those long-term connections and has worked closely with the AFC to build a comprehensive cultural exchange program with South Australia's sister Chinese province of Shandong. This program has been integrated alongside all the other exchange and cooperation initiatives going on in terms of trade, investment, and education.

As a result, the past four years have seen significant growth of that cultural exchange program—including projects involving performing and visual arts, film and television, and an extensive exchange internship program. Indeed, the program is regarded as the most comprehensive and successful of all Australia's provinces to state cultural exchange arrangements and is often used by the Australian Department of Foreign Affairs and Trade (DFAT) as a blueprint and template for international cultural engagement.

The South Australian government has also been involved in this manner in similar work the AFC is engaged in, in Hong Kong, West Java, Penang, and India, and the AFC has been the cultural agency that has been at the heart of these initiatives. Cultural engagement has come to be enshrined in the state government's overall Asian engagement strategy plan, which is the set of guiding principles for this activity. The AFC was invited to sit on the main consultative panel to assist with the formulation of this plan and to be involved at the heart of the cultural implementation. It is generally agreed that the inclusion of the cultural component in the overall strategy has contributed greatly to its success. Indeed, the international horizons of the AFC have grown in tandem with those of the state government.

## Federal Government

The Australian federal government has been greatly supportive of the AFC's international initiatives, mainly through close working relationships with the Department of Foreign Affairs and Trade (DFAT) and the Australian embassies in the relevant nations. There has also been strong support from the federal department of the arts and the national arts council, which recognize the AFC's Asian engagement efforts and the unique and valuable nature of the Oz Asia Festival.

The AFC consistently cooperates with Australian diplomats, and the importance of cultural exchange is very much part of the agenda and ethos of the Australian diplomatic service. Cooperative projects in this regard with significant embassy support, in country, are ongoing in Indonesia, China, and Hong Kong. Furthermore, at home DFAT regularly schedules meetings for AFC with Australian ambassadors to relevant Asian countries, who are in Australia on duty visits and with foreign diplomats. The consistent approach the AFC follows with this key partnership is vital to the performing arts center's international profile, network, and ongoing programs and initiatives.

## Municipal Government

The Adelaide City Council is a supporter of cultural activity within the city and is a collaborator with the AFC. In the international space, this collaboration is most valuable in the context of sister city relationships, which usually have a strong cultural element.

Two key examples for us have been the sister city relationships with Georgetown, Penang in Malaysia, and Tsingtao in Shandong Province, China. Again, the AFC has been the main instrument of the cultural exchange—in Penang it is an arrangement with the Georgetown Festival—probably one of the most progressive performing arts festivals in Asia, as well as specific programming in the Oz Asia Festival. This festival-to-festival partnership is discussed in detail later in this chapter.

The sister-city relationship with Tsingtao is buttressed by the state relationship with Shandong, the province in which it is situated. However, Tsingtao is not the capital of its province—but it is the largest commercial city in the province, and it has an international/cosmopolitan approach to business and culture. Tsingtao was the old German treaty port, and it has a large Korean community. It is also a center for music making, with many concert halls, a good symphony orchestra, and a national violin competition, as well as a center for classical guitar teaching and playing in China. Therefore, the AFC's activities in Tsingtao have been focused on music.

A final important note on our collaboration with governments is that foreign governments that are seeking to bring performing and visual arts projects to Australia are increasingly coming to the AFC as a first point of contact and facilitator that can activate and interest the Australian touring network. For example, the AFC recently facilitated a meeting of all the Australian capital performing arts centers—Sydney Opera House, Melbourne Arts Centre, Queensland Performing Arts Centre and Perth Theater Trust—for the Indian high commissioner. This individual is planning to bring Indian performances to Australia over a two- to three-year period, but he was uncertain how to tour them around this large country and which venues to approach or how. Increasingly, the AFC is serving as the contact point for foreign governments and cultural institutions for such initiatives.

## AFC Memoranda of Understanding With Asian Cultural Organizations

Memoranda of understanding have been put in place progressively over the course of the last 10 years, and they have been carefully thought through in terms of benefits and synergistic value to the AFC and each partner, on a mid- to long-term basis. Sustainability and specific outcomes have been key criteria in the selection of international cultural partners. These arrangements are all vital for sustaining and developing the AFC's engagement in the Asia-Pacific region and for the energy and momentum that makes this engagement successful. The key organizations with which the AFC has such arrangements follow, with a brief description of the nature of the collaborations.

## National Center for the Performing Arts—Beijing

This is the premier performing arts center in China with a range of resident companies and music-based festivals. The AFC's arrangement with the National Center for the Performing Arts (NCPA) is primarily based around the chamber music genre and involves reciprocal performances of chamber music ensembles associated with or resident in the two PACs. It also involves the combination of Chinese and Australian players into new ensemble combinations, again with performances in both PACs. Furthermore, both PACs endeavor to arrange for tours in their national networks of ensembles from the other PAC. There is also an exchange of arts administration staff.

## Shandong Province Cultural Bureau—China

This is the main arts bureaucracy and policy body for arts and cultural development in the Shandong province of China. It is a province with a population of around 110 million people. It is the birthplace of Confucius and has a rich and diverse cultural heritage. The bureau is also concerned with bringing Shandong cultural treasures out to the world, in both visual and performing arts.

The agreement involves a comprehensive set of exchanges across a range of creative genres for which the AFC has been the catalyst and driver. This has included a major Shandong presence at the 2013 Oz Asia Festival—two large-scale theatrical and dance troupes as well as a range of visual and decorative arts exhibitions. This was reciprocated in 2015 and 2016 with a range of South Australian presentations and collaborations in Shandong, including projects with our film corporation, symphony orchestra, guitar festival, library, and living artists' festival. Supporting this relationship has been an internship program that provides for a number of young Shandong arts colleagues to spend time in Adelaide's premier cultural institutions In 2015, at the request of the Bureau, the AFC led a South Australian creative industries delegation to Shandong such that the heads of South Australian cultural and creative organizations could meet with their opposite numbers from the various equivalent organizations in Shandong. The result has been a number of collaborations between most of those organizations; these now have their own momentum and are a vital part of South Australia's overall engagement with its sister province of Shandong.

## Chinese Cultural Centre Sydney

The Chinese Cultural Centre Sydney was set up to coincide with Chinese president Xie Yi Ping's state visit to Australia in 2014. It is devoted to showcasing diverse aspects of Chinese contemporary and traditional culture and highlighting the work of Chinese Australian artists in all fields. The center is also interested in bringing Chinese and Australian artists, cultural managers, and policy makers together for dialogue and collaboration.

Almost directly after its launch, the AFC approached the center to see if we could begin an alliance with it in terms of helping to tour their exhibitions and performances across Australia. This approach was supported and given credence by the AFC's good track record in working with the Chinese embassy in Canberra, the ministry of culture in Beijing, and our Shandong project. In the initial stages of the relationship, we took exhibitions of contemporary art into our galleries and encouraged other PACs around Australia to do the same, leveraging our place in the Australian touring network for this advocacy. Furthermore, the AFC actively encouraged and facilitated meetings and discussions between Australian colleagues in charge of PACs, galleries, and cultural precincts to consider some of the work on offer from the Chinese Cultural Centre Sydney so that meaningful national tours could be mounted.

The AFC's relationship with the Chinese Cultural Centre has developed to the extent that we have now a formal agreement in place, performing arts groups from China are now in the mix, and we have begun jointly presenting Chinese New Year concerts. Additionally, there is now a major project in planning with the AFC, the Chinese Cultural Centre and a range of other partners including national governments of both sides for a high-level dialogue between Chinese and Australian arts leaders who have been involved in the cultural exchange between the two countries. This dialogue will map the current state of the existing projects between the two countries and plan for future cooperation. Plans are in development for the first conference to take place at the AFC during the annual AAPPAC congress in 2016 and for the following year's dialogue, in a city in China, and then alternate between the two countries on an annual basis thereafter.

### Province of West Java—Indonesia

This agreement is with the Ministry of Arts and Education of our sister province (West Java) in Indonesia. This agreement was a by-product of a comprehensive showcasing of the creative arts of this province in the 2015 Oz Asia Festival, which was the most significant presentation of contemporary Indonesian performing arts in Australia to date—particularly in dance and theatre. During the festival, there were also many workshops and discussions about the nature of contemporary art, art and society, and art and religion in Indonesia. Because Indonesia is Australia's closest neighbor and the relationship is not always smooth, any improvement of mutual understanding through arts and culture is highly valued and appreciated by both sides. This memorandum of understanding is for reciprocal performances, exhibitions, and cultural events over a number of years, with also a goal for collaborations and joint commissions of new work.

The capital of West Java is Bandung, which many regard as the creative capital of Indonesia. The city is about to build a new performing art center and discussions are under way with the Indonesian government for the

Adelaide Festival Centre to provide consultative services for the project with regard to infrastructure, programming, and staffing.

## Georgetown Festival—Penang, Malaysia

This is the only working agreement that the AFC has with another performing arts festival. The agreement is festival to festival—that is, between the Oz Asia Festival and the Georgetown Festival—and the synergies between the two are excellent. The Georgetown Festival is one of the most progressive and culturally ambitious in South East Asia. It is also set in a multicultural context with all the challenges and opportunities that that context brings, just like Oz Asia. The arrangement is specifically for the exchange of artists and joint commissioning; the notion of cross-cultural influences and intersections of culture in the Asia-Pacific region is a key theme.

## Hong Kong Arts Development Council

The Hong Kong Arts Development Council is responsible for developing the work of young artists in Hong Kong and fueling the creative momentum in terms of homegrown work, local artists, and ensembles for the considerable arts infrastructure and venues that exist in Hong Kong. The council has also recently taken on the role of the flag bearer and agency for the international promotion of young Hong Kong artists and ensembles and fostering collaborative work for those artists with creative individuals from other countries.

Alongside the financial and business acumen of Hong Kong is a great tradition of creativity in film, contemporary music, visual arts, and modern dance. The Oz Asia Festival has featured work from Hong Kong for many years, notably some fine film retrospectives involving many of Hong Kong's best film directors.

The memorandum of understanding with the council serves to formalize and amplify the Hong Kong cultural presence in Adelaide, also diversifying cultural expression to include modern dance, visual arts, and multimedia. The agreement allows for joint commissioning and presenting, specifically in the areas of modern dance and multimedia. In addition, there is to be an exchange of personnel from both sides involved in the management of creative processes. The opportunity to have an ongoing working relationship with some of the freshest and most energetic initiatives from this international creative hub and to make the link with some of Australia's best young creative talent is a very great asset in the AFC's portfolio of Asian cultural links.

## Adelaide: UNESCO Creative City for Music

A decade of hard work of the Adelaide Festival Center in developing the international profile of the performing arts center and its community culminated in Adelaide being named a UNESCO Creative City for Music in 2015.

This successful bid was conceived and driven by the AFC and involved enthusiastic collaboration with many of the organizations profiled throughout this chapter.

The UNESCO "Creative City" international network was launched in 2005 and includes a number of art forms and city networks for those arts forms. This is an international initiative to develop a network of creative cities in specific genres that recognize the value of creativity, culture, and diversity to their communities, as well as the contribution of those attributes to social and economic wellbeing and good civic society. In applying for a UNESCO "Creative City" designation, the city is evaluated as a center of excellence in one of the seven designated art forms. Full details of the concept and the membership can be seen on the UNESCO creative cities website (en.unesco.org).

To summarize the application process, the bid began with an assessment that representation in the Creative City music category was very sparse in the Asia-Pacific, the only member from this region being in Japan. A number of cultural leaders in Asia-Pacific, including the Adelaide Festival Centre, suggested that it was time for better representation and to bring the considerable diversity and creativity of the region's music making into the UNESCO network. It was viewed that there would be considerable benefits for any nominated city, and that the international horizons for any participants in the network would be considerably enhanced.

In the case of Adelaide, the city's music credentials are diversified and significant, and with assistance of the state government music office, the city council, and a number of the existing UNESCO Creative City network member cities (particularly Seville), we were able to produce a successful bid campaign.

The secretariat for Adelaide UNESCO Creative City for Music is now housed in the Adelaide Festival Centre and staffed by the AFC head of music, which gives the activation of the membership a great platform, a solid working organization, and a set of venues behind it. The AFC also understands the great opportunity for collaboration among the city's music organizations that this status brings. Accordingly, one of Australia's best-known composers and the head of the Conservatory of Music at Adelaide University has been asked to head up the advisory committee which consists of representatives of radio stations, orchestras, popular music bodies, agents, and music educators.

This Creative City status is a real chance to expand international horizons under the banner of the biggest and most recognized cultural organization on earth (UNESCO) and in the company of some of the most creative cities around the world. And, the Adelaide Festival Centre is right in the thick of the process. This international opportunity for the performing arts center and its community is no accident; it was gained by design and hard work.

## Conclusion: Pursuing International Horizons in PAC Management

This chapter has offered a case study of the Adelaide Festival Centre as a unique PAC leadership model focused on international engagement through-out the Asia-Pacific region. While the geopolitical context of this region calls for a distinct set of management approaches, there are nonetheless valuable lessons that can be learned by senior managers of PACs in cities around the world regarding approaches and strategies to adopt international horizons in their organizations' visions, missions, goals, and operations.

The most valuable lesson, as emphasized throughout this chapter, is that the AFC's international focus and leadership were clearly identified as long-term strategic goals, which also required the right vehicles and partners to be put into action. Additional key lessons for PAC leaders around the world have to do with strategic programming, education, and professional net-working initiatives. The following are specific recommendations for urban performing arts center management to initiate a sustainable international focus and profile.

First and foremost, the international focus of the PAC must be clearly iden-tified in the PACs goals and priorities. The most effective way to ensure that this happens is to engage all key stakeholders in a rigorous strategic planning process, making sure that the process is inclusive and that all stakeholders are "on board" with the articulated PAC vision, mission, strategy, goals, and objectives. Buy-in on international priorities is especially important for senior PAC managers to secure among their ownership entity, the board of trustees, or any other key oversight groups (as determined by the PAC's organizational structure). The PAC's strategic programming—specifically, an international focus of presenting—should follow the international priorities articulated in the strategic plan. Adopting a festival programming/presenting model can be particularly helpful in engaging specific international, cultural, or ethnic groups of interest to the PAC's community.

The specific international focus of the PAC will likely be influenced by many external factors, such as (1) municipal/state international priorities, (2) the community's existing international partnerships and relationships (e.g., among government, business, and ethnic/immigrant groups), and (3) the relevance of the specifically articulated international focus (such as a geographic or cultural group focus) to the local community. All such inter-ests should be engaged in the strategic planning process, as they are crucial to the long-term success of the PAC's international strategy. In addition, senior management and staff must proactively and continually invest in positive relationships with all key stakeholder groups engaged in the PAC's international focus.

A second—and related—recommendation is for PAC managers to actively pursue long-term partnerships for implementing the international strategy. Such partners can be found among governmental entities both at home and

abroad, specifically targeted cultural organizations, an array of political figures, diverse business sponsors, and university partners. Organized groups in the home community that authentically connect with a specific international cultural or geographic focus are also very helpful as the PAC expands its international horizons.

Partnerships with educational institutions such as universities are particularly supportive of long-term sustainability of a PAC's international strategy. Collaborative activities can include internship and fellowship programs, staff and student exchanges, joint teaching and research initiatives, international professional development and consulting, and international convenings (meetings and conferences). All such activities provide collaborative investment in cultural-sector leaders of the future and support the continual strengthening of the creative and cultural industries sector as a whole.

Related to professional development is the third key recommendation for PAC managers: it is crucial to engage in and lead professional networks and associations—domestic, regional, and international. Within these networks and associations, it can be beneficial to develop specific memoranda of understanding with targeted cultural organizations as key international partners. When possible, it is useful to leverage existing international relationships that your city maintains, such as sister-city programs, or international trade relationships. Strategic partners for these programs can often be found in governmental entities at the federal, state, and local levels, as well as among diverse agencies, embassies, consulates, and trade commissions. And, don't hesitate to explore networking opportunities through international organizations such as UNESCO!

A fourth and final recommendation to PAC managers is to establish yourself as a highly knowledgeable and well-connected cultural resource for cultural-sector leaders at home and abroad. It is imperative to exhibit the willingness and capacity to serve in support of international cultural exchange, touring and presenting, tourism, and more general diplomatic efforts. Becoming a key player in municipal and state international strategy will open doors to positioning the PAC as a leader in the community and nation's ongoing international engagement efforts—and help expand everyone's international cultural horizons.

## Reference

Luqiang, Q. (2010). "Spring up like mushrooms"—the burgeoning growth of China's performing arts centres. *Asia Pacific Journal of Arts and Cultural Management,* 7(2), 595–603.

# 13 Executive Leadership for Performing Arts Centers

*Robyn Williams, Ken Harris, and Patricia Dewey Lambert*

With Paul Beard, Ted Dedee, and Adina Erwin

## Introduction

*Performing Arts Center Management* is about executive leadership to proactively adapt the relevance of the PAC to its community in an environment of constant change and evolving public expectations. Indeed, the overarching theme in all of the chapters of this book has to do with leading the relationship between the PAC as a cultural institution and its diverse communities' needs and desires. It has been demonstrated that performing arts centers are key components of the creative and cultural industries ecosystem, yet research to date on *hosting* and *presenting* performing arts organizations—the focus of this book—is surprisingly scarce. Performing arts centers that host and present performances produced by other entities are found in all community sizes and locations, as well as universities, throughout North America and internationally. These institutions are frequently an anchor of economic development of downtown areas, and massive investment in both building and renovating these facilities can be seen around the world.

This book project has taken a qualitative and applied approach to research to advance ongoing professionalization of performing arts center management. The contributing authors to this volume represent diverse voices from renowned academics, consultants, and executives, as well as some individuals poised for leadership in this field of scholarship and practice. The foundational chapters contributed by Steven Wolff, Duncan Webb, and Tony Micocci provide an excellent overview of the field of performing arts center management as a whole, and how the role of the PAC in communities is evolving. The two chapters written by Richard Pilbrow and Joanna Woronkowicz present important information for civic leaders to consider as they begin the process of identifying the kind of PAC that should be built or renovated to meet a community's needs, as well as important advice for engaging in the PAC building process. A series of three chapters contributed by Patricia Lambert and Robyn Williams, Patrick Donnelly, and Larry Henley then turns the reader to important considerations for designing and implementing ownership, governance, and management structures

and systems for both urban PACs and collegiate PACs. Finally, three case-study chapters prepared by Annie Wilson, Gretchen McIntosh, and Douglas Gautier provide in-depth insight into three key PAC leadership considerations: assessing the impact of the PAC on the local community, critically engaging opportunities for the PAC to serve as an intermediary in providing support to local performing arts organizations, and developing an international strategy for the PAC and its community.

This final chapter of the book summarizes and reflects on the major arguments and findings made across the chapters, and concludes the book as a whole with an in-depth discussion of executive leadership competencies and strategies required of current and future leaders in the field. To that end, the contributing coeditors of this book invited Ken Harris, vice president of operations with the Adrienne Arsht Center in Miami, Florida, to coauthor this chapter. These authors were joined by a focus group comprised of Paul Beard (chief operations officer, Smith Center for the Performing Arts in Las Vegas, Nevada), Ted Dedee (president and chief executive officer [CEO] of the Overture Center for the Arts in Madison, Wisconsin), and Adina Erwin (vice president and general manager of The Fox Theatre in Atlanta, Georgia). This team of senior executives generously provided extensive input and editing of this chapter. Valuable material from numerous additional PAC managers was also contributed through an interactive session titled "Executive Leadership in Performing Arts Center Management" at the 2016 International Association of Venue Managers' Performing Arts Manager's Conference.[1]

The pages that follow begin with articulating the scope, extent, and nature of the ways in which the *public value* of a performing arts center is being reconceptualized in communities across the United States. The fundamental shift in public expectations that repositions the PAC at the heart of the community propels the need for new strategies and approaches in leading performing arts centers. Inextricably tied to this shift is the need for *transformational leadership* in performing arts centers due to these organizations' changing role in their communities. The second half of this chapter addresses in detail the approaches that are needed for transformational leadership of performing arts centers.

## Redefining the Public Value of a PAC

Current understandings of what the term *public value* means for those providing leadership in the field of public management are largely framed by concepts introduced by Mark Moore (1995) in his seminal book *Creating Public Value: Strategic Management in Government*, as well as several of his subsequent publications.[2] One key idea developed by Moore to conceptualize and operationalize public value is his "strategic triangle," which serves as "a framework for aligning three distinct but interdependent processes which are seen to be necessary for the creation of public value" (Benington &

Moore, 2011, p. 4). These three processes are identified as public value outcomes, the authorizing environment, and operational capacity. This final chapter of *Performing Arts Center Management* implicitly addresses all three processes involved in creating public value by PACs in their communities but begins with clarifying emergent strategic goals and public value outcomes that have been identified throughout the field.

With their extensive consulting experience working with performing arts centers nationally and internationally for decades, contributing authors Steven Wolff and Duncan Webb have a unique perspective on fundamental shifts taking place across the sector. In this volume, Wolff convincingly argues that we are currently shifting from what he terms "Generation 3" PACs, which function as the community's center with an emphasis on access and civic engagement, to "Generation 4" PACs, where the organizational role is to serve as a nexus for providing creative public value opportunities for the community. This new role has to do with fostering diversity, inclusion, and innovation throughout the community, as well as for providing support for high quality and emerging arts and other forms of creative expression. As a Generation 4 PAC, the organization is not only a welcoming and supportive venue for artistic and cultural activity; it also now serves an important public leadership role in providing a learning environment where new knowledge and other forms of creative expression are cultivated. Wolff suggests that, in addition to being a home for the traditional performing arts, the evolving PAC now also serves its community as a *destination* and a *showcase*, as well as an *incubator*, *educator*, *innovator*, *partner*, and a *thought leader*.

Characteristic of the current shift taking place within PACs is the ever-increasing emphasis on *relationships, inclusion, relevance, sector-wide support*, and *participation* within the community. In his chapter, Duncan Webb provides excellent suggestions to PAC leaders to help meet this redefinition of what the public value of the organization is and can be. He recommends that PACs (1) focus on communities, (2) anchor cultural districts, (3) make the PAC a destination, (4) return more control of the experience to audiences, (5) help audiences to prepare for and process the experience of a live performance, (6) make facilities and the experience more attractive to younger audiences, (7) find community problems to solve, and (8) measure the PAC's success. In short, public perception of what the role of the performing arts center is and should be in the community has already undergone a significant transition. There is a heightened public awareness of what happens at the PAC, a drive to serve much broader and previously underserved audiences, and a recognition of the increasing individualization of artistic taste. Prior identifications of a "mainstream audience" have become obsolete, and smaller venue spaces that allow innovation and niche artistic expression have become increasingly important. The cultural observer is now a cultural participant, and the performing arts product is now a process of audience engagement.

The chapters in this book contributed by Richard Pilbrow and Joanna Woronkowicz provide important insight to civic leaders for envisioning, planning, and building a new or renovated performing arts center for the community. The spaces in and around a community's PAC provide a unique "place" in the community for the public to gather and to "belong." The core mission of most PACs involves education and providing a platform for artistic expression. Ensuring access and inclusion for all members of the community is central to the ability to serve as the community's PAC—the PAC that "belongs to" everyone in the community. A commitment to access and inclusion requires the development of a wide array of education and community engagement programs, free events, affordable ticket pricing, and a subsidized "home" for local performing arts organizations. All such efforts in anchoring and positioning the PAC at the heart of the community will support the institution's value to its diverse community members.

As one of the key components of a vibrant mix of community amenities, PACs are multifaceted: they offer shows and events representative of the community, act as a place for assembly of the community on topical activities, build a sense of unity in the neighborhood(s) and, often, drive development in the vicinity. A PAC should be thought of as the "glue" for a community—a welcoming place for residents and visitors to enjoy the performing arts but also a place to learn, to celebrate, and to assemble. The PAC's main responsibility to the community is to stay interconnected. In order to do this, the PAC must be a convener, facilitator, educator, programmer, revenue generator, and advocate. At any point in time these functions can play a role in community engagement, whether it be introducing new art forms to the community, educating fifth graders on the role of artists during the civil rights movement, or advocating for more public funding for arts and culture. Ultimately, how a PAC "shows up" in the community is driven by the needs and wants of the community and the positioning of the PAC to be able to effect change.

In Chapter 1 of this volume, it was argued that performing arts centers have long played an important role in the "downstream distribution infrastructure" (Cherbo, Vogel, & Wyszomirski, 2008, pp. 15–16) of the creative and cultural industries sector. A new role, however, seems to be rapidly emerging for the Generation 4 PAC and its managers to be engaged in the upstream infrastructure of a community's arts and culture sector. That is, the role of performing arts centers' executives has expanded from its prior focus on presenting artistic products to now include significant engagement in education for, participation in, and support of the entire local performing arts community.

The contributing authors of this book agree that the primary role of the PAC and its executive leaders is now focused on advancing and promoting a vibrant arts and culture sector throughout the community. Leaders of performing arts centers must now be willing to advocate for arts and culture

among other civic leaders, to engage in urban planning and development initiatives to ensure that arts and culture are "at the table," and to provide wide-ranging support for experimental, start-up, and community-based arts groups. Annie Wilson's case study analysis of how the impact of a PAC can be assessed in the local community provides a framework for better understanding the community-wide economic, cultural, and public engagement values of a PAC. This study will hopefully help PAC leaders, in particular, more clearly substantiate their leadership role in building the local performing arts scene, especially concerning the capacity and efficiency of their resident companies.

Promoting collaboration and partnerships is often the key to success in advancing cultural-sector development, but PAC leaders are also wise to heed Gretchen McIntosh's cautionary findings for how a PAC might go too far as an intermediary, thus jeopardizing the long-term sustainability of local performing arts groups. With a distinct rise in curatorship as evidenced by the increasing prevalence of presenting among PACs, strategic partnerships are key. Tony Micocci's chapter provides an indispensable toolkit of programming options that are the likely result of such partnerships and offers ways to assess the risk involved in the choices available to PAC managers as they continue to develop their important presenting role. Collaboration and partnerships are also crucial when considering oversight of the PAC in its ownership, governance, and operations structures. The corresponding chapters by Patricia Lambert and Robyn Williams, Patrick Donnelly, and Larry Henley address the complexities of effective PAC structures and systems in urban and collegiate contexts and discuss how different options for structuring the oversight of the PAC can lead to distinct challenges and opportunities. All of these chapters offer valuable insight to PAC leaders for adapting their structures and operations to adapt to new public expectations for the PAC.

In summary, all the chapters of this book demonstrate that the public value of the ubiquitous performing arts center is changing and growing in importance. Throughout the United States and internationally, PACs are eschewing their former role as cultural fortresses that exist solely to support resident companies and offer touring productions to local audiences. Just as the "arts" have blurring boundaries, the walls of the PAC have become permeable to partner with and serve the needs of all community members. This relationship between the PAC and its community is constantly evolving and transforming, as demographic changes, global trends and influences, economic factors, and technological developments all impact the ever-changing environment within which the PAC operates. The environment of rapid and turbulent change, shifting community expectations of the PAC, and a reconceptualization of what the public value of a PAC should be in its community calls for nothing less than transformational leadership on the part of the field's senior executives.

## What Is Transformational Leadership?

A plethora of resources, professional development opportunities, and reference materials on the topic of "leadership" can be at one's fingertips through an Internet search or a library search. Among the literature on *leadership* and *leading change* are numerous reference materials on the term *transformational leadership*. The concept of "transformational leadership" resonates strongly among senior executives in performing arts center management, and thus merits a deeper exploration within the context of this particular professional field.

James MacGregor Burns (1978) first brought the concept of transformational leadership to popular awareness through his descriptive research on political leaders. Burns initially defined this form of leadership as a process that would allow for leaders and followers to help each other to advance in both morale and in motivation. In transformational leadership, the leader's personality, traits, and ability to make a change are apparent through leading by example while articulating the organization's vision and shared goals. This definition was further expanded by Bernard M. Bass (1985), who explained the impact of evaluation measures on follower motivation and performance. More recently, the concept of transformational leadership has come to refer to effective leadership in working collaboratively with a team of colleagues to manage change (Bass, 1998; Bass & Avolio, 1994; Bernard, 2000; Kotlyar & Karakowsky, 2007).

For PAC executives, transformational leadership starts with identifying the need for change. It entails possessing a high tolerance for change, embracing technology and innovation, remaining interconnected with your internal and external communities, and staying aware of what's on the horizon in your business. Transformational leadership begins with knowing the *why* about change—versus the *what* and *how*—followed by building consensus and buy-in around change.

Transformational leadership has to do with challenging the definition of impossible, which involves taking risks and maximizing and realizing unfulfilled potential. When a challenge is presented or discovered, these leaders envision ways to engineer the methodology to achieve the best results. Steps include pulling together a top-notch team, defining the desired outcome, sculpting the route for establishing the new norm, and identifying the barriers—either real or perceived. Leading change takes into account the emotional, business, financial, and long-term impact of the proposed change(s). And transformational leaders ensure that strategic goals and objectives are actually implemented through specific action steps and follow-through.

Leadership is not achieved singularly or without buy-in. Transformational leaders emphasize the importance of a strong team in place to address change—the oft-cited need to "get the right people on the bus, the wrong

people off the bus, and the right people in the right seats" (Collins, 2001). An effective transformational leader finds the need for change with the support of a team, and together, a plan is developed with common purpose as the guidepost. The transformational leader develops measures and mechanisms to keep the team focused and encouraged, and challenges the team members to take greater ownership. It is crucial to understand the individual skill levels of the team members and align them with tasks and responsibilities that can enhance their results. This process also provides the opportunity to define stretch goals for individual team members, who will perform at a higher level if they are challenged to work outside of their range of comfort. Growth opportunities can always be of great benefit.

In order to lead change, it is important to have a solid foundation. A multitiered approach has proven to be the most effective. This starts with establishing a strategic plan for the organization, which is crucial to having a reliable decision-making model. The strategic plan guides the organization in developing the vision ("to be") and the mission ("to do"). Once a vision and mission are established, the organization can better define the "brand." This becomes fundamental from both a programming and marketing perspective and helps to identify the PAC's goals and objectives. Business plans are born from these foundational stepping-stones to ensure that the PAC's actions have a stable financial platform. All of these tools are shared broadly with the PAC's respective board(s) and operating management team. Members of management can then generate personal development plans, which guide both career growth and support the organization's foundation of vision, mission, brand, and financial stability.

Certain personal characteristics are repeatedly exhibited by transformational leaders, whether or not they are found in a performing arts center. Such qualities generally include taking initiative, comfort with risk taking, and a strong capacity for decision-making. To be effective, leaders must actively lead planning processes, but not become consumed by "analysis paralysis." In other words, transformational leaders must possess vision and be able to engage an idealistic lens, while remaining pragmatic and focusing on what is actually possible to do.

While the leader at the top of the pyramid is implicitly responsible for leading and implementing change, the engagement of the full team and creating buy-in within the organization are crucial for achieving the best possible outcome. Transformational leaders create an environment of mutual respect, in which team members take charge based on their skill sets and in turn support other team members. The team will instinctively turn to the transformational leader—someone who exhibits leadership traits that are purposeful—for guidance and direction. The culture of the organization and of the team is very important, as leaders thrive in an atmosphere that supports divergent thinking and encourages team development as a whole. By creating a positive and constructive atmosphere for implementing change,

transformational leaders serve as "change agents." However, a change agent does not necessarily need to be the leader in charge and, instead, can be—in part or in total—the amassed team on a journey of common vision. A team following a change agent path may indirectly create leaders and strengthen those individuals in a leadership role.

Transformational leaders coach, mentor, and inspire their teams toward individual and collective success. In order to do so, leadership involves keeping an eye on the big picture and a long-term horizon. Fostering trust is imperative, and leading by example helps the team to understand that no one's individual success will necessarily lead to the best outcome. Rather, it is by building toward a carefully orchestrated collective series of desired achievements that leads to transformational change within an organization. The most effective way for a transformational leader and, in turn, their organization to succeed involves four main areas of focus.

### First, a Common Vision

Whether referencing a goal, a strategy, or an objective, a leader is most successful when the team has a comprehensive and consistent understanding of the task(s) on all levels. This can be often achieved by using the organization's mission and vision as a foundation. Establishing the common vision can come as a directive (with supportive reasoning) or as a collaboration of ideas and suggestions. It is important to recognize that organizations are inherently complacent and averse to change. Transformational leaders must structure the environment for the team to establish goals and objectives, and will often need to push employees to step up to take part in change processes underway. Leaders ask questions and talk to people instead of "telling" them what to do in order to achieve team agreement and buy-in on strategic direction and action steps.

### Second, Goal Setting

In most cases, the ultimate goal comes after a series of objectives and tasks have been achieved. There should also be consideration of multiple outcomes to any goal. Helping the team understand the goals and the pathway forward, while developing ownership of the organization's future, should garner the best outcome. Leaders should leave room for judgment calls along the way by the team, understanding that mistakes are OK. What is important, however, is to learn from those mistakes and broadcast them in a productive manner. Transformational leaders actively create a culture in which staff members are free to get uncomfortable, to take calculated risks, to make mistakes, and to learn from them. These leaders recognize that their team members will thrive when they are reaching toward, accomplishing, and stretching for mutually determined goals.

## Third, Process

Everyone needs process. Whether we fully comprehend it or not, establishing a methodology toward our goals enables the entire team to have a common language. In most cases, this leads to higher efficiency and improved productivity. It is fine to course correct during the journey, and leaders need to look ahead to help the team to adjust as needed. Transformational leaders provide opportunities for their employees to provide input along the way and to be part of a collective decision-making process. Ultimately, however, the leader is responsible for making decisions and taking action steps to move the organization forward, and to ensure that the collective decision-making process serves as a means to an end rather than an end unto itself. By using the organization's mission, vision, and goals as a constant point of reference, it is possible to get messy within the process of implementing change. Integrating strong evaluation and assessment methods throughout leading change will help the team to stay on track toward achieving major goals.

## Fourth, Communication

Those who work in a silo and keep all of the information too close will not succeed as a leader. It is advisable to communicate in the clearest, most simplistic ways possible, and it is virtually impossible to communicate too much. Transformational leaders recognize that each of their team members has a different frame of reference. A leader may believe that they are working effectively by laying out the objectives, assigning tasks, and monitoring the process, but each team member has a unique skill set and framework for understanding the task at hand. Transformational leaders should recognize this multiplicity of working styles and harness this as a collective team strength to achieve a better outcome.

Transformational leaders also recognize that, with demographic shifts in the workforce, the working styles of their employees have changed. The image of the leader as someone who is the "bringer of the tablets" to the masses who are dying for inspiration and are willing to march forward unquestionably to achieve the vision is obsolete. Younger team members typically possess very different expectations for workplace engagement, communications, and decision-making. Likely due to their extensive participation in social media over the years, younger people expect to have many opportunities to have a voice in matters under discussion, and to more fully participate in organizational decision-making. As a result, the hierarchy of organizations has changed to be more egalitarian and to provide opportunities for all staff members to feel important and involved. Executive leaders' key role is often to listen to and learn from staff, and often not to *do* anything. Rather, transformational leaders often see their primary role as removing roadblocks so that their team members can get their jobs done. Transformational leaders are focused on engaging the hearts and heads of

their increasingly diverse team members. They also recognize that, ultimately, the organization's leader will need to make the tough decisions that will strengthen the organization as a whole.

Effective executive leadership must now be focused on adapting the organizational culture in response to the very different needs, wants, and demands of today's workforce. It is imperative to create a space where leaders can emerge and be mentored, and where it is acceptable to disagree with each other. In the new organizational hierarchy, leaders must expect questions and constructive criticism from their staff members. Instilling values of transparency and communication is key, as is fostering an environment that encourages calculated risk taking (and failure) in pursuit of collaboratively determined strategic goals. Staff members no longer work *for* the executive director; they work *with* the executive director.

The leader of a performing arts center is absolutely crucial to the organization's success. Civic leaders and umbrella organizations responsible for overseeing the senior executive staff of a performing arts center would be wise to evaluate candidates for a position according to the recommended key qualifications, experience, and personal qualities described in Box 13.1.

---

### Box 13.1   Hiring a PAC Leader

The following are questions for hiring committees to ask in evaluating candidates for senior executive positions in performing arts centers:

1  Does the candidate possess and embrace appropriate professional, artistic, and academic qualifications for this position in our community?
2  Does the candidate have the work ethic and integrity to oversee this organization, and does he/she have demonstrated experience in financial management in good times and in bad times?
3  Has the candidate demonstrated the capacity to enhance public value and perception of an organization?
4  Has the candidate presented compelling evidence of experience in leading change and providing transformational leadership within a prior organization?
5  Does the candidate demonstrate a commitment to a collaborative working style, including compelling and transparent communications?
6  Has the candidate presented solid examples of times he or she has taken calculated risks and learned from failure?
7  Does the candidate provide evidence of strategic, visionary, and process-oriented leadership?
8  Does the candidate possess an inspiring, positive, and charismatic personality?
9  Has the candidate demonstrated and proved to be a leader within his or her community?

## Transformational Leadership for Performing Arts Centers

Strong transformational leadership for performing arts centers embraces good business practices and a solid foundation for processes, just as all other business entities do. Excellent PAC leaders will embody the approaches to executive leadership discussed in the prior sections of this chapter, but they will do so as tailored to the unique needs of their performing arts center. They also do so while encompassing an ethical and integrity-based approach to ensuring the relevance of their PAC to their community.

As argued throughout this chapter, PACs urgently need transformational leaders due to their shifting role in communities. In simple terms, effective leadership of a PAC engages three core organizational functions: facility management, content (programming/booking, and marketing), and financial stability—all of which are necessary to fully activate the business. Executive leaders will start with the mission and the vision of the organization, support goals with solid and diverse programming, encourage taking calculated risks, engage the community, and gain support from allied partners. These leaders will work with their staff to proactively respond to the changing environment and the ongoing diversification of their markets. They will lead the process and take the necessary action to continually reposition their PAC as a community center focused on access, inclusion, civic engagement, and creative expression.

---

### Box 13.2   Miami's "Town Square"

When the current president/CEO of the Adrienne Arsht Center, M. John Richard, came on board, he began to refer to the PAC as "Miami's Town Square." One of the first things done under his leadership was to host the next presidential inauguration simulcast for the community at the Arsht Center with local dignitaries and arts groups presenting and performing. Additional community-focused programs included the Community Homecoming for the Inaugural Poet Richard Blanco and AileyCamp Miami. The Arsht Center even formed a board comprised of civic leaders, the Town Square Neighborhood Development Corporation, which is deeply engaged in aspirational planning for the community. Now, if you look up the address of this PAC on Google Earth (1300 Biscayne Blvd., Miami, FL 33132), the Arsht Center Campus comes up as well as the words *Town Square*.

---

The successful performing arts center is one that serves with pride as a community center or a town square. All of the activity surrounding the PAC is important since community members have to want to come to the facility for more than just what is programmed on the stage. To truly be inclusive as a community center, the PAC needs to engage diverse communities of racial and ethnic backgrounds, immigrants, socioeconomic demographics,

age groups, and abilities. Broadening thinking to understand how the PAC can become "everyone's performing arts center" leads to dramatic shifts in programming and services to address the interests and needs of significantly expanded community groups. Transformational leadership involves effectively communicating throughout the community that "this is *your* performing arts center; this center belongs to *you*." It is crucial to truly embrace a commitment to diversity, equity, and inclusion in all aspects of PAC staffing, programming, and operations.

In Atlanta, for example, the Fox Theatre is constantly mindful of ways to promote diversity, equity, and inclusion while engaging with the PAC's neighborhoods and communities, which benefits the PAC as well as its various communities. The return on investment in this area goes beyond financial results to include brand identity and growth of the organization. In making strategic decisions, the Fox Theatre asks, "How does that uphold the mission of the PAC?" Taking a holistic approach to community engagement and programming ensures that the organization will have a long life and continued development, which includes changing with the local culture.

The PAC's role in the community now involves so much more than merely providing the artistic product. It is now about the experience, the "moments of magic," and the welcoming activities and services surrounding the facility and the performances. What happens outside the four walls of the PAC has become significant from the lens of approachability. The location of the PAC is key in assessing the positioning of facilities and affiliated services within a community. The physical nature of going to a destination and being part of something in the community must make people feel good about what they are going to experience and goes far beyond what is programmed on the stage. Animating and creating activity surrounding the PAC is an important dimension of reframing the PAC as a relevant destination place in the community. For example, imagine a family arriving at the PAC two hours before the published curtain time. Why are they there so early? They can be having lunch or dinner at the PAC or a neighboring restaurant. They can be roaming through a bookstore or sitting in the bustling neighborhood enjoying the kinetic activity, including buskers on the street. There is an energy before a performance that can lead to an overarching enjoyable experience, which includes the performance on the stage(s).

In light of shifting community needs for PAC programming and other services, executive leaders frequently navigate the delicate balance between artistic decisions and financial decisions. The economics of programming are complex, and assessing calculated risk has become essential. Many performing arts centers are forced into making safe choices because of the need to play it safe in order to balance the budget. In taking a portfolio approach to programming, PAC leaders need to assess how they will make money on certain productions to offset anticipated losses, and how they will secure subsidies to also help to mitigate losses on risky programming. Some PACs are also building their own presenting in order to find and articulate their

artistic voice in the community. Many of these curated performances and activities are focused on underserved audiences and specific community needs, and are largely mission-driven. A recurrent theme for leading programming is the importance of constant innovation in order to continue to make the PAC relevant to the community.

---

**Box 13.3   Determining Community-Relevant PAC Programming**

When Ted Dedee, president and CEO of the Overture Center (OC), first moved to Madison, Wisconsin, he immediately immersed himself in all of the community's summer festivals. This exposure introduced him to local cultures and community pride and helped clarify for him the ways in which the OC could be relevant and engaged in the neighborhoods. The next summer, OC sponsored three of the summer festivals, which was a bold step forward in investment, partnership, and community buy-in. One of the festivals led to the OC's annual presentation of a World Music Festival, which brings in audience members who may not have previously attended performances at the venue.

---

Diversification of audiences, artistic tastes, and ancillary activities is constant, and PAC leaders acknowledge that rapid societal and technological change is propelling the reconceptualization of what "mainstream" arts programming might mean to a community. Smaller theaters allow for people to be creative and to try experimental work that will appeal to specific audiences, and activating smaller spaces (experimental theaters, lobbies, and other spaces) is becoming increasingly important. The increasing role of PACs in curating and artistic risk taking is resulting in new art forms and new forms of collaboration. The relevant, community-focused performing arts center is no longer a fortress that presents only classical symphony orchestras, operas, ballets, and theatre productions, a Broadway series, and a splattering of other mainstream entertainment options to a homogenous public. Instead, transformational leaders are guiding performing arts centers forward to embrace a new set of crucial community-based roles and functions. PACs are also finding innovative ways to use their facilities in new ways that deepen and enhance the audience member's experience. For example, audiences do not necessarily need to enter the lobby and sit in the seats within the theater. What if they enter via the loading dock and experience the performance while sitting or standing on the stage?

The emerging role of the performing arts center as a leader in the community encompasses two primary roles. First, the PAC is a key element of the urban planning, facilities, and amenities infrastructure of the community. Second, the PAC serves to lead the local arts community as a legitimizer, an incubator, and a steward.

## Leading the PAC within the Community Infrastructure

As argued in chapters throughout this book, performing arts center facilities are understood to be core elements of a robust community amenities infrastructure. Policy makers, urban planners, and civic leaders alike recognize the important role of PACs in urban revitalization, development of cultural districts, and animating a downtown area or a neighborhood. PACs partner with urban planning and cultural affairs practitioners, as well as convention and visitors' bureaus, to enhance the quality of life for citizens, to support the creative vitality of the community, and to promote cultural tourism in the region. PACs are now considered to be destinations—regionally, nationally, and internationally. Their role extends far beyond the advertised show or performance, as PACs are frequently historic and architectural landmarks with a broad appeal. There is a heightened public awareness of these facilities as their presence has become solidified in the urban core as a contributor to the overall economy.

---

### Box 13.4  The PAC in the Las Vegas Cultural Desert

The Smith Center in Las Vegas, Nevada, is changing the city's self-image. The community is making use of the Center by attending performances that differ artistically from typical Las Vegas offerings, and the public actively participates in the Smith Center as subscribers, members, and donors. Together, the Smith Center and its engaged community of supporters are changing the notion that Las Vegas is a cultural desert. While there were peculiarities of this market compared with those of other urban PACs, the Smith Center has succeeded by understanding its community and matching the programming to the community's needs. In planning the Smith Center's opening in March 2012, civic leaders recognized that all successful PACs require three basic elements: (1) adequate capital to build the venue correctly, (2) great leadership from the board and senior staff, and (3) a viable market that can sustain the venue.

---

In addition to their important role in the downtown cultural core of a city, transformational leaders of performing arts centers are increasingly embracing opportunities to go out into diverse neighborhoods to engage with underserved audiences. By going "on tour" locally and taking programming into communities whose members prefer to stay close to their neighborhoods (for instance, immigrant communities), the PAC staff member can better learn the programming interests and needs of diverse groups of citizens. Additional steps can be taken to build relationships with underserved communities, such as welcoming audience members with bilingual staff in the box office and as greeters, or partnering with other community-based organizations that serve these same publics.

For example, the Overture Center in Madison reached out to the Hispanic community to reposition a Latino Art Fair. The PAC partnered with the

Chamber of Commerce to bring the art fair onto the Overture Center site and coupled it with a Latino Music Festival. This event embraced both music and visual arts, and drew a Latino demographic to the center, encouraging an underserved group from the community to make the Overture Center their own.

Another example of broad community engagement by the Overture Center is its annual partnership with community centers on a talent audition that leads to competition. A panel of professional judges adjudicates the auditions at six different locations in diverse neighborhood communities. The key to the success of this initiative (hundreds audition each year) is that the event is going into the communities where these individuals live and feel most comfortable. The event culminates as a final list of 25 performers who compete at the Overture Center's 1,100-seat theater. Cash prizes are awarded across all art forms in various age groups and demographic populations.

It can be argued that all communities are underserved by the performing arts center. In fact, it is estimated that only about 5 to 10 percent of America's citizens ever attend their local performing arts centers at all. A major goal of PAC staff members is to increase diversity in visitation and participation in the PAC's offerings, and it is necessary to program to the targeted audience groups and work with their communities to encourage buy-in. It is imperative for new participant groups to have a stake in the programming, which relies on social, educational, and philanthropic viability. Expanding programming and PAC visitation builds upon strong community relationships.

Engaging new audiences within the community also requires risk capital since many times initial steps to be taken to attract new and different audiences are often loss leader programs. For example, the Overture Center in Madison, Wisconsin, had a donor who subsidized family four-packs ($75 total) that included a pizza party and tickets to the *Lion King*, along with a souvenir for the kids. This kind of investment brings new audiences to the PAC who had never been there before. However, it is also important to remember that touring productions booked by the PAC do not always match diverse community members' needs and desires. Meeting with local groups will help the PAC to determine what kinds of activities and events are needed, and these may not involve ticket sales at all. In some cases, community members are most attracted to free or low-cost events, which can be funded by grants or corporate sponsorships.

Educational programming is key to community engagement and is central to PAC missions. Educational initiatives can be tied to other programming or serve as a stand-alone opportunity, and many funding streams (sponsorships, grants) exist that can help make a PAC's educational programs possible. Classroom space and rehearsal rooms would be beneficial to the PAC, and a conjoined venue with these attributes could also be a revenue generator for the PAC.

## Box 13.5   Engaging Portland's Diverse Communities and Neighborhoods

Portland'5 Centers for the Arts in Portland, Oregon, strives to develop its presenting series to serve diverse communities in a variety of ways. This PAC's school shows target Title 1 schools only, and Portland'5 provides funding so that none of these schools has any out-of-pocket expenses for their students to participate. In the past, transportation was a huge barrier to these schools due to the expense. Portland'5 staff were shocked to hear about the number of these students who had never been to downtown Portland, let alone in one of the Portland'5 venues. The PAC staff welcomed the students to these school shows by thanking them for coming to "their" theater. One teacher mentioned to the staff that these students had never before thought of the Portland'5 theaters as "theirs."

Portland'5 has created a new full-time education/community engagement staff position to deepen the PAC's reach into the diverse communities of Portland. Staff talk to the media who serve these communities about what type of performing arts and entertainment various communities want to see and how they like to purchase tickets. For example, Portland's Hispanic/Latino community is more comfortable purchasing tickets at their neighborhood store, and some segments of local immigrant communities prefer to use cash instead of credit cards. Portland'5 is also looking at communities that don't want to come downtown and is identifying the need to program within these communities' neighborhoods. The staff of this PAC believes that, if Portland'5 is going to be "Portland's performing arts center," then they need to make sure they are focusing on *all* of Portland—especially the communities who are underserved.

Many of America's performing arts centers offer vibrant arts education programming to their communities. For example, the Arsht Center formed AileyCamp Miami in collaboration with the Alvin Ailey American Dance Theater. This camp teaches self-discipline, respect, and communication through dance, and each year more than 100 students from widely diverse and underserved neighborhoods in Miami participate in this six-week full-scholarship program. Furthering the impact on the community, AileyCamp culminates with a free performance for family, friends, and the community. The Arsht Center has also developed a program called "Learning through the Arts" which educates all fifth graders in Miami-Dade County Public School about Greek mythology through Homer's *Odyssey*. In this program, the Arsht Center provides to school teachers an in-the-classroom curriculum centered on Homer's work. The journey is completed when the students are brought to the Center to experience a live musical based on the literary work. Both AileyCamp Miami and Learning through the Arts are fully

subsidized by public–private partnerships and are offered at no cost to the students or the schools.

As part of Jazz Roots: Soundcheck, the educational component of the Arsht Center's Jazz Roots concert series, more than 100 high school students experience a full day of music education. The students sit in on a real working soundcheck and are invited to a Q&A with the artist. The band sometimes surprises the young musicians by inviting them to jam with the band on stage. This educational experience, a partnership with Miami-Dade County Public Schools, is offered for every Jazz Roots concert at the Arsht Center and has brought more than 7,000 high school music students to the center since its inception in 2008.

Another vibrant set of educational programs is provided by the Overture Center in Madison. The Overture Center engages the local school district and the city to participate in the Kennedy Center's Ensuring the Arts for Any Child program. The primary goal of this program is to assist communities in developing and implementing a plan for expanding arts education in schools, ensuring access and equity for all students in Grades K through 8. The Overture Center also works with its community to participate in the Disney Musicals in Schools program. This initiative builds sustainable theatre programs in under-resourced public elementary schools. By providing free performance materials and free professional development to participating teachers, Disney Musicals in Schools has helped schools across the country launch new theatre programs.

The Smith Center in Las Vegas offers a range of educational programs, which were actually established long before the Smith Center actually opened. Educational programs are a centerpiece of the Smith Center's mission and are possibly even more popular within the community than the PAC's entertainment offerings. Sample programs include bringing students to the PAC for programs that are integrated into the school system's curriculum, as well as a range of musical-theatre educational offerings like Camp Broadway, Disney Musicals in Schools, and High School Musical Awards (a competition among school-aged kids from across the country).

Despite these vibrant community-focused offerings, a challenge for PAC leaders is how to make their large venues relevant to the community beyond the standard 2:00 p.m. and 8:00 p.m. curtain times. Are there ways to occupy the building for higher use when they would otherwise lie dormant? Some examples that employ capital investment for educational programs and patron services exist—such as with the Straz Center's (Tampa Bay, Florida) and the Broward Center's (Fort Lauderdale, Florida) brick-and-mortar educational facilities, as well as the Broward Center's enhanced patron service locations as an upsell for additional amenities that supplement the show experience with a VIP location for an exclusive food and beverage experience—but this aspect of PAC programming for community relevance and engagement remains a significant challenge and opportunity.

*Leading the PAC Within the Local Arts Community*

The performing arts center and its staff members play a key role in the local arts community and are often charged with their mission with serving a supporting role to specific resident companies. Savvy PAC leaders recognize that local arts organizations are likely not looking to the PAC to play an artistic role but, rather, serve as a supporter, a collaborator, and a partner for their activities and performances. The facilities are public assets, and transformational leaders will proactively engage these assets to help and to promote local arts activity. However, the ability to provide excellent performing arts facilities for local arts organizations to use is key, and many of America's PACs are now aging facilities that require substantial capital to keep the venues in proper working condition. PAC leaders need to help their boards and municipalities understand that, in addition to address ongoing repairs and housekeeping, the PAC must be able to maintain and replace high-cost finishes like carpets, seating, mechanical systems, stage equipment, and technology.

Smaller start-up cultural activities and events will benefit from the imprimatur of staging their work within the PAC, providing "legitimacy" to their arts offering. Similarly, the PAC has a unique role and opportunity to serve as an incubator for local artistic work, especially for risk-taking artistic ventures. The PAC leader also stewards a wide array of local arts organizations in providing a community space for performances, as well as extensive support and subsidy to these organizations. Many urban PACs now include smaller producing organizations within the PAC, and the substantial influence of these organizations in the aggregate influences change across the local performing arts scene.

---

## Box 13.6   PAC Support of Start-Up Community Arts Groups

Many performing arts centers provide valuable start-up and incubation support to local arts organizations through special facility use arrangements. Three examples can be found at the Arsht Center, Overture Center, and Portland'5 Centers for the Arts.

The Arsht Center has been able to provide their smaller theater—Carnival Studio Theater, a black box space—to local arts organization at an affordable rental rate. As such, it has become the home for a long-running short play festival in the summer as well as a theatre festival focused on Spanish-language plays from the Americas. Through its own Theater Up Close Series, the Center has helped to launch a new company, ZoeticStage, into one of the area's most critically acclaimed theatre groups. The series has also served as a bridge program offering local university students an opportunity to work alongside theatre experts on a professional production at the center. This grows the community from an arts perspective and increases the viability for the theatre community to grow and become even more viable.

The Overture Center has a Community Arts Access program that provides a subsidy for nonresident arts groups. This allows the rent to be waived in any of the Overture theaters, although the 200-seat black box theater is typically used. The arts groups can apply for up to two years of subsidy. This arts incubator is intended for these groups to focus on their art and on reaching the greater community.

Portland's5 Centers for the Arts offer their smallest theater, a black box theater called Brunish Theatre, rent free to local nonprofits. The nonprofit is only responsible for paying the house manager's fee, and shares costs associated with the stage door, coat check, and security with the other two venues in the house. The PAC provides all of the equipment and the local nonprofit using the space can use its own stagehands. The PAC also provides volunteer ushers at no cost.

By serving the community as a *legitimizer*, an *incubator*, and a *steward*, the PAC possesses a tremendous opportunity and responsibility to support local arts organizations and local creative expression. In activating these three roles, the PAC can remain deeply engaged in and relevant to the local arts community. By extension, the PAC executive leader can promote a crucial community role in convening sectorwide leadership and advocating for the arts and culture sector within additional public-sector gatherings.

All local arts activities that take place in the performing arts center benefit from the experiential dimensions of the facility, including ticketing, parking, greeting on arrival, concessions, and the entire experience of the building and its surrounding amenities. Transformational leaders of PACs will always watch for emerging trends and opportunities to enhance the guest's experience, and will seek to introduce new elements to the facility and the audience accordingly. They will always look for ways to deepen their engagement with their entire community.

In addition to a commitment to continual improvement in the guest experience, PAC leaders are carefully monitoring emerging trends in the use of technology. Many resident companies (such as the local symphony, opera, and ballet) tend to fight the use of technology by their audience members, while simultaneously the use of technology by audiences and in theatrical productions is rapidly evolving in new directions. PAC leaders need to serve as community leaders in recognizing and advising on the integration of new technologies in the arts and need to constantly monitor their facility as a public asset that is expected to remain current in the national performing arts production and presentation field. And to support the guest experience, many performing arts centers are currently investing in new technologies such as the following:

- Wi-Fi throughout the building and the facility wired for high technology conferences
- TV accessibility via T1 lines throughout the venue

- State-of-the-art audio systems
- Digital signage (ticketing, future shows, way finding, merchandise, food & beverage, etc.), through high-definition touch-screen digital boards
- Use of social media in the venue, using a Wi-Fi distributed system
- Tweet and Instagram walls in lobbies and theaters, and "Tweet Seats" for shows
- Use of smartphones for program notes
- Interacting with guests through mobile devices (guests opt in)
- Post show surveys that allow for enhanced customer relationship management interactions
- Ticketing via mobile technology
- Enhanced closed-circuit systems for security surveillance

Ways in which technology can be used to enhance the guest experience are exemplified by the Fox Theatre in Atlanta, as described in Box 13.7.

---

**Box 13.7   Technology-Enhanced PAC Guest Services**

At the Fox Theatre in Atlanta, staff are starting to strategically use technology to engage with the guest before, during, and after their PAC visit, and to integrate across the guest services that are provided. For example, they are looking at a system to engage their guests when they first arrive at the Fox. This system will prompt guests to opt in on their mobile device to a series of interactive communications like *beacons*, which allow guests to learn about the opportunities they have at the PAC facility that day or evening. Through mobile devices, the PAC can offer excellent guest service that also provides for sponsor engagement and increased patron purchases during the visit. Mobile technology will then be paired with digital signage throughout the facility, which promotes ticketing for future shows, provides way finding, advertises merchandise sales, and promotes food and beverage purchases (e.g., preordering drinks for intermission). This technology would further enable dynamic pricing for ticketing as well as food and beverage. And, after the show, an audience survey is communicated via technology to the patrons, thanking them for attending and collecting responses to patron services. This survey allows the PAC to reach out immediately to the guest if any concerns arise and permits possible phone or e-mail follow-up interaction.

---

The use of technology in performing arts centers also applies to safety and security measures. In the United States, urban performing arts centers are sometimes viewed as "soft targets." A *soft target* is a public place where groups of people can gather and that have little to no security. If a PAC has not already put vital safety and security measures in place, it is crucial for them to partner with local law enforcement to make the venue safe and secure. Besides engaging with security companies and local law enforcement

agencies, cameras, communication devices, screening devices, and other technological equipment greatly facilitate this process.

With regard to safety and security, there is no doubt that the terrorist events in Paris in November 2015 and San Bernardino, California, in December of the same year—as well as the two theater and nightclub shootings in Orlando, Florida, that took place within a 26-hour period in June 2016—all signal the need for strengthening the security protocols of all public assembly venues, including performing arts centers. Beyond terrorist events, it is noteworthy that PACs are often located in urban settings in which the current surrounding landscape requires more attention to safety and security (for instance, to address patrons' perception of safety in urban areas where there is a large transient population).

Most of America's PACs have recently reviewed their security operating procedures, and many PACs are now developing strategies for enhancing this important aspect of operations. The Adrienne Arsht Center, for example, is working closely with local law enforcement agencies to improve coordination and familiarity with the facilities and increase staff training and awareness of emergency and terrorism situations. This venue and other PACs have recently developed a detailed, scalable security response system that is coordinated with the Department of Homeland Security and the National Terrorism Advisory System, and they have initiated new security screening and bag check policies for the PACs' patrons.

## Conclusion

It is not easy to manage a performing arts center. The pages of this book discuss ways in which public expectations have shifted over the past decade or so, resulting in a very different role of the institution at the heart of its community. The ever-increasing complexity of the relationship between a performing arts center and its community requires savvy, visionary, and strategic leadership. The transformational leader of today's performing arts center needs to fully embrace the role of the PAC in urban planning and development, and the PAC's role as a linchpin in the local arts community through legitimizing, incubating, and stewarding other arts groups. This chapter has drawn on expertise shared by renowned PAC senior executives to summarize and reflect on strategic leadership responses to all of the challenges and opportunities outlined in the twelve preceding chapters of this volume.

The contributing authors in this book have collectively sought to provide a solid foundation for current and future leaders in performing arts center management. Critically engaged readers will recognize that, with the current scarcity of scholarship on *renting* and *presenting* PACs, this book is only a first step in addressing the needs for research and professionalization of this field. Indeed, the field is wide open for further investigation on any of the topics introduced in the pages of this book. It is hoped that the

ubiquitous PAC will begin to become fully recognized for its integral role within the creative and cultural industries.

## Notes

1 The authors thank Larry Henley for his important role in programming this session at the conference and for participating as a panelist in the session.
2 Multiple book and article publications by Moore exist on this topic, but see Moore (1995, 2013) and Benington and Moore (2011) for foundational concepts.

## References

Bass, B.M. (1985). *Leadership and performance.* New York: Free Press.
Bass, B.M. (1998). *Transformational leadership: Industrial, military, and educational impact.* Mahwah, NJ: Erlbaum.
Bass, B.M., & Avolio, B.J. (Eds.). (1994). *Improving organizational effectiveness through transformational leadership.* Thousand Oaks, CA: Sage Publications.
Benington, J., & Moore, M.H. (Eds.). (2011). *Public value: Theory and practice.* New York: Palgrave Macmillan.
Bernard, M. (2000). The future of leadership in learning organizations. *Journal of Leadership & Organizational Studies, 7*(3), 19–31.
Burns, J.M. (1978). *Leadership.* New York: Harper & Row.
Cherbo, J.M., Vogel, H.L., & Wyszomirski, M.J. (2008). Toward an arts and creative sector. In J.M. Cherbo, R.A. Stewart, & M.J. Wyszomirski (Eds.), *Understanding the arts and creative sector in the United States* (pp. 9–27). New Brunswick, NJ: Rutgers University Press.
Collins, J. (2001). *Good to great.* New York: Harper Collins.
Kotlyar, I., & Karakowsky, L. (2007). Falling over ourselves to follow the leader. *Journal of Leadership & Organizational Studies, 14*(1), 38–49.
Moore, M.H. (1995). *Creating public value: Strategic management in government.* Cambridge, MA: Harvard University Press.
Moore, M.H. (2013). *Recognizing public value.* Cambridge, MA: Harvard University Press.

# About the Editors and Contributors

**Patricia Dewey Lambert**, PhD, co-editor, is associate professor at the University of Oregon (UO), where she leads the performing arts management area of study. She directed the UO Arts and Administration Program from 2011 to 2016 and its affiliated research center, the Center for Community Arts and Cultural Policy, from 2009 to 2016. Patricia holds a bachelor's degree in vocal performance from Indiana University, master's degrees in international business (Vienna) and arts management (Salzburg), and a PhD in arts policy and administration from The Ohio State University. Her work experience includes positions in the United States and in Europe as an arts administrator, professional classical singer, marketing communications consultant, foundation programs manager, English teacher and translator, college teacher, and researcher. Patricia has published articles in *Higher Education*; the *International Journal of Arts Management*; the *International Journal of Cultural Policy*; the *Journal of Arts Management, Law, and Society*; and *Studies in Art Education*. As contributing editor, she recently published a book on *Managing Arts Programs in Healthcare* (Routledge, 2015). Patricia's research lies at the intersection of the arts, humanities, and social sciences, and engages four interrelated thematic areas: arts administration education, international cultural policy, regional cultural planning and development, and arts in healthcare.

**Robyn Williams**, CFE, co-editor, has worked across the United States in the public assembly facility management field for more than 30 years and is currently the executive director for Portland'5 Centers for the Arts in Portland, Oregon. Robyn is deeply engaged in professionalization of the performing arts center management field through her active engagement in the International Association of Venue Managers (IAVM). She served on the IAVM Performing Arts Committee (chairing it in 1993 and 1994), chaired the first Performing Arts Facility Management Seminar in Chicago, and served on the IAVM board of directors as the director at large–performing arts. She was a 15-year instructor and past chair of the board of regents for IAVM's Venue Management School, where she

introduced the first class on stage operations and rigging safety, and led the development of the school's Graduate Institute. She served as the vice-chair of IAVM's Leadership Task Force, which debuted the successful Leadership Institute seminar in San Diego in 2001. She was an inaugural member of IAVM's Security and Safety Task Force, where she represented performing arts venues and drafted the initial best-practices emergency planning guide for performing arts centers. Robyn has a degree in technical theater design from Western Illinois University and did graduate work at Texas Tech University. She is a certified facilities executive (CFE) and past president of IAVM. She currently serves on the IAVM Foundation board of trustees. In 2007, Robyn was voted one of the "Top Five Women of Influence" by *Venues Today* magazine.

**Patrick M. Donnelly**, CFE, is Director of Theater Operations for the Kauffman Center for the Performing Arts in Kansas City, Missouri. He joined the organization during its construction phase in 2009, to help it prepare for its 2011 grand opening. He currently leads a team that oversees presented performances, rental performances, and production infrastructure at the Kauffman Center. Prior to relocating to Missouri, Patrick served as Director of the Roselle Center for the Arts on the campus of the University of Delaware, and as Director of audience services for the theatre program at Western Michigan University. He entered the venue world as a stagehand-turned-production manager, before pursuing an administrative career. Patrick is an active member of the International Association of Venue Managers (IAVM), the Association of Performing Arts Presenters (APAP), and the Plains Presenters consortium. He writes periodically for various trade publications, and has taught arts administration at Western Michigan University. Patrick graduated from the Master of Arts Management program at Carnegie Mellon University.

**Douglas Gautier**, AM, has served as Chief Executive Officer and Artistic Director of the Adelaide Festival Centre in Australia since 2006. After completing studies at Flinders University and the Bristol Old Vic Theatre School, he began his career with working for the BBC as a music and arts producer in London before transferring to Hong Kong, where he headed up the Music and Arts channel of Radio Television Hong Kong. He moved back to Australia in 1987 as Head of Concert Music for the Australian Broadcasting Corporation. He then returned to Asia as an executive with Newscorp's pan-Asia satellite TV service, StarTV. In 1997 he was appointed Deputy Executive Director of the Hong Kong Tourism Board, and in 2003 he became Executive Director of the Hong Kong Arts Festival. Douglas has served on a number of arts, media, academic, and tourism boards throughout his career and is currently Chairman of the Association of Asia Pacific Performing Arts Centers. He is also Director of the Asia-Pacific Centre for Arts and

Cultural Leadership, a joint venture with the University of South Australia. He serves as a Council member for Flinders University. Douglas was awarded an Order of Australia (AM) in 2016 for his service to the cultural and academic sectors.

**Ken Harris** is the Vice President of Operations at the Adrienne Arsht Center for the Performing Arts of Miami-Dade County in Florida. He has been an executive with the Arsht Center since 2008. Ken's career has spanned 35 years in the theatre and entertainment industry, beginning with repertory theatre companies including The Alley Theatre in Houston, Texas, Seattle Repertory Theatre, and the Folger Shakespeare Theatre in Washington, D.C. He then worked for over 20 years for the Disney Company in Orlando, Florida, holding positions in the Entertainment Line of Business for Creative, Production and Operations. While with Disney, he particularly enjoyed touring shows nationally and internationally, developing shows and events for guests in the parks, and producing television shows. Ken holds a Bachelor of Arts in Theater Arts from SUNY College at Fredonia and a Master of Fine Arts in Drama from the University of Washington.

**Lawrence D. Henley**, CFE, is Director of Artistic Programming and Production at the UNLV Performing Arts Center, Las Vegas, Nevada (2002–present). Previous to that he served the UNLV PAC as Facilities Manager from 1988 to 2002. A member of the International Association of Venue Managers (IAVM) since 1991, he has served on the Performing Arts Program Committee as Vice-Chair and, currently, as Chair of the Performing Arts Sector. A founding member of the IAVM Research Advisory Committee, Larry also has served as Chair of the IAVM Universities Sector and on the IAVM Board of Directors and Executive Committee. The author of numerous articles for IAVM's *Facility Manager* magazine, he is also an annual contributor to the Utah Shakespeare Festival's *Midsummer Magazine* and *Insights* education publications. Larry holds both a Bachelor of Arts in Theatre and a Master of Arts Degree in Theatre Management from the University of Nevada, Las Vegas. He served from 2004 to 2014 as Vice-President of UNLV Chapter 100 of the Honor Society of Phi Kappa Phi.

**Gretchen D. McIntosh**, PhD, currently serves as Director of Evaluation & Stewardship at Dublin Arts Council in Dublin, Ohio. Gretchen recently earned her PhD in Cultural Policy and Arts Management from the Department of Arts Administration, Education & Policy at The Ohio State University in Columbus, Ohio. She received her Master of Arts in Arts Administration from Ohio State and her Bachelor of Arts in Communication from Wittenberg University. Gretchen serves on the board of Thurber House, Ohio Arts Presenters Network, and as Vice-President of Emerging Arts Leaders Columbus.

**Tony Micocci's** career began in tour management during the international heyday of American contemporary dance with the renowned companies of Alwin Nikolais and Murray Louis and, by extension, working with legends such as Rudolf Nureyev and Dave Brubeck. A subsequent decade of performing arts center management involved setting up the highly successful Flynn Center in Burlington, Vermont, in the historic Flynn Theatre, followed by the presidency of New York's City Center during a period of robust growth. In both, Tony was instrumental in historic restoration, operations and programming, fund development, and staff management. In 1992 Tony established Micocci Productions, LLC, as an institutional frame within which to produce festivals and international tours of significant productions, and to manage a luminous roster of international touring artists and productions. Highlights of this work included artists of the stature of the mime Marcel Marceau, choreographers Twyla Tharp and Elizabeth Streb, puppeteer Basil Twist, and writer and director Lee Breuer. Tony's association with academia began in 2005 with a lecture tour in arts management in Russia under the U.S. State Department, which resulted in publication of his textbook on the international tour booking process titled *Booking Performance Tours: Marketing and Acquiring Live Arts and Entertainment*. In 2011, Tony relocated from New York City to New Orleans at the invitation of the arts management training program at the University of New Orleans.

**Richard Pilbrow** is one of the world's leading theater design consultants, a pioneer stage lighting designer, an author, and a producer. He founded Theatre Projects in 1957, now the preeminent theater consulting organization, with over 1,200 projects in 80 countries. Richard was chosen by Laurence Olivier to be theater consultant to the National Theatre of Great Britain. His books *Stage Lighting* (1970) followed by *Stage Lighting Design* (1997) remain standard texts. In 2003 he wrote (with Patricia MacKay) *The Walt Disney Concert Hall—The Backstage Story*, and in 2011, *A Theatre Project—A Backstage Adventure*, about which critic Michael Coveney wrote, "It is an absolute joy to read . . . a history of theatre from an entirely new and fresh perspective."

**Duncan M. Webb**, President of Webb Management Services, Inc., has been a management consultant for the development and operation of performing arts facilities for 29 years. Duncan entered the theatre profession as a lovesick maiden in Gilbert and Sullivan's *Patience* in 1969. Since then, he has completed degrees in economics and business administration, worked in international banking, produced commercial, industrial, and experimental theatre and has been teaching for New York University's graduate program in performing arts administration since 1990. He worked for Theatre Projects Consultants from 1989 to 1995 and founded Webb Management Services in 1997. That practice

has completed over 350 feasibility studies, business plans, and strategic plans for facilities, organizations, and districts. Duncan is also the author of *Running Theaters: Best Practices for Managers and Leaders*, published by Allworth Press in 2004. He lives in New York City with his wife and two children.

**Ann Patricia Salamunovich Wilson,** CPA is the Assistant Production Supervisor at Portland'5 Centers for the Arts in Portland, Oregon. Annie Wilson holds degrees from the University of Notre Dame and the University of Oregon. She is a licensed CPA and has worked as a Senior Auditor and Revenue Manager in the United States and internationally. She is overjoyed to spend her days (and some nights) working backstage. Annie is an active member of the International Association of Venue Managers (IAVM), where she serves on the Performing Arts Committee and presents at the Performing Arts Managers Conferences. Annie was selected as one of IAVM's "30 Under 30" Venue Professionals in 2015.

**Steven A. Wolff,** CMC is the founding Principal of AMS Planning & Research Corp. and AMS Analytics LLC. For over 25 years, Steven has provided counsel to leading arts, culture and entertainment enterprises on strategic initiatives, the planning and development of capital facilities, and arts sector and consumer research. AMS has played an instrumental role in the planning, and operation of dozens of the most significant performing arts center projects in North America representing community investments of nearly $8 billion. Steven provides research and management counsel that explores innovative business models including change initiatives, governance evolution, operational and strategic planning and program evaluation for diverse organizations. His blog, *Re-thinking Success*, explores new models of operation in the arts sector in a time of dynamic change. AMS's research practice, AMS Analytics LLC, is an acknowledged industry leader in benchmarking, operations analysis, and arts consumer and market information. PAC Stats$^{SM}$, introduced in 2002 is now used by more than 40 large performing arts centers across North America, the United Kingdom, and Australia. Steven is a frequent keynote speaker at industry conferences and is on the faculty at the Yale School of Drama where he received his Master of Fine Arts degree in theater administration.

**Joanna Woronkowicz,** PhD, is an assistant professor in the School of Public and Environmental Affairs at Indiana University in Bloomington, where she conducts research in cultural policy and nonprofit management. She studies artist employment behavior and facility development for nonprofit arts organizations. Her work can be found in the *Journal of Planning Education and Research, Cultural Trends,* and *Nonprofit Management and Leadership.* In 2014, Joanna released a coauthored

book, *Building Better Arts Facilities: Lessons from a U.S. National Study* (Routledge). The book examines the ways in which arts organizations planned and managed building projects during the most recent cultural building boom, and investigates organizational operations after projects were completed. Before Indiana University, Joanna served as the Senior Research Officer at the National Endowment for the Arts. She received her PhD in Public Policy from the University of Chicago.

# Index